DIVINE NAMES

The 99 Healing Names of the One Love

DIVINE NAMES
The 99 Healing Names of the One Love

by Rosina-Fawzia Al-Rawi

Translated by Monique Arav
Arabic Calligraphy by Majed Seif

OLIVE
BRANCH
PRESS

An imprint of Interlink Publishing Group, Inc.
www.interlinkbooks.com

To my companions on the path
Mona and Maryam
and to my sons
Nour and Qais
in deep love

First published in 2015 by

OLIVE BRANCH PRESS
An imprint of Interlink Publishing Group, Inc.
46 Crosby Street
Northampton, Massachusetts 01060
www.interlinkbooks.com

Library of Congress Cataloging-in-Publication Data
Al-Rawi, Rosina-Fawzia B.
[Hauch der Ewigkeit. English]
The 99 healing names of the one love : the most beautiful names of God / by Rosina-Fawzia Al Rawi ;
translated by Monique Arav ; with calligraphy by Majed Seif. -- First American edition.
 pages cm.
Translated from German.
ISBN 978-1-56656-987-3
1. God (Islam)--Name. I. Arav, Monique. II. Title. III. Title: Ninety nine healing names of the one love :
the most beautiful names of God.
BP166.2.A38913 2014
297.2'112--dc23
 2014021490

This book is intended to supplement, not replace, the advice of a trained health professional. If you know or suspect that you have a health problem, you should consult a health professional. The author and publisher specifically disclaim any liability, loss, or risk, personal or otherwise, that is incurred as a consequence, directly or indirectly, of the use and application of any of the contents of this book.

Printed and bound in the United States of America

General Editor: Michel Moushabeck Proofreading: Jennifer Staltare
Editor: John Fiscella Cover design: Pam Fontes-May
Editorial Assistant: Lauren Delapenha Book design: Leyla Moushabeck

TABLE OF CONTENTS

ACKNOWLEDGMENTS

My thanks go out to all the great souls Allāh has given me to meet, with whom I was allowed to stay, and from whose light and wisdom I could drink.

To my husband and my children I offer my deepest thanks for their patience and love.

I would like to thank Mona M. Arav for her devoted help, her great effort in translating this work, and making this project possible, and Maryam L. Day for the time she devoted to proofreading.

To my teacher, Shaykh Sidi Muhammad al-Jamal al-Rifa'i, I would like to express my special gratitude and love. With infinite love and patience he has accompanied me through the mountains and valleys of my self, showing me what it means to become a human being. More than anything, I thank him for sowing in my heart the seeds of trust, telling me time and again, "Everything is in you. Learn to read!" I was privileged to spend twelve years of my life close to him, and to be allowed to sit near him in silence, basking in the light of his great soul. A deep bond developed in those precious years, both as his student and as his daughter-in-law following my marriage to his son. I will treasure these years all my life.

NOTES ON THIS EDITION

Sources

All quotations from the Holy Qur'an are from *The Message of the Qur'an*, translated and explained by Muhammad Asad (Islamic Book Trust, 2011).

In attempting to illuminate the Divine Names, I am indebted as well to the oral tradition of wisdom transmitted by Shaykh Sidi and other teachers in the form of commentaries, sayings, and stories. Other quotations in this book are from the author's personal notes and from the several sources listed in the bibliography.

Translation

Throughout this translation, the plural form has been used wherever possible to refer to both genders. Wherever the masculine has been used without referring to a male person, this choice was made so as not to hamper the flow of reading. But it is intended to convey a universal meaning and refers to both women and men.

For the sake of simplicity and consistency, Allāh, God, the Eternal Great Beloved, is referred to as 'He' in this book, although the Absolute is clearly neither male nor female, but encompasses both, yet is beyond everything.

Calligrapher's Note

The *Diwani* style of Arabic calligraphy was chosen to create the artworks of this book. *Diwani* is a cursive style and is the most flexible, artistic, and decorative of all the Arabic calligraphy styles. It is derived from the *Riqa* and *Nasta'liq* styles and was developed during the reign of the early Ottoman Empire (sixteenth to early seventeenth century). It was labeled the *Diwani* style because it was used in the Ottoman *diwans*, or ministries and official departments of the empire, and was one of the secrets of the sultan's palace. The rules of this script were not known to everyone, but confined to its masters and a few bright students. It was used in the writing of all official decrees and resolutions. A sub-style of the *Diwani* is called the *Jeli Diwani* style. The letters in this style are very intertwining, and the diacritical marks are written in a full and very compact way.

—Majed Seif

PREFACE

This book is meant to serve as an introduction and modest contribution to the understanding of the Divine Names. It reflects knowledge gathered from my teacher, Shaykh Sidi Muhammad al-Jamal al-Rifaʻi, as well as other teachers and scholars.

Sidi comes from the tradition of the Shaduliyya school, a widespread Sufi school named after the great Sufi master Abu al-Hasan ash-Shaduli, who was initiated by the distinguished Moroccan Sufi master ʻAbd as-Salām ibn Mashish and who spread his knowledge especially in Tunisia, and in Egypt where he was buried in 1258.

The path of the Shaduliyya school reflects modesty. Outer deeds should be balanced, marked by moderation and harmony, while on the inner level seekers are meant to connect their heart to Allāh through remembrance. One of the prerequisites on this path is to be involved in life: seekers have a job, a family, and a community, and lend expression to their inner development through their outer deeds. Indeed, it is not so difficult to be balanced, dignified, and peaceful when you live in seclusion in a cave. But to hold to these qualities while living among people demands magnanimity, composure, trust, willpower, and self-control, as well as reflection, contemplation, and deep love. Learning to draw from our deep self, to see things from inside, in their primeval quality and in Unity, calls for a deep transformation because the ego loves to look at things from the outside and to view them as fortuitous, thus outside of the Divine.

INTRODUCTION

On Sufism

Sufism is a path that teaches us a way to discover our own self, our talents, our potential, and to find our own true reality and the miracle that we are.

Sufism is not a theoretical system arrived at by conclusions or reflections, but an unfolding practice to be experienced. It was revealed by the messengers and prophets who were living examples of this path and who used it to attain the state of absolute knowledge.

Two forces, longings, live in us human beings, a vertical one and a horizontal one: love of God and love of humankind and the Creation.

We are undecided, lost, and confused when we do not know where we stand, when we go through life aimlessly, constantly gasping for breath as we react to outer circumstances. Every day we go through a whole range of states: one moment open and friendly, the next annoyed and fearful, honest then hypocritical, courageous then afraid, deeply satisfied then unhappy, tolerant then petty, generous then calculating. What do all these changing states mean? Why do they occur? How should I respond to them?

The more we know God, the more we love Him, just as the best way to know human beings is to love them. Love of our fellow human beings and compassion are the most elementary expressions of our journey to becoming whole. This love is strong enough to break the chains of isolation and to dissolve the stubborn and passionate separations between me and the other, the rest of the world. It purifies the heart and frees the spirit from egocentric obstacles. Loving our fellow human beings requires the elimination of selfishness. It is an expansion that occurs when the heart cleans itself of the dark stains of greed, envy, and arrogance. Indeed, sympathy for all living beings and love of one's fellow human beings are the basis of an authentic morality.

From the ordinary perspective of separation, we human beings are nothing; from the perspective of Unity, of Divine Reality, we are everything. Wholeness is perfection, and we are part of it, we are a part of Creation. Depending on the point of view, we are either "nothing" or "everything" compared to God. With respect to the universe, we are a part of this created perfection. Wholeness vibrates in our center, our divine core whose outermost periphery is the ego.

The Sufis' aim is to go through the periphery of the ego and become present to the divine center, while at the same time seeking their own wholeness. It is the journey that leads us back home from

exile, back to our center, to our true self, through recognizing the unity of existence. The path and the center are the landmarks on this journey.

Cognitive powers are the greatest gift to humankind. The Prophet Muhammad, Allāh's peace and salvation be upon him, said, "God created nothing nobler than the cognitive powers and His wrath descends on those who disdain them."

We human beings have been given cognitive powers, but temptation always tests our willpower. Human willpower is the wind—if it rests in the divine will, it reflects clearly the eternal, perfect ocean within us. If it is disturbed by the turbulence of the ego, the reflection of the sun becomes disturbed and the divine reflection distorted. Evil and disharmony are not the opposite of God, but resistance to Him. Everything comprises and comes from the same source. The Divine contains both black and white, male and female.

The concept of duality is there for us to find our bearings in this world, not to remain imprisoned in it. Duality only exists in this world in order to lead us to Unity. Duality is a world of seemingly opposite poles that actually complement one another and are not truly antagonistic. Everything is interwoven in an inseparable energetic pattern.

Using and going deeper into the Divine Names, especially pairs such as Aḍ-Ḍār, An-Nāfiʿ (the One who creates harm and the One who creates what is useful) or Al-Qābiḍ, Al-Bāsiṭ (the One who pulls together and the One who widens) helps us to transcend the linearity of the mind and grasp the reality of the interconnectedness of all things. Sufis seek refuge in the Divine until they can but call out, "Beloved," whether they are with one name or the other, in a confused or an easy situation, because they are able to grasp everything with the wisdom of the heart. The deeper and wider our consciousness becomes, the more we free ourselves from the isolation of the ego and the more we can understand this reality.

The way consists in bringing the periphery of the ego closer and closer to the center of the true being. The variety of outside manifestations is meant to help us take the path that leads to the inner dimensions where everything flows into Unity, dies, and is born again.

To find the balanced center between the two forces we carry within us is the path of the Sufis. We are both celestial and earthly beings. We are celestial like the angels who can do but good, resting in the praise of the One, and we are earthly like animals that follow their instincts and needs. Both angels and animals are determined and cannot choose their path. Yet we human beings have been granted cognitive powers. We are therefore capable of understanding and reflecting. Thus we inherit the duty and burden of free will. Since we are aware of ourselves and of our deeds, we also carry the consequences of our acts. If we turn to our true, deep divine being, with all the struggle that entails, we rise above the angels because of our conscious decision. If we choose to follow our impulses and selfish, egocentric needs, we fall lower than animal life.

Human dignity lies in this conscious decision and exertion. Step by step, breath after breath, we steadily win the ego over, transforming it and taking on the colors of the divine attributes, always more, always deeper. Thus do we human beings reach our true destiny and nature. It is therefore essential to get to know oneself in order to use those methods that will lead us to our true being, to love, to the meaning of our existence, to the Great Beloved, in and around us and beyond everything!

Rumi aptly defined the human being as "a donkey's tail with an angel's wings!" Human beings carry within themselves the unity of all existence and are thus called the core of Creation.

Be aware of your eternity and of the "timeless instant" brought about by your remembrance of Allāh! As the Sufis say, become "the daughter, the son of the moment" and not worry about tomorrow! For it is only in the present, irreplaceable moment, in the Divine "now," that we belong completely to God.

Stand up and start walking, open your heart, let yourself whirl and turn in the divine perfection, knowing that everything comes from Him and returns to Him. The Sufis' ultimate goal is to know the Divine, to become one with God, dissolving the chains of the complacent, selfish, anxious ego, to focus our being on love as the uniting force. Rābi'a al-'Adawiyya tells us, "Neither the fear of hell nor the hope for paradise are important, only the experience of God's eternal beauty."

Introspection and spiritual purification of the heart are essential for those who seek to know the Divine, the Eternal Reality. This is what the Sufis call the "greater jihad," or *jihad un-nafs*, "the great battle against the wounded ego's striving for isolation." Therefore, jihad means "effort for the Divine" against selfish passions and weaknesses. Jihad comes from the verb *jahada* and means to strive, to fight, to work on oneself, to exert oneself for something good and against evil. It takes a great effort of will to fill the ego or *nafs* (نفس), with compassion, with love of one's fellow human beings, with the knowledge that their state and situation are indeed connected with one's own, and the only way to realize this is to discover the original source and essence that connects us all. So I slowly open my heart and say, "Yes, trust, come, love, come and touch me! I'm afraid of the consequences. I'm afraid that pain may come, too. But I want to become whole, I want to dive out of isolation, and I will go into the required battle and care so that I may be healed!" In this sense jihad is a healing, holy battle, until such time that the state of the "soul in peace" is reached.

The practices entail prayer, meditation, dance, music, retreat (*khalwa*, خلوة), and remembrance and awareness of God (*dhikr*, ذكر). But the focus is always on everyday life, dealing with fellow human beings and deeds. This is the true arena for practice and reflection. Divide your day into two parts and be in the quality of gratefulness (*shukr*, شكر) inhaling experiences during the day, and in the quality of remembrance, *dhikr*, exhaling in contemplation and inner learning during the night. Day and night are meant as symbols whereby "day" is the God-given capacity of human beings to gain insight through

conscious, sensible thinking, and "night" the intuition that comes out of silent, quiet devotion and answers the voices of your heart.

Sura al-Naml, سورة النمل, The Ants (27:86)
Were they not aware that it is We who had made the night for them, so that they might rest therein, and the day, to make [them] see?

The first steps to depart from the evil of the complacent, selfish ego, and to start walking toward the Divine, are often accompanied by a heartrending loneliness. One separates from the familiar, often also saying goodbye to existing relationships.

Sura al-Nisā', سورة النساء, Women (4:100)
And he who forsakes the domain of evil for the sake of God shall find on earth many a lonely road, as well as life abundant.

In order to walk this path, the seeker needs a teacher—someone who has walked this path, who knows the ego's intricate traps, and who is steeped in the love of God. But the seeker also needs supportive and encouraging companions.

The path and goal is beauty, *ihsān*. *Ihsān* comes from *husn*, beauty, grace, and it means to approach, live, and carry out everything in the most beautiful way possible, for according to the Prophet's transmission, *ihsān* means to worship God as if you saw Him, for even if you cannot see Him, He can see you. *Ihsān* is the perfectly sincere worship of God, when knowledge and will have completely merged with the Divine.

Sufism teaches us that human beings are the perfect image of the universe! If we look at the universe, at nature, we find so many manifestations of harmony, balance, and peace. Why do we find so little harmony, balance, and above all no peace among people?

The ego has been granted a mind and free will, and it uses them to fulfill its wishes and satisfy its appetites as best it can. In its egocentric attitude, the ego rejects the true holy balance and is willing to destroy not only our personal and social relationships but also nature and the entire planet in order to satisfy its appetites. Although we do everything to reach satisfaction, we keep feeling that something is missing, and this feeling pushes us constantly towards more "progress."

Yet our true identity is not a conglomeration of appetites and behaviors. Although from the genetic viewpoint we are very similar to stones, plants, and animals, there is a core, an essence, an inner light, an existence that distinguishes us human beings and that we can consciously reach with our mind and our heart.

It is to this existence that all the prophets and great masters have turned, according to the circumstances of time and space. Although the insights differ, they all show the One Reality. They do not

address our feelings, our behavior, or our intelligence. Their words are always directed at our essence that exists from the very start until the end, eternally. Everything changes: our body, our thoughts, our ideas, our relationships, our inclinations, and our aims. Yet, this true self is undying, eternal.

To harmonize ourselves with this true self means to make ourselves available for our true destiny. We first have to connect to our true nature before higher forms of energy can begin to manifest clearly and free of distortion. The isolated, self-serving ego, which so often enslaves us to our hypocritical and petty needs and impulses, is sluggish and slow. To leave the ego-self and open to the true self is to be gripped by love's fast whirling that repulses everything heavy and attracts the divine light. It means to carry in one's heart a commitment to humankind and to this planet, indeed to the whole universe. It means to fall in love with oneself, with this eternal divine nature that vibrates in our center and, if we allow it, leads us through life with its boundless grace and mercy. It is the daily battle for light, love, kindness, harmony, tolerance, and peace.

In essence, the prophets have all brought us the same message: "Know thyself!" The Prophet Muhammad, Allāh's peace and salvation be upon him, also said, "He who knows himself knows his Lord!"

It is our destiny, in our finite nature, we who are subject to the changes of time, to set out to discover the eternity that also pulsates in us.

The aim of Sufism is to guide people there, to enlighten them, and to lead them to their sanctum, to divine energy. The path is love, and love is nourished through spiritual practices and sincerity, until the heart and the spirit understand the meaning of existence. As Rumi says, "The result of my life is contained in but three words: I was unripe, I ripened, and I was consumed!"

The wisdom of the Sufis dwells in the core of all religions through knowledge, *ma'rifa*. It uses the difference between the Absolute and the manifestations, essence and form, inside and outside, in order to connect and unite the truth, *ḥaqq*, and the world, *dunyā*. That union takes place in the human heart.

The aim of this book is to help open a space in the heart of the reader, where the seeds of longing and love for the beauty and the majesty of the Divine Names can be sown. Eventually, this may allow the reader to taste the beauty and the dignity of this world, to see the majesty of the Creator, and to come closer to their fellow human beings.

The Divine Attributes
All Divine Names reflect the various aspects of the One, All-Encompassing Love, Allāh. Through the Divine Names, we try to sense the presence of the infinite in the finite. The Names describe how to come closer to God. Since they have themselves been created by God, they cannot contain Him, but they give us the possibility of knowing Him through them. Still, this knowledge will always be according to

human assessment. The only way to approach Him is to "take on" the colors of His attributes, namely, to set out to our own perfection and to use His attributes on ourselves until such time when the divine light out of which we were formed shines through our earthly shell and we become that which we truly are and were—before we came to this earth.

To repeat the Divine Names is to clad the ego, the *nafs,* with the divine attributes. In doing so, we aid the eternal holy part in us to blossom, and for that, the *nafs*—the complacent, selfish part in us—must first relinquish or transform its weaknesses, prejudices, and negative habits. Opening and awakening the heart leads to an expansion that enables us to feel connected, thus touching and uniting the Creation.

God creates the world anew in every instant. Should He not, the world would collapse, and so He is at work in every manifestation. No other origin, no law of nature, could be effective between God and the manifestations save through human beings, who have been created as those who bring about unity between heaven and earth. As God's representatives on earth, human beings were granted both celestial capacity for knowledge and earthly free will. Through their existence, they can bring harmony or disharmony into this world.

God created the world out of opposites; He created a God-willed inequality in order for us to come together and gain knowledge.

It is therefore not by chance that human opinions and ideas are characterized by endless differences. This is a fundamental, God-willed aspect of our human existence. Had God wanted us to share a single viewpoint, there would have been no progress, no possibility for growth, and our free will, which enables us to choose between right and wrong, thus endowing our life with a moral sense and a spiritual force, would have been invalidated.

When the world came into existence, its longing to return to the original state of Unity was born, too. Any bear is stronger than a human being, any leopard can run faster, any fish swims better, and any bird flies higher. Yet only human beings have the capacity to lead the world to Unity and to bring heaven and earth into harmony.

Whether we acknowledge it or not, we human beings are searchers. We seek to understand, we want to know and to be known. Our quest may take many forms, yet ultimately it ends in nothing but pure praise of God, even if this comes after our last breath. In the end, all that remains is present in all levels of existence. Praising God, knowing the Divine, is the true meaning of Creation.

Nothing in this world is alien to us human beings. All the creatures of this world are interwoven in our being and permeate our spirit. When we recognize that we are the soul of Creation, the gates of life open to us, and our deeds, words, and thoughts can reflect the divine truth embedded in Creation.

Recitation of the Divine Names, or *dhikr*, is an outer ritual that should have an inner meaning. Conversely, an inner attitude receives its ultimate value when it is reflected in our deeds.

The outside always furthers the inside because the task and the meaning of life is always about reuniting and connecting everything on the outside to its inner truth. It is the knowledge of the heart that is always able to bring unity. Such is the path of the Sufis.

Outer deeds leave memories out of which inner values can grow. The regular repetition of outer spiritual practices and rituals strengthens and stabilizes the inner attitude of unification, until more and more parts of our being participate in this path. It is like an oar regularly lowered into the water to give the boat steady progress towards its destination.

> For there is a Unity between meaning and form. As long as they do not come together, they are of no use, just as the peach kernel will not grow unless you plant it with its shell.
>
> —Rumi

We simply cannot gain knowledge before choosing a path. First we must start on our way, and only then are we granted knowledge. God's gifts cannot be predicted or planned. First we must plough, sow, and water—then we harvest. We therefore have to take a risk. Abiding by spiritual rules does not guarantee an easy life in this world. Yet, a transformation takes place when we let go of complacent pictures, open ourselves, and start walking on a spiritual path without expectations. New doors open, our views and our ways of thinking undergo a transformation, leading us to a new attitude. Standing on the shore and wanting to understand the ocean does not work. We have to go into the ocean and start to swim, to experience, in order to gain knowledge.

It would be overly simplistic, and contrary to the meaning of being human, for us to delegate our deeds back to God and to be content with abiding by a host of rules. The human path is—and remains—a venture, a challenge, a test of courage. We cannot gain security by observing rules, and it is futile to look for guarantees. We can only learn, step by step, one heartbeat after the other, to put ourselves unconditionally into God's hands.

> Yet the true aim of prayer and meditation is not the fulfillment of our wishes. Rather, it is to transform our will so that it may unite with the Divine will. Then Divine will can flow through our soul and transform us so that we accept our fate as our own choice.
>
> —Iqbal

The 99 Divine Names indicate how God can be seen and known in this world.

> Allāh said, "I was a hidden treasure and I wished to be known. So I created the Creation (humankind) for Me, so that they know Me through Me." The Names hidden in Him longed to manifest. And so, just like the breath escapes the body when it has been held for too long, the Divine Names broke out of the hidden and forever inaccessible Divine Being, because

they longed to be known and loved. This is described as *nafas ar-raḥmān*, the divine breath that blows throughout the Creation and lets the divine words work. The Names encountered nonexistence, which reflected them like so many mirrors. Thus, to a certain extent, the world is a reflection of the Divine Names. It only exists as long as its face—the surface of the mirror— remains turned towards God, failing which it will vanish because it depends absolutely on God. Yet God remains unchanged, untouched by the world and He may only be approached through the reflection, so that everyone knows Him in his own way, according to the Names which manifest most strongly in them.

<div align="right">—Ibn al-'Arabī</div>

The Divine Names polish the mirror of the heart so that we may come to know the Creator both in His transcendence—greater than the created world, and in His immanence—present in everything. All 99 names are an expression of love that heals the heart, and so our entire being.

Seekers learn to let go on the inner level, while walking the right path on the outer level, their feet steady and their hearts awake. They learn to deal with paradoxes and to discern the all-encompassing Unity behind duality. They learn to become loving warriors on the path of unconditional love whose outer expression is kindness and compassion towards self and others, and whose inner expression is freedom.

USING THIS BOOK

Reciting the Divine Names

The recitation of the Divine Names is a form of remembrance of God, or *dhikr* (ذكر). By using the Divine Names, by repeating them, the mirror of the heart is polished from the rust of mundane thoughts and activities so that our essence, our divine light, may show itself free from any distortion and in its full brightness.

Readers who are unfamiliar with the Arabic language and wish to listen to the Divine Names are welcome to download the corresponding MP3 files (www.fawzia-al-rawi.com/en/downloads/). They will find two recitations of the 99 Divine Names (one slow, one fast), as well as individual files for each name, which may assist them with pronunciation and tone stress. It is recommended, especially at the beginning, to say the Divine Names aloud, in such a manner that we can hear our own voice. The Divine Name moves and resonates throughout our body, through our entire system. Slowly, our voice and the inherent vibration of the name come closer, and the essence of that name starts moving us. We often experience various forms of resistance, but also an intense echo within. Sometimes a Divine Name will touch precisely that spot where we are separated—from awareness of our soul, from our family, our community, from humankind, from God, from the all-encompassing eternal existence. The field of the subconscious is touched because this is the locus of our separation wound, the wound that we try to protect at all costs, sometimes by most intricate means.

The silent repetition of the Divine Names is especially recommended once the seeker can be called *murīda* (feminine) or *murīd* (masculine), meaning someone who clearly wants to put all his energies, aspirations, and will into the path to Allāh, to the Absolute, to the eternal Love, to the Beloved.

To forget oneself, to open oneself beyond the ego, the *nafs*, so as to be touched by the Divine Names, is essential in order to reach the deeper layers of existence.

When we work with the Divine Names, we can choose them so as to touch a weakness, to touch what is missing, so that we become aware of it and integrate it into the wholeness of our being. Alternatively, we can choose them so as to stimulate and develop a quality that is innate and already strong in us. This quality then starts spreading through our whole being, giving us the strength to turn to our weaker, wounded areas.

It is important to keep a balanced approach. Excessive insistence on what we are lacking can starve us, while extended concentration on what we have in abundance can be exploited by the ego.

To discover our true nature, that being, that soul that is an image of the Divine, to become an intact, integrated, embedded individual is the inspiration conveyed by the Divine Names. Thus, the Divine and the human, mercy and love, unite within us.

If a human being starts seeking the Absolute and puts every effort into that search, they will find the Divine Names to be a gate through which they can go. If, for the time being, a human being focuses attention on the relative, namely on becoming whole and embedded, may the Divine Names grant them the blessing and the love they need.

Reciting the Divine Names helps and supports us human beings on our path towards individual completeness through their meaning, through the form and sound code they contain, through the force of their letters, which are connected to various parts and organs of the body, and through their numerical value, which is derived from the combination of letters and indicates the most useful number of repetitions.

Each Divine Name is filled with divine vibrations that are reflected in everything around us. They protect us and permeate our body and our whole being. Every syllable of a Divine Name contains resonance that transforms the atmosphere. The contemplation of the Divine Names bears a direct gift of peace and happiness, turning us away from the mundane and toward the Divine. We should neither exert ourselves nor try to achieve any specific aim when we repeat a Divine Name. Rather, we should attempt to be sincere, to feel our love for God, and to make our heart available for this opening. The power will follow, whether we perceive it or not.

Despite the power of the Divine Names, we will perhaps not feel their effect straight away, but results will come. We can change things through reciting the Divine Names, singing them, or repeating them silently. There is no fixed or limited time to practice. We can let the Divine Names accompany us and flow into our heart all day long. Then the heart begins to vibrate and gradually takes over the singing of our tongue, and later our soul starts repeating the sound that it has been yearning for, for so long. Whenever you can, cultivate contemplation of the Divine. You can do that during any activity, although it is easier with a physical activity involving no mental work. It has been demonostrated scientifically that the regular practice of meditation aids our mental, emotional, and physical health in many different ways, while benefitting our daily life in a deep, inspiring manner.

Each Divine Name in this book is followed by three numbers. These three numbers represent the total number of repetitions of a name used for healing on the level of: (1) the body, (2) one's family or social community, and (3) awareness of our connection to the Divine.

The suggestions contained in this book for reciting the Divine Names with a specific number of repetitions and at particular times of the day or night have been transmitted by several teachers: Shaykh Sidi Muhammad al-Jamal al-Rifa'i, Shaykh 'Abd al-Maqsud Muhammad Salim, and Shaykh Tosun Bayrak al-Jerrahi al-Halveti.

All the indications, explanations, and supports mentioned in this book are meant to help us discover the jewel, the true eternal being to which all the prophets have turned. One layer after another, we take off the veils of isolation in the search for the Absolute, the primordial cause of all existence, Allāh, seeking His closeness, asking for His help, feeling His love. This is a search with the eyes of the heart and the light of the mind, uniting dignity and joy, bringing together this world and the beyond, uniting the visible and the invisible.

There are 99 names that belong to Allāh, he who learns them,
tastes them, understands them, and can list them
will enter Paradise and attain salvation.

— Prophet Muhammad

ALLĀH

1 Ar-Raḥmān
2 Ar-Raḥīm
3 Al-Malik
4 Al-Quddūs
5 As-Salām
6 Al-Mu'min
7 Al-Muhaymin
8 Al-'Azīz
9 Al-Jabbār
10 Al-Mutakabbir
11 Al-Khāliq
12 Al-Bāri'
13 Al-Muṣawwir
14 Al-Ghaffār
15 Al-Qahhār
16 Al-Wahhāb
17 Ar-Razzāq
18 Al-Fattāḥ
19 Al-'Alīm
20 Al-Qābiḍ
21 Al-Bāsiṭ
22 Al-Khāfiḍ
23 Ar-Rāfi'
24 Al-Mu'izz

25 Al-Mudhil
26 As-Samī'
27 Al-Baṣīr
28 Al-Ḥakam
29 Al-'Adl
30 Al-Laṭīf
31 Al-Khabīr
32 Al-Ḥalīm
33 Al-'Aẓīm
34 Al-Ghafūr
35 Ash-Shakūr
36 Al-'Alīy
37 Al-Kabīr
38 Al-Ḥafīẓ
39 Al-Muqīt
40 Al-Ḥasīb
41 Al-Jalīl
42 Al-Karīm
43 Ar-Raqīb
44 Al-Mujīb
45 Al-Wāsi'
46 Al-Ḥakīm
47 Al-Wadūd
48 Al-Majīd
49 Al-Bā'ith
50 Ash-Shahīd

51 Al-Ḥaqq
52 Al-Wakīl
53 Al-Qawīy
54 Al-Matīn
55 Al-Walīy
56 Al-Ḥamīd
57 Al-Muḥṣī
58 Al-Mubdī'
59 Al-Mu'īd
60 Al-Muḥyī
61 Al-Mumīt
62 Al-Ḥayy
63 Al-Qayyūm
64 Al-Wājid
65 Al-Mājid
66 Al-Wāḥid
67 Al-'Aḥad
68 Aṣ-Ṣamad
69 Al-Qādir
70 Al-Muqtadir
71 Al-Muqaddim
72 Al-Mu'akhkhir
73 Al-'Awwal
74 Al-'Ākhir
75 Aẓ-Ẓāhir
76 Al-Bāṭin

77 Al-Wālī
78 Al-Muta'ālī
79 Al-Barr
80 At-Tawwāb
81 Al-Muntaqim
82 Al-'Afūw
83 Ar-Ra'ūf
84 Māliku-l-Mulk
85 Dhū l-Jalāli
 wa-l-Ikrām
86 Al-Muqsiṭ
87 Al-Jāmi'
88 Al-Ghanīy
89 Al-Mughnī
90 Al-Māni'
91 Aḍ-Ḍār
92 An-Nāfi'
93 An-Nūr
94 Al-Hādī
95 Al-Badī'
96 Al-Bāqī
97 Al-Wārith
98 Ar-Rashīd
99 Aṣ-Ṣabūr

ASH-SHĀFĪ

THE DIVINE NAMES

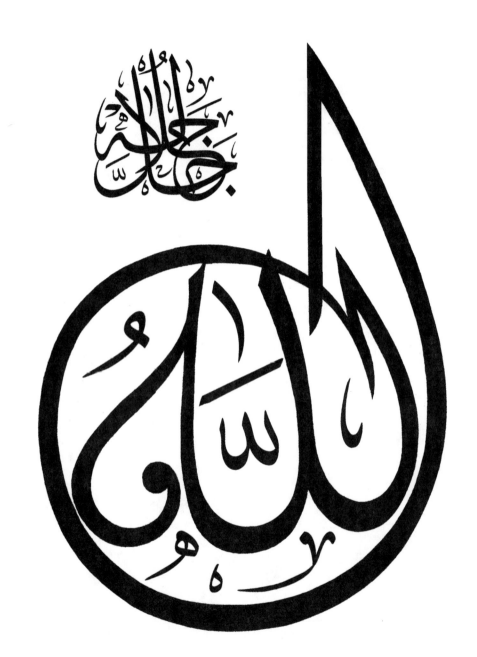

<div align="center">

الله

ALLĀH

The Eternal Reality
That which Is
66–264–4,356

The first step is to say "Allāh" and nothing else.
The second step is intimacy, and the third, combustion.
— 'Attar

</div>

Allāh is the presence of all names. Allāh is the name of the Absolute Being that embraces all the other Divine Names. Allāh is the all-containing Divine Reality. The Divine Names flow out of the one Divine Being, at one with Him and carrying Him within the manifested world.

The essential meaning of Allāh is deep, passionate love, all other Divine Names being different aspects of this One Love. The 99 Divine Names were given to us to help us break through to our true nature and to the source, the origin, of all existence. Generally speaking, each Divine Name works on two levels—taking us closer to the Divine, while aiding us to come closer to our true self, our true nature.

Allāh longed to make His being visible in an all-encompassing being—the world. The Divine Names flowed from His being into the manifestations, and this was the beginning of a tale of yearning between the Creator and the creature. In the depths of our being lies a divine spark that contains all the Divine Names. This is the place of inner peace and submission. Yet by sending the Divine Names into

the world of manifestations, Allāh removed peace from the world so that it now whirls in search of the Divine, while we human beings seek inner peace, between inner quiet and outer disquiet, outer quiet and inner disquiet.

Allāh is beyond gender and should not be used in the plural. Yet the divine magnificence shows itself both in the masculine and the feminine.

As Ibn al-'Arabī tells us:

> We ourselves are the attributes by which we describe God. Our existence is merely an objectification of His existence. While God is necessary to us in order that we may exist, we are necessary to Him in order that He may be manifested to Himself.

Allāh is the greatest, most magnificent name of the One, the Lord and Creator of the worlds, to whom nothing and no one can be compared, who sent His revelations to human beings, among them Noah, Abraham, Moses, Jesus, and Muhammad—peace be upon them all.

The Divine Names and their attributes come into existence through our discerning mind. Yet there is only one truth, so that the qualities of one name are found in the others in some form. It can only be this way because truth is one, and although this oneness carries the outer quality of differentiation, there is reciprocity, a correlation, an omnipresence.

Diversity does not contradict the uniqueness of divine existence. Ibn al-'Arabī uses the example of fire to help us understand. Fire has a specific nature, but its effects vary. Fire burns wood, it burns paper into ashes, and it has another effect on water. Through fire copper becomes white, gold liquid. Despite its different effects, the nature of fire—its being—remains unchanged. The different effects of fire manifest according to the essence and the state of that which it encounters. This is how the uniqueness of the Divine and the variety of its manifestations should be understood.

Sura al-Baqarah, سورة البقرة, The Cow (2:255)
GOD—there is no deity save Him, the Ever-Living, the Self-Subsistent Fount of All Being. Neither slumber overtakes Him, nor sleep. He is all that is in the heavens and all that is on earth. Who is there that could intercede with Him, unless it be by His leave?
He knows all that lies open before men and all that is hidden from them, whereas they cannot attain to aught of His knowledge save that which He wills [them to attain].
His eternal power overspreads the heavens and the earth, and their upholding wearies Him not. And He alone is truly exalted, tremendous.

The name Allāh contains the aspects of transcendence and all-encompassing wholeness, radiating serenity, sublimity, and mystery.

All Divine Names are various perspectives and insights of the name Allāh, the One Almighty All-Encompassing Love. They all melt and unite in this name.

Sura al-Anʿām, سورة الأنعام, Cattle (6:162–164)

Say: "Behold, my prayer, and [all] my acts of worship, and my living and my dying are for God [alone], the Sustainer of all the worlds, in whose divinity none has a share: for thus have I been bidden—and I shall [always] be foremost among those who surrender themselves unto Him."

Say: "Am I, then, to seek a sustainer other than God, when He is the Sustainer of all things?"

To hear ourselves when we repeat Allāh aloud gives us the strength to dissolve the illusion of separation, the fixed idea that so often turns into an obsession, so that we may catch the fragrance that connects us to our own essence, healing the wounds of separation and isolation. The stream of Unity removes the stubborn barriers of separation, taking us to the core where eternity pulsates in us and where we are filled with the divine qualities. Nothing can dissolve the illusion of separation like the power of ecstatic love through Allāh.

Every Divine Name can be recited together with Allāh. Jesus too used the Aramaic word *Alaha* for God.

Everything begins with the treasures hidden in this name.

"The perfect knower recognizes Him in all the manifestations in which He reveals Himself and in every form in which He shows Himself."
—Ibn al-ʿArabī

"And when the journey to God comes to an end,
comes the beginning of the infinite journey in God."
—Iqbal

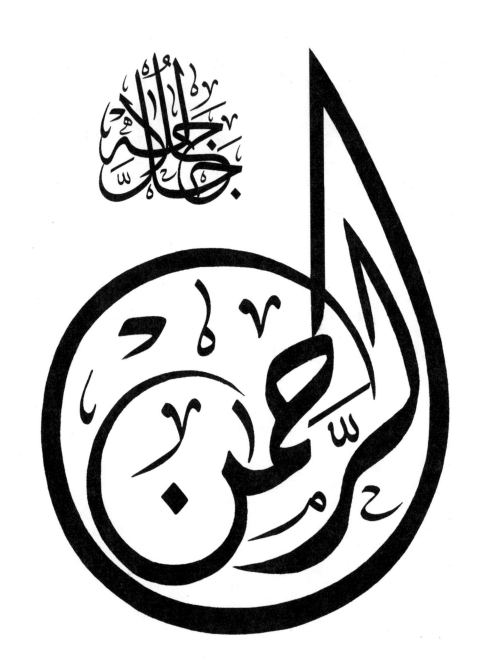

1

AR-RAḤMĀN

The Most Gracious, the Most Merciful, the One who brings blessings, the Compassionate
298–1,192–88,804

Ar-Raḥmān is like the ocean of infinite kindness and beauty. Ar-Raḥmān is the tide, overflowing in its mercy, all-embracing in its nature. It is the gate through which all the Divine Names flow.

The 99 prayer beads correspond to the 99 most beautiful Divine Names, which start with Ar-Raḥmān, Ar-Raḥīm, the Most Gracious, the Most Merciful, the two names of mercy that mark the beginning of each sura in the Qur'an (except the ninth) and that should also be used whenever we start something.

بسم الله الرحمن الرحيم
bismillāh ar-rahmān ar-rahīm
In the name of the Most Gracious, the Most Merciful.

May this invocation call your heart to lead every deed back to its truthfulness!

This name contains all the qualities of love, generosity, mercy, and compassion. It symbolizes the compassion that flows forever and ever to all creatures without distinction as it contains the divine quality of blessing and joy that touches them all.

Repeating this name induces the feeling that one is enfolded in the gentle clouds of mercy, and starts to dissipate the isolation, the feeling of separation that so often accompanies us human beings. This Divine Name dispels the demons of doubt and despair, bringing joy, contentment, hope, and a feeling of connectedness. Repeating this Divine Name 100 times during the second third of the night brings a clear memory, awakens consciousness, and frees us from the burden of worries and

cold-heartedness towards self and others. The second third of the night always means about one hour before dawn, *fajr*.

When Allāh loves a human being, He summons the angel Gabriel and tells him, "I love this human being, so love him too!" And Gabriel loves him. Then Gabriel calls the heavenly beings and tells them, "Allāh loves this human being, so love him too!" and the heavenly beings love him. The beauty of this earth is then revealed to him. Allāh loves all His creatures. Then there are those who start seeking Him in order to search for that which cannot be found through searching. When the seeker takes one step towards God, the Divine runs towards her. Such is the meaning of Allāh's love for one human being.

Let compassion and kindness touch your heart and influence your words and deeds. For those who treat the creatures of this world—minerals, plants, animals, and humans—with kindness find themselves enfolded in divine kindness which they then come to feel within themselves and around them. So repeat 10 times the Divine Name Ar-Raḥmān after each prayer, so that your heart may widen with each beat and you may perceive the wonders around you and the beauty that lies in you. Indeed those who feel kindness in their heart know neither doubt nor worries. Repeating this Divine Name brings joy and trust to the heart, melting away the illusion of doubts and despair.

Kindness in one's heart means to carry a gentleness in one's heart which opens the eye of the heart and induces a deep feeling of connectedness to all the beings of this world which we then truly understand.

When the heart is healthy, it makes the whole body healthy, and when sick, it weakens the entire body. So let your heart become your guide and let your mind connect to your heart so that you may become whole. Allāh, let me become whole through Your kindness! Through Your kindness, let me feel the inner sun that shines on everything and everyone without distinction. This inner sun we often feel within ourselves is part of our true being.

The root *r-ḥ-m* from which the Divine Names Ar-Raḥmān and Ar-Raḥīm are derived also means womb, kinship, compassion, and sympathy. These two names are especially healing for human relationships and they stimulate love and loving compassion among the creatures. By repeating them, people who have the feeling that God has forgotten or abandoned them will find again the opening that they thought had closed.

The sound code and meaning of Ar-Raḥmān express the qualities of eternal existence and of infinity. It is the deep, innate, eternal quality without which nothing can exist. Besides Allāh, out of whom all names flow and accentuate the various aspects of the One, Ar-Raḥmān is the door or mother through which all Divine Names come into existence.

The Qur'anic verse *kataba 'alā nafsihi r-raḥma*, "*Allāh has willed upon Himself the law of grace and mercy*," (6:12), means that Allāh has written on the divine heart the word *raḥma* (mercy), thus indicating that all the Divine Names flow through this door before manifesting in the world.

Death itself is connected to this root. Thus, the word *marḥūm* (the one upon whom God has bestowed compassion and mercy) indicates a dead person. Before we are born, we are all in this *raḥma* and after death we return to it. So we human beings travel from one womb of love into the next—in between we are in a world where we stand and are responsible for our deeds in order to express this primeval knowledge. Trust and follow your destiny!

To be truly pregnant means to carry kindness and mercy in your heart and to let all creatures become your children.

To improve someone and bring them to their wisdom, their knowledge, their balance, and their harmony, means to connect them again with the heavens, to tie again the broken band and help them free themselves from the control of their desires and the prison of the material world so that they may unite again with the world of the spirit and cheerful clarity.

When you repeat this Divine Name, lay your hand on your belly, time and again, and breathe calmly into your heart so that you may discover and know your inner sun, and shine unconditionally. Find the light of Ar-Raḥmān within yourself by using your free will to do good for yourself and others.

Both Ar-Raḥmān and Ar-Raḥīm heal our deepest wounds, our feelings of insufficiency and inadequacy. They connect us with the time before we were born and restore our link to the eternal pulsation of compassionate love. Besides strengthening the womb and the male and female sexual organs, repeating those two Divine Names also activates all our organs.

O Allāh, open my closed heart with Your name of mercy!

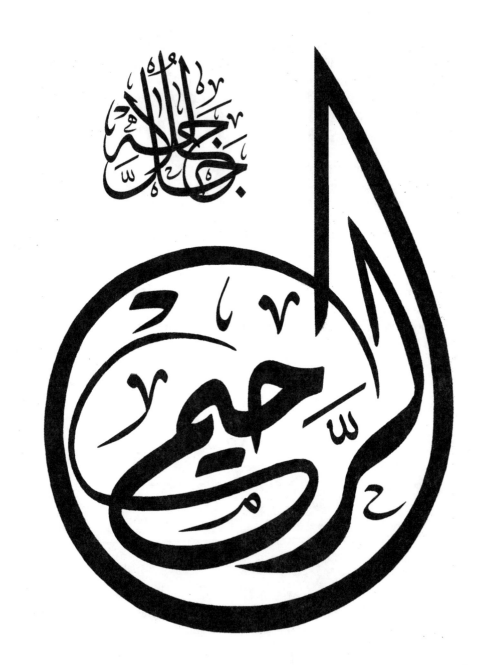

2

AR-RAḤĪM

The Most Compassionate, the Most Kind, the Merciful,
the Performer of blessed deeds, the Most Gracious

258–1,032–66,564

Mercy encompasses compassion, sympathy, and the ability to forgive. There is a form of mercy that manifests before the need for it arises, a compassion that flows continuously from the Divine to all creatures, protecting, preserving, and guiding them to the light and to a higher life.

Ar-Raḥmān is the ebb that takes us back to our origin. It is the grace that enables us to grow beyond our human and earthly limitations so that we may breathe the paradise of Unity. Wisdom, knowledge, and balance are basic qualities of our deep being.

In Sufism, the ocean symbolizes Unity, whereby Ar-Raḥmān and Ar-Raḥīm are like ebb and flow. Allāh has sent us tidal waves from the sea of infinity to the shores of our finite world through the revelations of His messengers. Sufism is the longing to throw ourselves into this wave and to let it sweep us back to our infinite Source, our boundless origin. For most believers, only the water left behind in the hollows matters, namely the outer form of religion. Yet the Sufis want to understand, to know, to love unconditionally. They use the outer form in order to comprehend the inner, uniting wisdom.

We human beings carry in us much pain and loneliness, and a deep need to be free. Most of us react to unpleasant experiences by blocking our feelings. But our feelings are the connection between body and spirit. When we block them and they become stiff, we hamper the natural flow of energy, thus preventing ourselves from developing and maturing.

31

Ar-Raḥīm and Ar-Raḥmān enable us to come closer to those painful areas, gently awakening hope and reminding our soul of its nature and destination.

Divine mercy is in all things and for all things. With every new fold of trust that we discover in the invisible divine mantle laid on us with our first breath, we come to know more the divine mercy manifested through all creatures. In this way, the presence of every creature and every encounter becomes an enrichment because every existence carries a part of the divine mercy. We are confronted with different situations throughout life, and each one offers us the chance to deepen our self-knowledge.

Human beings who have tasted this name carry in their heart softness, refinement, and a whole symphony of tenderness. Innate compassion is distinctly stressed in Ar-Raḥīm.

If you repeat the Divine Names Ar-Raḥmān and Ar-Raḥīm every day 100 times after a prayer or a meditation, the resulting intimacy will further your tolerance and capacity to help, while freeing your heart of the blindness of judgment. Although they are not identical, those two Divine Names are not different because they both dwell in the ocean of love. They are the key to all that is good and the lock to all that is bad. Every action initiated with those two names carries the divine blessing, so always start by saying:

بسم الله الرحمن الرحيم

bismillāh ar-raḥmān ar-raḥīm
In the name of the Most Gracious, the Most Merciful.

By saying this formula, you appeal to your heart to consciously enfold your every deed with its truthfulness and expressly interweave it with the divine mercy, so that the divine light may be spread on earth through your existence.

The Divine Names Raḥmān and Raḥīm both derive from *raḥma*, which means mercy as well as having mercy. Raḥmān is the hidden, eternal, all-prevailing mercy, while Raḥīm is the unlimited outer expression and manifestation of this quality.

The world comes into being through Ar-Raḥmān, and Ar-Raḥmān is the reality of love. All the conditions for life on this earth arise from endless mercy and tenderness. Ar-Raḥīm is humankind's grace and salvation. The manifestation of those two names sows the seeds of love and mercy on earth and distributes blessed deeds among humankind. We can discover the seeds, press them deep into the earth of our heart, nurture them with loving attention, water them with compassion, and they will blossom through our trust in Allāh. Thus the Sufis say, "Rain is Allāh's blessing!" for He reminds us of the rose we carry in our heart, the inner process of growth and maturity.

When we repeat Ar-Raḥmān and Ar-Raḥīm, a conscious, intimate encounter unfolds between divine mercy and our human limitations. We need to be aware of our own powerlessness in order to

become a vessel of trust, receptive to mercy. Then the drop begins to adopt the vibration of the ocean. That union is Ar-Raḥmān and Ar-Raḥīm.

The name Raḥmān is like the wide open sky, and Raḥīm like a sun ray whose warmth brings us life.

Repeating this name fervently, with a passionate heart, will protect you from forgetfulness, confusion, and any hardening of the heart. If you repeat this Divine Name 100 times during the last third of the night, you will come to feel compassion and connectedness to all creatures.

Those who suffer from sinus troubles should lay one hand on that area and repeat Ar-Raḥīm 258 times.

Repeating this Divine Name turns an enemy into a friend, bringing peace and calmness to body and soul.

Be compassionate on this earth, and heaven will show you His compassion. The fastest path to transformation goes through service. Serving is not self-sacrifice. Serving means to let compassion grow in your heart and to connect the mercy of the heart with the reason of the mind, to polish the heart with the sun of the mind.

Sura al-Nisā', سورة النساء, Women (4:1)
O MANKIND! Be conscious of your Sustainer, who has created you out of one living entity, and out of it created its mate, and out of the two spread abroad a multitude of men and women. And remain conscious of God, in whose name you demand [your rights] from one another, and of these ties of kinship. Verily, God is ever watchful over you!

In Arabic, the word *al-'arḥām* can be translated as "wombs" and carries the meaning of "ties of kinship."

Two things are essential on our spiritual path, which always expresses itself on the social level: to become aware of God and to become aware of the womb. The womb is the place of conception, the place where nurturing and protection come together, namely the two qualities a being needs in order to grow up in a balanced manner. The womb represents also an inner, pleasant, and comforting state. We need to respect the womb that gave us birth as the locus of the Creation of humankind in this world, which reminds us of our common origin and of human kinship. To respect the womb means to always stand by the weak and the oppressed, to stand up for justice, and to fight the oppressors. It also means to respect and look after the cosmic womb—nature, for nature is, and always will be, the companion of faith.

Sura al-Nisā', سورة النساء, Women (4:1)
And remain conscious of God, in whose name you demand [your rights] from one another, and of these ties of kinship.

To bring together God and the womb is to bring together the visible and the invisible, this world and the hereafter.

God informs us of our rights and duties towards one another and He shows us how they are organized in terms of order, priority, and proportions. We fulfill them through our consciousness, out of the Source of loving kindness.

We human beings should never forget to testify to the absolute Unity of all beings or to remember the womb that brought us here, in other words our human kinship and the outer multiplicity of existence.

All these words and explanations are meant to aid us dissolve the isolation induced by the ego, the separation from the "we" to which we always tend, out of various types of fear. Indeed, it is through trust in the Divine, not through the hopeless walls of the ego, that we attain the longed for protection and necessary submission.

Our kindness, our mercy, our warm, nurturing, and protective love should first and foremost be aimed at orphans and those who have been abandoned, for they need twice as much protection.

"The Sufis have ways of learning to pray so that you are really praying in the heart, from the heart, not just saying words, not just thinking good thoughts or making intentions or acts of the will, but from the heart."

—Thomas Merton

3

الملك

AL-MALIK

The Sovereign, the Ruler, the King

90–270–8,100

The Sovereign is the king who rules over all creatures. This Divine Name expresses the connectedness between human beings and the Divine. He is the Master of all creatures and their true, eternal Ruler. He rules not only their bodies, but their souls and hearts. Repeating this name 100 times induces a quality of respect towards self and others as well as respect from others, to oneself. When you repeat this name, you invoke the divine generosity and absolute might. Al-Malik brings patience and gratefulness to the heart of those who invoke Him. Through Al-Malik, they become content with everything that comes from Him.

Do your best and have trust! Turn away from the world of your little ego and turn trustingly towards the whole, towards Unity. Do your best and trust! Do not rush, stay in your center, your inner being, connected to your heart. Everything that is meant for you will come to you without fail, even if it has to go around the world in order to do so.

This Divine Name lets us recognize that we are free of all possessions, and knowing that nothing belongs to us leads us to enjoy everything that we have. It opens a feeling of gratefulness for the deep moment of enjoyment of beauty without the heaviness of clutching. This Divine Name allows us to open our desperately grasping hand and to hold everything in deep safety.

Say:

ربي زدني علماً

rabbi zidnī ʿilman

Allāh, grant me knowledge and widen my understanding!

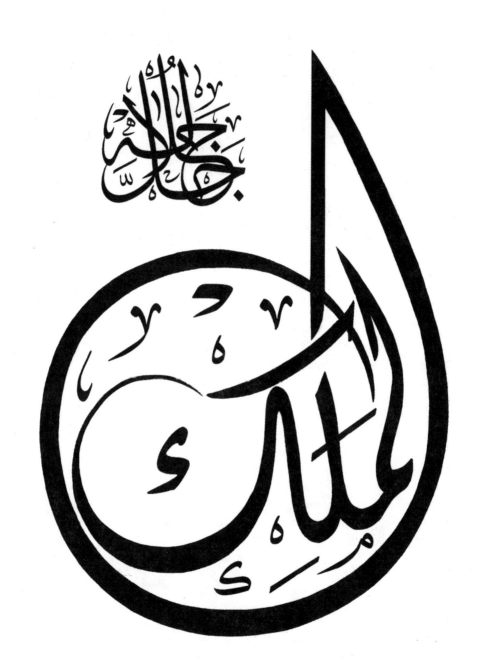

Repeating the following prayer 3 times over someone who is sick will bring them relief and healing if it is meant for them.

اللهم أنت الملك الحق الذي لا اله الا أنت يا الله يا سلام يا شافي يا شافي القلوب

allāhumma anta l-malik ul-ḥaqqu ladhī lā 'ilāha 'illā anta, yā allāhu,
yā salāmu, yā shāfī, yā shāfī l-qulūb

O Allāh, You are the true King. There is no other but You, O Allāh,
You source of peace, You healer, You balm of the heart.

When we meet someone we are afraid of, our fear often reduces us to silence. Repeating this Divine Name gradually unties the tongue and lets the words flow while the breast becomes filled with a warm light. Recite this name especially at night, silently. It gives you patience and contentment, and a feeling of gratefulness will grow in you. May His reign come, *Teete malakutah!*—thus spoke Jesus in Aramaic.

Once you have drunk from that name, you realize that nothing belongs to you—neither your possessions, your wealth, or your social position—and Allāh alone will be sufficient for you.

Repeating this name also helps those people who are afraid to own anything or who feel they do not have a right to do so because they worry they will be taking on too much at once or because they do not feel they deserve to.

The Divine Names Al-Malik and Māliku-l-Mulk (84) both come from the root *m-l-k*, whose basic meaning is "to hold in one's hands," "to own the existence of something." It expresses the fact that with the name Al-Malik, Allāh holds the essence of all things firmly in His hands and that this essence has and will always be majestically embraced by Him, for all eternity.

Through repeating Al-Malik, we become aware of this inner stance and we experience one of the greatest possible liberations in this life—that we belong to Him and to Him we will always return. Knowing that frees us from the primordial fear of being rejected and finding ourselves alone, and enables us to follow the path of becoming human.

Both the names *malāk* (angel) and *malakūt* (invisible world) come from the same root. Thus, the different meanings of that root show us that worlds and beings are in His hands on all levels.

"O Allāh, whatsoever You have apportioned to me of worldly things, Give that to those who have forgotten You, and what You have apportioned me in the hereafter, give that to those who love You, for You suffice me."

—Rabi'a' al-'Adawiyya

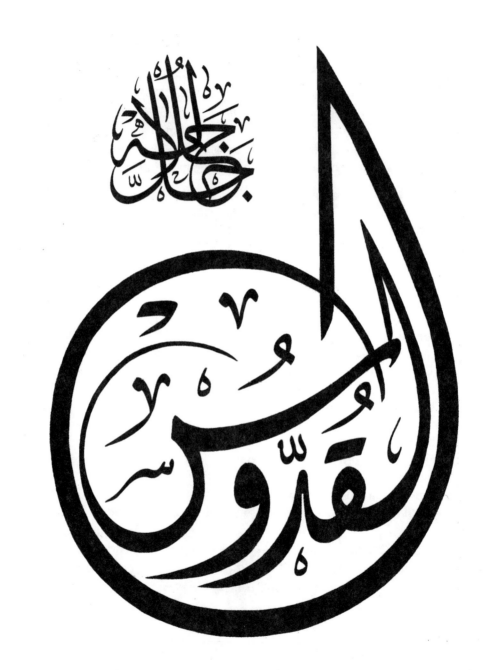

4

القدوس

AL-QUDDŪS

The Most Holy

170–680–28,900

This name carries the divine quality of purity and freedom. It carries the qualities of perfection and holiness in their eternal, infallible form. Repeating this name fills the heart with a feeling of respect and the knowledge that all creatures worship and praise Him, knowingly or unknowingly. This name awakens a feeling of gratitude in us, together with the realization that we cannot thank in a really adequate manner—and that, beloved, is the very essence of gratitude. To repeat every day 100 times Yā Quddūs with a pure heart frees it from thoughts and activities that forebode worries, pain, and restlessness.

To find the sacred space within ourselves means to develop the space where we feel at home in order to discover what truly matters to us in life. It means learning not to judge things or observations on the sole basis of the first outer impression born from our sensory perception.

The divine qualities are eternal. To understand that opens the prayer space in us. Our prayer to God then becomes a pure act of worship, and He becomes our eternal, perfect protection.

Allow your breathing to enter the rhythm of your heart. Feel how your heart becomes a mirror capable of reflecting the divine light within you and around you. Let your soul, *rūḥ* (روح), invite all your inner voices to a roundtable and welcome them all in the inner circle of Unity.

The Divine Name Al-Quddūs carries the qualities of beauty and majesty. It makes you capable of patience, wisdom, and gratefulness, and protects you from the weaknesses of the lower impulses. Al-Quddūs influences all our senses, and it enables our sensory perceptions to return to their sacred

origin, to the place where true understanding and knowledge connect us to our deep self, to that which is eternal and sacred in us.

Al-Quddūs comes from the root *q-d-s*, which means to be healed, holy, purity, paradise. It gives us the strength to let go and leave everything in order to come closer and closer to our essence, step by step, one experience after the other. It also gives us the strength to take our mundane experiences inwards and understand them on an intimate level, thus coming closer to the Divine. The shining, pure soul calls louder and louder, and the ego surrenders to that calling light, acknowledging its holiness. It is the way towards uniting heaven and earth, eternity and time. Al-Quddūs is the way back home.

Those who suffer from slandering can free themselves through repeating this Divine Name: slander will cease and their true intent will come to light.

Those who know and understand this name cleanse their self from the lower impulses, from negative passions and self-serving deeds. They take care not to make a living based on exploiting or oppressing others, they free their heart from envy, greed, and hypocrisy. Through our relationship to them, all earthly creatures become equal, the blade of grass as holy as the stars in the sky.

Take only Allāh into your heart and you are whole.

5

As-Salām

The Source of peace and security, the Peace, the Salvation

131–524–17,161

As-Salām is the quality of those who have purified their heart from hatred, envy, treachery, jealousy, anger, and revenge, of those who have put their heart in a safe place—*salām*. Repeating this name 100 times over a sick person brings relief, starting on the level of the heart. Security and peace are born from the connection to the Divine. As-Salām protects and saves from dangerous situations.

The Arabic root *s-l-m* comprises the meanings of peace and surrender, of being safe and sound, unharmed, unimpaired, intact, safe, secure, blameless, and faultless. The word *sillam,* سلّم (ladder), also derives from that root, indicating that it provides the tool to go higher, a tool as safe and solid as a ladder. So is the word *salm* (snake bite), indicating that this Divine Name can protect us from the venom which sometimes resonates in people's words.

This name also means mutual greeting: May you be immersed in peace and surrender (in your heart) and the (resulting) security! May As-Salām nurture and protect you from all evil.

As-Salām gives us the capacity and inner creative strength to give up that which we want to renounce, such as bad habits.

The word *salam* describes inner peace, well-being, and safety from all types of evil, whether on the physical or spiritual plane. *Salam* means to feel the divine protection wherever we are, regardless of the situation we are confronted with. It is obeying the divine laws exposed through the revelations of the prophets. Most people understand Islam to designate the religion of the Muslims, yet in the Qur'an it is meant as all prophetic revelations. Thus, Islam started with the Prophet Adam, Allāh's

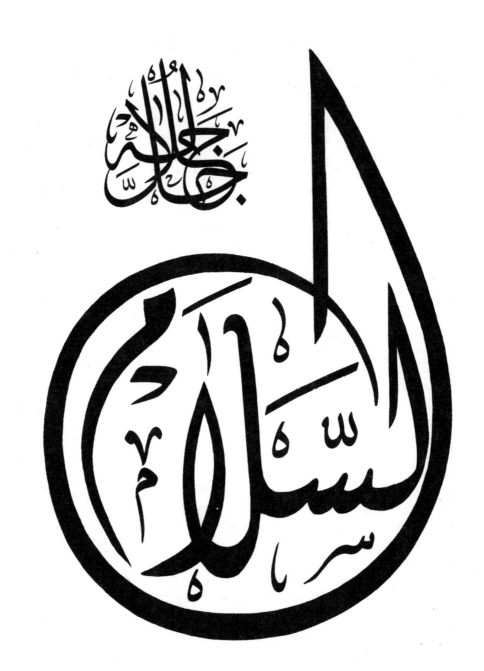

peace be upon him, it continued among others with Abraham, Moses, Jesus—Allāh's peace be upon them—and ended with the Prophet Muhammad, Allāh's blessings and peace be upon him, as the last link sealing the chain of revelations.

Yā Salām, O Allāh, heal my body, mind, and heart, and grant me reconciliation, peace, and security so that I may see Your immortal power and love in all Your revelations. Free me from errors, visible and invisible, so that I may surrender to the stream of Your eternal Unity.

When a human being who masters his ego and who is connected to the Divine repeats the name Yā Salām 160 times for a sick person, that person's heart will heal.

اللهم أنت السلام ومنك السلام واليك يعود السلام فأنا بالسلام

allāhumma anta s-salām wa minka s-salām wa 'ilayka ya'udu s-salām fā ana bi salām

O Allāh, O God, You are the peace, from You comes the peace and to You the peace returns. Let me live in peace.

Picture life like a caravan with the past in front of you, the future behind you. We follow those who came before us, while our descendants follow us. Many are those who came before us, many those who will come after us. Everything moves: nature, human beings, time, and space. Everything moves in the quality, the mystery, of the Divine Name As-Salām. *Salām*, peace, is not the opposite of war. This name refers to the creative force that was at the beginning of all things and still exists, now and forever, in the caravan of present and future. It is to this quality that we refer when we use this name in a greeting: remember the time when none of us existed. In the great mystery of life, what difference do our problems, our conflicts, our differences of opinion really make? Peace, *salām* (سلام)! This name connects us to the past and the future, lifting us from the narrow circles of our self, widening our vision, and bringing lightness to our hearts.

Keep three things in your heart: if you cannot help someone, beware of harming him; if you cannot bring him joy, beware of bringing him heaviness; and if you cannot praise him, beware of letting your tongue harm him through your words.

O Allāh, protect us from distraction and carelessness, from the tongue and from the deeds of those who are unjust, and grant us trust!

Give As-Salām to your every feeling, your every thought, your every deed. Give As-Salām to every person you meet. Give As-Salām to all those who have ever helped you—relatives, friends, masters. Give As-Salām to all creatures.

As-Salām carries the quality of the past and the future meeting in the moment. It gives us the strength to keep our inner balance amid the turmoil of this world, that which the Sufis call the cheerfulness on the way to perfection.

As-Salām is the surrender of the self to its true nature. Those who taste their true nature free their heart from need, fear, melancholy, and worries, for peace loves peace and gives peace to those who ask for it. Those who rely on God As-Salām will never fear because God's power will carry them, protect them, and grant them strong faith.

Sura al-Ḥashr, سورة الحشر, The Gathering (59:22–24)
God is He save whom there is no deity: the One who knows all that is beyond the reach of a created being's perception, as well as all that can be witnessed by a creature's senses or mind: He, the Most Gracious, the Dispenser of Grace.

God is He save whom there is no deity: the Sovereign Supreme, the Holy, the One with whom all salvation rests, the Giver of Faith, the One who determines what is true and false, the Almighty, the One who subdues wrong and restores right, the One to whom all greatness belongs! Utterly remote is God, in His limitless glory, from anything to which men may ascribe a share in His divinity!

He is God, the Creator, the Maker who shapes all forms and appearances! His [alone] are the attributes of perfection. All that is in the heavens and on earth extols His limitless glory: for He alone is almighty, truly wise!

"A true human being mixes and associates with the people without ever forgetting God, not even for one moment!"

—Abu Saʿid Abul-Khayr

6

المؤمن

AL-MU'MIN

The Believer, the One who grants safety, the Protector, the One who makes secure

136–544–18,496

Allāh Al-Mu'min is the Giver of faith, protection, and safety.

This name derives from the root *'a-m-n*, and it means both to be safe and to believe. No creature can know God as He knows Himself, and it is in this way that the Sublime describes Himself as a believer, testifying His qualities and His majesty to the creatures.

This root also carries the following meanings: to be faithful, reliable, and trustworthy; to be safe, to feel safe, to provide, to ensure, to trust, to have confidence, and to have faith; safety, peace, security, protection, assurance of protection, harmless, trusteeship, confidentiality, secrecy, loyal, upright, honest.

When human beings in whose heart the name Al-Mu'min has manifested repeat Yā Mu'min 70 times, they are protected from everything harmful, and their tongue cannot lie. The name Al-Mu'min protects from punishment and strengthens honesty. It grants security to those who seek refuge in Him. It engraves faith, protection, relief, trust, and self-confidence in the seeker's heart. Al-Mu'min is not blind faith; on the contrary, it protects from narrow-minded faith and lets courage flow into the heart. For believers are brave. They have the courage to own up to their mistakes and weaknesses, and to apologize for them. Believers look at their fears and doubts and walk through them. They accept their fate.

Yā Mu'min, O Allāh, let the attitude penetrate my heart and direct my senses, that You are the Absolute from whom everything comes and to whom everything returns. Let me be a believer, *mu'min*, let me observe Your divine laws and find in You confidence, a peaceful heart, and peace, *'amān*!

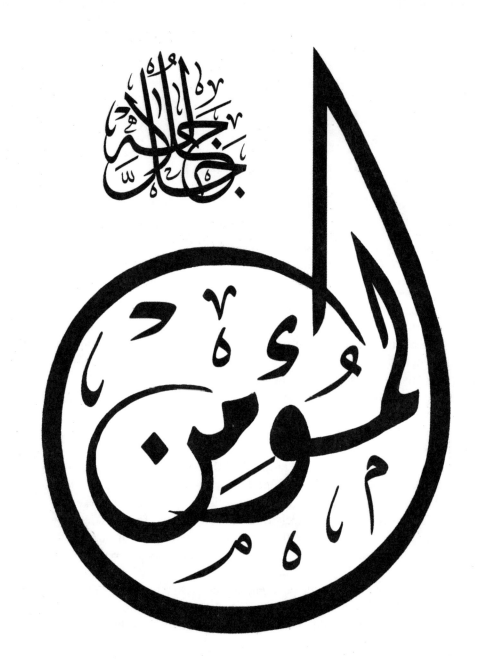

When people wish to be sure that others will tell them the truth, they often start their sentence with *'amānatullāh*—by your faithfulness and your belief in God.

'Amāna is also a concept that indicates everything entrusted to someone, whether in the physical or moral sense. It is a quality one expects from a true friend. For a believer, *'amāna* also applies to the truths they were imparted through the Scriptures, truths that they should live and carry as goods entrusted to them. This moral responsibility manifests as the exercise of social justice, as one's embedding in the divine laws.

May your heart be enfolded neither in fear nor worries. May you pronounce your promises with care. Al-Mu'min means to take refuge in Allāh.

Al-Mu'min shows the heart that the gentlest hand of all invariably lies behind the harsh hand and the soft hand of life. Those who carry this quality can protect their fellow human beings from mistakes and weaknesses, and from the bondage of the lower self.

Those who carry the quality Al-Mu'min are free from all forms of fear and doubt in any life situation. Al-Mu'min is particularly helpful when we feel lost, but it is also good to repeat this name when we tend to be gullible.

Whenever you feel capable of tackling something, when you see that you can give or hold back, do good or evil, be constructive or destructive, turn to Allāh and ask Him for support, and beware of your own arrogance and of the illusion of separation and independence. Everything comes from Him, and yet there is always a part in us that feels separate and needs protection in its doubt. Open the bubble of separation with the vibrations of Al-Mu'min. Everything comes from Him, yet at the same time we are the manifestation of the Divine on earth, and we carry the freedom of choice and the responsibility because our deeds change the face of existence. If you wish to act authentically, carry two things in your heart: devotion (*tawakkul*, توكل), and the clear intention to learn from past mistakes and not to repeat them (*'ināba*, إنابة). All mistakes, all weaknesses, as slight as they may be, can dissipate through intention and will. Every iniquity, every catastrophe we have brought about, can be undone by the phrase "I ask for forgiveness and refuge in You" (*'astaghfiru llāh*, أستغفر الله).

Al-Mu'min helps you decide what is just and adequate in the moment. With Al-Mu'min Allāh granted the greatest and most precious gift—faith, *imān*. This name fills our heart with warm kindness and our eyes with the beauty of existence. True faith does not make us into radicals or fanatics, but enables us to know the fundamental, eternal spiritual truths proclaimed by every divine messenger. Faith in God is a river that grows wider with every brook, recognizing multiplicity on the way to the Ocean of Unity into which it flows.

Every creature is made safe by those who carry the quality Al-Mu'min and upon whose help we can rely, both on the spiritual and mundane levels.

This name helps us find trust in Allāh and remove all doubts and fears from our heart. It is good to use it when we work with deep wounds of the soul.

Sura Hūd, سورة هود

He answered: "O my people! What do you think? If [it be true that] I am taking my stand on a clear evidence from my Sustainer, who has vouchsafed me goodly sustenance [as a gift] from Himself—[how could I speak to you otherwise than I do]? And yet, I have no desire to do, out of oppostion to you, what I am asking you not to do: I desire no more than to set things to rights in so far as it lies within my power; but the achievement of my aim depends on God alone. In Him have I placed my trust, and unto Him do I always turn!

Know, my heart, that He created the universe in a harmonious balance and that we human beings were appointed special creatures therein.

7

المهيمن

AL-MUHAYMIN

The Watchful, the Protector, the Guarantor,
the One who determines without limitations

145–725–21,025

Allāh is the Protector of all things. Those who repeat this name are enfolded in a watchful light. Al-Muhaymin is a Divine Name whose sound and meaning penetrate us deeply and shake the foundations that separate us from our true self. Despite its power, the lightness and the softness that resonate with this Divine Name protect us and soften our heart so that we become "like wool in God's hands." Al-Muhaymin determines what is true and what is false, and it gives us the capacity to pay careful attention to our deeds, words, and thoughts. Nothing conquers the ego as powerfully as loving mindfulness. Al-Muhaymin should not restrict our joy of life: rather it should enhance it as our awareness of right and wrong deepens.

Al-Muhaymin is connected with the Divine Names Ash-Shahīd (50) and Ar-Raqīb (43). They help us watch our thoughts, words, feelings, and deeds.

Al-Muhaymin watches over everything, protects everything, and sees the Creation's every deed. He determines the fate, the span of life, and the well-being of all creatures. Al-Muhaymin knows that which is hidden and secret, it knows what is buried in the heart, what human beings show and what they conceal, it sees things and what is hidden behind them.

Human beings who activate this quality in themselves and fill their being with it know how to observe and see themselves clearly, without any sentimentality, without ever losing sight of the balance of inner and outer expression. They see the Existence and divine laws everywhere. They have

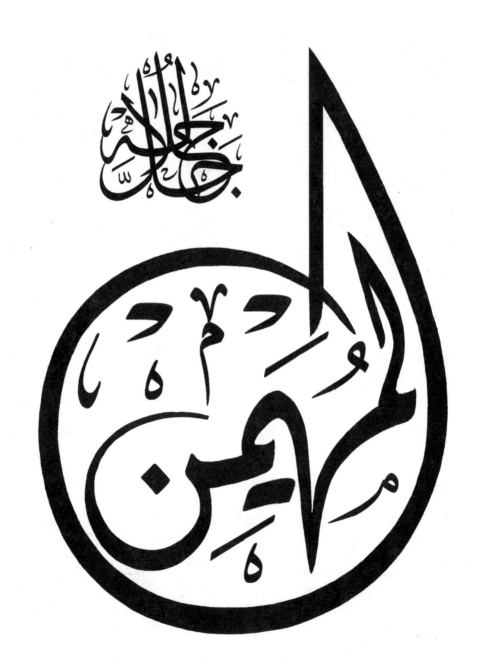

the strength to follow the straight path and to lead others on that path, while protecting them and themselves from weakening deeds.

Yā Muhaymin, free my heart and thoughts from ulterior motives and hidden expectations, and lead me to sincerity, show me the path of truth and correctness, let me not do wrong to others out of fear or restlessness, and grant me Your majestic protection.

The heart of those who repeat this Divine Name 100 times after each prayer fills with the light of deep faith that silences the inner voices of doubt, fears, and affliction, and dissipates forgetfulness. Connect yourself to God through remembrance, through *dhikr* (ذكر), and He will free your heart from worries and grant your eye the capacity to see that which is hidden and invisible. God gave us human beings the ability never to lose and always to win, if we want!

The Divine Name Al-Muhaymin comes from the root *h-m-n*, which carries the following meanings: to put in a side pocket or a bag, to protect someone from fear and worry, to observe someone, to attest. Originally, it comes from the same root as Mu'min, namely '*a-m-n*, but the '*a* was changed to an *h*. Thus, this name combines the quality of faith with that of protection. On the inner level, it helps us relax and let go of the wall laboriously built and defended by the frightened, worried ego, so that we may taste true safety. Then we can experience the universe as a safe locus where we have a place, enfolded in the deep faith of the heart, protected from worries and fear, our heart filled with God.

When you repeat this name, guide your breathing towards all those inner spaces where you feel unsure of yourself and defenseless. May the divine breath in you fill you completely and bring you relief. You may also accompany this Divine Name outwardly and strengthen others by enfolding them in it.

If you are aware and attentive, in your inner as well as in your outer life, if you write this name on a piece of cloth and you burn a mixture of musk, amber, and sugar, above which you hold this cloth while repeating 5,000 times Yā Muhaymin, and you do so for 7 days before putting it under your pillow, you will dream of the events that will influence your material and spiritual life, Allāh willing.

Sura al-An'ām, سورة الأنعام, Cattle (6:82)
Those who have attained to faith, and who have not obscured their faith by wrongdoing—it is they who shall be secure, since it is they who have found the right path!

Allāh lives in all our hearts—
in the hearts of the guilty, the angry, and the suffering too.

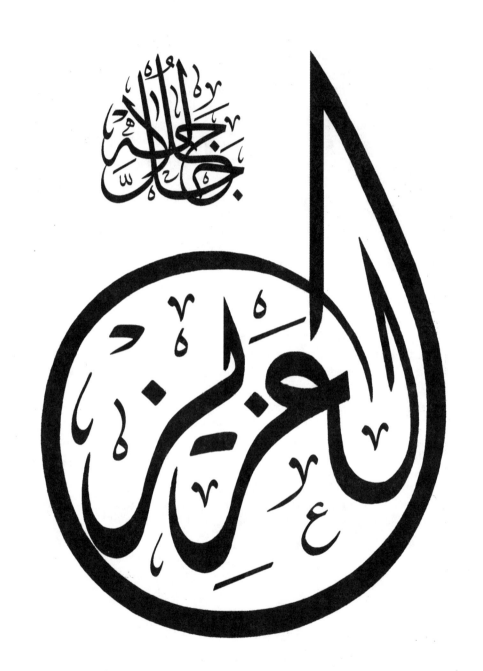

8

العزيز

AL-'AZĪZ

The Powerful, the Honorable, the Precious, the Friendly

94–376–8,836

This Divine Name encompasses the Valuable, the Majestic, the Powerful. Allāh rules the heavens and earth and everything in-between. Those who repeat this name every day 40 times for 40 days in the second third of the night, eventually come to a place where they are free of the needs of others, free of their own needs, and they enter a quality of trust that everything they need comes to them.

We find traces of this Divine Name when we overcome the illusion of being alone by learning to transform our lower self, who believes "I must fulfill my needs and find my happiness, regardless of anyone or anything else." Clear-sightedness, honesty, and an authentic kindness towards self and others let this quality grow in you.

The remembrance, or *dhikr* (ذكر), of a name must also be carried by deeds, thoughts, and emotions, failing which it becomes a mere game of self-delusion and self-centeredness. In order to taste, understand, and experience a name, it is important to repeat it over quite a long period of time. Slowly we start discovering the echo of this name around us. Slowly our essence, where all the names exist in a slumbering state, starts calling us lovingly and showing us the way home with this expression of divine love. The deeper we go into the meaning of a name, the more it permeates our qualities and capacities.

Al-'Azīz lets the good overcome the weaknesses, that which is not yet good, by acknowledging the preciousness of that quality, carried by modesty towards Allāh, Al-'Azīz. If you wish for strength and power in both worlds, obey Al-'Azīz, for Al-'Azīz is the source and the ocean into which they flow.

The Divine Names 'Azīz and Mu'izz (24) both come from the root '-z-z, which contains the following meanings: to be strong, powerful, respected, to be or become rare, scarce, to be or become

dear, cherished, precious, to be hard or difficult for someone, to make strong, to strengthen, to reinforce, to fortify, to corroborate, to confirm, to solidify, to invigorate, to harden, to advance, to support, to consolidate, to honor, to raise in esteem, to elevate, to exalt, to love, to prize, to make dear, to feel strong, to overwhelm, to overcome, to hold dear, to value highly; sense of honor, self-respect, self-esteem, friend, ruler.

Al-'Azīz combines two opposite qualities: strength and power, but also gentleness, preciousness, and mildness. The power and strength pulsating in this name give the reciters the capacity to overcome their weaknesses by recognizing the innate preciousness, richness, and dignity that God has given us. Acknowledging this honor enables us to express our dignity in our life—and dignity shows itself in generosity.

Al-'Azīz has the capacity to lead us from the state of weakness, guilt, and shame into a deep sense of self-esteem. The wounds of shame and humiliation can be healed. This name restores our most intimate sense of worth so that inner strength can grow. To know that our true self, our soul, is infinitely precious enables us to become free of our identification with the wounded ego and to connect with our gentle nature. For those who know that they are precious can be gentle. This gentleness rests on inner strength. Such is Al-'Azīz.

Allāh's power, which manifests in Al-'Azīz, is invariably connected with justice and compassion. Allāh Al-'Azīz is therefore connected with punishment, reckoning, reprimand, so that we human beings can awaken our consciousness and correct our course. Yet it is also connected with gentleness, with a loving, strengthening hold, because the source is nothing but eternal love.

Fear disappears from the heart of those who repeat this Divine Name time and again, and others acknowledge their worth. Those who repeat this name for 7 days open the heart of their fellow human beings, who see them with compassion and gentleness.

Yā 'Azīz, You precious, You powerful, You beloved, You so hard to attain, pick me up and give me the strength and the gentleness to serve You in noble sincerity!

The earth shows the individuality and the multiplicity of our material manifestation; it shows how we are connected to everything around us and to the universe. Heaven shows the light, the energy in us that is connected to everything and makes us equal. It lets us know the source from which we come and to which we flow back.

The Sufis say matter plus energy equals us. Spiritual practices do not serve to distance us from the earth, from the here and now, but to embed us in what is, to teach us how to surrender to His sweetness.

None of us on this earth escapes wounds: wounds that come from childhood, wounds experienced as adults, sometimes buried so deep that we partly fear to look at them. Yet it is those very wounds that

lead us to our humanity, untying the knots of our mind and widening our understanding, enabling us to know our heart and stretch out our hand.

Life is the place where blessed transformations can take place. So use your disappointments to let the clouds of illusion drift away and see what is true with all your being. Feel the strength of the earth below, feel how it rises into your bones, breathe deeply into your inner space and feel how you are connected to everything around you. Where is the strength in me? What qualities in me manifest the strength that lives within?

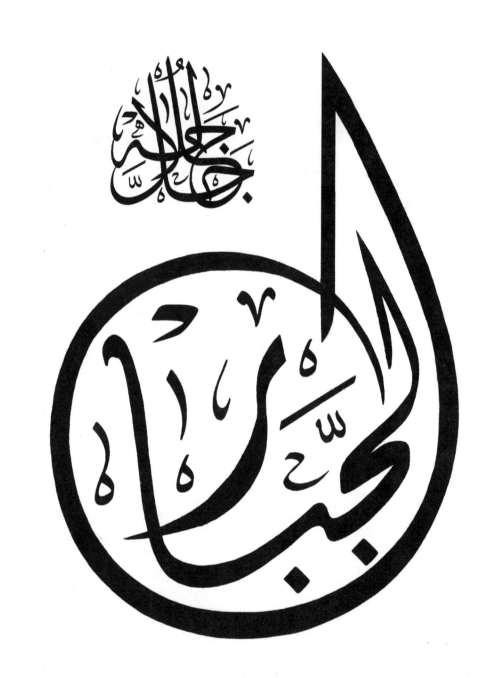

9

AL-JABBĀR

The One who unites, the Healer who realigns, the One who has power,
the One who improves

206–824–42,436

This Divine Name contains the qualities of correcting, improving, regulating, relieving, balancing, and appeasing. He is also the One who soothes and leads to the heart. Al-Jabbār is the One who restores us to health, restores that which has broken into pieces or has suffered an accident, the One who defeats injustice and restores justice. He is the One who evens out and compensates His creatures' poverty and neediness.

Repeating this name sincerely protects us so that we do not find ourselves in situations against our will. It protects us from violence, harshness, and unfriendliness.

يا جابر كل كاسر ويا مسهل كل عسر

Yā jābira kulli kāsirin wa yā musahilla kulli 'asrin

O Jabbār, You who bring together everything broken, You who ease all difficulties.

When you repeat this Divine Name, focus on your weaknesses, acknowledge their importance, and join them with your strengths. Often our weaknesses make us strong and lead us on the straight path. Invite them, be a good host, be polite to your guests, unconditionally and without distinction—that is generosity.

Collecting our being brings us peace and our mind becomes calm and quiet. In one day, how often do we move from a state of majesty, openness, and lightness to a state of strong severity toward ourselves? Al-Jabbār heals the hearts, unites the splintered opposites, and removes from the heart the veils of blindness, envy, arrogance, selfishness, and hypocrisy.

By repeating the name Al-Jabbār, we take care, on our path, not to fall into the illusion of believing ourselves to be above anyone, for superiority belongs to Allāh alone. We use the strength of this name to avoid falling into the traps of irony and cynicism towards others. Al-Jabbār also helps us not to act violently against others, not to fall in love with our own opinions, not to become full of ourselves because of our knowledge or possessions, not to feel better because our social or professional status is better or higher than others' or because we have more money than them.

Repeating this Divine Name brings healing to those who have either themselves, or their children or possessions, suffered fractures, wounds, or weakening, provided they let their heart and soul become immersed in patience and trust, and they are aware that being weak or penniless is neither a punishment nor a shame.

First of all, one must know that the first step on the path of healing always is to accept and honor the given situation or station. In other words, to carry modesty in our heart in order to let the Giver's greatness expand.

Al-Jabbār is the One's creative force coursing through the veins of Creation. Al-Jabbār gives us the strength to admire the Creation and to let ourselves be enfolded in the force behind it. That is healing.

The physical world is made of individual, material objects, and it is for us a constant source of separation. We are separated from one another through the different parts of the earth and geographical regions, and we also seem to be separated from the Divine. The moment we open our eyes in the morning, every object differentiates itself from the other. The toothbrush is separate from the toothpaste, the plate is separate from the food, the shoes are separate from the feet. In this world, borders are always clearly visible: the walls that surround us, the floor beneath our feet.

This consciousness has even penetrated our human relationships so that we automatically see ourselves as separate and we let ourselves be determined by the limitations of our habits and belief patterns that create a distance between us. Yet if we reach beyond the limitations of physical consciousness, we can see that there is another way to live and that the world as it appears to us is but a mirage. If humankind experiences the mysteries of Unity, the plane of unity on which all life is perceived as intertwined, if human beings open their spirit to this knowledge, then a new age can begin. It is in Unity that we come to know our true place in the wholeness of life, and that gives us a feeling of belonging and a sense of the true individuality arising from this belonging, together with the way to live in harmony with ourselves and with every form of life. Wholeness encompasses the Divine: in Unity He is present.

Before social conditioning cuts them off from their true self, children live completely in the moment. Many children experience a closeness to God that their parents have lost. Once they have accepted the world of adults, most of them renounce this natural contact and close their eyes to the

wonders of this world. But the one Divine Being can become so many and yet remain one, for the one and the many reflect each other. Become like little children! Was that not what Jesus asked us to do?

Sit down, collect yourself in your heart, and repeat Yā Jabbār while leaning forward on the inhale and backwards on the exhale, until the time comes when you find yourself embraced by the Beloved.

> The Prophet Muhammad, peace and blessings be upon him, said, "Only those who do not carry the smallest grain of pride in their heart shall enter paradise." Someone then asked, "O Prophet, if they take care of their outer appearance, their clothes, their possessions, is that pride?" And the Prophet answered, "No, it is not. For Allāh is beauty and He loves beauty. Pride is having a low opinion of human beings and not respecting their rights."

Human beings who revive the divine quality Al-Jabbār in themselves, learn to connect the inner and the outer worlds, and thus to serve Unity. Once inside and outside unite in our consciousness and in our life, something new can come to life. It is the secret of the masculine and feminine, inside and outside, up and down, mind and matter.

The beauty and the suffering of this world, *dunyā*, will remain, but we will discern its meaning and purpose with greater clarity.

Al-Jabbār comes from the root *j-b-r* and carries the following meanings: to restore, to bring back to normal, to help up, to console, to comfort, to treat someone in a conciliatory or kindly manner, to set broken bones, to force, to act strong; might, power; mighty, powerful.

The basic meaning of Al-Jabbār is healing. The sound code of this name shows that the quality of healing that pulsates in it is eternal and continuous. Al-Jabbār can correct and heal everything that needs healing.

A bonesetter who wants to set a broken leg uses force that brings a lot of pain. Yet the aim is not to cause pain, but to bring healing and recovery where it is required. This is Al-Jabbār, the Forceful, the Uniting, the Healer!

The many basic aspects show that Al-Jabbār works on the most diverse levels—body, soul, and spirit—uniting opposites and bringing together what has been separated, straightening up people like strong trees, bringing fertility and life where there was weaknesses, flaws, and limitations, integrating and uniting the various parts of our self. It helps us when we feel powerless in the face of worldly events, incapable of changing anything. Al-Jabbār unites power and confidence, stabilizes our focus, thereby supporting us and giving us the strength to heal.

The world of humans, *'ālam an-nāsūt*, is the material, visible world, also known as the first world. The world of angels, *'ālam al-malakūt*, is the second world. The world of powers, *'ālam al-jabarūt*, is the third world, and it comes from the same root as the name of the angel Gabriel, *jibrīl*.

O Jabbār, who can know You and invoke anyone but You? O Jabbār, who can know You and ask for the help of anyone but You? O Jabbār, who can know You and turn to anyone but You?

Al-Jabbār brings strength by raising the magnetism of the body. Illness decreases magnetism or life force. Magnetism is the force that holds body and soul together. When magnetism is low, the body can no longer hold the soul and we die.

Beware of not having time for the One who created time
before the moment comes that He has assigned for your time to be over.

10

AL-MUTAKABBIR

The Majestic, the High and Mighty, the Sublime, the Proud

662–3,310–438,244

The greatness of this name manifests in all things and all forms. It contains the quality of the beyond, a quality beyond all Creation. It is unique in its magnificence and induces modesty and humility among human beings in the face of the Divine. This name is meant to protect us from arrogance towards others and to repeatedly rebuke the ego so we may recognize that no one stands above anyone else.

One night a Sufi asked in his dream, "O Allāh, how can I come closer to You?" "Come closer to Me with that which is not in Me!" "And what is not in You?" "Poverty and neediness."

The inner attitude of poverty and neediness brings freedom and closeness. To live this attitude is to experience oneself as part of the whole, of the universe, of Creation, and that everything comes from You, Beloved!

Those who wish to feel this quality in themselves will only find it by working hard on themselves to reach their highest inner potential, without ever falling prey to pride. Repeating this name burns all longings and desires connected to this world, and it gives us the strength to ignore everything that distracts our heart from its connection to Allāh. Al-Mutakabbir leads to the kingdom of obedience and shows us that "everything that the heart can carry, it can also fulfill." This name gives us the strength to concentrate and keeps us from starting anything without completing it.

Just like the formula *allāhu 'akbar*, the Divine Names Al-Mutakabbir and Al-Kabīr (37) have the same root, *k-b-r*, which carries the following meanings: to be great, to grow, to increase; powerful, spacious; greatness, magnitude, importance, pride, glory, fame, nobility, prestige.

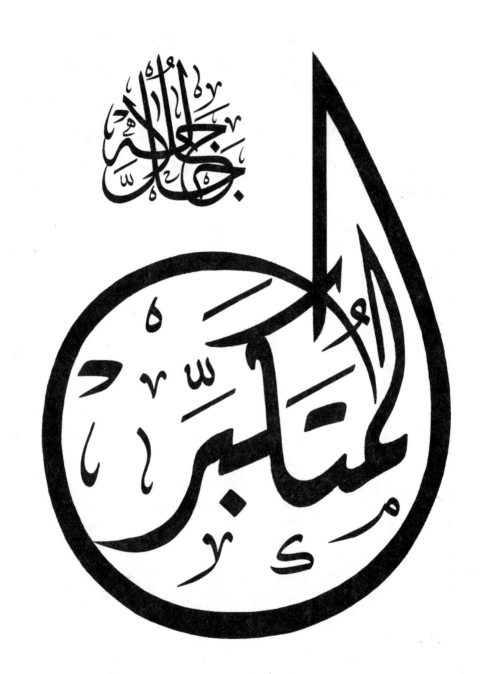

Al-Mutakabbir means that, whatever we experience, Allāh is greater. Al-Mutakabbir opens to us this experience in time and space, taking us from one dimension to another. This name also helps us to let go of and relinquish our own borders so that we may discover that God exists both within and beyond these borders. Al-Mutakabbir helps us break through the limitations of pettiness and narrow-mindedness in which we sometimes become entangled, or even drown.

Here is a practice from Abd al-Qadir al-Jilani. Lay one hand on the level of your heart, in the middle of your chest where the heart of flesh meets with the subtle heart, and breathe in deeply and calmly with the name Al-Mutakabbir. Observe how the rhythm and the quality change, with time. Go deeper and deeper into your heart. After a while, bring into this rhythm the question that is in you, or the decision you must take. Take all the possibilities and breathe with each of them for a moment while repeating the Divine Name Al-Mutakabbir. How do you feel: wider, lighter, or uncomfortable and constricted? Observe the changes that manifest in you without expecting an answer. Learn to look outside from within yourself. At the end, let go of all the possibilities and breathe with the name. Repeat this two or three times for a given situation.

Allāh is Al-Mutakabbir. This quality shows His perfection and sublimity, while human arrogance is a quality of weakness, falsehood, foolishness, and ignorance. May you be protected from it.

Al-Mutakabbir opens the door to those parts in us that are waiting to be acknowledged and lived. This name allows us to immerse ourselves in the process of growth. Arrogance and arrogation are qualities that overcome us time and again, or creep so subtly into our mind and heart that we hardly realize it. Arrogance is the basis of every one of our talents and abilities. It is the door through which the dispositions we have received become individualized, the force that separates us from Unity. We have to overcome it, climbing over its back—thus we return, thus we remember, *dhikr*, the existential Unity of all beings. With this in mind, it is important to take a closer look at the Divine Names Al-Mu'izz (24), the One who raises, and Al-Mudhil (25), the One who humiliates.

Al-Mutakabbir should always remind us that vanity and arrogance are the gates through which the satanic force lures and seduces us on the intellectual, material, human, and political levels, thereby involving us in the world in a way that closes the gates of the heart.

Yet ultimately it is only through love that we are taken to the Unity of Being.

11

الخالق

AL-KHĀLIQ

The Creator

731–2,924–534,361

This divine quality should remind us that He created earth and the heavens, day and night, life and death. Al-Khāliq is the absolute expression of this capacity, the infinite potential of opportunities. This name is the cloth which is later cut by Al-Bāri' (12) and designed by Al-Muṣawwir (13).

It is from this black cloth, this black inkpot, that Allāh created humanity for and through Himself, and again the Creation for humankind, out of ecstatic love for the veiled treasure and the potential for insight.

Al-Khāliq is derived from the root *kh-l-q*, which carries the following meanings: to create, to make, to originate, to shape, to form, to mold, to change, to invent, to fabricate, to think up, to perfume. Also based on the same root are the words *khalq* (creation, everything created, humankind) and *khuluq* (innate qualities, character, disposition, humanity, courage, faith, good natural abilities, characteristics, and anger).

When we go deeper into Al-Khāliq, we discern the primeval substance of which humankind was created. Kindness and humanity are our core, courage and faith were given to us, our nature contains all the good natural abilities, we are unequaled and unique carriers of an intimate truth. But anger is also present. Anger is the opening that feeds on arrogance, self-satisfaction, defiance, and fear.

The Divine Name Al-Khāliq is not only connected with the names Al-Bāri' (12) and Al-Muṣawwir (11), but also with Al-Qādir (69), which unites capacity and the quality of that which is fated.

Al-Khāliq is repeated during the night meditation. Through those recitations, an angel manifests who stands next to the reciter and protects them until the end of their life, while the deeds of that angel are credited to them.

Al-Khāliq is the force that does not follow a specific form, giving every creature its own shape and fashioning them in harmony to one another.

Al-Khāliq brings into being that which does not exist. It shapes the doer and the deed. Isn't our deepest yearning to integrate spirit and matter, to merge everyday life and the depth of human existence? So whatever you start, make sure that you act in an upright manner, and against your lower, selfish self, your *nafs* (نفس). For the *nafs* knows only itself, the *nafs* loves its illusory satisfactions, it loves its mistaken self-interest, it loves to blame others, to profit from others, and truly the *nafs* loves to debase, denigrate, and insult itself.

We are all visited by bad thoughts. Yet if we do not use them, they gradually become our crown. It is the daily-renewed assertion, the hourly refuge taken in the Divine, which prevents us from stumbling, from losing ourselves in the sea of the *nafs* until we learn to drown that sea in the Ocean of love, and we become the drop that reflects the universe, visible and invisible.

Take care of your self and your deep being. Listen with your deep ear that can truly hear, see with the eye that cannot be blinded or distracted by outer forms. Weigh every thought, every word, every action in your heart. Whenever a question, an idea arises, weigh them, filter them in your heart. Listen with great respect to your true self so that in time you may dive into the depths of your being, leaving your superficial self to come closer and closer to your true self, where there is neither fear nor sorrow, where you can see the light of your infinite existence and drink from that source.

Sura al-Baqarah, سورة البقرة, The Cow (2:38)
And those who follow My guidance need have no fear, and neither shall they grieve.

Once we know the splendor of the benevolent source of our life and of life itself, we know and recognize ourselves in harmony. As we develop our capacity to relate to our fellow human beings and to trust them, so we develop our capacity to relate to God. Whoever wishes to be close to God should respect His creatures and treat them with love. For Allāh loves those who love His creatures. The longing in our breast has been calling since time began. Let me fall back into the depth of eternity! Remember, remember, *tadhakkar(i)* (تذكري)!

In sura 2, verse 115, the Qur'an says that wherever you look is the face of God, everything vanishes but this One Face. Through love we dissolve in order to become love. For men, the path of transformation goes through self-knowledge, for women through self-love.

The Divine Name Al-Khāliq shows the divine quality of creating. He is the Creator of the Creation. He created everything from naught. He gives all creatures their states, their capacities, and their distinctive features. Everything was created in perfection and divine wisdom. And everything follows the way it is meant to follow. Nothing in the universe is accidental. Allāh made the Creation from deep love.

Hadith Qudsī
I was a hidden treasure and I cherished the wish, born from love, to be known,
so I created the Creation (mankind) for Me so that they know Me through Me.

Hadith Qudsī refers to messages whose contents were received from God by the Prophet, who expressed them in his own words. Those words are not part of the Qur'an, yet they are ascribed to God.

Allāh created everything for humankind, and He created humankind for Himself.

The circle begins with love and separation, and it ends with love and union. Love is not only the basis for the Creation of the world, but also for the return to God. God is in the center of this circle, while the circumference is made by the diverse manifestations of the Divine—*tajallī*. And the human being is the center of the periphery, because he is the only being in whom the Divine can manifest in a complete form. Thus is he called God's vice-regent.

The word *tajallī* comes from the root *j-l-w* and can be translated as follows: to reveal, to unveil, to polish, to clear, to shine, to distinguish, to make or become clear, to go away, to show, to remove, to manifest, to reveal itself, to appear, to come to light, to be cleaned, to disappear. In its global meaning *tajallī* refers to divine manifestation in the world. On the individual, personal level, *tajallī* means God's revelation in the heart of the believer.

God steps out of the invisible, reveals Himself in the world, and shows Himself through the Divine Names. The all-encompassing world was created through its longing to be, and in its being all the Divine Names are one with the Divine Being. They carry the One Love through which the world comes into existence. Thus, all of Creation is a mirror reflecting the Divine. God's love shows itself through His continuous manifestation in the Creation. The created world is the outer aspect of that which is God in its inner aspect. Yet the One remains, whereas diversity is in constant movement through the eternal cycle of birth and death. Opposites are here in order to become reconciled, and ultimately to unite, for the many must become one again.

Then is love not the driving force? It is love, it is the Divine Names that brought restlessness into the world because the world is constantly seeking that love and that peace, in a mutual longing between the Creator and all creatures. It is as if the universe were ice and God the water of which that ice is made. The name "ice" was given to the frozen mass whose true name is "water."

Every being in the universe has a source, a core of stability. In human beings, this core is located in the heart, the center of love. For it is love that leads us back to God, it is love that forms the umbilical cord to Him. This is why Sufism turns to the heart. Knowing the heart unites us again, always assigning everything on the outside to its inner reality. This is how we understand that nothing in this world exists as an independent reality; everything is utterly connected to the core of the hidden treasure whose beauty we were created to unveil.

People who deal with plants, such as farmers or gardeners, protect them and support their growth and health by repeating this Divine Name.

We also repeat Al-Khāliq when someone is away or has not visited us for a long time. We then start reciting Ya Khāliq in the evening until we fall asleep.

The Divine Name Al-Khāliq is reflected in the beauty and uniqueness of every form.

12

<div align="center">

البارئ

AL-BĀRI'

The Creator of harmony, the One who shapes, the One who brings into existence

213–852–45,369

</div>

The three Divine Names Al-Khāliq (11), Al-Bāri', and Al-Muṣawwir (13) all carry the qualities of creating and forming. As already mentioned, Al-Khāliq is the original cloth that is later cut into various pieces by Al-Bāri', each piece receiving its individual shape through Al-Muṣawwir. Some of their meanings connect these three names, others differentiate them.

Al-Bāri' symbolizes the archetypes that emerge from the sea of infinite potential. It corresponds to the third world where the Divine Names exist in their essence, prior to manifesting on the outer level. This third world is called *'ālam al-jabarūt*, the world of powers. It is on that level that the soul of the world, or universal soul, manifests in the different Divine Names through God's creative energy. It is the world of the archetypes and substances from which the further manifestations flow.

This is how the Divine Name Al-Bāri' helps us set aside and uncover everything on our path so that we may reach and unveil the essence of things.

Al-Bāri' carries first and foremost the quality and meaning of giving. Every creature is given in accordance with its behavior, its harmony, and its relationship to others so that it can enter into the appropriate relationship with everything. Al-Bāri' separates individual manifestations from the cloth of Unity. Through Al-Bāri' nonexistence comes into existence.

Let the harmony that lies in your nature express itself in your life. You have received from Him all the capacities, as well as the freedom, to choose between harmony and disharmony, not alone on the top of a mountain but amid all creatures. They all serve as a mirror, reminding you of the neediness,

the compassion, the love, the sincerity, the beauty, the longing, and the sadness that connect us all and that we all need.

The root *b-r-'* from which Al-Bāri' is derived carries the following meanings: to create, to become free, to be cleared, to recover, to cure, to heal, to free someone from responsibility, to declare someone innocent, to be innocent. All of the above have the basic meaning of "becoming free of." On the spiritual level, this name gives us the strength to free ourselves from the tyranny of our lower impulses in order to come closer to our true self. On the physical level, it frees us from disease.

People who have been sick for a long time and who are seen to be beyond hope should repeat this Divine Name. May Allāh, in His mercy, take that sickness from them!

Al-Bāri' is the Creator of harmony. Love is the reason the universe was created. Allāh created all things in their proportions. He is the Creator of all forms. He grants each of His creatures its specific appearance and form, so that every form is distinct from the others, yet they all come from the same original substance.

Sura al-Ḥashr, سورة الحشر, The Gathering (59:24)
He is God, the Creator, the Maker who shapes all forms and appearances!
His [alone] are the attributes of perfection. All that is in the heavens and on earth extols His limitless glory: for He alone is almighty, truly wise!

13

<div align="center">المصور</div>

AL-MUṢAWWIR

The One who gives shape

336–1,344–112,896

This Divine Name gives things their final shape or color, and it invokes a focusing that leads straight to the goal. Al-Muṣawwir is the Divine Name that lends all things their form. Every creature is shaped in a unique, special manner, and the uniqueness of each individual manifests again within each species. Your life is constantly being formed and divine reality takes shape through you in a lifelong process. So never look down on others because, just like you, they have been created from the Divine.

Out of the Divine Names Al-Khāliq (11), Al-Bāri' (12), and Al-Muṣawwir, the latter stands closest to the world of material manifestation. Although it only becomes fully visible through Aẓ-Ẓāhir (75), Al-Muṣawwir expresses its constant moving in that direction.

The root ṣ-w-r contains the following meanings: to form, to shape, to fashion, to create, to illustrate, to make a picture, to describe, to portray, to imagine, to conceive, to think; former, shaper, creator; form, shape, image, idea, figure, statue. These basic meanings clearly show that this Divine Name does not express the clear manifestation, but indicates the eternal flow that leads thereto.

Al-Khāliq, Al-Bāri', and Al-Muṣawwir show the love flowing from the Divine Essence into the manifestations, as well as the way that takes them back to the Essence, through their love for the Essence.

Breathe with the Divine Name Al-Muṣawwir and feel how it enfolds and shapes your creative powers so that they may blossom at the right moment.

Many scholars repeat the three Divine Names Al-Khāliq, Al-Bāri', and Al-Musawwir together. When you recite them separately, you realize that Al-Khāliq is the One who shapes destiny, Al-Bāri' the

One who creates harmony, and Al-Muṣawwir the Painter who brings shapes and pictures into existence.

The Divine Name Al-Muṣawwir helps artists express their creative powers and become masters in their craft, and guides them towards success, God willing.

Allāh, fill our hearts with the longing to remember You and wet our tongue with thanksgiving!

Sura al-Mu'minūn, سورة المؤمنون, The Believers (23:12–14)
NOW, INDEED, We create man out of the essence of clay,
and then We cause him to remain as a drop of sperm in [the womb's] firm keeping,
and then We create out of the drop of sperm a germ-cell, and then We create out of the germ-cell
an embryonic lump, and then We create within the embryonic lump bones, and then We clothe
the bones with flesh—and then We bring [all] this into being as a new creation: hallowed, there-
fore, is God, the best of artisans!

Make us into human beings who encounter the Creation with care and attentiveness,
and lead it back to You in their heart!

14

الغفار

AL-GHAFFĀR

The All-Forgiving, the One who forgives, the One who forgives time and again
1,281–5,124–1,640,961

Al-Ghaffār is the One who is there to forgive whenever something should be forgiven, the One who forgives time and again in His infinite kindness. Al-Ghaffār is the divine forgiveness that flows from God's endless mercy and love for humanity. Al-Ghaffār is the One who covers mistakes, bad deeds, and bad thoughts, rendering them ineffective so that human beings may live in mutual love and trust.

Every human being makes mistakes. The idea is not to be free of mistakes—the idea is not to insist on them. Indeed, to acknowledge and admit one's mistakes is a great virtue and a sign of wisdom. A true friend is a person who brings our attention to our mistakes with kindness and compassion. Do not be ashamed to admit a mistake or to apologize. Only those who persist in their mistakes should be ashamed. The bitterest situation comes about when we defend our mistakes and try to pass them as the truth. To defend one's mistakes is to defend one's whims and moods. When done inadvertently, it should be forgiven; however, if done deliberately, it is wise to distance oneself from such a person, because character weaknesses are contagious.

Those who repeat this Divine Name 33 times after having recognized a mistake enter forgiveness. Al-Ghaffār is the Divine Name that forgives all mistakes and puts a veil over all weaknesses, in this world and the hereafter. Those who forgive others and cover their faults so that no one can see them enter this kindness, and their faults too are forgiven. When people can see things and events with a compassionate heart and repeat Yā Ghaffār 100 times, their own faults are also forgiven. Whenever anger or rage well up in your heart, repeat the Divine Name Yā Ghaffār and they will pass. Blessed be

those who show what is beautiful and hide what is ugly. Allāh always pardons our mistakes when we beseech Him sincerely.

We often feel misunderstood or hurt by the ignorance of others. We try to protect ourselves by becoming thick-skinned or giving in and accepting everything, or we become ultrasensitive, reacting intensely to everything. But all these strategies turn us into victims, and being a victim is the greatest obstacle to inner harmony and inner peace. So what is the solution? Understand that there is no solution and that at the same time we can only develop and open our heart. To open the heart is to connect mind and feelings, and let the light of life shine. Learn and understand this by acknowledging that things are not always as you would like them to be. Sometimes things happen that you do not want and that are good for you, and sometimes things happen the way you want and they are not good for you.

Sura al-Baqarah, سورة البقرة, The Cow (2:216)
But it may well be that you hate a thing the while it is good for you, and it may well be that you love a thing the while it is bad for you: and God knows, whereas you do not know.

The quality of forgiveness burns everything but love. Love is the most powerful and creative force in the whole universe. Love is as strong as death. Let your heart simmer until it becomes tender. Use the strength of anger and rage in a positive manner, polishing the mirror of your heart until it is clear again, purified of life's wounds. Be a fearless warrior on the path of love—above all, do not fear yourself.

Summon the reflection of a wound in your heart and imagine yourself burning the imprint left by the wound so that the part of you that has become separated through the pain can again see itself clearly in the light of Unity. To see things in the light of Unity means to be able to see the positive even in difficult and heavy situations. It means to recognize that aspect of the situation that helps you understand and know yourself better. Every problem also carries a solution. Learn to read in the widest sense of the word. Reading is not limited to your eyes. In their own way, your ears, nose, tongue, mind, heart, and soul, indeed your whole being, are all reading tools.

The Divine Names Al-Ghaffār and Al-Ghafūr (34) are both derived from the same root *gh-f-r*. The various meanings ascribed to this root are: to forgive, to grant pardon, to remit, to apologize, to watch over, to cover.

The major difference between Al-Ghaffār and Al-Ghafūr is that Al-Ghaffār keeps the door open, always inviting us to return, even if we have broken our promise a thousand times. Al-Ghafūr penetrates and touches the deepest part of our heart, the place where our most grievous offenses, our greatest slips lie. Al-Ghafūr goes to the worst that was ever done to us, reaching that which we believed could never be forgiven. Both names carry the basic quality of covering and healing inner wounds,

moistening and softening the inner cracks and tears, closing them with the divine balm so that the water of life may once more flow through our being.

One of the sentences most frequently repeated by the Sufis is *'astaghfiru llāh!* It comes from the same root as the abovementioned names and can be translated and used in many different ways: I seek refuge in You! I ask for forgiveness! I seek protection in You! Whenever I assert something and my ego wants to puff itself up in self-admiration, I protect myself against it with *'astaghfiru llāh*. Whenever I have done someone an injustice, *'astaghfiru llāh* helps me humbly take one step back. If I get entangled in superficiality and carelessness, *'astaghfiru llāh* takes me back to my center. *'Astaghfiru llāh* is the wind that purifies us daily of the soiling brought about by our slips, our acts of negligence, small and large. But it is also the wind that frees us from our wish for retaliation and revenge, giving us the possibility, time and time again, to act out of our deep self. So repeat every day *'astaghfiru llāh* 70 to 100 times, and may the divine wind of freedom, purity, and kindness dance in and around your entire being.

Use your breathing and the repetitions of Al-Ghaffār to simmer your heart and soften that which has hardened in you. It will soothe and dissolve the offense and heal the wounds. A protective scab will form, underneath which healing can begin.

Human beings who carry the quality of Al-Ghaffār are capable of forgiving faults, indeed they do not even see them as such. So learn to forgive those who have mistreated you, the friends, the parents, the grandparents who did not understand you or failed to see you as you are. Be kind to those who need kindness and watch your behavior and your manners, letting them be carried by your dignity, your generosity, your loyalty, and your wisdom.

Whenever strong anger comes up, repeating Al-Ghaffār helps us calm down and recover our balance.

Sura Ṭā Hā, سورة طه, O Man (20:82)
Yet withal, behold, I forgive all sins unto any who repents and attains to faith and does righteous deeds, and thereafter keeps to the right path.

Be tolerant of others' mistakes, do not go into accusations but transform through understanding, clarity, and true help.

Sura al-Nisā', سورة النساء, The Women (4:110)
Yet he who does evil or [otherwise] sins against himself, and thereafter prays God to forgive him, shall find God much-forgiving, a dispenser of grace.

You who heed my tears,
You know my secret remorse.

15

القهار

AL-QAHHĀR

The One who overcomes, the One who defeats everything, the Almighty,
the Invincible

351–1,404–123,201

This name also carries the meaning of dominance. Even when someone claims to dominate another totally, only the Divine has complete control over our body, our movements, and our soul.

The qualities of Al-Qahhār and Al-Laṭīf (30) rest in one another. One reflects the darkness in and around us, the other the subtle, clear light. So take refuge from Allāh Al-Qahhār into Allāh Al-Laṭīf. The miracles of the universe rest in the divine heart where there is no separation.

Repeating the name Al-Qahhār 66 times enables us to gain control over negative needs and impulses, and to attain spiritual satisfaction and inner peace. Repeating this name also protects us from negative deeds.

The root *q-h-r*, from which Al-Qahhār is derived, carries the following meanings: to subject, to subjugate, to conquer, to overpower, to overcome, to force; forcible, compulsory, compelling. An image may help you understand the meaning of the power and the love that are connected with Al-Qahhār: the heat of the fire that extracts the juice from the meat. Al-Qahhār triggers in us a process of longing and burning passion. Regardless of what we do in life, no matter how busy we are, the longing for God always burns in the depths of our heart. Nothing can extinguish this deep yearning—it is always there. Al-Qahhār is the fire of love, the fire that always burns in us, no matter how bad things are in the world. It is the fire that connects us to our light.

Repeating Al-Qahhār burns out the identification with our wounded *I*, with the shame, the

humiliations, and the insults, until nothing remains in us but the divine flame. Al-Qahhār overcomes all outer attachments until our true being shows itself.

Every Divine Name finds a different echo, a different taste in the heart of the reciter, and its influence is perceived according to the reciter's state. The deeper the quality can enter their heart, the more open their heart is, the stronger the influence, the sweeter the taste, hence the wider and deeper their understanding and knowledge of a Divine Name.

Al-Qahhār takes you to what He wants, whether you like it or not. By repeating this Divine Name, you learn to curb your anger, to master your appetites, to overcome your inner enemies, and to forget all your concerns but one—to be close to God. Al-Qahhār burns out everything in our life that we no longer need. Feel the fire and the purifying strength of Al-Qahhār, and use it to cleanse and bring clarity to your heart.

When people who sense that they are being controlled by their lower self repeat Al-Qahhār with an open, fervent heart, they are given the strength to control it.

A human being is both the walker and the path.
If the walker wants to know the path, he must first know himself.

16

AL-WAHHĀB

The Bestower, the Dispenser of all mercies, the Giver of gifts

14–56–196

Al-Wahhāb is the One who gives steadily, lavishly, without moderation, the One who surrounds His creatures with gifts and blessings without expecting anything in return because He needs nothing in return and everything finds help in Him. Al-Wahhāb is to give a truly free gift, without expectations.

This is the Divine Name of the One who forever gives, the Giver of all opportunities, both visible and invisible, in this world and the hereafter. This name shows us that we are naked and destitute, that all possessions are a gift. To recognize that we all share a need for love, compassion, understanding, and tolerance touches our heart and makes us at the same time poor and rich. And human beings awaken between these two qualities.

Repeating this name 7 times after the morning meditation opens a space and lets wealth flow. When people do not have enough to live or feel that they need more, they should repeat this name 100 times at midnight, after a meditation, on three to seven consecutive nights. People who are confronted with enemies and, through them, fall into great difficulties or are taken prisoners, should repeat this name in the same way.

Understand this name, hear and recognize others' requests and needs, and stay connected to your deep inner self when you ask. Ask only Him, rely on none but Him, and you will receive through His Creation, through life itself. Drape yourself in gratefulness so that you may recognize the blessings. The difference between those who can see the blessings and those who cannot is peace in one's heart and the ability to be nurtured by life in all circumstances.

Al-Wahhāb comes from the root *w-h-b* and contains the following derived meanings: to give, to donate, to grant, to accord, to present, to endow; gifted, talented; giver, donor; gift, donation, present, talent, gratuity. It also means to accept a gift without feeling any obligation, in the same way that clouds rain on everything without distinction.

The love manifested through Al-Wahhāb draws its gifts from abundance. This is why it is good to repeat this name when we fear or worry that we may not have enough, be it on the spiritual, social, or material level. Al-Wahhāb changes our perspective and our way of thinking, and enables us to see the abundance.

Doors open to those who repeat this name, often unexpectedly—doors we never even suspected could exist. Allāh is the All-Knowing, thus He knows how and when something is to be given, how and when the gift is adequate. So ask Allāh when you need something and ask Allāh when you need help. For when the gift comes from Al-Wahhāb, no one can oppose it. If a given destiny is meant for you, this task—this gift—will come to you even if all oppose it. So turn to Him in times of lightness and ease so that He may turn to you in times of heaviness and difficulties, and know that patience and perseverance lead you to the heart of everything.

Prayer is always an act of worship and love of the Creator through His creatures. It is connecting, (*ṣila*, صلة), stepping out of the noise of the world of time and entering the open space of eternity. Prayer is not a request for support. Prayer is coming home—where the limitations of the ego no longer matter.

Sura al-ʿImrān, سورة آل عمران, The House of ʿImrān (3:8)
O our Sustainer! Let not our hearts swerve from the truth after Thou hast guided us; and bestow upon us the gift of Thy grace: verily, Thou art the [true] Giver of Gifts.

Human beings who carry the quality Al-Wahhāb have been granted by Allāh the power to give, regardless of the response that may or may not follow.

For tolerance is gain.

17

الرزاق

AR-RAZZĀQ

The One who looks after all beings, the Provider, the Nurturer

308–1,232–94,864

Allāh in the quality Ar-Razzāq is the One who provides human beings with their livelihood, as well as everything they need for their material and spiritual life.

Gratefulness manifests when we become providers and nurturers for the hungry and the needy. It is the divine quality that lies in us and makes us realize that we participate in shaping this world and that we are a part of social justice. May our hearts be protected from hardening!

If you repeat this name, you will be given help and support. Those who hang this name in their workplace will be successful in their deeds. Whoever repeats this name 100 times at noon on a non-working day will be relieved from stress and discouragement.

Ar-Razzāq is the One who nurtures all beings, the All-Sustainer. The body is nurtured with material food, the soul with spiritual knowledge, *ma'rifa* (المعرفة). Some become rich through material possessions, by taking generous care of others, or by knowing the Provider.

Pray to Allāh that He may grant you deep knowledge, a wise tongue, and a good, generous hand. For when Allāh loves a human being, He blesses him by having others need him, and He puts into his heart the love to fulfill their needs.

A Sufi was once asked, "What do you live on?" And he replied, "From the day when I knew my Creator, I stopped doubting my Provider." So do not ignore the flow of blessings that surrounds you.

The root *r-z-q* contains the meanings of giving, parting with material and spiritual goods, being talented, nurturing oneself, being successful, living; gift, good deed, life provision, and basis of existence.

The concept *rizq*, food, denotes everything good and useful to us human beings, be it of a physical nature (water, food, clothing, and shelter), of a mental nature (reason and knowledge), or of a spiritual nature (faith, patience, compassion). It concerns exclusively positive and useful things, never things that are physically, morally, or socially disgraceful, reprehensible, or harmful.

Al-Ghazālī, one of the great Sufi masters of the thirteenth century, emphasizes the importance of mental and spiritual food, which he deems superior and more important to humankind than material food.

> At the end of time, Allāh will say, "O, children of Adam, I asked you for food and you didn't feed Me." And the souls will answer, "O Provider of all the worlds, how can we feed You?" "Haven't you seen My creatures who were starving? Don't you know that when you feed them, you feed Me and by so doing, you come to know Me?"

Repeating this name brings clarity to the mind, improves and strengthens memory, and gives trust and serenity to the heart.

Breathe with the name Yā Razzāq, center in your heart and let the ensuing feeling guide you so that you know which food you need now—whether on the physical, emotional, or psychological level. Which part of you, which voice, feels hungry? What food can your deeper self give?

Do your best to nurture yourself and others, then say, "Yā Razzāq Yā Allāh is my Nurturer, my Provider."

Sura Hūd, سورة هود, (11:6)
And there is no living creature on earth but depends for its sustenance on God; and He knows its time limit [on earth] and its resting place [after death]: all [this] is laid down in [His] clear decree.

There is no doubt that Allāh supports all beings. Yet it is our responsibility to sow and irrigate the earth and to look after our sustenance. For that is our part of the task, our part of integrating into the whole, our part of devotion, in the knowledge of the divine laws of healing and harmony.

O You, You who hold open all the doors to Your gifts,
be they compassion or daily bread, make us rich by being content!

18

AL-FATTĀḤ

The Opener, the One who reveals, the One who separates
489–1,956–239,121

Allāh offers us human beings liberation through the path of peace. This divine attribute has three meanings: opening, beginning, and success. Truth opens at the moment of death. Allāh opens the doors to success so that we may open all problems and obstacles. He is the One who opens the hearts to the truth and the One who lets knowledge and sincerity flow over our tongue. He is the One who lifts the veils and enables us to see what is essential in all things, who gives us the strength to be truthful. Repeating this name 60 times brings clarity to mind and heart, and opens the way.

This Divine Name opens up dead-end situations and lightens difficulties. Open yourself to His generosity and recognize the relief He brings. Feel how solutions are revealed to you through His kindness and mercy, because He is the One who reveals, the One who opens everything that has become hard, closed, or contracted.

In our life, there are always things that harden up or get tied into knots. Sometimes this happens on the material level, with work, income, friends, or family members. Sometimes it happens on the level of the heart where it manifests through sorrow, grief, and worries, or on the level of the mind where it takes the form of permanent doubts and ceaseless, circling questions that find no answer.

If your heart really longs to free itself from illusions, selfishness, anger, and moroseness, then lay your right hand on your heart and repeat Yā Fattāḥ 70 times after your prayers, before sunrise.

Al-Fattāḥ can open up all these situations. No force will then be able to keep them closed. And if they should not open yet, do not carry any despair in you because it is always beneficial for you that it

be so, even if you cannot see it as such. Behind the bitterest medicine is always the softest hand of all. Think well of Him, make space for trust in your heart, and you will see the good.

Sura Fāṭir, سورة الفاطر, The Originator (35:2)
Whatever grace God opens up to man, none can withhold it; and whatever He withholds, none can henceforth release: for He alone is almighty, truly wise.

To some of us Allāh opens up the doors of knowledge so that we may transmit it. To others He opens the doors of riches so that they may give to the poor and the needy. To some of us He grants strength and health so that we may help the weak and the sick. To others He opens the doors of child-bearing so that our eyes and hearts may rejoice.

So open as best you can the doors of kindness, hope, and compassion to human beings so that Al-Fattāḥ opens for you even more than you opened for His creatures. Be careful not to hurt them, for wounds close human hearts and then kindness must wait outside.

The quality Al-Fattāḥ is mirrored in the faces of people who have overcome their problems or their suffering, and whose joy is such that they can no longer hide it from others.

Al-Fattāḥ comes from the root *f-t-ḥ*, which has the following meanings: to open, to turn on, to dig, to build, to introduce, to begin, to conquer, to capture, to reveal, to open the gates, to inspire, to endow, to unfold, to respond from the heart, to blossom, to emerge; opening, key, beginning, victory, triumph, achievements, openness, receptivity (spiritual or mental). The word *al-Fātiḥah*, the opening sura in the Qur'an, also comes from this root.

Al-Fattāḥ is the Arabic expression for enlightenment—continuous, constant enlightenment. God's light is hidden even in the darkest corners. Learn to work with this hidden light, with humankind's deepest longing. The light of our own surrender leads us to the place where we are needed, and it shows us the backdoor that was left open. Al-Fattāḥ is the key that opens the heart to Allāh so that we may find Him in us. Al-Fattāḥ enables us to go deeper and deeper into this opening. Everything blossoms; all of nature develops and reveals itself with Al-Fattāḥ.

Respect the right of others not to want to know, to be prisoners of illusions, to follow the path of their own wishes. Independence also means the freedom to make mistakes and to err. Never judge, respect the right of every human being to determine their own fate, to lose themselves time and again. Sometimes you will be given permission to show the way, to reach someone a helping hand. Instinctively your heart will open and you will allow yourself to be used. But be very careful not to cling to those deeds and so satisfy your ego. Give everything back to the Ocean of Love; everything comes from Him, and to Him everything returns. Remain open and connected so that love may flow freely and your help does not become intrusive.

To restrict someone else's freedom, to deny others the right to choose their own path, means to put ourselves above God who gave us this freedom of choice. When the arrogant ego believes that it achieves everything itself, we lose the protection and guidance that we are given. Caught in the clutches of the ego—even a "spiritual ego"—we remain in its sphere of illusion and isolation. By following our own ideas, no matter how well meant, we bring a veil between us and the light that guides and protects us. By identifying with the ego, we only trust ourselves and we put up tiring walls of separation. But when we surrender our ego to the arena of true service, then we trust Him, the original cause of all existence. Only then can we participate fully in life without risking to become prisoners of our illusions and our castles in the air.

Breathe into your heart with this Divine Name and open your inner eye to examine the various situations in your life that require more opening.

Al-Fattāḥ is the quality of love that will help people who are driven by impatience, as well as those who collapse and find themselves unworthy and worthless when they fail to receive that which they deeply wish for or feel entitled to. When we experience pain and disappointment, the wounded self tends to cut itself off and to identify with the idea of worthlessness and being a hopeless case, while the deep pain grows into self-pity. In order to avoid that pain, the ego develops protection mechanisms that take various forms according to different personalities. Identifying with the painful experience—with the lack—the ego expresses it either through despair or through a boasting, pompous, overblown posture, to give but two extreme examples. Invoking Al-Fattāḥ helps to bring about the opening, the connection. It helps us find the way out of the belief that we have been abandoned, the feeling that we are destined only for lack.

Malice is one of our traits, as is fear, yet kindness and mercy are also our traits, just like purity. We are the source of all purity and all impurity. Something happens on the outside, watch what you allow to surface from within, where both qualities exist, and know that the choice is yours.

After repeating Al-Fattāḥ, it is recommended to repeat the Divine Name Al-Wakīl (52), which expands the space of trust.

Those who carry the quality Al-Fattāḥ in their heart have succeeded in pouring all their different qualities into Unity. Their wisdom and their experience enable them to solve both their own and others' material and spiritual problems. They are given the keys to deep knowledge and the capacity to open up, solve, and heal.

Jesus, may peace surround him, said in Aramaic, *eth fatah!* ("Be open!") when he restored a deaf man's hearing.

Yā Fattāḥ, You open to us closed hearts, You open the truth in our souls, You open to us the gates of kindness, You open for us our entanglements and lighten our burden, You open to us knowledge and inner vision, and You open for us our abilities and our potential, so open to us, O Allāh, the gates of the knowledge and the love of You!

19

AL-ʿALĪM

The Omniscient, the absolute Owner of wisdom

150–600–22,500

This name symbolizes God's omniscience and absolute knowledge since time immemorial.

Al-ʿAlīm, as well as al-ʿĀlim, are based on knowledge, whereby Al-ʿAlīm is the superlative form of Al-ʿĀlim, in the same way that al-Qadīr is the superlative form of Al-Qādir (69).

Al-ʿAlīm knows the secrets that lie in the heart and that which is expressed through the tongue. It knows the visible and the invisible. If you repeat this Divine Name 100 times after prayer, your eye will see things previously unnoticed. This is the opening of the third eye, also known as the mystical eye.

If you develop the habit of repeating this name 150 times every day, your comprehension, as well as your understanding of everything around you, will widen.

Knowledge, *ʿilm* (علم), and love, *ʿishq* (عشق), are the wings that give us flight on the path of transformation of the self.

Do not let the beauty of the veils bewitch you. Act as honestly and truthfully in secret as in public—in other words, do not act differently when you are in company or alone. Lift the veil between the inner and outer world. The whole existence is eternally present in Al-ʿAlīm's knowledge. Human knowledge is born of the things that exist, and existence itself is born of Allāh's infinite knowledge. What is the life of a human being, compared to the infinite future and infinite past? The mere twinkling of an eye! What can we see? Happy is the one who sees that he cannot see.

A Sufi came to a town where an angry, unfriendly man spoke to him, "Go away, no one here knows you!" "That is true," the Sufi replied. "But I know myself and it would be far worse if the reverse were true!"

Only a human being who knows himself can discard the veils of arrogance, for he who knows

himself, knows his Lord. All those who set out on the path to knowledge, are on the path to God. Thus the Qur'an says, *"And wherever you turn, there is God's countenance"* (2:115).

Human beings who carry the quality Al-'Alīm have been granted knowledge without learning anything from anyone, without studying, without thinking. A knowledge born purely of the clear light out of which we were created. Al-'Alīm unites the mind and the heart, abstract and intuitive knowledge. Our consciousness approaches and tunes to the consciousness of the One Knower. It is an act of utmost concentration on a single aim, until everything else ceases to exist and perfect mastery over one's own consciousness is attained so that it becomes like divine consciousness.

Let Al-'Alīm fall into you with your breathing, all the way down to your solar plexus, the level of the first higher consciousness, and let it flow from there into your heart and your mind.

Awaken to a different quality of knowledge—a knowledge that comes to you in dreams, inspirations, signs, or visions.

None of us stands higher on the ladder, be it the ladder of worldly success or that of spiritual achievements. Rather, each of us is complete and important, indeed indispensable for the whole. Every human being plays a meaningful and decisive part in the course of this world. The knowledge of every individual is precious, and their participation therefore essential to our life. To know that this completeness is present is the first step. Completeness is given; we need not reach for it. We just need to accept the gift.

The only prerequisite is that we relinquish the patterns of conditioning that bind us to the hierarchic models of performance and failure, praise and reprimand, shame and guilt. Admit to yourself that you have grown tired of this perspective, that you are tired of the demands of success, worn out by the battles against failure, defeat, and exploitation.

God needs us so that we bring to life the mystery He has hidden in His world. We human beings are the agents, we are the mirrors, and we hold the secrets of Creation in our hearts.

Al-'Alīm is the awareness and the knowledge of His love. Love always pulls us back to Unity. In love there is but unity—the rose and the thorn are one.

Human dignity is based on knowledge and understanding. Yet the mind needs the quality of humility in order to acknowledge its limitations and open to the necessity of faith.

A scientist's first sip of knowledge turns him into an atheist. Yet it is always God who awaits him at the bottom of the glass.

Our heart is connected with the heart of the world. We protect the mysteries of the universe in our heart. Time and time again, through the rising and falling breathing movements of the worlds, we are granted access to the different secrets, to diverse, renewed forms of knowledge.

Sura al-Baqarah, سورة البقرة, The Cow (2:32)
They replied: "Limitless art Thou in Thy glory! No knowledge have we save that which Thou hast imparted unto us. Verily, Thou alone art all-knowing, truly wise."

Each and every one of us is given according to our nature and to the work we are meant to do. Open your heart and the knowledge, the power, and the energy required for your work will be given to you, as well as enthusiasm, love, and freedom.

The following list contains some concepts derived from the same root ‘-l-m which give us a deeper understanding of the domain ruled by the Divine Name Al-‘Alīm: ‘alima: to know, to be taught, to recognize, to notice, to perceive, to experience, to distinguish; alm: beings, creatures; ‘ilm: knowledge, realization, art; ‘alam: sign, signpost, symbol; ‘ālam: world, cosmos, universe, ‘a sign for something’; ‘ālima: scholar (feminine), singer (feminine); ’a‘lam: the one who knows; Allāh ’a‘lam: God knows best; mu‘allim: teacher, master; ma‘lama: encyclopedia; ulamā’: a source of water hidden underneath a mountain; ma‘lam: footprints on a path which one can follow.

Sura Fuṣṣilat, سورة فصّلت, Clearly Spelled Out (41:53)
In time We shall make them fully understand Our messages [through what they perceive] in the utmost horizons [of the universe] and within themselves, so that it will become clear unto them that this [revelation] is indeed the truth.

The Arabic words ‘ālam (world), ‘alam (sign), and ‘ilm (knowledge) all come from the same root. Their etymological connection helps us understand that the things we perceive in the world are signs, therefore a source of knowledge of those things, but also of the existence of the One who created the world—Allāh. Thus, the all-encompassing being—the world—becomes a symbol of His existence for the knower.

Deepening our vision and opening it to the miracles of the universe helps us to reach a deeper understanding of our true self. Experience leads to understanding, insight, and knowledge. Insight and knowledge have their roots in the Divine and are the means to reach Him.

In Sufism, human beings are seen as the perfect image of the universe. Whatever exists in the universe exists in us, too. To learn to read into nature, into the universe, but also into ourselves, to discern the signs and symbols makes us understand that everything around us is the reflection, on a lower level, of a reality of a higher order. We realize through this experience that everything that lives is holy.

The core of Sufism is to allow us human beings to discover the Divine that we carry in our heart and take us to that which is sacred, thus transforming the world of manifestations into a place filled with the living experience of the Divine.

"See the world as contained wholly in you,
for the world is a human being and the human being is a world."

— Shabistari

95

20

القابض

AL-QĀBIḌ

The One who contracts, the One who assesses, the One who seizes and contracts, the One who holds back

903–3,612–815,409

21

الباسط

AL-BĀSIṬ

The One who relieves, the One who eases, the One who unfolds, the One who apportions generously, the One who widens, the One who spreads out

72–288–5,184

The two Divine Names Al-Qābiḍ and Al-Bāsiṭ are connected like the opening and closing of the heart, day and night, joy and sorrow.

Al-Qābiḍ is derived from the root *q-b-ḍ* and Al-Bāsiṭ from the root *b-s-ṭ*.

The following meanings come from the root *q-b-ḍ* : to seize, to take, to grab, to clutch, to take hold, to receive, to collect, to contract, to oppress, to dishearten, to shrink, to close one's mind, to withdraw; gripping, holding, receiving; grip, grasp, clasp, fist.

The following meanings come from the root *b-s-ṭ*: to spread, to spread out, to level, to flatten, to enlarge, to expand, to extend, to unfold, to unroll, to grant, to offer, to present, to submit, to please, to delight, to spread one's arms, to extend a helping hand to someone, to be simple, to be openhearted, frank, to set forth, to explain, to be sincere, to speak openly, to confess frankly, to be friendly, to be completely at ease, to broaden, to be merry, to be delighted, to be or become happy, to overcome shyness; communicative, sociable, cheering; magnitude, capability, simplicity, plainness, simplification, joy, gaiety, cheerfulness, carpet, earth, world.

Al-Qābiḍ is the One who stops, the One who puts pressure, who seizes the heart, who can conjure difficulties or depression, leading to isolation and despair. This is the time when tears flow, the time of quest, when nothing has taste or meaning. Yet it is also the time that can, like no other, bring you closer to Allāh.

In the face of all the despair, many a lover longs for this state: with all the difficulties, the pain, the separation from all human beings, only He remains to whom the heart can then turn. It is the sweetness in the pain. In that moment when I have been abandoned by all, only You remain!

Qabḍ (قبض) is when the soul is pressed as if through the eye of a needle. When you are given great difficulties, use it. Do not complain, wail, or crumble. Do not just beat your breast in despair, but let the movement knock on the deep layers of your heart. Become a lover even in times of grief.

Al-Qābiḍ contracts the souls at the time of death, and it expands them when they enter the body.

Qabḍ is the time of fasting when the impulses begin to fight and to feel restricted in their freedom of movement and choice. To a certain extent, the fasting month of Ramadan is the *qabḍ* of this world for the *basṭ* (بسط) of the hereafter.

The *khalwa* (خلوة), or spiritual retreat, can also be compared to the *qabḍ*. In many Sufi schools, seclusion is practiced in nature, or under the supervision of a teacher in an isolated room, so that one may go from the *qabḍ* into the mercy of the *basṭ*. For this purpose, exercises for spiritual expansion, *jalwa*, (جلوة) are practiced in the *khalwa*. *Jalwa* means clarity, unveiling, human ascension in the Divine, and all practices serve to support the person doing the retreat and lead them to recognize and discover the divine splendor. The *dhikr* (collective practice), the *fikr* (silent invocation), and whirling are examples of *jalwa*.

Qabḍ enables us to see our virtues, to turn to our heart. Spiritual maturity then manifests in the *basṭ*, although the veils often come up as soon as the pressure of *qabḍ* relents.

Al-Bāsiṭ is the time of lightness, the state of happiness and success, the time when our heart expands, overflowing with joy, high spirits, and cheerfulness, the time when we feel connected to everything. Yet it is also often the time when we are intoxicated and forget the truth behind all things, and the time of arrogance. *Basaṭa llāhu* (بسط الله) means "Allāh has opened the doors for a human being," be they the doors of knowledge, good manners, physical features, material goods, or children.

The word for carpet, *bisāṭ* (بساط), also comes from this root. We human beings cannot understand the whole chain or all the threads that together form the carpet, but we do have the capacity to feel connected to everything, to rise up in the air, become a flying carpet, *bisāṭ ar-rīḥ* ("carpet of the wind" or "carpet of the soul"), and inhale the freedom of Unity.

Enjoy the beauty on this earth and be grateful. *Basṭ* (expansion) often induces an all-embracing, holy consciousness where we feel wide, huge, and magnificent, where we feel that we contain everything that exists and rejoice in His all-embracing love.

When you repeat Al-Bāsiṭ in the depth of your heart, your heart livens up, your sorrows and worries fall off, and everyone who sees you takes you into their heart.

Sura al-Baqarah, سورة البقرة, The Cow (2:245)
For, God takes away, and He gives abundantly; and it is unto Him that you shall be brought back.

People who carry the quality of Al-Qābiḍ are capable of protecting themselves from bad influences and they can help others to do so too. The Divine Name Al-Qābiḍ is used above all when people are tyrannized by their surroundings or mobbed. Repeat the name 903 times and you will be protected. The person who carried it out will leave or the circumstances will change.

Some people are given more favors, comfort, goodwill, beauty, charm, knowledge, or children. This deep difference, this God-ordained inequality among humans, countries, and other beings, serves to open the generous gates of sharing, tolerance, exchange, and communication. It is meant to give us the possibility to grow and bring about balance. However, if we fail to do this and instead remain prisoners of our selfishness, then the ensuing disharmony is the result of our own free choice.

Human beings who carry the quality of Al-Bāsiṭ know how to bring joy to the heart of others. They can give generously, and they can also be generous to themselves on the inner level. If you make it a habit to repeat this Divine Name, peace will grow in your heart and you will see that everything comes from Allāh and everything returns to Him, that there is nothing to judge and that our virtues grow from our weaknesses. Repeating this name reduces stress, while income and respect (both towards and from our fellow human beings) increase.

Repeating Al-Bāsiṭ dispels sadness and doubt from the heart, replacing them with joy and trust.

Al-Qābiḍ and Al-Bāsiṭ are normally repeated together, but if you can carry the deep meaning of Al-Qābiḍ without falling into worries or anxiety, you may recite it on its own. If you do so, bear in mind that Al-Qābiḍ means to contract and to hold back that which is bad and dangerous for you. Then you will see the justice and the mercy in Al-Qābiḍ, the kindness and the gift in Al-Bāsiṭ.

When we repeat the two Divine Names Al-Qābiḍ and Al-Bāsiṭ together, our heart begins to see that the Divine, Allāh, is at work as much in contracting as in expanding. Slowly, our heart learns to touch serenity in all states and situations, and it reaches a state of composure that grows on an increasingly firmer ground—the faith in Allāh's goodness, mercy, and wisdom. Whether we are given the One who seizes or the One who relieves is not in our hands. Yet what we make out of those states—that is our responsibility. When we can be brave and confident in both, when equanimity and serenity can expand in both, then our chest and heart begin to expand in ecstasy and we experience divine vastness, Al-Wāsiʿ (45)!

Sura al-Shūrā, سورة الشورى, Consultation (42:27)
For, if God were to grant [in this world] abundant sustenance to [all of] His servants, they would behave on earth with wanton insolence: but as it is, He bestows [His grace] from on high in due measure, as He wills: for, verily, He is fully aware of [the needs of] His creatures, and sees them all.

22

الخافض

AL-KHĀFIḌ

The One who lowers, the One who humbles, the One who curbs
1,481–5,924–2,193,361

23

الرافع

AR-RĀFI'

The One who raises, the One who elevates, the One who distinguishes
351–1,404–123,201

When something carries the quality of being low, it leads us to lower our head to our chest in order to see it. This movement expresses humility and a turning inward.

Al-Khāfiḍ comes from the root *kh-f-ḍ* and Ar-Rāfiʿ from the root *r-f-ʿ*. By examining the different meanings derived from these roots, we shall see how these two Divine Names complement one another.

The following meanings come from *kh-f-ḍ*: to make lower, to decrease, to reduce, to diminish, to be carefree, to settle, to lower, to lower one's voice; low, soft; reduction, restriction, ease of life.

Meanings that derive from *r-f-ʿ* include: to lift, to lift up, to raise aloft, to heave up, to raise one's head, to raise in esteem, to make high or higher, to elevate, to promote, to fly, to take off, to place, to fasten or attach, to erect, to remove, to pick up, to put an end to, to remedy, to free, to relieve; thin, fine, delicate, subtle; high rank or standing.

The quality of elevation comes from inside, opening the face, widening and softening it, thus expanding the field of vision.

One quality is based on ignorance. Acknowledging ignorance leads to humility and later to inner elevation. The other quality is based on knowledge clad in the protective garment of humility. Our spiritual and material deeds lead to elevation or humbling. There are no straight lines in life. The stream of love flows between the two shores of 'elevation' and 'humbling,' and this applies to all complementary poles, be they masculine and feminine, poverty and riches, joy and sorrow. In each pole lies the effect of the other.

The divine attribute Ar-Rāfiʿ reflects in the poor who become free of poverty, the sick who recover, the ignorant who are enriched by knowledge, those who, having lost their way, feel guided again.

All these motions bring you closer to the truth—to your truth. By reciting together Al-Khāfiḍ and Ar-Rāfiʿ, and tasting the truth that pulsates in these two names, reality is revealed to us and the isolated ego is allowed to slowly let go, clearing the path towards peaceful freedom beyond all outer movements.

Allāh elevates truth and lowers falseness. Elevation lies in simplicity, lowering lies in arrogance.

At times God increases our possessions and our possibilities so that we may show ourselves worthy of them. Love of our fellow human beings and compassion for the world are expressions of this richness.

Human beings who carry the quality of Al-Khāfiḍ protect themselves and others from debasement, a debasement born of lies, injustice to others, speaking badly about people behind their back, and hypocrisy. Those people are protected against selfishness and cold-heartedness, and they are committed to social justice. If you repeat this Divine Name 889 times, you will be protected against your enemies. Humiliation will come to those who are controlled by their egos, who tend to cheat and lie, who constantly get involved in arguments and who set traps for others.

Al-Khāfiḍ is also the One who lowers everything that was up, the One who humiliates the proud and the arrogant, who brings down the despots, who depresses the oppressors and causes them distress.

Repeat this name and invite those parts in you that feel neglected, that have little space, and let the eye of your heart examine the outer circumstances in your life that bring this about. Give them all a place and an equal voice. And take the time to listen!

The Divine Name Ar-Rāfiʿ leads to a higher level of consciousness. It elevates the weak and the oppressed. Repeating this name 100 times leads to a higher position or to increased power, which are meant to be used to help others.

Allāh elevates those whose tongue is gentle, who would rather give than take, who do not let pride and arrogance harden their heart, who cover others' mistakes instead of shaming them, who build rather than destroy, who are strong, friendly, and kind.

Center in your heart and repeat this Divine Name while gently breathing into your belly. Observe which part in you feels elevated and honored. Repeat Yā Rāfiʿ and connect with Unity. May the elevation in you give you wings and strength on the path of love.

24

المعز

AL-MU'IZZ

The One who grants honor, the One who honors, the One who grants rulership
117–351–13,689

25

المذل

AL-MUDHIL

The One who humiliates
770–2,310–592,900

We understand the meaning of the Divine Names Al-Muʿizz, the One who honors, and Al-Mudhil, the One who humiliates, when we recognize that only Allāh, the Absolute, leads us to honor or humiliation.

Al-Muʿizz and Al-Mudhil are states we sometimes go through several times in one day in the form of high or low self-confidence, yet their absolute reality rests in the One.

Honor and humiliation, praise and reprimand are situations that constantly recur in our life. These experiences reflect in our relationships with other human beings: How do others see me? How am I being treated?

Al-Mudhil comes from the root *dh-l-y*, which carries the following meanings and gives us an insight into the areas touched by this name: to be low, to lower, to debase, to degrade, to humble, to humiliate, to overcome, to break, to conquer; lowly, humble, contemptible; disgrace, shame, humiliation, submissiveness.

Al-Mudhil takes us to the deepest places, those where the ego feels worthless and identifies itself with this self-abasement. Al-Mudhil leads us to these abysses where we fall on our knees and bow our head deeply. It takes us where we feel useless, weak, and rejected by humankind. Al-Mudhil tears open the limitations of the puddle we think we are and let the water of the puddle be touched by the water of the Ocean. Soaked in the love of the ocean, we free ourselves from our human, limited representations of what is high and what is low, humiliating and honoring. A greater stability comes to be, and above all we understand that, in their deep meaning, all outer circumstances—whether we are perceived as being high or low—are but different ways of being held by Allāh.

Al-Muʿizz is not opposed, but complementary, to Al-Mudhil. Al-Muʿizz activates and connects us with the power that arises when we discover our true self, our eternal, immortal soul. By repeating these two Divine Names together, we can tear not only the dark veils of self-contempt but also the dark veils of how we are seen by the world, by other people. When we recite Al-Muʿizz and Al-Mudhil together, it is like the meeting of human imbalance and innate divine balance, both resting in the eternal ocean of divine love.

Healing begins when we reconcile the two qualities Al-Muʿizz and Al-Mudhil.

Al-Muʿizz is the One who grants honor. Those who wish for honor should walk this path until they approach the source, for it leads from Him to Him.

Like Al-ʿAzīz, Al-Muʿizz comes from the root *ʿ-z-z*, which contains both strength and gentleness.

The gift of divine honor brings wisdom and joy, far from the inflated ego-self. The honor comes from knowing that everything comes from Him, the honor comes through serving. Some people serve by painting, others by sharing their money with those who have less, others through their prayers, and yet others by tending their garden. Honor means to serve with kindness in one's heart, knowing and taking one's place. Honor is based on the knowledge that we are all different vessels filled with

the same water and that at the end of the day the vessel will break so that the water may return to the boundless ocean. Honor also means to greet the other in the middle of the fiercest argument, knowing that the Infinite lies in them. Knowing oneself leads to Allāh. The honor we sometimes attribute to ourselves or the honor in which others hold us often leads to distortion and arrogance; and that often brings humiliation in its wake or sets ablaze the fire of greed.

The Divine Name Al-Mu'izz can and should be repeated when we are aware of our ego and of the need to control it, invoking His help, be it in the form of outer circumstances or the granting of inner strength.

If you are tyrannized by someone who abuses their position of power, you can repeat the Divine Name Al-Mudhil 40 times on a Friday night. After the last repetition, perform the ritual ablutions and the prayer, and then ask for the tyranny to be averted.

Do not isolate the small from the big, the light from the heavy, or the rich from the poor in you. It is by learning to know one through the other that you become whole. Wisdom often comes from a part in ourselves that we do not value or accept. Sometimes this voice shows us that we may be doing something that we actually do not want and only do because it is required of us, or because we believe that we must do it in order to be accepted, loved, or to belong. This can lead to inner weakness and to a feeling of inner fracture. We begin to taste part of the quality carried by Al-Mudhil.

Sura al-Ṣāffāt, سورة الصافات, Those Ranged in Ranks (37:180–182)
LIMITLESS in His glory is thy Sustainer, the Lord of almightiness (al-'izza), [exalted] above anything that men may devise by way of definition!
And peace be upon all His message-bearers!
And all praise is due to God alone, the Sustainer of all the worlds!

Does a tree not need to push its roots deep into the earth before it can majestically reach for the sky? In the same way, we must acknowledge and develop the depths of our self before we can rise to the heights of our true being.

We are forever surrounded by that which furthers our evolution.

26

AS-SAMĪ‘

The One who hears, the All-Hearing, the Listener

180–720–32,400

As-Samī‘ is divine hearing. Thus, Allāh hears all the sounds, absolutely, without limitation, be they silent or aloud, separate or joined. Allāh hears the Creation's every prayer, sound, and movement, ceaselessly.

Take the time to listen to the voices of divine unity around you. In every voice, every sound, and every silence lies a sound, a drop of Unity—in that sound lies the endless orchestra, the ocean of all Divine Names and qualities, and to Him they all return.

If you repeat this name 100 times on a Thursday between late afternoon and sunset, with an open heart and without speaking to anyone during that time, your longings will be heard. So call Him in times of ease and in times of difficulties.

Sura al-Shūrā, سورة الشورى, Consultation (42:11)
There is nothing like unto Him, and He alone is all-hearing, all-seeing.

As-Samī‘, the Listener, and Al-Baṣīr, the All-Seeing, are repeated together eleven times in the Qur'an, and each time hearing precedes sight. It is through hearing that the invisible worlds open to us, through hearing that we connect to the invisible hereafter, and through hearing that the soul's longing to return home unfolds. Hearing opens to us the path to the soul and to the invisible unlike any other sense. The divine attributes As-Samī‘ and Al-Baṣīr both help us on our way to inner wisdom and outer balance, which is why they are often repeated together.

The pleas of those who repeat this name often after their prayers will be heard, and people will listen to their words and follow them.

سمع الله لمن حمده

sami'a llāhu liman ḥamidāhu
Allāh hears the praising of those who praise.

As-Samī' comes from the root *s-m-'*, from which the following meanings are derived: to hear, to learn, to be told, to listen, to pay attention, to hear someone out, to learn by hearsay, to give ear, to overhear, to recite, to listen closely, to obey; hearer, listener, reputation.

Every spiritual path should lead us to become aware of all the creatures who have traveled before us in the caravan of life, those who are traveling with us, and those who will come after us. It should lead us to include the whole universe in our consciousness, in our viewpoint. Listen and welcome all of life so that you may become free from the limited world of your own understanding.

Through As-Samī', Allāh grants us the capacity to hear signs and symbols in everything around us. Every sound, every rhythm takes on a holy and healing quality.

When we understand the essence of things in our heart, we human beings have the capacity to hear without ears, see without eyes, speak without a tongue. This is especially true of hearing when our heart understands the sounds, when our heart becomes our ear.

People who can listen and open their heart to others are endowed with great maturity, for nothing touches another human being like the feeling of being heard.

On the symbolic level, hearing is connected with the throat, and the throat is in turn connected with truthfulness. The throat is the bridge between the mind and the heart. It is the place of the parting of the sea, the place where we open to divine truth and make space for union. So open to the path that leads to your true self, as Moses, peace be upon him, led his people to freedom.

Center in your heart and repeat Yā Samī'. Take in all the sounds without concentrating on any. Listen more and more inside. Where is the source of your hearing?

"I seek refuge in You from a heart that knows no humility, from a request which does not deserve to be heard, from an ego which cannot be sated, and from knowledge which is not useful. Protect us from those four."
—*Prophet Muhammad*

27

البصير

AL-Baṣīr

The All-Seeing, the One who sees everything

302–1,208–91,204

This divine quality contains the capacity to see. Al-Baṣīr means to see everything as a whole while not missing the slightest detail. Al-Baṣīr is to see the visible and the invisible, the manifested and the nonmanifested.

This divine quality contains the ability to see. He is the All-Seeing. He can even see a black ant moving on a black stone on a moonless night. Watch your thoughts and let trust be your cloak. Repeat this Divine Name 100 times between two meditations or after a prayer. Your inner eye—the eye of your heart—will open and you will not be overlooked by people. Al-Baṣīr is the One who sees the outside as well as the inside. So see the Divine in everything and see everything in Allāh.

Al-Baṣīr serves spiritual development, so that we may develop our vision of light and our receptiveness to inspiration, such as clairvoyance. Inner sight completes outer sight. Seeing through the eye of the heart means to perceive from the inside, without using our senses. This inner sight can open everything, including the human heart.

In a growing number of cultures, the modes of expression focus on sight, nearly excluding all other senses. Everywhere pictures claim our attention, almost overwhelming us. Although many traditions advise us to turn away, the Sufi path says, "Do not close your eyes, let Allāh use them. What you see, does it mirror your life and what is inside you? Can you see 'the others' as a part of you? Can you carry what you see with the kindness that rests in your heart? How much compassion shines in you?" Let the kindness and tolerance that you wish to receive from Allāh through His creatures also radiate from you.

All human virtues are connected with knowledge and awareness.

The Prophet Muhammad, Allāh's blessings and peace be upon him, said, "Act and serve Allāh as if you could see Him because if you cannot, verily He can see you."

Center in your heart and repeat Yā Baṣīr. Lead that strength to your eyes and let it flow outward. Relax your forehead, your jaws, and your eyes, and let them become the window of your soul through which He can see.

Do not fill your eyes with the shadows of confusion and worries. Fill them with light. Let your gaze calm others and may peace come to your heart.

Like the Divine Name Al-Baṣīr, the word *baṣīra* (بصيرة) comes from the root *b-ṣ-r*. It means to see with the eye of the heart. And the eye of the heart does not stick to outer forms. It can see through duality, it can see Unity, it can see the underlying light, it can see inside human beings. The Sufis call it *'ayn al-qalb*, and it is in fact the third eye, that place of knowledge carried by the heart, where the origin and the aim of perceived multiplicity unite, where intuition encounters reason.

Thus the Sufis sing: "Open the eye of your heart so that you may see the spirit, thus you will see that which cannot be seen." May Allāh grant us this sight!

The following meanings are derived from the root *b-ṣ-r*: to look, to realize, to understand, to comprehend, to grasp, to enlighten, to inform, to behold, to perceive, to notice, to observe, to recognize, to consider, to reflect, to gain or have a keen insight, possessing knowledge or understanding; vision, eyesight, insight, penetration, perception, power of mental perception, mental vision, enlightenment, information, consideration, eye.

Use your eyes to recognize the signs around you and train your sight continuously to recognize in you the Divine that is reflected outside.

Asked, "Can any of us be like you?" Jesus, peace be upon him, answered:

Those who only say what God allows them to say, those who, when they are silent, are only silent because they are remembering God inside, those who, when they see things, know that what they see is not God but from God, and those who learn and draw experience and wisdom from what they see—those are like me.

Soft eyes are the sign of a gentle heart. And what are soft eyes?
Eyes that constantly bathe in the water of mercy.

28

AL-ḤAKAM

The Judge

68–204–4,624

The Divine Names Al-Ḥakam, the Judge, and Al-Ḥakīm (46), the Wise, are based on the same root, *ḥ-k-m*, which contains the following meanings: to judge, to pass judgment, to express an opinion, to sentence, to impose, to inflict, to award, to take, to have judicial power, to govern, to rule, to order, to command, to check, to determine, to choose, to make firm, to fortify, to do well, to master, to have one's own way, to handle, to be in control, to be in possession, to be consolidated; solid, firm, deep-seated; judgment, opinion, decision, sentence, wisdom, authority, power.

Indeed there is no judgment without knowledge and no judgment without wisdom. Wisdom is healing knowledge for only knowledge that heals can be called wise. Furthermore a judgment can only be accepted if it is fair. The Divine Name Al-Ḥakam gives us insight into the intention behind wisdom.

Every thought, every deed affects life, here and in the hereafter. If you are lucky, you will be able to recognize the fruit of your deeds—or at least some of them—in this world, in this dream. Indeed, is life not a dream from which we awaken when we die?

Some people are given in their dreams a hint of that which the future holds in store for them so that they may expand their spirit and their perception, or take into account and integrate that which they had overseen. The Divine Names are like so many lights on our path to this expanding spiritual attitude.

Sura Yūsuf, سورة يوسف, Joseph (12:67)
Judgment [as to what is to happen] rests with none but God. In Him have I placed my trust: for, all who have trust [in His existence] must place their trust in Him alone.

Al-Ḥakam is the carrier of justice and truth. He is the judge, the court, and the sentence. The movements of the universe all rest on one cause. When you repeat this Divine Name, your heart fills

with confidence that there is an order and that everything has a meaning, leading to an all-encompassing order. And that a just force exists that cannot be grasped by reason, but felt and known in the depths of the heart. This is how we human beings realize that what happens to us is not meant to shame us for our mistakes, and that the fruit of those errors is not punishment.

Knowing that this just force exists warms our heart, lets it shine, dissipating the coldness of worries and fear. But where is justice when one is poor and the other rich? Where is justice when children are traumatized and tortured, and old people abandoned to a bitter solitude?

We are here, born with the longing and the strength to act justly and to judge fairly when circumstances demand it. Repeating the Divine Name Al-Ḥakam helps us connect to this eternal force and make it visible in the world. It is incumbent upon us to open ourselves up to this force, to assume our responsibility on this planet so that we may leave the world more beautiful. Indifference, greed, and fear are our greatest obstacles on the way to a humane world.

Children often have to carry the burdens of their parents; aging mothers must often put up with the weaknesses of younger generations. In some of us, kindness only unfolds when we are poor, yet some others only retain their humanity as long as they are rich.

Things that happen to us are not meant to make us feel guilty or accuse us of our mistakes. Everything comes from a deep, loving care. Therefore, when you are exposed to the storms of life, when you starve, know that everything only serves to open your heart and widen your consciousness, giving you the opportunity to go through the fear and to become free.

So love and keep loving, time and time again. For even in your forgetfulness, your heart does nothing but precisely that, whispering day and night, "I want to love." The many *I*'s, the many different opinions and feelings within us, all come home in the divine heart, in the only true self, the one addressed by all the prophets in their words, demands, and deeds.

Human beings who carry those qualities have a clear consciousness, as well as deep knowledge, a kind heart, and their mind is sharp as a sword. Their deeds are never self-serving, influenced by anger, aggression, or revenge. They know that divine judgment is different from what human beings understand as justice. Yet this mystery can only be grasped by those who candidly accept Allāh's sentence, whether it be kind or difficult.

The Divine Name Al-Ḥakam is the complete and perfect knowledge of what was, what is, and what will be. No judgment comes from ignorance. This name expresses complete and perfect will because there is no judgment without a will, it carries the quality of realization because there can be no judgment without the ability to enforce it, and it carries the quality of justice because no judgment can be accepted unless it is fair. This is why corrupt, greedy, and embezzling judges contribute in an inordinate measure to destroying the values of a given society.

Sura al-Qaṣaṣ, سورة القصص, The Story (28:14)

NOW WHEN [Moses] reached full manhood and had become mature [of mind], We bestowed upon him the ability to judge [between right and wrong] (ḥukm) as well as [innate] knowledge (ʿilm): for thus do We reward the doers of good.

This type of knowledge, which expresses itself in wisdom and discernment, is the divine blessing manifesting as the gift of a spiritual consciousness connected with rational thinking. Both are present in judgment, namely in the ability to distinguish between right and wrong.

Al-Ḥakam grants discernment and teaches balance. It helps us become aware of ourselves, to judge with dignity and in a balanced way by not allowing ourselves to be greedy when we can be generous, mean when we can be merciful, unfriendly when we can be respectful.

If you repeat the Divine Name Yā Ḥakam at night until you fall asleep with the name on your lips, it will fill your heart with divine secrets and mysteries.

29

العدل

AL-'ADL

The Just

104–312–10,816

Sura al-Raḥmān, سورة الرحمن, The Most Gracious (55: 1–9)
*In the name of God, the most gracious, the dispenser of grace, the most gracious
has imparted this Qur'an [unto man].*
He has created man: He has imparted unto him articulate thought and speech.

*[At His behest] the sun and the moon run their appointed courses; [before Him] prostrate
themselves the stars and the trees.*
*And the skies has He raised high, and has devised [for all things] a measure, so that you [too,
O men,] might never transgress the measure [of what is right]: weigh, therefore, [your deeds]
with equity, and cut not the measure short!*

The Divine Name Al-'Adl carries the face of love, which brings balance and harmony. Fairness
brings opposites together, and they start to understand that they complete one another. Al-'Adl brings
balance both on the outer (material) and inner (personal) levels. For us human beings, Al-'Adl unites
mercy and knowledge.

This name comes from the root *'-d-l*, which also contains the following meanings: to act justly,
equitably, and with fairness, to treat everyone with indiscriminate justice, to be equal, to counterbal-
ance, to outweigh, to equalize, to place on the same level, to be in a state of equilibrium, to deviate, to
refrain, to abstain, to turn away, to leave off, to abandon, to renounce, to give up, to drop, to straighten,

to set in order, to balance, to rectify, to fix, to settle, to adjust, to change, to modify, to improve, to adapt, to amend; legal, judicial; impartiality, fairness, honesty, uprightness, straightness, straightforwardness, integrity.

On the physical level, the words derived from the above root show the aspect of self-control. Indeed, if you wish to be just, you must learn to center and to remain centered, and you must also be capable of assessing and balancing. The root '-d-l carries so many different forms of balance that Al-'Adl is often added to balance out a pair of opposed Divine Names. In such cases, Al-'Adl is both the needle of the scales and the force which can bring reconciliation because it is fair and reasonable.

To us human beings, justice is a natural wish that we often lose in the tumult of life. Yet deep inside, we remain open to, and ready for, justice, fairness, and honesty.

We are aware of our imperfection; we have the capacity to acknowledge it and are therefore responsible. At the same time, we also carry an innate divine perfection. When we say, "my will and Your will become one," it means to unite the imbalance on the periphery with our innate divine balance, and to experience that union. The Sufis say that the heart is the place of divine attraction and the seat of justice.

We human beings have been chosen by God, and it is incumbent upon us that the Divine Creation fulfill its destiny. And all of Creation was given to us so that we may be up to the task.

Sura al-Baqarah, سورة البقرة, The Cow (2:30)
AND LO! Thy Sustainer said unto the angels: "Behold, I am about to establish upon earth one who shall inherit it."

Because we human beings are the guardians of Creation, we are neither completely angel nor devil. Rather our superiority arises from uniting these two poles. Our good and our bad sides make us perfect, grant us superiority and beauty. The world is not God, yet nothing exists but God—*lā 'ilāha 'illā llāh*. In view of the absolute, everything is imbalance. The sufferings of this world are witness to the mysteries of this distance, this separation. They exist because the world is not God. Only absolute mercy, absolute love is Allāh.

The world moves according to a great plan and follows the cosmic order. Time and time again, we human beings experience inherent, eternal justice in order to realize how cause and effect are connected in our deeds.

Sura al-Naḥl, سورة النحل, The Bee (16:90)
BEHOLD, God enjoins justice (al-'adl) and the doing of good (al-iḥsān) and generosity towards [one's] fellow-men.

The Prophet Muhammad, God bless him and grant him salvation, said, "Verily, deeds [are measured] but by intentions and verily, every man shall have but that which he intended." Truly sincere intentions means to carry out the truly divine laws with a sincere heart.

It is our capacity for knowledge that perceives God because it is of divine nature itself. The closer we come to our true self, the more we understand the meaning of coincidences, the more we discover the meaning and the aim of the world and of human beings. The one who knows God, *al-'ārif*, awakens from the dream. As the Prophet said, "My eyes sleep, but my heart does not sleep."

The just soul, *an-nafs al-muṭma'inna*, is the soul that rests in itself, in the Divine, in peace and contentment.

Sura al-Nisā', سورة النساء, The Women (4:58)
And whenever you judge between people...judge with justice.

On the outer level, knowing that Allāh alone is perfectly just spurs us on to bring justice on earth, to express it in our deeds, our words, and our intentions, to stand up for social justice and against oppression. On the inner level, we embed ourselves in the ocean of God's justice, truly leaving everything to Him.

Allāh has linked us human beings to one another through family ties, through our being responsible for the poor and the orphans, through our mutual rights and duties as friends and neighbors, as well as through our moral and spiritual obligation to treat all living beings with love and compassion. Thus are we meant to remain aware of the unity of purpose and follow our path.

Al-'Adl helps those who, although fair in their words and deeds, are not recognized as such by others.

Every one of us is judged according to their destiny and how they deal with it, because each fate is endowed with a unique and intimately individual quality.

Learn to be fair towards yourself, without tyrannizing yourself with feelings of guilt, or becoming weak and lacking clarity. For being fair is a great honor that nurtures us from inside. The Prophet Muhammad, peace and salvation be upon him, said, "None of you truly believes until he wishes for his brother what he wishes for himself."

So practice gratefulness, *shukr* (ركش), because it will remove the burden of dissatisfaction from your heart, practice faith in God, *tawakkul* (لكوت), because it will give a direction to your soul and help you balance between times of effort and self-control and times of relaxation and leniency, and practice contentedness, *riḍā'* (ءاضر), because it will bring peace to your soul. But never forget on your path that one man's medicine is another man's poison.

30

AL-LAṬĪF

The Subtle, the One who is beyond reach, the Tender, the gently All-Pervading

129–516–16,641

This name means subtlety so fine that it cannot be discerned by the eye, so delicate that it registers all vibrations and the tenderest mysteries. It is so gentle that it carries the most blessed gifts. Al-Laṭīf means gentleness towards all creatures. It means alleviation, caring, and unconditional gifts. Its tender kindness works in the background. So be gentle to all creatures, and when you call them, do so with softness and tenderness in your heart.

Repeating this name 100 times will help those who have fallen into poverty and helplessness find sweetness and fulfillment. This name is often connected to femininity, yet being a woman means to be strong, stronger than a man. For it is the woman who elevates the man to the level of her heart. Her soul precedes the man's soul. A woman's sight is wide and full of nuances, her deeds often work in the background. She contains the world, whereas the man penetrates it.

Al-Laṭīf comes from the root *l-ṭ-f*, and so does the word *laṭīfa* (plural *laṭā'if*), which indicates the body's spiritual magnetic centers. This root contains the following meanings: to be kind and friendly; to be thin, fine, delicate, dainty; to be grateful; to be amiable; to make mild, soft, and gentle; to mitigate, to alleviate, to ease, to soothe, to moderate, to temper, to reduce, to tone down; to treat with kindness or benevolence, to be civil and polite; to be indulgent; to humor; to flatter; to caress; to be tempered, to be moderated; to do secretly; gently, carefully, with caution, covertly; affectionate; brilliant; courteousness, delicateness, daintiness, loveliness, charm, benevolence, intellectual refinement, soothing remedy.

Al-Laṭīf is a softening energy of love that helps us relinquish that which is coarse and turn to that which is delicate and subtle in us, not out of weakness but in order to come closer to our true self.

So trust yourself, for those who trust themselves trust Allāh.

Al-Laṭīf is a powerful name whose recitation brings answers fast. The subtle omnipresence of being vibrates in this name. Al-Laṭīf, He alone is unfathomable.

Al-Laṭīf is recited when people are seriously ill or when they live in captivity, when they experience major difficulties, when they undergo torture or pain, whether in their body or in their soul. When used for cancer, it is recited in cycles of 129 repetitions.

The curative effect of Al-Laṭīf is used in everyday life to lessen the shock of collisions, for instance when a car crashes or a child falls. It is also recited when a soul suffers a shock as a result of bad news or severe physical pain, both nearly unbearable. Al-Laṭīf is a mystical, healing, protective, and supporting love. Al-Laṭīf brings relief and refinement, and reduces consequences.

The subtle love energy of Al-Laṭīf comes from the heart and conquers the mind. Our understanding is given a more delicate, contemplative quality, and this in turn influences our deeds.

Al-Laṭīf accompanies the reciter into the subtle spheres of knowledge. This is why Al-Laṭīf is often linked with Al-Khabīr (31), the Knowledgeable, the One who knows. Al-Laṭīf is mentioned seven times in the Qur'an, out of these five times combined with Al-Khabīr.

Sura al-An'ām, سورة الأنعام, Cattle (6:103)
*No human vision can encompass Him, whereas He encompasses all human vision: for He alone is unfathomable (*al-laṭīf*), all-aware (*al-khabīr*).*

When they combine these two Divine Names, reciters find themselves accompanied into hidden, mystical knowledge.

Al-Laṭīf has an intense influence on the heart, from which it quickly removes worries. Those who repeat this name continuously are granted gentleness in all matters. Those who remember and invoke Him through this name should not share everything that comes up in their heart, and they should become listeners instead of talkers. This name is only rarely given by a teacher for remembrance because it contains so many secrets.

All things in life deserve nothing but love. We human beings are divine life. What does it mean to become wise if not to polish the mirror of our heart so that it becomes blank and we can recognize our own divine face in it? For Allāh, without You I am nothing. The flow of the timeless present is stored in the vessel that You are. The mystery remains an active force in the universe, so throw yourself unconditionally into the light of life and have trust.

Al-Laṭīf refines the veils of our ego that lie on our heart, so much so that the divine light shines through in us.

The inner eye of those who carry this quality is open to the inner beauty of things. They are gentle in their deeds as in their words. Their efforts are like a soft rain: wherever it falls, beauty blossoms. Al-Laṭīf is the eye of the heart.

That Allāh is Al-Laṭīf means He has veiled Himself from all creatures through His utterly clear manifestation and He has enfolded the whole universe in His light. Because everything in the heavens and on earth bathes in His light and is permeated by it.

"At a distance you only see my light.
Come closer and know that I am you!"
—Rumi

31

AL-KHABĪR

The Conscious, the Perceptive, the Knowledgeable

812–3,248–659,344

This divine quality means to know and to see all things and all states. If we wish to free ourselves from a bad or weakening habit, it helps to repeat this name continuously, that is, as often as possible.

Al-Khabīr symbolizes His knowledge of the details of all things. Be careful with your thoughts, words, and deeds.

This name comes from the root *kh-b-r*, from which the following meanings are derived: to try, to test, to experience, to know by experience, to know well, to be fully acquainted, to advise, to inform, to tell, to write, to contact, to negotiate, to inform one another, to explore, to search, to ask; experience, knowledge, intelligence, inner nature or being, exploration, spirit, soul, message, sense, test.

If we examine the various meanings that take their seeds from this root, we reach a deeper understanding of how the sphere of influence of Al-Khabīr works. Those who wish to go in search of knowledge of themselves, life, and God must be ready to set off for the depths of existence, ready to discover and experiment in order to understand the inner essence. Knowledge is not attained from the shores of the ocean. Whoever thirsts for knowledge must dive deep into the sea, to the furthest limits, to the place where the lotus tree can be seen, that most remote tree of paradise that symbolizes the long journey. May your own ground become loose and soft, and may the borders of your subconscious and of your higher consciousness open on your way to Unity. May the ground become loose and soft, enabling us to walk through the outer forms and veils, penetrate into the invisible worlds and grow the fruits of inner knowledge. May the milk of knowledge nurture and bring unity to our whole inner

being. The *dhikr* of the heart is the staff of knowledge of the mystery of Creation that you knock into the ground of your existence.

Most concepts that form the basis of this Divine Name are used on a daily basis in the Arabic-speaking world as names, verbs, and adjectives. Thus, everyday vocabulary is the medium through which the Divine keeps manifesting, time and time again.

One of the characteristics of this name is that it can be used to become clear about something. You then repeat the name before going to sleep until you fall asleep. Clarity about a situation can then come to you, through dreams or in your daily life, Allāh willing.

Every name grants insights to the reciters according to the intensity of the recitation.

The mind is the light of the heart, and that light is ignited with the oil of a blessed tree. In turn the tree is rooted in the heart, and its branches reach all the way to the sky.

Human beings who carry the quality Al-Khabīr have a deep understanding. They understand not only the consequences of things but also their nature. People who worry about the consequences of their deeds should repeat this name, and they will see the results of their actions in a dream.

يا الله يا حكيم يا عدل يا لطيف يا خبير

Yā Allāh, Yā Ḥakīm, Yā ʿAdl, Yā Laṭīf, Yā Khabīr
O Allāh, You the Wise, You the Just, You the Unfathomable, You the Omniscient

32

AL-ḤALĪM

The Gentle, the Tolerant

88–352–7,744

This name means tolerance, patience, friendliness, kindness, and wisdom. Al-Ḥalīm is gentle, kind love that nurtures on the physical and emotional levels. It is love manifesting everywhere, it is the nature of love, and it is found in everything around us. Al-Ḥalīm brings a gentleness that soothes all anger, all impatience. Just like nature around us, it has an opening, pacifying magic and fills the heart with a peace and quiet that goes by the name of *sakīna*, that peace that arises from being aware of God's presence.

Sura al-Fatḥ, سورة الفتح, Victory (48:4)
It is He who from on high has bestowed inner peace upon the hearts of the believers, so that— seeing that God's are all the forces of the heavens and the earth, and that God is all-knowing, truly wise—they might grow yet more firm in their faith.

Al-Ḥalīm comes from the root *ḥ-l-m*, from which the following meanings are derived: to dream of being, to reflect, to mediate, becoming, doing; dream, gentleness, forbearance, patience, insight, understanding, reason, sexual maturity, indulgence, nipple, simple souls.

Ḥilm is a state of cheerful composure that cannot be shaken either by an inner anger or by an outside threat.

Al-Ḥalīm lets us dream of God and nourishes us with visions and dreams of mercy. Al-Ḥalīm is as universal and all-embracing as the womb for the fetus. Al-Ḥalīm grants us peace at times when we are

overcome by anger and rage, helping us to free ourselves from the claws of revenge that our ego often stretches immediately—an anger that comes, most of the time, from feeling misunderstood, abandoned, or demeaned. A love vibrates in Al-Ḥalīm that can forgive because it allows empathy, understanding, and leniency to arise. Al-Ḥalīm leads you beyond pain, pride, grief, and disappointments, to the place where the gentle, patient Beloved is waiting for you.

If you wish for more affection and tolerance in a relationship, then write this name on an apple and eat it. Al-Ḥalīm also means to be patient with someone without ignoring them.

The Divine Name Al-Ḥalīm puts a veil over weaknesses and delays punishments and consequences. Carry in yourself this divine quality towards those who, in your eyes, act correctly and also towards those who, in your eyes, act wrongly. Be patient and tolerant with people and treat them with respect.

Human beings who carry psychological burdens and who have surrounded themselves with severity and worries loosen that spell by repeating this Divine Name. Look at the earth, it carries everything—beauty and ugliness, heaviness and lightness, yet flowers and fragrances sprout from it. Such is the divine quality of Al-Ḥalīm.

Al-Ḥalīm helps us awaken the virtues that live within us and protects us from distress in difficult times. It opens the inner barriers and makes space for gentle reason, the wisdom of the heart, insight, and patience.

When you feel a strong anger and that anger wishes to express itself to the outside or against another human being, repeat Yā Ḥalīm 88 times and the anger will come into perspective.

If you write Yā Ḥalīm on a piece of paper, then dissolve it in water and use that water to sprinkle fields or gardens, it will keep pests away and the earth will carry more plants and fruit, Allāh willing.

Those who carry the quality Al-Ḥalīm carry gentleness and forgiveness. Even when they have the power to punish or take revenge, they forgive nevertheless and handle those who are impolite in a friendly manner. Thus, they always succeed because they can hold the space of hope, love, and trust.

This world is a reed pipe through which He plays His melody.

33

AL-'AẒĪM

The Magnificent

1,020–4,080–1,040,400

This name stands above everything. He is the One who will always be. He is the Protector and the Keeper, the One who grants strength and honor as He wishes.

Al-'Aẓīm is the One whose splendor knows no beginning and whose majesty knows no end. So be content with what He has given you and spread your wings.

The root of this Divine Name is *'-ẓ-m*, and it carries the following meanings: to be great, to be huge, to enlarge, to be proud, to boast, to be hard; grand, magnificent, powerful, majestic, glorious, lofty, superb, big, large, imposing, vast, enormous, tremendous, immense, grandeur, distressing, bony, supercilious; calamity, noble descent, bone.

Repeating Al-'Aẓīm gives us a deep inner feeling of being blessed, a deep inner satisfaction, a sense of the divine sublime omnipresence. And that feeling goes deep into our bones, our foundation. Those who can feel Al-'Aẓīm all the way to their bones are capable of great achievements. Al-'Aẓīm brings up a feeling of greatness within and enables us to recognize divine greatness.

At the same time, Al-'Aẓīm protects us, like an antidote, from our own arrogance and from false pride that can lead to inner and outer violence. Al-'Aẓīm grants us a stable foundation, an anchoring that enables us to be with God inside while diving into life's activities on the outside.

When we repeat this name, a part of our being resonates and brings up in us a nourishing modesty, while those around us acknowledge and respect us.

Those who learn and who teach what they know and act according to their knowledge are called *'Abd-ul-'Aẓīm,* عبد العظيم, servant of the Magnificent.

One of the greatest obstacles in life is regret: "Had I only…" "If only…" Such a vision of life can really weaken us, and our next steps in life become uncertain because our self-pity feeds on that vision. So listen deep within yourself and a sentence will come up that says, "Forget the past and go forward!" On the inner level, we must be free of regrets for past deeds inside, but at the same time we must remember them on the outer level in order to take the necessary action.

When you repeat the name Yā ʿAẓīm, concentrate your breathing on your heart and let the name widen into your solar plexus and all the way to your third eye; Yā ʿAẓīm will then nourish all the centers in you that give you strength, enabling you to use all your capacities in life.

The Divine Names Al-ʿAẓīm and Al-Ḥalīm (32) are both used to strengthen the bones.

Al-ʿAẓīm is one of the Divine Names of majesty. Its majesty expresses itself in the fact that He knows no beginning and no end, that all creatures praise Him, knowingly or unknowingly, that all strength comes from Him, and that there is no life or death without Him. His majesty also expresses itself in His boundless kindness and in His mercy towards His creatures, which is greater than our mercy to ourselves.

Whenever you would like to do something, start by putting this deed into your heart and asking yourself whether it is truthful. Always do this, and if you have asked others for advice, put their advice into your heart before following it. For the heart is God's organ.

Become kinder with every hour,
for every hour takes you closer to your departure.

34

الغفور

AL-GHAFŪR

The All-Forgiving

1,286–5,144–1,653,796

This name means to forgive all weaknesses and errors. Compassion lies in this name. When we find ourselves in situations of trial and sorrow, we should never see them as a punishment, but as a path.

Al-Ghafūr and Al-Ghaffār (14) both come from the root *gh-f-r*.

The main difference between Al-Ghaffār and Al-Ghafūr is that Al-Ghafūr penetrates the deepest places in our heart where our greatest offense, our biggest slip lies. Al-Ghafūr goes to the worst thing ever done to us. Al-Ghafūr touches this place deep in our heart. This divine forgiveness reaches that which we thought was unforgivable, inexcusable. Al-Ghafūr is the One who forgives a specific, given situation.

Al-Ghafūr lifts the veils of shame and embeds us in love that comforts us, uniting our imperfection with our perfection and thus bringing healing.

People who have a fever or who suffer from headaches should repeat this name constantly; pain and fever will cease, God willing.

If you feel guilty and the guilt makes your heart heavy, repeat the name Yā Ghafūr 100 times after a meditation or a prayer. May you be forgiven for your errors, Allāh willing. Al-Ghafūr is the One who puts a veil over our mistakes and weaknesses.

To wrong someone or to be treated badly provokes in us a similar state of darkness, and our heart is then enfolded in the gloom of separation.

The deeper, the stronger we have been hurt—or have hurt others—the more difficult it is to come out of the vicious circle. Pain fills our every thought, and we fail to widen our vision and raise ourselves to a more luminous level.

Al-Ghafūr erases those shadows and rescues us from them, helping us to transform them with light. Consequences cannot be undone, but our perspective changes because our consciousness is no longer under the spell of this shadow. The divine gift of intuition can induce a transformation, and our spirit can become creative again.

Carry the quality of forgiveness in your heart, for as you forgive, so you will be forgiven. At every stage of our life, we find ourselves confronted with various challenges or problems. They recur time and again, until the solution matures within ourselves and we receive a hint of the next stage. So embed yourself into the thought that behind the hardest hand of the moment lies the softest hand of eternity, that behind the bitter medicine is the sweet hand of healing.

The ability to forgive opens doors on the way to Unity. Healing is always Unity. Every sickness of the heart comes from the feeling of separation. Healing means to dissolve the illusion of separation. The nature of forgiveness and love is a unifying movement; the nature of sin is a movement that leads to separation.

The quality of sin is present whenever we do something that leads us astray and separates us from the truth, causing suffering, inflating the ego, and thus separating our soul from the divine light. Sufism sees lack of presence, or the state of half-sleep, as the basis of all sin.

A healer is someone who accompanies another human being and supports them on the path so that they can relinquish the illusions of separation.

All beings are perfect in their essence and their path on this earth. Indeed the whole universe serves to help you on your unique path towards completion. Nothing that happens to you comes from the quality of punishment unless you experience and carry it as such in your heart. But this feeling leads to a veil, one more veil of illusion. So be the daughter, the son of the moment. Be ready to die at every instant to the illusion of separation in order to be reborn in the connectedness, the unity, of all things.

The quality of forgiveness is like a soft, swathing cloak that protects your heart from hardening and separation.

To carry the quality Al-Ghafūr means to open the eye of your heart and to see the greater inter-linking of all events beyond the present moment. I can raise my head again because I have made space for forgiveness, because I can become connected again, step by step, and there will come a moment when I feel the dignity and the strength to love.

To ask for forgiveness, to "demean oneself" in front of another human being, is the most touching gesture of growth. Al-Ghafūr means to bow before one's own weaknesses, and with this inner bowing to become a mirror for the outer bowing.

Hold me, O Allāh, for I am ready to throw myself into the depths of my being with Al-Ghafūr!

The heart is a vessel of knowledge, a source that reacts with great sensitivity to all the deeds of the body. Do not allow your heart to harden by being careless or indifferent.

35

<div align="center">

الشكور

ASH-SHAKŪR

The Grateful, the Receptive, the Understanding

526–2,104–276,676

</div>

Allāh is the One who receives all our good deeds, and His rewards are always greater than what we could imagine. When we are not grateful to other people, we cannot be grateful to God either because our gratefulness to Him manifests in the way we behave towards His Creation. Ash-Shakūr is the One who acknowledges and rewards generously our few good deeds, even if no one else does.

Ash-Shakūr comes from the root *sh-k-r*, from which the following meanings are derived: to thank, to be thankful, grateful, to praise; meritorious; thankfulness, gratitude, acknowledgement, laudation, praise, sugar.

Because of its sound code, Ash-Shakūr belongs to those names whose influence penetrates most deeply. Ash-Shakūr can open the connection to our true self, where grateful love enables us to enter again the dance of the joy of life and where our eyes turn away from flaws, from that which is lacking, and realize the abundance.

Ash-Shakūr does not make us rich through receiving more, but we acknowledge differently what we have, as the veils of our taking things for granted lift. Ash-Shakūr connects us and makes us generous. Ash-Shakūr also brings humility to the heart when it has become all too arrogant, complacent, and insensitive, and this humility links us with the Creation and the All-Giving. Ash-Shakūr is the antidote that counteracts our feelings of separation, loneliness, and poverty.

The Prophet David, peace be upon him, said, "Oh God, how can I thank You when I can only do so thanks to a further blessing which You have given me?" And the divine answer came up in him, "Once you know this, you have thanked Me."

So use this name to strengthen both your physical and your subtle body, and to support and carry you through the efforts of life.

Enjoy the abundance Allāh has granted you, for those who do not enjoy and show their abundance do not have any. If you want to show your gratefulness to Allāh, show gratefulness to His creatures. When you can feel this name in your heart, follow all the way to its source this divine light that you have been given and that lives inside you.

O Allāh, help me carry You in my heart and be with You with every breath; help me be grateful to You at any moment, and help me serve You in everything!

Ash-Shakūr is a name that brings about transformation, because gratefulness transforms things. Gratefulness also means to be awake to all the qualities you carry and to bow before them all as you bow before guests. Listen to them, listen to their voices, to their wisdom, and invite them to take part in the banquet, because through acknowledgment and gratefulness all things are transformed and human beings come closer to their perfection.

Gratefulness manifests in very small and very great things. For instance, if you start to eat and you forget to bless the meal or to pronounce the divine formula *bismillāh ar-raḥmān ar-raḥīm* (بسم الله الرحمن الرحيم), "in the name of the All-Merciful, the All-Compassionate"), you need not feel bad about it; instead, you can make up for it by saying *bismillāh awwaluhu wa ākhiruhu* (بسم الله أوله وآخره), "in the Name of Allāh, the First and the Last"). The connection with Unity always carries the quality of boundless mercy, so live deeply anchored in the moment. For it is in the present, and only in the present, that we can recognize God.

The gratefulness of the earth manifests when it gives us a surplus of plants, the gratefulness of animals manifests when they give us more than we give them, the gratefulness of plants manifests when they give us generously even when there is little water or the soil is weak, and the gratefulness of human beings manifests through their tongue and their deeds.

In the Qur'an, we often find the following combinations of Divine Names: Ṣabbār, as in Aṣ-Ṣabūr (99), from the root *ṣ-b-r*, and Shakūr, as well as Ghafūr (34) and Shakūr.

When we recite together the names Yā Ghafūr and Yā Shakūr, this combination touches our heart deeply, and it softens any hardening of the heart towards people, situations, or groups of people.

Yā Ṣabūr and Yā Shakūr widen the spirit steadily and actively, and their penetrating power enables the mind to discover places in itself where the winds of expanding greatness, patient sublimity, and grateful closeness blow.

Show your gratefulness by using your spiritual and mental talents. In this way, you will protect yourself from the dangers of envy, selfishness, lethargy, and indifference. Indeed, spirituality is tantamount to gratitude. Gratitude unites the material and the subtle world, the heavens and the earth, and makes the world into a place filled with wonders.

"Free will is trying to thank God for His favors." —Rumi

36

AL-ʿALĪY

The Sublime, the High One

110–330–12,100

This divine quality means the Outstanding, the Magnificent, the Sublime, the Most High. If you keep reciting this name in sequences of 33 repetitions when your faith is weak, it will become stronger and you will find your way. You can also write this name on a piece of paper and carry it with you so that you are always reminded to repeat it in times of weakness. Be watchful, gentle, and lenient on your way.

The root *ʿ-l-w* is one from which the two Divine Names Al-ʿAlīy and Al-Mutaʿālī (78) are derived, as well as the following meanings: to be high or elevated, to loom, to tower up, to rise, to ascend, to heave (chest), to exceed, to excel, to surpass, to overcome, to overwhelm, to turn upward, to overspread, to cover, to come, to befall, to emphasize, to rise aloft, to be raised, to become loud; highness, sublimity, lofty, greatness, grandeur, heavenly, divine.

Al-ʿAlīy summons us: "Come, raise yourself to Me! Raise up and don't live below your capacities!" Al-ʿAlīy shows us that God is always higher than we can ever imagine. It shows us the transcendent Divine. By repeating this name, a vision of the highest opens to us, and we find ourselves being opened, lifted up to the lofty worlds in and around us.

Those who know the sublime truth and whose thoughts, words, and deeds are humble in the face of Unity will be sublime among the creatures. The highest among human beings are those who know that they belong to the low ones because they are willing to grow, to serve, to understand, and to know.

If you can transform the ego and grow beyond the self-isolating *I*, you will see that you are the highest in everything because the universe was created for human beings and not the other way around.

Sometimes a sweet date, a piece of chocolate, a kind word, or a caress on our cheek is all that stands between the high and the low in us. Deep faith manifests through friendliness and good manners, and human beings can reach untold depths when their tongue is connected to their heart.

There is a part in the human body that when it heals, heals the entire body, and when it is sick, makes the whole body sick. Is that not the heart?

Those who carry this divine quality also carry the gift of modesty and generosity; that gift makes them support and help all beings around them, and they thus become known as the highest.

The way opens clearly and quickly to all seekers who repeat this Divine Name in deepest surrender, and they can reach in one hour what usually takes a month or more. Those who repeat a Divine Name in deep surrender, *dhikr*, are like birds: time and space open to them as if they were phoenixes in the flames of Love. Nothing remains but Love.

If you wish to carry beauty in this world, always choose the middle way between the finest garment that feels softest on your skin and the one that feels roughest. Always heed the middle way in your life.

Whenever you repeat this Divine Name, enfold yourself with the divine potential and power it carries. Feel how all the qualities in you are present in their highest form, while nevertheless avoiding any identification with the self-centered ego. Above all, repeat Al-'Alīy in difficult, dangerous situations. People whose expectations keep meeting with disappointment, or who are constantly confronted with the feeling that they are being cheated or exploited, find it helpful to recite Al-'Alīy. The recurring view or feeling of disappointment or betrayal comes from an ego that has put itself so high, whose dominance has become so strong that it has placed itself on a throne that belongs to God alone. And from that throne the ego judges and comments on everything, most of the time condescendingly.

Al-'Alīy can straighten out the ego. Al-'Alīy is the sublime, elevating love that puts the Divine on the throne of the heart and frees the ego from the agony of jealousy and arrogance. Al-'Alīy also helps when someone's self-esteem is so low that it borders on self-abasement. Al-'Alīy gives us a new orientation by enfolding us in heavenly, protective, and elevating love.

O Allāh, open in me the tall gates of faithfulness!

الكبير

AL-KABĪR

The Greatest
232–928–53,824

This name means greatness, pride, and dignity. He is the Creator and Sustainer of all beings in all worlds, in all heavens, on earth, and in all places between heaven and earth. Al-Kabīr is the boundless expansion in time and space, the infinite, omnipotent presence in everything. Nothing is excluded from Al-Kabīr—it encompasses presence and absence and holds them both in the infinite, endless ocean of the Great Love. Do not connect anything evil, imperfect, or bad with Allāh.

Like the Divine Name Al-Mutakabbir (10), Al-Kabīr comes from the root *k-b-r*, from which the following meanings are derived: to exceed in age, to be or become great, big, large, to grow, to increase, to become greater, to gain significance, to become important, to disdain, to enlarge, to magnify, to enhance, to expand, to oppose, to resist, to contradict, to praise, to show respect, to be proud or haughty; largeness, magnitude, prestige, importance, nobility, eminent, grave offense, deference, respect, esteem.

The all-encompassing greatness of Al-Kabīr also includes opposites, so that it is used to dissolve the arrogance, the competitiveness, the inflation, and the excessive stubbornness of the ego, especially when they result from a basic feeling of lacking and being worthless.

Al-Kabīr helps us to free ourselves from the identification of the ego with this basic feeling. To disintegrate boundaries and to overcome separation—such is the power of love of Al-Kabīr. If we wish to discover the greatness and boundlessness of the Divine, we must let go of our boundaries so that we may experience the Divine both beyond and within them.

The two names Yā ʿAlīy (36) and Yā Kabīr are often recited together. This combination has a deep effect on the senses and on the mind.

The task of the mind is to form thoughts and to compare. Learn not to compare, for comparing is a veil that keeps you from recognizing the uniqueness of a creature, a human being, a situation, or a

problem. Comparison and judgment veil the eye of the heart. Repeat the Divine Name Yā Kabīr and let the transformation begin. The idea is to transform—not develop—the qualities that you have been given, because the unique combination of all your capacities, your whole potential, is present in you.

The transformation takes place with us and for us, yet it depends on our work. Transformation means to turn to our soul and to free ourselves from the clutches of our ego that is at the center of our being, and to connect our senses and perceptions with our deep self, to taste the greatness that exists in us. It is the noble path to our true dignity that protects us from that which is low in us.

The secret of this name is also that it allows us to recognize that our smallest deeds are connected to the greatest and that they are always a part of something greater. The Divine Name Kabīr is often repeated in the sentence *Allāhu 'akbar* (الله أكبر), so that the reciter may see that Unity is the only power there is, that it is greater than the created world and at the same time contained in everything. The world is not Allāh, yet there is nothing but Allāh!

The heart is a vessel of knowledge, a source that reacts with sensitivity to the deeds of the body. This means that every deed that is not good, every negative deed provokes irritations in the heart; those irritations lead to veils that cover more and more our own humanity. Thus, every negative deed already carries its own punishment. Every crime we commit is first and foremost a crime against our own heart, which affects our whole being. So be careful how you nourish your heart, because carelessness starves the heart and robs it of its spiritual awareness. Then you enter the realm of unconscious life, thereby also losing the connection to life after death. Yā Kabīr protects you from such carelessness and helps you refine your heart, bring about peace, and connect to that which is great and eternal in you.

"Three things allow greatness to develop in us human beings:
to be grateful when we are given, to forgive when someone harms us,
and when we feel anger, to let softness wash over that anger
before we express it."
—*Abu Sa'īd*

147

38

الحفيظ

AL-ḤAFĪẒ

The One who preserves

998–3,992–996,004

This attribute of Allāh means to preserve, to protect, to safeguard. Allāh has given the angels the task to protect us from evil.

In the Qur'an, the Verse of the Throne (2:225), 'Āyāt al-Kursī (آية الكرسي), is called the most powerful protection verse, and Al-Ḥafīẓ is the One who protects everything, be it the size of an atom. Nothing is overlooked. He does not change and nothing influences Him. So remember Allāh in times of lightness and in times of difficulties and He will grant you His protection.

Al-Ḥafīẓ is the Divine Name of protection. This all-encompassing protection expresses the fact that everything is enfolded in divine protection.

Al-Ḥafīẓ comes from the root *ḥ-f-ẓ*, which has the following meanings: to preserve, to protect, to guard, to defend, to bear in mind, to comply, to be mindful, to be heedful, to keep up, to maintain, to sustain, to hold, to have in safekeeping, to take care, to put away, to save, to store, to retain one's memory, to know by heart, to learn by heart, to stay, to discontinue, to watch out, to pay attention, to follow, to keep a secret, to ask someone to guard or protect, to entrust, controlling, complying; maintenance, guarding, safekeeping, defense, caution, precaution, protection, vindication, bag, briefcase.

Al-Ḥafīẓ is especially important when we have the feeling we lack protection or never had enough. This feeling lets inner insecurity and fear develop. According to our personality, those will either manifest in the form of angry, aggressive deeds, or as servility and self-denial. Al-Ḥafīẓ takes us back to an inner uprightness that leads us to our truthfulness. We can go through the indignation at not having

received the protection we needed. Finally, we can be released from the feeling of being alone and having to take everything upon ourselves, freed from the spell of having to do everything ourselves: The universe is a safe place and I have my protected place in it! Al-Ḥafīẓ brings back a healthy, honest form of courage. Fear for one's existence and existential panic dissolve because Al-Ḥafīẓ reaches the foundation of our being and links us to the eternal protection through love.

Use this name to protect yourself against the ways of the egocentric *I*. Use it to protect yourself against negative thoughts and deeds, and use it also to help and protect others. The protection granted by this name works on the inner and outer levels, until you understand that there is truly no inside or outside, until you can dive completely into the quality of Al-Ḥafīẓ.

People who carry this quality radiate protection on all beings who come near them. Protection also means protection against negative feelings in the heart, negative thoughts in the mind, and freedom from judgment. It is a protection that leads you to the truth that you carry within yourself.

If the name Al-Ḥafīẓ did not exist, the strong would oppress the weak and the forces of duality would collide. By repeating this Divine Name, you protect your senses and your heart from the turmoil of anger and rage, from the power of your lower impulses, from the illusions of the ego, and from your own arrogance.

Repeating the Divine Name Yā Ḥafīẓ helps those who suffer from a weak memory or find it difficult to remember what they have learnt or what they know. It stimulates the capacity to absorb and strengthens memory. Keep the Divine Name Al-Ḥafīẓ in your heart so that you never lose sight of the fact that the divine protection is omnipresent because Allāh works through human beings and through His creatures. May this name help you remember that and give you the strength to protect and defend, wherever your protection and defense are needed.

Those who repeat Al-Ḥafīẓ on their travels and with all their heart will be protected on their path and return home safe and sound. This name has a fast effect and it removes fears from the heart and from the mind.

We also use Al-Ḥafīẓ when we can see and acknowledge the beauty of a human being, their special talent, or their possessions, and we wish to protect them, especially against envy or greed.

Focus your breathing on your heart and give each quality, each feeling, a touch of this divine quality. Every weakness can be your virtue if you recognize it. For we human beings are but the melting point, indeed the dot where the infinitely great and the infinitely small can meet. Feel how a circle of protection appears around and through you. The moral meaning of virtue is not the absence of illicit desires, but the inner victory over such desires.

We are the miracle of being human and the mircle of being divine.

39

المقيت

AL-MUQĪT

The Preserver, the Protector, the One who nourishes

550–2,200–302,500

Allāh is the loving Preserver and Protector. If you wish to help someone who is in a bad mood, repeat this name 33 times over a glass of water before giving it to them to drink, and the bad mood will dissipate. Al-Muqīt is the One who has power over everything, the Shaper of fate, and the One who assists in all spiritual situations. So strive for the good in all your dealings for He is the Preserver.

Al-Muqīt comes from the root *q-w-t*, which carries the following meanings: to feed, to nourish, to subsist, to sustain, to support, to provide for, to be fed, to be supported, to live, to eat; nutriment, aliment, nourishment, food.

The Divine Name Al-Muqīt gives each creature its strength, each body its food, and each heart its knowledge, vision, and intuition. Al-Muqīt is the food of the heart. It imparts the deep, comforting knowledge that nourishment is given when we ask for it, when we need it. Al-Muqīt is nurturing love, it opens and relaxes the pineal gland, enabling us to connect with the eternal source of nourishment. Those who repeat this generous name receive from Allāh the strength to feed the hungry, to clothe the naked, and to take the lonely by the hand.

Al-Muqīt also helps to free people who are prisoners of their listlessness.

Those who carry the quality of the Divine Name Al-Muqīt are granted an awareness that lets them see the needs of others, and they are given the strength to satisfy those needs in the right way and at the right time.

If you believe in you, you believe in the Protector.

The difference between Al-Muqīt and Ar-Razzāq (17) is that Al-Muqīt creates the food and is responsible for everything the body needs, both on the spiritual and physical levels. Through eating we feed the body, with knowledge we feed the heart. Ar-Razzāq has a wider dimension that includes everything we need—from a job to love and compassion.

The intensive repetition of the Divine Name Al-Muqīt enables us to overcome hunger so that we no longer feel any hunger pangs.

Let your love for this world be a path to God.

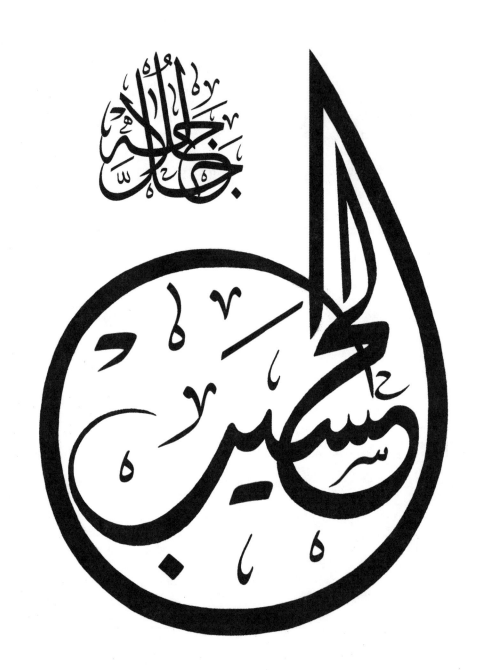

40

AL-ḤASĪB

The One who calculates precisely, the One who demands account

80–320–6,400

All the deeds of a human being are recorded, even if the good is the size of an atom and the bad that of a mustard seed. Nothing gets lost; nothing is overlooked.

Al-Ḥasīb comes from the root *ḥ-s-b*, which contains the following meanings: to compute, to reckon, to calculate, to count, to charge, to credit, to take something or someone into account or into consideration, to consider, to think, to believe, to suppose, to assume, to regard, to be of noble origin, to be highly esteemed, to get even, to call, to hold responsible, to be careful, to measure, to extend, to account, to amount, to value, to render account, to use the alphabetic letters according to their numerical value; thinking, enjoying someone's protection or shelter; respected; opinion, view, reflection, Day of Reckoning, arithmetic.

Al-Ḥasīb is the divine love that enables us to see what we really need in order to develop, to transform. To weigh honestly our words, our deeds, and even our thoughts gives us the possibility of a new beginning. Allāh demands account from us; He demands vigilance and tact from us human beings because attention and sensitivity bring respect for ourselves and for everything around us, thus granting us nobility. Mindfulness comes to be when I take the time, peace, and quiet to contemplate and reflect.

الشكر نهاراً والذكر ليلاً

ash-shukru nahāran wa-dh-dhikru laylan
Live your days in the quality of gratefulness
and your nights in the quality of contemplation and inner learning.

The day is formed from the night. Brightness, the visible, your deeds, and how you deal with everything around you and everything that happens to you—all develop out of the darkness of the night, that inner, introverted period.

Yet to reflect and contemplate does not mean to sit down at the end of the day and ask oneself, What have I done wrong today? How can I improve my mistakes? If you treat yourself in this way, you will become exhausted and angry. You might even fall into self-contempt. You ego will puff itself up, sit on the judge's chair, and distribute insults and humiliation.

Al-Ḥasīb opens us to the richness of the soul, to that divine sparkle, that treasure of omniscience that has always been lying in our heart and that connects us to the primeval cause of all existence.

This is how the path begins. When I see that I haven't acted correctly, I go back to Allāh with 'astaghfiru llāh: I ask for forgiveness and take refuge in You. O Uniting Love from which I have departed out of carelessness, take me in, treat me, and purify me!

When I see that I have done something good, then I drink from the Great Source with al-ḥamdu li-llāh: praise be to God, for I know that everything comes from the One Source of love!

And when I do not know whether what I did was right or wrong, then subḥāna llāh: praise and honor to You, will help me let go of everything in the ocean of praise and surrender everything to You in order to find the shores of clarity.

Sura al-Nisā', سورة النساء, Women (4:85)
Whoever rallies to a good cause shall have a share in its blessings; and whoever rallies to an evil cause shall be answerable for his part in it: for, indeed, God watches over everything.

Al-Ḥasīb demands introspection, which links it with the Divine Names Al-Muḥṣī (57), the One who knows, and Ar-Raqīb (43), the Vigilant. Al-Muḥṣī blasts the boundaries of our ego by showing us how limited human knowledge is compared to Allāh's omniscience. Once we have seen our limitations, Al-Muḥṣī helps us dive into the omniscient ocean so that we do not remain stuck in our anxious self. In turn Ar-Raqīb gives us the strength of loving watchfulness and quietness required for true concentration and introspection.

There is nothing superfluous on earth, neither is there any lack. Excess and lack exist only when the excess does not fill out the lack. Excess in one shows lack in the other. Do not remove anything, do not add anything, but lead the 'excess' to the 'lack,' lead everything to its proper place. Lack is a sign of excess, excess a sign of lack. Lead one to the other in the name of Unity and all will be well. Everything has a meaning in life, yet the order of things lies in our hand.

A student once went to his beloved teacher and said, "Master, I have this bag of nuts, could you distribute it among the students?" The teacher took the bag and asked, "Should I distribute

according to Allāh's laws or according to our human laws?" "According to Allāh's laws" the student answered. So the teacher took a handful of nuts out of the bag. To some students he gave two nuts, to others five nuts, and yet others ten nuts. The student looked at him in astonishment and the teacher smiled and asked, "Should I distribute them according to human laws?" The student nodded, the nuts were collected, and every student was given the same amount.

—Nasruddin folktale

People who carry the quality Al-Ḥasīb take care that their life, their possessions, their knowledge, and their talents be used well and enjoyed to the full. They make sure that the gifts are truly lived. To live truly means to take care of one's body, to inhabit it, being aware of this body and all the things it carries, and also to enjoy inhabiting this planet and participating in His being.

If you repeat the Divine Name Al-Ḥasīb and carry it in your heart, your attention grows inside and is reflected by people on the outside. It helps you live that which is noble, refined, and correct in you.

It is no coincidence that the Divine Name Al-Ḥasīb holds the fortieth position. Forty is a special number taken into consideration by many traditional cultures. It stands for preparation and transformation. According to an Arabic saying, whoever lives with a group of people for forty days becomes part of them, becomes like them, adopts their points of view and their habits. Symbolically, human beings are separated from God by forty levels. This is why the forty-day retreat (*khalwa*) is an important exercise in which the seeker comes closer to God through meditation. Al-Ghazālī's *Revival of the Religious Sciences* is also divided into forty chapters intended to prepare the believer through instructions on the encounter with God, on death and mystical love.

Hadith Qudsī

A Bedouin once came to the Prophet Muhammad, Allāh's peace and blessings be upon him, and asked, "Who will demand account from the people on the day of resurrection?" The Prophet answered, "Allāh, sublime is He!" So the Bedouin asked, "He Himself?" and the Prophet answered, "Yes." Then the Bedouin laughed and the Prophet, Allāh's blessings and salvation be upon him, asked, "What are you laughing for?" The Bedouin answered, "When the Generous One asks for account, He is forgiving, and when He judges, He is forgiving."

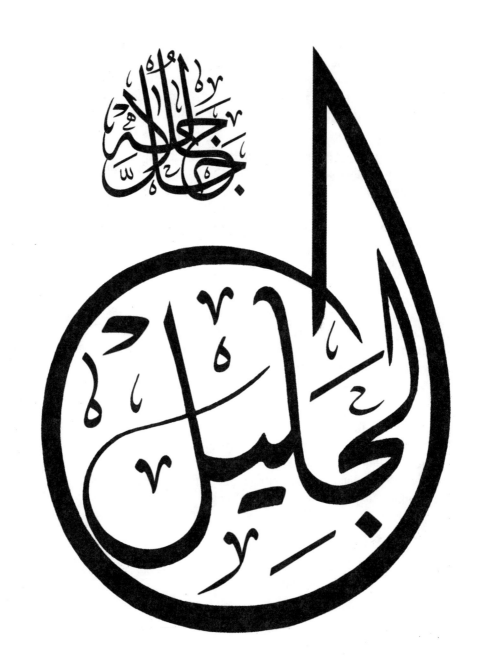

41

AL-JALĪL

The Glorious, the Majestic, the Magnificent, the Honorable

73–292–5,329

This name expresses the majesty and magnificence of the Divine. Al-Jalīl is the penetrating, absolute divine force that manifests in everyone and everything, without exception. Know that majesty and perfection only belong to the Creator, so let your heart be soft toward the Creation.

Al-Jalīl, but also Al-Jalāl (Dhū-l-Jalāli wa-l-Ikrām [85]), comes from the root *j-l-l*, which contains the following meanings: to be great, to be beyond something, to be far above something, to honor, to dignify, to exalt, to cover something, to border, to dignify, to revere, to touch the whole earth with rain, to envelop, to wrap, to clothe; lofty, exalted, illustrious, sublime, outstanding, important, momentous, weighty, bulky; splendor, glory, majority.

Allāh's manifestation in things, *tajallī*, is so bright and shining that it both covers and reveals. The most obvious is covered in the visible. Al-Jalīl is the rose fragrance that lets you discover the rose garden. The divine signs have been engraved in our heart in the form of the Divine Names since time began, and everything around us resonates in a Divine Name. Everything calls, praises, and sings the divine song, so lean your ear towards your heart and follow the tracks to the secrets.

Not only does the sound code of this name point to its omnipotent, all-pervasive force, the various meanings of its root indicate its collective presence. Al-Jalīl's loving force is reminiscent of the drop of the ocean and brings about integration.

God does not manifest through His being, which remains transcendent, but through His names and

attributes. If the essence is water, the Divine Names are the oceans, seas, rivers, brooks, and waterfalls. Yet the essence—water—remains something else. The essence is one, the Divine Names form a multiplicity of concepts. God is beyond all the creatures' qualities, yet Creation is nothing but God since it is the manifestation of His names.

In essence, Allāh is, and remains forever, hidden and invisible. In this respect, He remains completely transcendent: "I was a hidden treasure." In the second respect, He shows His immanence: "I had the wish, born out of love, to be known, so I created the world." The world becomes the place where God's most beautiful names, *asmā´u llāh al-ḥusnā*, manifest because in God His manifestations are one with Him.

Al-Jalīl shows the manifestation of divine force as it appears and begins to expand. Repeating this Divine Name removes fear, worries, and weaknesses from the heart, and awakens in the reciter the feeling of closeness to the Divine.

A true friend will not expose you. But again and again, we human beings have the urge to express ourselves, and we sometimes hear ourselves say things that would have best been left unsaid. Reciting Al-Jalīl helps us when our tongue is sometimes quicker than our thoughts.

When you repeat this name, angels surround you, whose prayers resonate for you and enfold you with light. Al-Jalīl lets deep joy and freedom come up in the heart, as well as a deeply touching reverence for the Divine. Whenever you become excessively carefree, Al-Jalīl brings reverence, and whenever there is too much fear, Al-Jalīl gives trust and confidence.

Repeat this name of majesty after each prayer.

اللهم أنت السلام ومنك السلام وإليك يعود السلام
تباركت ربنا وتعاليت يا ذا الجلال وألاكرام

allāhumma anta s-salām wa minka s-salām wa ilayka ya'udu s-salām
tabārakta rabbanā wa-ta 'ālayta yā dhā-l-jalāli wa-l-ikrām

O Allāh, You are the peace and from You comes the peace and to You the peace returns. Blessed be You, O Majestic, O Glorious One!

Divine attributes such as Al-Aẓim (33), Al-Qawīy (53), and Al-Ghanīy (88) come together under Al-Jalīl , namely under the quality of majesty. Divine attributes such as Ar-Raḥmān (1), Al-Laṭīf (30), and Al-Karīm (42) come together under Al-Jamīl, namely under the quality of beauty. Between beauty and majesty, confidence and fear, the heart moves homewards.

After reciting the 99 Divine Names, we say, uniting them all:

جل جلاله وتقدّست أسماؤه

jalla jalāluhu wa taqaddasat asmā'uhu

His Majesty be announced and His names sanctified.

Those who carry this quality are just in their deeds and honest in their promises.

In life, there are phases and situations when we cannot contribute or change anything from the outside. In such times it is essential to develop the inner qualities of strength, confidence, trust, and surrender. The Divine Name Al-Jalīl teaches us to develop those qualities so that the wave may grow and, when needed, flow out.

O Magnificent, Yā Jalīl,
enfold my longing with the power of Your presence!

42

AL-KARĪM

The Generous, the Magnanimous, the Noble-Minded, the Charitable
270–1,080–72,900

This name contains Allāh's most generous quality, a generosity that reaches everything without exception. It contains all the giving required to preserve life. This name contains the mercy and kindness that exist between Allāh and the Creation. Al-Karīm is the constant flow of Allāh's gifts to the Creation.

Al-Karīm and Al-Ikrām (which is found in the Divine Name Dhū-l Jalāli wa-l-Ikrām [85]) both come from the root *k-r-m*, from which the following meanings are derived: to be noble, to be precious, to honor, to revere, to venerate, to treat with deference, to bestow honor, to view in generosity, to meet politely, to treat hospitably, to show one's generous side, to be friendly, kind, to present, to bestow graciously; high-minded, noble-hearted, magnanimous, generous, liberal, munificent, beneficent, gracious; noble nature, standing, mark of honor, miracle that God works through a saint or allows to happen to him, amicability, noble deed, grapes, wine, garden, orchid, precious stone, object of value.

Al-Karīm's gifts are of both a spiritual and material nature. Repeating Yā Razzāq (17) Yā Karīm addresses the material gifts, Yā Ghanīy (88) Yā Karīm the spiritual ones. When we say *karrama llāhu wajhahū!* (Allāh has honored him!) about someone, it means that Allāh has inspired their heart, and the signs of knowledge and honor can be seen on their forehead.

If you repeat this name 270 times, you will value and respect others more, and conversely you will be more respected and valued, for Allāh's mercy and kindness to you exceed your kindness and your mercy for yourself. So turn to Him with all your senses and become a mirror of His generosity and His magnanimity.

Those who repeat and carry Al-Karīm in their heart will find their livelihood effortlessly, and abundance will come to them, both on the inner and outer level, by the grace of God.

Sura al-Infiṭār, سورة الإنفطار, The Cleaving Asunder (82:6–8)
OH MAN! What is it that lures thee away from thy bountiful Sustainer, who has created thee, and formed thee in accordance with what thou art meant to be, and shaped thy nature in just proportions, having put thee together in whatever form He willed [thee to have]?

What growth is to plants, what movement is to animals, giving is to human beings. Human beings can smile. Do not only smile when you are in a good mood. Smile a creative smile, for angels dwell in a smile. The smile is the bridge. A smile born from the depths of one's soul is a mystery. To smile is to be generous.

Smiling, language, and creativity are human traits. Use them to express your generosity. Asking and requesting are signs of lacking. Yet without a lack there would be no space to give. Still, requesting is a sign of audacity in the face of God's generosity, but He overlooks that and accepts the request. Show your magnanimity!

God's generosity and kindness are boundless. Every refinement you have been given is generosity: patience is generosity, inspiration is generosity, reason is generosity, and generosity itself is generosity. Turn to the noble character traits—*makārim ul-akhlāq*—in you. Generosity is something we human beings need urgently.

He gave us the whole world and the freedom to treat it as we wish. The Prophet, peace and salvation be upon him, said in the hadith, "Allāh, noble is He, carries the name Al-Karīm, the Generous, the Magnanimous. He loves the noble, generous traits of character and loathes the low ones."

The heart is where the beginning, the end, and the joy are. Of all creatures, human beings are the cruelest. Yet man and woman are the cradle of eternal joy and harmony. Unused, untransformed strength can turn devastating, poisonous, and disruptive. Show your generosity and your magnanimity by going the path of your own transformation, by fanning the fire of love in your heart, and by learning to transform everything in you through that fire. Learn to burn in trust. Evil is that which is no longer good. It can be transformed into that which is not yet good. Show and live your magnanimity for yourself and in this way for all the creatures of this planet.

To be grateful for our fellow human beings' help and support, and to express this gratitude, is precious because we often become arrogant and we forget, especially when we have received plenty. Remember the support and the gifts of your fellow human beings and forget what you have given, because the ego loves to remember its good deeds and to water down those of others.

Arrogance and ungratefulness make people around you retreat. But Allāh is and remains generous. Al-Karīm helps us overcome the arrogance of the ego.

Those who carry the quality Al-Karīm learn to see the qualities and expectations that lie in them. They give when they are asked, they are present when someone comes to see them, and when they make a promise, they keep their word. They look after the affairs of the weak and the poor, knowing that those who help the needy will be helped in their hour of need. People in whose heart the seed of Al-Karīm has blossomed give without expecting anything in return, without paying attention to the others' reaction. The grapes of knowledge have matured in their warm, generous heart and they give the wine of paradise.

Sura al-Isrā', سورة الإسراء, The Night Journey (17:70)
NOW, INDEED, we have conferred dignity on the children of Adam.

Allāh has distinguished human beings by granting us the capacity for logical thinking.

Magnanimity finds its inherent support in dignity, a dignity that knows that everything comes from Him and to Him everything returns. Thus, magnanimity is the love of beauty in the widest sense of the term—and Allāh is beauty.

People who have the feeling that they have done many negative deeds in their life should repeat this Divine Name. May their deeds thus be forgiven and their weaknesses veiled, for Allāh is the Most Generous.

Three impulses in human beings are most difficult to transform. They are located in the belly, in the genitals, and in the tongue. They can be transformed through *adab* (أدب), which means courtesy, a feeling of honor, decency, education, wide reading, patience, compassion, and kindness. Conversely, they can be strengthened through indecency and arrogance.

Adab is the ship of love and knowledge steered by the wind of courtesy. The place of *adab* is the heart, and when the heart is free, so are the parts of the body because they follow the inspiration of the heart. So use the Divine Name Yā Karīm in the *dhikr* so that your tongue may become the translator of your heart.

Show your generosity in your thoughts, too, because energy follows the thoughts and one thought calls the next. This is not about guilt or innocence. Every woman and every man has a path on this earth, and each of us is fulfilling their part. We are not here to judge or to be judged. We can weigh and assess, but above all we are here to reach our hand to one another. The heart needs loving attention. It lives on love and love is attention lived.

<div align="center">

43

AR-RAQĪB

The Watchful, the Vigilant, the meticulous Observer, the Protector

312–1,248–97,344

</div>

This divine quality contains the divine vigilance that grants security and protection to the Creation. Ar-Raqīb watches over the states, words, and deeds of human beings. Everything is visible, so be attentive whether you are moving or not, whether you are active or passive.

Ar-Raqīb comes from the root *r-q-b*, which contains the following meanings: to observe, to watch, to regard attentively, to supervise, to control, to wait, to await, to guard, to take into consideration, to heed, to respect, to fear, to be on one's guard, to watch out, to be careful, to keep an eye on something, to expect, to anticipate; stubborn; observer, spy, keeper, inspector, guardian, observation, control, watchfulness, anticipation, expectation, surveillance, controllership, neck.

Murāqaba, one of the contemplation and breathing techniques used by the Sufis, comes from the same root as Ar-Raqīb.

Ar-Raqīb observes in the same way that a mother observes her child—without judgment, yet noticing and then gently correcting. Introspection has nothing to do with humiliation or abuse. It has nothing to do with self-pity, megalomania, or a mere exaggerated opinion of oneself. All these are various faces taken by the ego to prevent us from developing on a deep level, to distract us from the connection to our true self. "I decide which way you go! I am your ruler. I think about and judge your state and your deeds," calls the ego. The way in which we see ourselves influences the way in which we see God, and vice versa. Self-reflection always involves collecting oneself in the one and only original soul, in Unity.

Those who repeat Ar-Raqīb 7 times over themselves, their family, or their possessions place themselves, once more, consciously under the protection of Allāh. Repeat this name as often as possible when you are by yourself or with others, for a whole month or longer, and the eye of your heart will begin to see things that are hidden to others. Repeating this name also gives you the capacity to understand the language of animals, plants, and lifeless things, if Allāh has meant it for you.

Those who carry the quality Ar-Raqīb are more aware of unity with the Divine than of themselves. This awareness expresses itself in their thoughts, words, and deeds, and it lets a longing grow to open a space for beauty and light. So create a space for beauty to enter and know that energy follows thoughts and that one thought will attract similar ones.

If you have lost something, repeating this name will help you find it again. People who are afraid of being under a curse or a spell should repeat this name 312 times a day for one week, and the influence of the curse or the spell will dissipate, God willing.

This name of majesty increases your own vigilance towards yourself, and it intensifies awareness and modesty in the heart. This Divine Name is best expressed in the words of the Prophet Muhammad, may Allāh's peace and blessings be upon him, who said, "Honor Allāh in yourself and in everything as if you could see Him, because even if you cannot, He can truly see you." He sees your truth and the path you have taken to reach completion.

Once upon a time there was a teacher who loved one of his students more than all the others, and they became envious. The teacher wanted to show them why he loved that particular student more, so he called them and said, "Each of you shall go out, catch a bird, and kill it in a place where no one can see you." Every student went out, caught a bird, killed it and came back. But that student returned with a living bird. The teacher asked him, "Why didn't you kill him like I had ordered you to?" The student replied, "Whenever I tried to kill the bird and looked for a place where no one could see me, the words came into my heart, 'Allāh can see you.'" Upon hearing those words, the students understood why the teacher loved this student above all.

— Traditional Sufi story

Hadith Qudsī
Practice almsgiving with every new day, every sunrise:
to mediate in a quarrel is alms, to help someone carry their burden is alms,
a kind word is alms, every step you take to perform the prayer is alms,
and every danger you remove from the path is alms.

AL-MUJĪB

The One who hears, the One who replies, the One who reciprocates, the Receptive

55–220–3,025

This divine quality means the One who answers prayers and fulfills them because when you turn to Him, it means that you believe in Him and hope to be heard. So repeat this Divine Name 55 times with an open heart and your prayers will be heard.

Al-Mujīb comes from the root *j-w-b*, which has the following meanings: to travel, to wander, to tour, to pierce, to penetrate, to answer, to reply, to comply, to hear, to fulfill, to grant, to agree, to resound, to break up, to disappear, to vanish (worries), to fade (darkness), to hear or answer (a prayer), to answer a request, to react positively, to pay attention, to meet, piercing, penetrating, traveling through the world; opening, answer, reply, conformity, harmony.

The great master al-Ghazālī explains the name Al-Mujīb as "the One who hurries to hear the requests of His creatures ere they have formed."

Al-Mujīb does not only mean to ask. Above all it means the capacity to become attentive and to listen, because praying to Allāh means to invite the divine light into the dark, confused spheres of our ego so that we may be surrounded by light and come to know what we are actually requesting. In this way we also begin to see the answers that are always there. It is this asking and praying that makes us into that which we must become, that opens us to the Divine. Hearing and answering must be attuned. When we stride through the space between the isolated *I* and the Divine—and this we human beings can only do by opening our heart—request and answer meet. Not knowing when, where, or how the answer comes protects us from our own limited imagination. But to know that the answer will come makes lovers out of us.

Al-Mujīb receives requests and questions. So turn to Him, for He hears each and every call, He knows all the needs of the boundless universe and of the whole Creation, and He looks after them in His all-embracing love and order. For He knows the causes and effects of every action, no matter how insignificant.

Whenever you wish to let the qualities of a Divine Name linger in you, whenever you ask from their resonance, you can repeat the name Al-Mujīb after that Divine Name.

Those who carry and repeat this name in their heart are granted gifts by Allāh in their material existence, their behavior, their deeds, and their knowledge. If you feel a narrowness in your heart, repeating this name will help your breast widen, and you will be able to remain confident.

When you repeat this name 137 times, you do so 7 times to free yourself from the narrowness in the breast, 30 times to know the strength that lies in all the names, and 100 times to be enfolded in the quality of that name and manifest its strength and its energy.

It is a major step to own up to our ignorance in the face of the Divine. To know that we do not know is the beginning of true knowledge.

Those who carry the quality of Al-Mujīb obey the sound and voice of truth, the voice of their deep self, and just as they obey and accept that voice, so does Allāh accept their voice. Repeating this name also helps to protect us from slander and gossip.

Know in your heart that your pleas are heard and that this happens at the right moment and in the way that is right for you. Have trust, patience, and perseverance, for nothing can happen until the right moment has come for you. Know also that when you repeat the name Al-Mujīb, you too should be someone who fulfills and answers the needs and wishes of the beings on this earth, for Allāh loves those who love His creatures. He loves those who forgive and those who love others. And He loves those who treat His creatures tenderly and lovingly. Al-Mujīb is one of the Divine Names that has a quick effect.

Sura al-Baqarah, سورة البقرة, The Cow (2:186)
AND IF my servants ask thee about Me behold, I am near; I respond to the call of him who calls, whenever he calls unto Me: let them, then, respond unto Me, and believe in Me, so that they might follow the right way.

O Allāh, my ego has oppressed and mistreated my soul, concealing it from the light and from the secrets, so help my soul conquer my egocentric, selfish, impulsive soul. O Allāh, forgive me for being negligent and inattentive, and grant me light through Your name Al-Mujīb so that I may remain grateful and in constant remembrance of You and live Your will, You who are capable of everything!

45

AL-WĀSI‘

The All-Embracing, the Endless, the All-Reaching

137–548–18,769

His fullness embraces all beings and things. This Divine Name manifests greatness, power, and open-handedness, and it shows God's boundless generosity and all-encompassing presence.

The root *w-s-‘*, from which Al-Wāsi‘ is derived, carries the following meanings: to be wide, to be well-off, to hold, to house, to have capacity, to have room, to contain, to comprehend, to include, to be large enough, to be possible, to be permitted, to be generous, to make rich, to be engaged extensively, to stretch far and wide; roomy, spacious, vast, extensive, capacious, patient, forbearing, big, tolerant, generous (heart); wideness, plenty, abundance.

Al-Wāsi‘ is the One who can hold everything and who makes space for everything. He widens that which is narrow or limited, be it on the personal, financial, or professional level, and through His open-handedness, makes space for new paths and opportunities.

Those who suffer from the weight of their responsibilities and their difficult work will find strength and relief if they keep repeating this name, which can also heal those diseases called jealousy and revenge. Depression can be alleviated and dissipated by repeating this name 137 times. This name also reflects the kindness and the mercy over and around everything. Know that, and know that you are protected, that you and all beings are taken care of. Open your heart, have trust, and grant your heart the honor of knowing the all-embracing wisdom.

To let the divine quality Al-Wāsi' grow in us means to develop the capacity to hold and embrace everything that comes to us, in whatever shape or form. No matter what happens to us, through all difficulties and problems, we human beings always have a choice either to stretch or to break. We are always between neediness and capacity. Therefore recognize the neediness so that the capacity may grow in you, and see that a situation that comes to you is there to teach you to expand inside in order to develop and bring to life new capacities in you.

To expand, to use every day of this life to widen our fearful heart, our sharp mind—that is a beautiful, lively task. What a beauty I carry within! The eyes fill with the water of mercy, and our breath reaches the limits of our breast. That is tasting true knowledge, that is bliss.

The divine quality Al-Wāsi' is often mentioned in the Qur'an with Al-'Alīm (19), the Omniscient. Learn to linger every day a little longer in blissful expanse and fullness, and to let yourself be led into the space of rich knowledge.

Sura al-Baqarah, سورة البقرة, The Cow (2:115)
And God's is the east and the west: and wherever you turn, there is God's countenance. Behold, God is infinite (wāsi'), all-knowing ('alīm).

If you repeat the two names Yā Wāsi' and Yā 'Alīm, your heart and your ability to know will expand because love also needs knowledge, true knowledge. Repeat this Divine Name without expectations, for expectations prevent us from living in the present, and we can only learn in the eternal present.

The divine quality Al-Wāsi', the All-Embracing, is meant to give you the strength to grow beyond your doubts and to transform them into a source of strength, because doubt is a form of energy that calls for transformation. To do so is an honor that should help you on the path of divine expansion, the path of unconditional love. Al-Wāsi' helps us relinquish bad, limiting habits.

Spend a whole day carrying this name written on a piece of paper, repeat it in your heart, and lend it expression in your behavior, and you will see how divine generosity grows in you, how the sources of wisdom start bubbling in your heart, on your tongue, and in your deeds.

The combination Yā Wāsi', Yā Raḥīm (2) helps us when we are afraid of closeness, of going into relationships, of letting go and surrendering, out of fear of losing our identity. Yā Wāsi' helps us find a balance between fencing off others and forgetting ourselves in a relationship through excessive identification with the other. Yā Wāsi' also helps us balance between the flexibility that life demands of us with its constant changes and the belief in continuity that enables us to participate in life in a constructive way.

Allāh is called *wāsi'u r-raḥma*, rich in mercy, and *wāsi'u l-'adl*, rich in justice. May repeating Yā Wāsi' let the divine wind of mercy set our heart upright and align it.

People who feel overwhelmed by the burden they carry in terms of work or responsibility find help in reciting this Divine Name. Yā Wāsiʻ is a name that fosters healing, especially in times of difficulty and depression, because the diseases of the soul always result from the feeling of separation. Depression is that state when the people and circumstances around us no longer touch or nurture us, when we can no longer touch them or connect with them, and we feel as if we have lost our place on earth. Yā Wāsiʻ opens again the gentle gates of connectedness, expanse, and joy. So repeat Yā Wāsiʻ with soft lips, massage your breast with the richness of this name, forgive yourself and others—and come back.

The Divine Name Al-Wāsiʻ carries endless kindness and the quality of forgiveness. It gives us the capacity to open our arms, even in times of constriction, and even to those who have brought about those difficulties and that constriction. On the physical level, Al-Wāsiʻ helps when we are overcome by a feeling of narrowness that can manifest in a stiff back, a tense womb, or flat breathing.

O Allāh, expand and increase my noble qualities and my knowledge of You,
and expand my light and my abilities so that I may recognize Your manifestations.

الحكيم

AL-ḤAKĪM

The All-Wise

78–312–6,084

Wise people are those who deal with things in the appropriate manner. Their words and deeds are in harmony, uninfluenced by current trends or fashions, free from their own impulses and moods. This Divine Name manifests the knowledge of true and authentic deeds.

Like Al-Ḥakam (28), the Judge, the Divine Name Al-Ḥakīm comes from the root *ḥ-k-m*, which carries the following additional meanings: wisdom, sage, philosopher, doctor, sharp intelligence.

Al-Ḥakīm is the source of all wisdom. Wisdom means to bring about unity in our spirit, unity and love for Allāh, and love for all of humankind. It means the capacity to take on all the roles that life demands of us: friend, daughter, son, mother, father, neighbor, teacher, servant. To be wise means to carry love and unity in our heart and spirit, to speak to all human beings in their language, to be able to carry all our duties and functions while remaining connected with the truth inside.

Sura al-Baqarah, سورة البقرة, The Cow (2:269)
And whoever is granted wisdom has indeed been granted wealth abundant.

In the Qur'an, Al-Ḥakīm appears forty-eight times with Al-'Azīz (8) and thirty-nine times with Al-'Alīm (19). The pair Al-'Alīm, Al-Ḥakīm shows intellectual, reflective knowledge combined with wisdom. Al-'Azīz, Al-Ḥakīm combines power and capacity with wisdom. It is the practice of wisdom, the capacity to attain wisdom on a practical level. It is wisdom expressed in everyday life, in our daily acts, in our behavior. Wisdom is an act of beauty, an act of sensitivity. It is the truth that brings about

peace, comfort, and harmony. Wisdom is to cultivate sensitivity in our thoughts, words, and deeds on the dual level of perception and expression. Wisdom means to liberate our consciousness from the clutches of negativity and ill humor.

As human children, we are born with free will in a universe that follows God's laws. Our free will wants to fulfill all our wishes, follow all our moods. Yet, life's constellations, influences, and circumstances keep confronting this will, testing it time and time again. The task imparted to our soul on this earth is to elevate ourselves over these opposing influences, to walk through them, to cast one illusion, one disappointment, aside after the other. Then every justice, every injustice, will finally flow into Unity and be complete.

Sufism attaches great importance to smiling, because a smile widens and softens the heart. Smiling expresses the connection with the soul; it is an act of will and an act of the spirit to want to look at the light side of life. It is to decide to walk the path of love. It is the path of the heart that knows that Allāh stands behind all outer manifestations, in His perfection and His fairness. To smile means to focus our attention on our heart and on the heart of others, because when we are friendly and subtle, we always end up charming hearts. This does not mean that we should not be clear and sharp in some situations. It simply means that we should always act according to what we see as being best. It means always making an inner decision in favor of the light.

To understand human nature and to meet it with sensitivity means to elevate ourselves and others to the higher spheres of our being. It means to overcome ill humor, depression, despair, and sadness, and to discover the good fortune and privileges within and around us. This path takes us from the wounded *I*, from the limitation of seeing ourselves as a puddle, to realizing that we are a river on its way to the perfection of the ocean of divine love. Such is the holy battle, jihad, that all the prophets have spoken about, and that is fought with willpower and faith in God's all-encompassing power of love. This battle heals the wounded *I*'s moods, which would have us believe that we are alone, which make us focus on the flaws in ourselves and others, and would like to convince us that the solution lies in standing up only for our own interests or the interests only of those closest to us.

Wise people are those who lead things to the right place at the right time, whose words and deeds are in harmony with the resonance of His truth. They can also control their impulses and selfish tendencies, and they are not moved by the winds of their moods.

Those who keep repeating this name will become free from difficulties at work and in their duties. Al-Ḥakīm is the All-Wise, the One who acknowledges that which is good, the One who realizes Himself in His creation. He is omniscient of the wisdom that He has preordained. He lays down everything in His way. So know that everything carries His wisdom and His purpose.

Those who carry this name and repeat it are granted wisdom by Allāh, together with a truthful tongue and the subtleness of deep knowledge. Know that the gifts of each Divine Name are in accordance with

the reciter's strength and the truth carried by that strength. It opens the gates of inspiration and lets the reciters recognize the subtle signs and clues around them.

The Divine Name Al-Ḥakīm belongs to the names of majesty and carries the knowledge and wisdom of Unity. Center in your heart and let your breathing flow in and out, gently and naturally. Then take your awareness from your heart up to the place between your eyebrows. Now, let your awareness go from your heart to your solar plexus. Connect those two centers with your heart and repeat the Divine Name Yā Ḥakīm, either aloud or silently. A rhythm will slowly develop—let it carry you.

Ḥakīm or *hakīma*, the wise one, is also used to address a doctor or a scholar, someone who has knowledge, experience, and discernment that they can use to heal people or the world.

May this name show you the mysteries of the divine purpose behind the Creation, and may your behavior and your deeds embed you into the reverberations of this knowledge. May this name give you strength when you feel that, despite all your efforts, you can find no solution or success, and may it open up new spaces for you.

Sura al-Baqarah, سورة البقرة, The Cow (2:269)
Granting wisdom unto whom He wills: and whoever is granted wisdom has indeed been granted wealth abundant. But none bears this in mind save those who are endowed with insight.

Wisdom belongs to those who are embedded in the inner and outer laws of existence. It comprises unconscious, as well as acquired, knowledge and strives for balance amid the confusion of the marketplace of this world. People who carry this quality can show the right path in times of doubt, indecision, and confusion, and fill hearts with renewed hope.

Sura al-Baqarah, سورة البقرة, The Cow (2:32)
They replied: "Limitless art Thou in Thy glory! No knowledge have we save that which Thou hast imparted unto us. Verily, Thou alone art all-knowing, truly wise."

Carry this name written on a piece of paper for a whole day, repeat it in your heart, and express it through your behavior. You will see how divine wisdom grows in you, and how the sources of true knowledge start flowing in your heart, on your tongue, and into your deeds.

Everyday life is a precious place for us to practice wisdom.

47

الودود

AL-WADŪD

The One who loves unconditionally, the endlessly Loving

20–80–400

When you repeat this name, you feel enfolded in sweetness, kindness, and mercy. Al-Wadūd is intimate divine love in the heart. You feel how your heart turns towards the Divine, leaving everything behind—possessions, children, relatives, and relationships. The longing for the divine nearness increases and the way to God opens through tender threads growing out of your heart.

إياك نعبد وإياك نستعين

iyyāka na'budu wa iyyāka nast'īn

Thee alone do we worship, and unto Thee alone do we turn for aid.

Those who carry the quality Al-Wadūd love you through their words and deeds, expressed by their faithfulness and purity, their love and truthfulness, expecting nothing.

Al-Wadūd comes from the root *w-d-d*, which contains the following meanings: to love, to like, to be fond of, to want, to wish, to make friends, to become friends, to try to gain someone's favor, to strive for someone's love, to show love or affection, to love each other, to be on friendly terms, to be friends; attached, devoted, fond, friendly, favorably disposed; love, affection, beloved, desire, amity, good terms, tent peg.

With Al-Wadūd, the tent of our existence in this world is held by the pegs of divine love. Those who follow the path of Al-Wadūd bring friendliness, harmony, and love among the people.

Sura Maryam, سورة مريم, Mary (19:96)
VERILY, those who attain to faith and do righteous deeds will the Most Gracious endow with love (wudd).

They are granted God's love and the capacity to love the Creation, as well as to be loved by their fellow human beings.

In the Qur'an, Al-Wadūd is found once in combination with Ar-Raḥīm (2), everlasting compassion, and once with Al-Ghafūr (34), the One who forgives deeply. Al-Wadūd is love penetrating the depths of the heart, therefore invariably manifesting as compassion. But love forgives. Whenever we can forgive, our heart opens to being connected; love rises through that connection and heals the wounded heart.

Al-Wadūd pulls you gently, lovingly near Him and fills your heart with His light, opening the space for you to be His servant, until you become a knower of unconditional love. Some describe Al-Wadūd as the greatest name.

Hadith Qudsī
My servant comes closer to Me through the deeds which I love and have put into his being, and he comes always closer to Me by doing good of his own volition until I love him. And when I love him, I hear through his ears, see with his eyes, take with his hand, walk with his feet, and when he asks, then all his pleas are fulfilled.

If there is a quarrel or a dispute between two people and one of them repeats this name 1,000 times over food before giving it to the other, the dispute will come to an end. If you want to be loved by God, come close to those who have abandoned you, give to those who are mean to you, and forgive those who hurt you.

The Prophet Muhammad, Allāh's peace and blessings be upon him, said, "When a human being looks at another with love, it is better for him than praying in the mosque for a whole year." So love what Allāh loves.

There are many people who need help, support, and love, who need to know that they are loved, for nothing heals a human being more than that knowledge. Accept the fact that you can help!

The Divine Name Al-Wadūd is like a magnet. Those who repeat this name often are loved by all creatures, and Allāh sends love for them to the hearts of His creatures.

If you write this Divine Name on a piece of paper and carry it with you, Allāh will put love into your heart and love in the hearts of those around you. Those who repeat this name begin to wish well to all creatures and to feel tolerant and understanding towards them. The name Al-Wadūd opens the space between the lover and the Beloved. The only way to understand love is through loving. The only way to understand friends is through a friend. The Divine Name Al-Wadūd gives you the strength and the clarity to make love stronger so that you can continue to love.

Lay your hands on your heart, center in your heart, and repeat the Divine Name Yā Wadūd, and while repeating, move your hands to your belly and then to your forehead. Feel how the quality Yā Wadūd touches all the parts in you, how the divine unconditional love opens a channel in you and how Allāh grows in you.

Allow yourself to be loved so that the fire of love can change everything in you. The idea is to transform the *I*, not to develop it. Transformation happens with us and for us. It is connected to our task and to what we carry in the world because everything we do has consequences for us, for other people, and for our planet, for everything is connected.

Take a comfortable position, either sitting or lying, and bring your attention to your breathing. Feel your breast, your belly rise and fall, and slowly start exhaling love. Let this breathing flow over your body, over your being, your strengths and weaknesses, your experiences, your forests, and your oceans, and feel the strength whose source lies in your heart. The aim of healing is always Unity. The feeling of separation that causes all diseases vanishes in Unity. Such is the aim of healing and the path is love. The only war that deserves the name of "holy war" is the inner battle against one's own demons and lower impulses, because only this war leads to healing.

To love unconditionally means to have the courage and the perseverance to see yourself as you are, in the deep knowledge that everything is perfect in its existence. To walk the path of love means to start on the journey to yourself.

The paths to Allāh are as many as His creatures, yet the shortest and simplest way is to serve others, not to disturb them, and to make them happy.

Be a mirror in which life can reflect itself. Let life see you and penetrate you. Let the impressions of the world come to you and become an active receiver. You will then stop to be the central point and you will become many central points instead. For the heart of those who become receptive to life fills with peace.

A wise man was once asked, "What should I do? My tongue makes difficulties for me and I cannot hold it when I am with people. I keep judging what they do and contradicting what they say. So what should I do?" The wise man answered, "If you cannot control yourself, then avoid people and live alone. Those who wish to live with others should not be square but round, so that they can turn to everyone and everything."

—Traditional Sufi story

Completion means to know love. Carry in your heart patience and love for your fellow human beings, transform yourself into a house of mercy where the prayer room is your heart. Watch your thoughts, your words, your deeds, and anchor yourself time and time again into the moment through your breathing so that you become capable of dying at any moment, because if God is to come, the ego must go.

Observe the signs in you. Signs of excessive self-satisfaction are: to be sensitive to your own rights but indifferent to others', to ignore your own mistakes as if they didn't exist while busying yourself with those of others, and to be very gentle and tolerant with yourself. Signs of dissatisfaction with yourself are: constant self-control, ceaseless blaming of yourself, constant suspicion of your motives and intentions. Practice balance so that you may grow harmoniously.

Are the conclusions we reach through inspiration to be compared with the results we obtain through logical thinking? Yes and no. Between yes and no, the soul leaves the body, the head becomes separated from the trunk.

—Ibn al-'Arabī

God gave human beings the task to recite His names so that they may reach perfect happiness. Because the greatest joy is to pluck the roses of the knowledge of God and to listen to the melodies of divine love in the garden of the heart. Those who practice the remembrance of the Divine enter the divine space, and henceforth know neither fear nor worries.

48

<div dir="rtl">المجيد</div>

AL-MAJĪD

The Glorious, the Magnificent, the Celebrated, the Gracious
57–228–3,249

This Divine Name manifests in dignity, noble-mindedness, venerability, generosity, and holiness. Those who repeat this name will lead an honorable life. Human beings pray for three reasons. Some pray for fear of punishment and strive for His reward. Some pray for the sake of praying and say, "When difficulties come, they come out of Your omniscient justice, and when good things come, they come out of Your omniscient grace." And then there are those who pray because the eye of their heart has seen divine truth in its majesty, its beauty, and its perfection, whose hearts have drowned in the ocean of love, their striving dissolved in divine contentment. All three know the meaning of the Divine Name Al-Majīd. They can see a part of its secret and recognize traces of this name in their feelings, in their behavior, and in their conduct.

The Divine Name Al-Majīd is mentioned four times in the Qur'an. It comes from the root *m-j-d*, which contains the following meanings: to be glorious, to praise, to glorify, to celebrate; illustrious, exalted, admirable, excellent, splendid; glory, splendor, magnificence, grandeur, nobility, honor, distinction. The Divine Name Al-Mājid (65) comes from the same root.

The Qur'an is called *majīd*: *kitabun majīd*. Al-Majīd is this overwhelming life force that penetrates our whole being like a river and lets us marvel at the divine mysteries. All at once, our heart experiences silence and amazement, sobriety and ecstasy, dumbfoundedness and enthusiasm, and it is precisely this emotional paradox that makes it wider, flexible, and open to happiness! Al-Majīd is

when the spirit illuminates in a flash before we lose ourselves in admiration.

Al-Majīd is amazement at the unfathomable, glorious divine power. This same amazement arose in Abraham's wife, Sara, as she received the news that at the age of ninety, she would be expecting a child.

Sura Hūd, سورة هود, (11:71–73)
And his wife, standing [nearby], laughed [with happiness]; whereupon we gave her the glad tiding of [the birth of] Isaac and, after Isaac, of [his son] Jacob.
Said she: "Oh, woe is me! Shall I bear a child, now that I am an old woman and this husband of mine is an old man? Verily, that would be a strange thing indeed!"
Answered [the messengers]: "Dost thou deem it strange that God should decree what He wills? The grace of God and His blessings be upon you, O people of this house! Verily, ever to be praised, sublime is He (ḥamīdun majīd)!"

Al-Majīd brings into our life gifts that amaze, astonish, and confuse us, and that allow a burst of bliss to leap from our heart. Whoever experiences Al-Majīd flows into the deep gratitude of praise, Al-Ḥamīd (56).

The ritual prayer closes with praise.

إنك حميد مجيد

'innaka ḥamīdun majīd
You are the One to whom everything commendable flows back,
You are the One who lets the glorious, immortal life energy flow through everything.

People who carry the quality Al-Majīd carry generosity and magnanimity, they are kind to others and brave, and a blessing emanates from them. This quality also manifests in fast action and standing up for social justice.

Those who repeat this Divine Name 171 times every day before sunrise begin to see the miracles created in this life by Allāh. Their breast expands, their humanity becomes stronger, and Allāh gives them the strength to serve humankind and this planet. When we see weaknesses in people and we can carry them, when we see their needs and we carry them in our hearts, then Allāh helps us to carry our own weaknesses and needs, and transform them into strength so that we may discover our deep truth and ability. Therefore spend time in meditation and in prayer so that you may be anchored and awake as you walk through your life, free from illusions and delusions.

Al-Majīd helps those who have become stuck in the material world and have lost all sense of joy and amazement. When we can feel the wonders of this world and of the universe, it helps us break out

from the prison of separation, lured by the call of beauty, the call of love, and the miracles that Allāh has given us.

When we recite the Divine Names and let them grow out of our heart, our heart expands, our love and affection become wider, and out of love for Allāh we learn to develop kindness and love towards His Creation. The secret of Creation lies in the knowledge of the qualities of Allāh. This is the root of everything, all life flows from this one source. All color, sound, and form literally emerge from this one origin. Be totally alert to the patterns of life, to the shapes that reveal themselves, all of them flowing out of the most perfect Divine Names. All of nature's and life's patterns come from the divine archetypes that we are meant to serve.

The beauty of this world lies in its diversity, in the existence of opposites and differences, and in the way in which man and woman bring opposites into harmony. The world needs the creative tension of opposites. Such is the miracle of diversity. There would be no Creation without the separation from Unity. It is amid diversity and opposites that Unity becomes known. When we are grateful, our heart fills with light and suddenly we can see the world as it truly is—we can see the miracle that it truly is. So recognize what the earth is giving you, be grateful for everything around you, for the visible and the invisible kingdoms. Appreciation and gratitude help you bring opposites together, and a space opens in your heart that shows you what you have to do. Remember that we all come from the same source. We all know each other beyond form, beyond time and space. Nothing is strange to you. Remember!

When you carry this name in your heart, your spiritual capacities and perceptions deepen, your self-control increases, and when you are moved by the state of this name, no one opposes your word. Repeating this name will bring relief to those who feel distressed or experience hardships, and their soul will awaken with spiritual knowledge.

49

<div dir="rtl">الباعث</div>

AL-BĀ'ITH

The Awakener, the One who causes, the One who releases

573–2,292–328,329

This Divine Name contains the following questions: "How did you use your life? How did you spend your youth? How did you earn your money? How and where did you spend it?"

Al-Bā'ith comes from the root *b-'-th*, which carries the following forms and meanings: to send, to send out, to dispatch, to forward, to delegate, to emit, to evoke, to call forth, to awaken, to stir up, to provoke, to bring on, to revive, to resuscitate, to be sent out, to be emitted, to be triggered, to be caused, to be resurrected, to originate; awakening, revival, evocation, mission, rise, source, point of origin.

The Divine Name Al-Bā'ith awakens in us the desire to free ourselves from the control of our impulses and to turn away from our moods and our listlessness, to the extent that it is humanly possible. This Divine Name give us the perseverance born from surrendering to the Divine, as well as the honest determination to embark on the boat of knowledge and longing in search of that which is eternal in us.

Al-Bā'ith helps us become free from our barriers. It carries the power that enables us to rouse ourselves and reach the next step to perfection and Unity, shaking off half-sleep in order to follow the scent of the living. Just as our body sheds dead cells and grows new ones every day, so should we human beings daily exercise watchfulness. Al-Bā'ith opens the path and helps us on the path to our humanity.

Every one of us carries a virtue in a particularly developed and refined form. For some of us it is joy, for others adaptability or discernment, others the capacity for relationships, gracefulness, a childlike nature, creativity, or courage. The Divine Name Al-Bā'ith helps you to discover or revive this

main quality. Once you know it, it helps you to develop other qualities and virtues, and bring them to the level of the main one, as if you were to take one central flower and surround it with others until you have one fine bouquet.

Those who carry this quality have experienced the traditional Sufi saying, "Die before you die," and their knowledge enables them to resuscitate those hearts that have died out of ignorance. Al-Bā'ith is the Awakener of the divine qualities and the One who resurrects on the Day of Judgment, so act accordingly!

Al-Bā'ith gives us the confidence we need to wait until the time has come and Allāh sends us out to start something. This name gives us the strength to be awake and cheerful without giving in to the urges and wishes of our anxious ego.

Spiritual resurrection is attained through purification of the heart and of the mind. In the Qur'an, life, *ḥayāt* (حياة), is associated with knowledge, *'ilm* (علم), and death, *mawt* (موت), with ignorance, *jahl* (جهل). So flee from ignorance as you would from a great danger. Step out of the grave of ignorance and darkness with the greatest human virtues: liveliness, knowledge, consciousness, will, and creative power. Look for the sources that lead you to knowledge and enable you to discover the truth.

When you repeat this Divine Name, turn its quality to all the relationships and projects in your life, and see them through the eye of this quality. Relationships and outer deeds all have a limited lifespan, and when they pass away, they all return to the one heart. See all things in their wider context. Let your spirit embrace the whole world and see your deeds and relationships in this all-embracing view. Never forget that, in spite of everything, we human beings are the hope of this world. We are here to get to know love, to become scholars of love, and to express it in our daily life.

50

<div align="center">الشهيد</div>

ASH-SHAHĪD

The Witness, the One who perceives, the Observer

319–1,276–101,761

In the Divine Name Ash-Shahīd, Allāh acts as a witness to His existence. It is this act of witnessing that nourishes our conscience and awareness, and elevates them to higher spheres of our being.

Allāh meets us in our thoughts, our feelings, our bodies, our dreams, and in everything around us. Everything bears witness to His existence.

Ash-Shahīd transforms us into witnesses and makes us aware of the divine presence, thus transforming our whole being into a symbol. Everything around us becomes a symbol of His beauty and shows us the glory of our true nature.

We need not have much knowledge about ourselves to attain self-awareness and witness our innate truth. We need but to engage, to melt with our true self, to penetrate into the core, and to unite inwardly.

Ask yourself which traces you want to leave in this world, which message you want to live, and you will contact your true image, the image Allāh created within you.

Whatever is present within your heart is your *shahīd*, your witness. Feel the ever-loving core within and that which is absent will become present. To love yourself is to advance and to penetrate your innate truth, because that love brings the distant beauty of the Divine into presence, and your heart becomes a witness.

In everything resides a *shahīd* for Him, a witness that attests to His oneness.

Ash-Shahīd removes forgetfulness from our thoughts and our heart. It calls yearningly His existence within all matter—visible or invisible, seen or hidden. Ash-Shahīd is the song of faith to the Divine's existence, showing us the tracks that lead back to whence we came, uniting time and eternity.

Sura al-Baqarah, سورة البقرة, The Cow (2:143)
And thus have We willed you to be a community of the middle way, so that [with your lives] you might bear witness to the truth before all mankind.

Ash-Shahīd comes from the root *sh-h-d*, from which the following meanings are derived: to witness, to experience personally, to see with one's own eyes, to be present, to attend, to see, to go through something, to undergo, to testify, to confirm, to give evidence, to inspect, to observe, to utter the Muslim profession of faith; martyr, one killed in action, witness, testimony, act, observation, perception, place of assembly, meeting, religious shrines venerated by the people (especially the tomb of a saint), index finger, honey, honeycomb.

Ash-Shahīd urges us to testify to the Divine, to use our senses, thoughts, and heart to look to the hidden, invisible world of Unity through the outside world of multiplicity. This name urges us to walk through the traps of external knowledge to reach inner knowledge. To bear witness to holiness means to connect the outer senses with the heart, with the inner senses.

The concept *shahāda* (everything that can be perceived by the senses and the spirit—sensory or conceptual) is often opposed to *al-ghayb* (that which is beyond a creature's perception). Allāh alone knows everything.

According to an oral transmission, the Prophet Muhammad, peace and blessings be upon him, said, "The best is the middle path." The middle path is the one that moves between Moses' authority and Jesus' gentleness, a balanced path between *jalāl* (جلال) or majesty, and *jamāl* (جمال) or beauty; between *ẓāhir* (ظاهر) or the outer, and *bāṭin* (باطن) or the inner; between *sharī'a* (شريعة) or commandment, and *'ishq* (عشق) or love; between *salāt* (صلوة) or prayer, and *dhikr* (ذكر) or remembrance; and between *islām* (إسلام) or surrender and *īmān* (إمان) or firm faith or certainty.

This is the path of *'iḥsān* (إحسان), virtue. *'Iḥsān* is beauty. It means to do our best in words and deeds. It means to strive for beauty and perfection, and to endeavor to express them in everything out of love—love for Allāh and love for His Creation. *Iḥsān* exists because something in us calls for unity, for eternity.

The word *shahāda*, profession of faith, comes from the same root.

لا الله إلا الله محمد رسول الله

lā 'ilāha 'illā llāh–muhammadun rasulu llāh

There is no reality but God, and Muhammad (the perfect one) is the messenger of God.

The *shahāda* is divided in two parts. The first part, *lā 'ilāha 'illā llāh*, says that only God exists and that all things depend on Him. There is no certainty outside the Absolute; everything manifested,

everything relative, is connected to the Absolute. The world is connected to God, and the relative is connected to the Absolute through the double bond of cause and purpose, origin and goal. The world is not God, yet nothing exists outside God. There is a difference between real and unreal, *lā ʾilāha,* yet there is a connection between the world and God, *ʾillā llāh,* because nothing can be considered as separate from Allāh.

The second part, *muhammadun rasulu llāh,* reflects the perfection of existence manifested in the Prophet in his being and in his way of being. The first part of the *shahāda* is annihilation, *fanā'* (فناء), and the second continued existence, *baqā'* (بقاء).

No one has the right to judge someone's religious faith unasked. Such a right can only derive from a mutual agreement—for example, within a spiritual community.

The Divine Name Ash-Shahīd points to the omnipresence of the Divine and to seeing, perceiving, and observing all things in that knowledge. People who are caught in a bad habit or behavior towards others should recite this Divine Name several times in cycles of 21 repetitions.

The same practice, this time while laying the index finger on a child's head, will help open the child's ear. Reciting this name brings light into the heart, along with understanding and knowledge. It brings the quality of observation and bearing witness to the Divine, both inside and outside. This deep knowledge of His watchfulness protects us from shameful and low thoughts, words, and deeds. It gives us the strength to see Allāh, the existential, eternal Reality, in all things and to rest in the eternal presence of the Divine. It opens the eye of the heart, and this sight leads us to know that everything is connected. Ash-Shahīd is eternal presence, eternal existence, eternal protection.

When you find yourself in trouble and difficulties, turn to Allāh in your lament. He is the Seer, the All-Knowing.

You may wonder about the difference between the Divine Names Al-ʿAlīm, Al-Khabīr, and Ash-Shahīd. All three are connected, each one contains the others, yet with each of them you feel something that you did not feel with the others. You say, "Allāh knows about my state" (Al-ʿAlīm), "He is well-versed in my secrets and my intentions" (Al-Khabīr), "He is the One who perceives my words" (Ash-Shahīd).

When we mean absolute knowledge, we say Al-ʿAlīm. When we add the One who is behind all things, the Hidden One, then it is Al-Khabīr. And when we add the visible things, then it is Ash-Shahīd. Understand that when you join two, they separate, and when you separate them, they connect.

—Al-Ghazālī

Sura al-'Imrān, سورة آل عمران, The House of 'Imrān (3:18)
GOD [Himself] proffers evidence—and [so do] the angels and all who are endowed with knowledge—that there is no deity save Him, the Upholder of Equity: there is no deity save Him, the Almighty, the Truly Wise.

This sura shows with the words "Allāh bears witness" that He is testifying to the divine power of His innate conscious plan through the nature of His Creation.

Those who serve this quality testify to the truth and to God's omnipresence.

Whatever you do in this world, it may express who you are, yet it does not define you.
You are your essence, and if you live your essence,
whatever you do will be guided by this essence.

51

AL-ḤAQQ

The true Reality, the True One, the Real One
108–216–11,664

Al-Ḥaqq contains the deep surrender to God, to nature, and to all things around you. This name is mostly recited in solitude, away from outside distractions. That which is behind reality is Reality, Al-Ḥaqq. He is the One to whom all divine qualities can be ascribed. It is the commencement that has no beginning and the end that has no ending. Allāh is Al-Ḥaqq, in His essence, qualities, and deeds, manifested through the light of His majesty and His beauty. He is the Truthfulness from which everything takes its truth.

لا إله إلا الله الملك الحق المبين

lā 'ilāha 'illa llāh al-malik, al-ḥaqq, al-mubīn

There is no god but God, the Sovereign, the truly real One.

If you recite this phrase 100 times every day, you will receive unexpected help and support in your life. If you are sad because you have lost something, repeat this name and you will find it again, God willing.

Al-Ḥaqq comes from the root *ḥ-q-q*, which carries the following meanings: to be true, to turn out to be true, to be confirmed to be right, correct, to be necessary, obligatory, to be incumbent, to recognize, to identify, to make something come true, to realize, to carry into effect, to fulfill, to put into action, to consummate, to set, to implement, to produce, to bring on, to determine, to study, to examine, to explore, to look, to check, to interrogate, to tell the truth, to be serious, to deserve; suitable, fitting, appropriate, worthy, deserving; truth, rightness, correct sound, proof, fact, the true state of affairs, true nature, essence.

Al-Ḥaqq is reality, truth, absolute in His immanence and transcendence. Al-Ḥaqq is like white light: when you put a lens in front of it, it refracts and you can see life, love, knowledge, ecstasy, joy, and so on, according to your inner maturity.

Yā Ḥaqq, enfold us with the light of truth so that we may know the Reality behind reality, without being distracted by outer pictures and manifestations. Let our intentions soak in the source of truth, let our tongues love the truth and our senses become instruments of truthfulness.

Divine truth brings liberation by giving back to the spirit its natural and supernatural motive, and thereby its purity, by reminding it that nothing exists but the Absolute.

If man is will, then God is love; if man is intelligence, God is truth.

Al-Ḥaqq is one of the Divine Names that works fast and brings the fastest answer when repeated in one's heart, in surrender. Keep a space open in your life where you can retreat and turn your face to Him unconditionally.

Hadith Qudsī
Nothing rejoices Me more than the moment when My slave approaches Me in worship as I have ordained. My slave keeps coming closer to Me in surrender until I love him; and when I love him, I am the ear with which he hears, and the eye with which he sees, and the hand with which he grasps, and the foot with which he walks and if he were to ask Me for something, I would truly give it to him, and if he asked Me for refuge, I would truly grant it to him.

This holy transmission is quoted more often than any other in Sufism. It symbolizes all of a Sufi's endeavors.

To the Sufis, truth is a synonym of God. Only truth is real, only truth is constant. *Ḥaqq*, truth, is the opposite of *bāṭil*, delusion. Everything that comes from Him is truth and everything that returns to Him is truth.

Ash-Shahīd (50), the Witness, immediately precedes Al-Ḥaqq, the True One, the Real One, in the list of Divine Names because only God's witnessing to Himself is truly valid. The famous mystic Al-Hallaj expressed it as follows: "Whoever witnesses that God is the One, places another next to Him, namely himself as a witness."

It is not man who must be a witness, but the Divine in man. Al-Hallaj's ecstatic cry that cost him his life was "I am the Truth!" (*anā l-ḥaqq!* [أنا الحق]). It expressed his direct contact with the Known and his melting with the One Reality, an existential fusion based on the Divine in us.

It is the Divine's longing for Himself that brings us to the path.
O Allāh, grant me knowledge of You from You to You!

52

AL-WAKĪL

The Protector, the One who has been authorized and never deserts, the Trustee

66–264–4,356

This name opens a space in the heart that never leaves because this is the place of certainty and silence.

Yā Wakīl, You who take care of me, my protector. You are the One to whom I leave all my concerns, You are the One to whom I entrust everything, You are the One in whom I trust absolutely!

All atoms circle through the hand of Allāh; infinity joins with the finite and eternity touches time.

This name spreads its light over the shadows of the mind, giving it the strength to be honest and preventing it from going where it does not belong. Gently, it deters the mind from circling thoughts of worries about the past and wishes for the future.

Al-Wakīl comes from the root *w-k-l*, which carries the following meanings: to entrust, to assign, to commission, to put someone in charge, to authorize, to empower, to appoint as representative or agent, to invest someone with full power, to be on a confidential basis, to be in a position of mutual trust, to trust, to be responsible, to rely, to depend; lawyer, attorney, indifference, trust in God, reliance.

Al-Wakīl transforms the storms of worries, sorrow, and dejection into a wind of confidence. It lets the ghosts of illusions and their insinuations bow in front of the serenity of the heart, opening a space that enables us to find solutions and thus find rest from tiring, ceaseless thinking.

Sura al-ʿImrān, سورة آل عمران, The House of ʿImrān (3:159)
Then, when thou hast decided upon a course of action, place thy trust (tawakkal) in God: for, verily, God loves those who place their trust in Him.

Al-Wakīl means to abandon ourselves without hesitation to the Divine, knowing in our hearts that He is trustworthy and that He is the One who knows best. Al-Wakīl is to admit consciously Allāh's full powers and to agree to them. Al-Wakīl does not mean, "Yes, I have understood that all power is in Allāh's hands." Al-Wakīl is to invoke consciously His help.

Sura al-Mā'idah, سورة المائدة, The Repast (5:23)
And in God you must place your trust if you are [truly] believers!

Al-Wakīl is the One in whom we can put our trust unreservedly. He grants us the capacity to take all the things and possibilities that come to us in an open and flexible way, without getting restless or lacking enthusiasm, because we know about Allāh's wise, caring, and protective power. This knowledge, this confidence, makes room in the heart for transformation. It gives us the strength to relinquish the qualities of our wounded self that lead to separation, and to take on more and more the colors of the divine qualities. It gives us the strength to accept life when it is easy and when it is difficult, and enables us to transform despair into confidence. So know that everything between heaven and earth lies in His hands. From one standpoint we have the capacity to act and we are responsible. Yet from the other, He is the One who acts and wills. There is no negation, but if we hold to only one aspect, we lose the other. Yet only He exists.

People who are in the quality of trusting surrender, *tawakkul*, do not see what happens to them as the result of their mistakes; neither do they see mistakes as a punishment. So trust in Allāh and do what needs doing so that goodness, kindness, and compassion may grow and thrive, and what is bad and unjust may be averted. Those who carry fears, such as the fear of drowning or of burning, should recite this name, time and again, in cycles of 66 repetitions. Know that Allāh always chooses the best for you, even if your ego does not always perceive it as such, even when you are in a situation that is difficult for you and you cannot see any way out. For His compassion and His mercy for you are endless, beyond anything you can imagine.

حسبيا الله ونعم الوكيل

ḥasbiyā llāh wa niʿm al-wakīl
I trust fully in You, and You are truly my confidant.

May this sentence also accompany you in times of ease, for it will bring balance into your life and a sweet, liberating joy.

When a problem crops up in your life, focus on it with the energy of your surrender, your love, your longing for Allāh. Immerse the problem, the situation into which you have been thrown, in that energy and leave it there. That is *tawakkul*, trust! Raise your head and soak your eyes, fill your breast with divine light before looking down at the facts again.

If you truly trust in God, He looks after you, in the same way as He looks after the birds in the sky, the beetles in the fields, the fish in the depths of the ocean, all of them busy doing and free from worry.

This Divine Name is especially connected to the Prophet Muhammad, God bless him and grant him peace.

Hadith Qudsī

A Bedouin rode his camel to a gathering with the Prophet, Allāh's blessings and peace be upon him. He jumped off his mount and ran because he was late. The congregation prayed and the Bedouin joined in fervently. At the end of the prayers, he left with a light heart and went looking for his camel. But lo and behold, the camel had disappeared. Dismayed and confused, he ran to the Prophet, Allāh's blessings and peace be upon him and cried, "I prayed with all my heart and I put all my trust in God, and when I came out, my camel was gone! Is that the reward for my trust?" And the Prophet, Allāh's blessings and peace be upon him, answered: "First tie your camel, and then put your trust in Allāh!"

The Divine Name Al-Wakīl frees our spirit from the illusion that we have been forgotten by God, it frees our hurt and wounded heart from believing it does not deserve to be held in God's mercy and love. It frees us from the deep pain of being overlooked.

This Divine Name contains the quality of service, and service always means to be a protector of life. Be aware that everything is connected. The aim of serving, the aim of healing, is always Unity. To truly help someone means to support him so that the feeling of separation, the illusion of separation, can dissolve, and he can start to walk on the path and unveil their perfection. When we discover our perfection, our illusion of separation dies.

Three qualities are the main obstacles on the path of service: stinginess, anger, and revenge. Connect your senses to your heart. The more intensely your senses—and thus your deeds and your serving—are connected with your heart, the stronger the fire that burns there will destroy everything that stands in your way to becoming whole.

Look at your life with the eye of your heart. Recognize that you are blessed,
and trust in Him more and more because life is an evolutionary process of trust.
For what is trust but surrendering to Allāh's love
that dwells in the innermost part of the soul?

53

القوى

AL-QAWĪY

The Mighty, the Strong, the Intense, the Energetic

116–348–13,456

When we repeat this Divine Name, we feel how small the universe is in the face of the Divine. From the depths of our heart, the feeling arises that all creatures receive their existence and strength from the Creator alone. When we repeat this name for a long time, we begin to feel that our strength comes through God and in God, so that we move in and through Him, and there is only space for Him in our heart.

Al-Qawīy comes from the root *q-w-y*, which contains the following meanings: to be strong, to increase in power, to have influence, to be sufficiently strong, to be able to cope with something, to be deserted, to starve, to be denied, to be withheld (rain), to encourage, to hearten, to intensify, to be poor, to be empty, to be weak; vigorous, forceful, mighty; potency, violence, courage, ability.

Every Divine Name is all-encompassing in its quality so that it can be used both as an antidote and a trigger. Since it invariably carries both opposites, it helps us become whole.

Al-Qawīy is an inner strength, a collecting energy that does not necessarily show itself to the outside. Al-Qawīy helps us not react to events on impulse and it gives us the strength to resist. Through Al-Qawīy we become aware of the divine firmness, of its intense capacity, power, and force, and this enables us to offer Him our poverty, our emptiness, our sense of abandonment, and to find love and comfort, to gain heart.

Strength (*quwwa*) and power (*qudra*, cf. Al-Qādir [69]) are both qualities that describe God's creative attributes.

Some Divine Names are based on divine mercy, like Al-Laṭīf (30) and Ar-Ra'ūf (83). Others are based on divine strength, like Al-Qahhār (15) and Al-Jabbār (9). We human beings move and are deeply influenced by both because it is the weak who need God's strength.

This divine quality was chosen to show us that we receive our strength—be it on the material, intellectual, or soul level—from the Divine. So hold on to this name on all those levels and act according to the best in you. If you feel weak or tired when you pray or meditate, repeat this name 116 times every day and you will find strength and joy in your prayers and meditations again.

Sura al-Dhāriyāt, سورة الذاريات, The Dust-Scattering Winds (51:58)
For, verily, God Himself is the Provider of all sustenance, the Lord of all might, the Eternal!

To feel God's omnipotence makes us modest. It is through the door of modesty that God's power flows. Modesty brings excellence to our behavior, makes our tongue accurate, our words adequate, and it strengthens our loyalty.

God's omnipotence and creative imagination manifest in the tenderest creatures and in the most powerful.

Those who are caught in quarrels or enmity will be protected from suffering and damage if they recite this name, Allāh willing. This Divine Name shows the strength, the intensity, and the fierceness in everything.

This name will also give you the strength to carry burdens, whether on the inner or the outer level, and it also strengthens the soul. It gives those who repeat it the strength to overcome their anger, as well as other negative influences. Repeat this name and let the divine power and strength grow in you.

O Allāh, strengthen my love for You and my loyalty to You!

54

AL-MATĪN

The Solid, the Reliable, the Firm, the Unshakeable, the Resolute

500–2,000–250,000

Just like the Divine Name Al-Qawīy (53), this name contains strength, intensity, and power, with the additional quality of staying away from weaknesses and change.

Al-Matīn is the perfection of His boundless power, and to a certain extent a superlative of the divine quality Al-Qawīy.

Al-Matīn comes from the root *m-t-n*, which contains the following meanings: to be firm, to be strong, to be solid, to strengthen, to consolidate, to fortify; main part, body, middle of the road, surface, backbone, firmness of character, conciseness of style, deck of a ship.

This Divine Name also shows firmness and intensity in distinguishing between truthfulness and falsehood. It has the quality of a sharp, clear, fierce yet compassionate sword. For the Sufis, it indicates the need to maintain an unshakeable stance in the face of the constant temptations of the material, visible world.

This attitude gives us spiritual strength and helps us keep to the chosen path. The quality Al-Matīn grants stability, steadfastness, and control to our thoughts and deeds, helping us to overcome the struggles and weaknesses on the path of light. It gives us the resoluteness and the strength to overcome the ego, our greed, and our ambition. Al-Matīn gives us the strength to carry on when distractions and weaknesses arise. When we want to give up a practice, Al-Matīn gives us the willpower and resoluteness to walk on.

It also helps in case of doubt or instability, whether they manifest inside or around us. Al-Matīn helps us summon and activate our inner strength, but it also helps us when we have lost our flexibility and have become too stiff. This is how Al-Matīn works in both directions.

If you are faced with difficulties, repeat this Divine Name and they will dissolve, God willing.

If you connect the Divine Names Al-Matīn and Al-Qawīy (53) as in Yā Qawīy, Yā Matīn, resoluteness and stability will spread in your heart, together with confidence. The most important thing when you repeat a Divine Name is your intention and positive thinking, the belief that whatever is right and essential for you will come to you. In this way, the core of joy will be present even in times of worries and difficulties.

The Divine Name Al-Matīn grants you strength in difficult times and it is paramount when you feel or fear that you are losing strength. As mentioned earlier, its influence is particularly strong when you connect it with Al-Qawīy. For instance, if you want to lift something heavy and feel that you are not strong enough to do so or that you need help, use Yā Qawīy, Yā Matīn to assist your body.

Keep connecting with Unity; ask for the salt in your food, ask for new laces for your sandals when they break, ask for your work to be blessed, ask for everything that you need and embed yourself in Unity.

55

AL-WALĪY

The protective Friend, the close One

46–138–2,116

Every Divine Name leaves in the heart a different kind of sweetness and expectation, and affects it in a different way, showing each time another color of the One Existential Love. The confrontation with the ego can only take place through remembrance of Him, through the *dhikr* (ذكر) of the soul, the heart, and the tongue. Then calm can flow into the heart and the veils can be lifted.

Why do we human beings carry such mountains of worries, sorrow, and suffering on our shoulders when everything that is meant for us will come to us, from the beginning of our life until the end? When you come to this earth, you are provided for, and even if you were to ride as fast as the wind to escape the life that is meant for you, it would also ride as fast as the wind, follow you, and find you.

Al-Walīy and Al-Wālī (77) both come from the root *w-l-y*, which carries the following meanings: to be near someone or something, to be close, to lie next to, to be adjacent, to follow, to border on, to be a friend, to be friends with, to be in charge, to manage, to run, to administer, to govern, to rule, to have power, to have authority, to come into power, to turn away, to avoid, to turn around, to be a helper, to be a supporter, to be a protector, to continue without interruption, to entrust, to take care, to assume the responsibility of; nearby, neighboring; guardian, supporter, a person close to God, saint, a friend of Allāh, loyalty, devotion, fidelity, goodwill.

Compared to Al-Wālī, Al-Walīy stresses first and foremost the intimacy to Allāh.

Why do we human beings get upset and angry when some of our requests and wishes are not fulfilled? Allāh's compassion for you is greater than your compassion for yourself. When your wishes

contain something good for you, they are fulfilled because He knows what is good for you and what harms you.

The Divine Name Al-Walīy contains a general quality and a specific one. He is the protective Friend of all creatures through His care, His compassion, and His attention. He is the intimate Friend of those human beings who live in surrender to Him. The friendship that develops between human beings who are together on the path to God and in God expresses itself in their love for each other, in the way they support each other, in their compassion, their kindness, and their knowledge of their own weaknesses. Each one is a mirror to the other, in which the magnanimity and warmth of the heart can grow. This Divine Name manifests the qualities of intimate love, closeness, and protection.

Sura al-Baqarah, سورة البقرة, The Cow (2:257)
God is near (walīy) unto those who have faith, taking them out of deep darkness into the light.

If you repeat this Divine Name 1,000 times on a Thursday night, in surrender and devotion, all material and spiritual barriers will dissipate. When there is a quarrel in a relationship, keep this name in your heart during the dispute and the quarrel will dissolve. This name sees and protects what is noble in you, and it helps you strengthen it. It inspires the heart and heals it from worries, sorrow, heaviness, and apparent loneliness, for He is the compassion and the love, the source from which the Creation comes to be, time and time again.

Sura Fuṣṣilat, سورة الفصّلت, Clearly Spelled Out (41:31)
We are close unto you ('awliyā'akum) in the life of this world and [will be so] in the life to come.

Human beings do not derive their superiority from their words or their deeds, but rather from the attitude of their heart. Those who carry the divine quality Al-Walīy in their heart are people who open their ears to the worries of their fellow human beings, who keep their eyes open for their rights, who use their strength to support them, and who help those around them open up to life.

Those who carry this name with them and repeat it are slowly led into the quality of divine regency and they recognize their place on this planet. They support the spiritual growth of others and awaken the divine spark in them. Al-Walīy symbolizes the love and protection that God grants those who revere Him with a pure heart and in complete surrender. They need nothing but God's closeness.

A *walīy* is someone who is continuously connected with Allāh, who is led and protected by Him. A *walīy* has forgotten himself; the dragon of the ego has fallen asleep. His attention, indeed his whole being, is directed towards Allāh, and He is at the service of His Creation. The *walīy* is a human being

who has been admitted to the state of closeness to God. He lives and is in harmony with God's commandments and leads all those who are in his care with kindness and justice. He is the helper, the benefactor, the friend, the holy one, because God's will and his will have become one. He is a human being who has become empty and a perfect mirror for the divine light.

Allāh has granted us the capacity to know Him, and He has conferred the honor on us to love Him. Our compassion for His Creation is the expression of our love for Him.

Consciousness means to know the essence of the essence of all things, the nature of all things. The moment it is known, it starts to grow and nourish the light in you and around you.

الحميد

AL-ḤAMĪD

The Praiseworthy, the Most-Praised

62–248–3,844

To be aware of our neediness is the source of our being grateful for the truth. *Al-fātiḥa,* سورة الفاتحة, The Opener, is the sura of praise and gratefulness.

Repeating this Divine Name brings love and respect. If you repeat it 99 times after the morning prayer, your day will be blessed. If you repeat it 66 times after the morning prayer and 66 times after the evening prayer, beauty will grace your words and deeds. If you repeat it 100 times, 5 times a day after prayers, love and attachment will develop between you and all creatures.

Al-Ḥamīd comes from the root *ḥ-m-d*, which contains the following meanings: to praise, to commend, to extol, to praise highly; praiseworthy, benign.

To praise Allāh, to thank Him, does not mean to see the blessing, but to see the One who has given it, because to praise is to know. Allāh demands that we know before we do something. Al-Ḥamīd is more comprehensive than Ash-Shakūr because it expresses gratitude for everything that comes from Allāh, whereas Ash-Shakūr is gratefulness for something specific. With Ash-Shakūr, we penetrate our heart with something that touches us and causes us to be thankful. Al-Ḥamīd encompasses us in our complete being, knowing that everything is praiseworthy, right, and good, even if the ego fails to grasp it as such and tends to divide everything in good and bad.

The name of the Prophet Muhammad, Allāh's blessings and peace be upon him, comes from the same root and means "the highly praised."

Al-Ḥamīd is the All-Praiseworthy. So praise Him for everything that exists. This name contains the quality of the subject and of the object, and it points to the attachment between the Divine and the

human. Human beings give and receive praise when they show gratefulness for the abundance and the goodness that surround them. So let yourself be led to the path of the praised One. Find your task in this world, fulfill it as best you can, and ask Allāh for help. Open your hands in prayer so that the blessing can fall into them and you may catch it. And be open—that is all you have to do.

Because when the heart is awake, it is in a constant state of prayer, and the prayer of the heart is a state of consciousness that always praises Him.

To admit one's own ignorance in the face of the Divine is a great and difficult step. It is a step of dissolution. It is the deep knowledge that all things, all beings in life are connected with one another. Then you stop being the center and become an essential thread in the carpet of life instead. To know that we do not know is the beginning of real knowledge, and true knowledge always leads to love. And is love not tolerance, compassion, joy, patience, helpfulness, and courtesy?

Praise is the opposite of criticism and disapproval. Praise is a form of gratefulness, yet praise exists regardless of help, favor, or good deed.

Those who carry the Divine Name Al-Ḥamīd in their heart are granted a noble state, and their self is nourished with knowledge and deep secrets. In this name lies a secret that enables them to unveil what is hidden, uncover treasures, and understand the deep meaning of symbols. Al-Ḥamīd helps the ego to free itself from complaining, moaning, and dissatisfaction. It helps us to not focus our thoughts and perceptions on mistakes and deficiencies to which we cling, thus losing more and more sight of the riches we have been given. Whenever we focus on darkness, we obscure progressively our senses, our tongue, and our thoughts. Slowly the great poverty by the name of self-pity comes into being. "I was not seen, therefore I shall not see!" is often the reason why the wounded self does not allow thankfulness. Open your heart with Ash-Shakūr so that you may overcome dissatisfaction and Al-Ḥamīd can conquer your heart, your thoughts, your tongue, and your limbs.

When you combine the Divine Name Al-Ḥamīd with Al-Walīy (Yā Walīy, Yā Ḥamīd) and repeat them as much as you wish, you will feel the divine force in you, especially in times of difficulties and need, and you will turn your face to Him.

The world turns with kindness to those who repeat the following sentence time and time again, as the great Sufi master Suhrawardi was wont to do.

يا حامد الأفعال ذا المني على جمع خلقه بلطفه

yā ḥāmid al-'af'āl dhā al-mannī 'alā jam'ī khalqihi bi-luṭfih

O Blesser of all deeds, You surround all creatures with Your sweetness.

*All Creation praises You
because Your Creation in itself is already the highest divine praise!*

57

AL-MUḤṢĪ

The One who knows, the One who counts, the One who records

148–592–21,904

Allāh created multiplicity and He gave each creature its place and wisdom. The Divine Name Al-Muḥṣī shows that none of your thoughts, words, or deeds are ever lost.

This Divine Name relates to the visible and the invisible.

Know that every good deed comes back to you tenfold and every bad deed only once. May we praise Allāh when we find something good, and may we question our ego when we find something bad. So be clear with yourself and turn your face to God in all your deeds, be they visible or hidden. When you see that your words or deeds have brought about damage or suffering, express your remorse immediately by letting them be followed by a good deed, thereby dissolving what happened before. May you leave this world free. The path to freedom is the transformation of the ego through love and discipline.

Al-Muḥṣī comes from the root *ḥ-ṣ-y*, which contains the following meanings: to count, to enumerate, to calculate, to compute, to debit, to charge; statistician, calculation, computation, counting, statistics, pebbles, little stones.

Sura Ibrāhīm, سورة إبراهيم, Abraham (14:34)
And should you try to count God's blessings, you could never compute them.

Al-Muḥṣī is the One who knows everything exactly, who assesses and weighs precisely. He has the capacity to know everything in detail, in the outer world just as within us. He then records the results, knows them, understands them, and controls them. Nothing gets lost with Allāh.

May every one of your days be filled with thoughts and deeds that take you closer to Unity. May the diversity of each day, the opposites and differences you encounter, constantly remind you of the underlying Unity, and may every day of your life take you closer to the Source.

Al-Muḥṣī helps us keep honest account with our life and with ourselves, it helps us behave openly, weighing up one stone after the other without ever forgetting the ocean of compassion that carries us.

Sura al-Naḥl, سورة النحل, The Bee (16:18)
For, should you try to count God's blessings, you could never compute them!
Behold, God is indeed much-forgiving, a dispenser of grace.

We have been showered with gifts and shaped into a complex masterpiece.

Al-Muḥṣī gives us the capacity to see the intention that underlies our deeds. It is one of the Divine Names that stimulates our knowledge. It promotes sincerity and honesty when taking account. Although taking account of our actions does not change the facts, it enables us to see more clearly where we are and where we would like to proceed. This is true both on the material and spiritual level.

At the core of our being, in our soul, we are completely free from the chains of this world. Always get to the root of everything around you, and especially everything in you. Observe and probe the way you live and the way you act. When you pray or meditate, let your mind sink into your heart, time and time again. Do not fear the void. Start on the journey to your center and unveil your true being—the face that was yours before you were born.

المبدئ

AL-MUBDI'

The Originator, the Creator, the Founder, the Initiator

56–224–3,136

When nothing was, only He existed (*mā siwa llāh,* ما سوى الله). The Divine Name Al-Mubdi' inspires us to reflect on the Creation and the Creator, and to contemplate them. One hour spent in silence, deeply collected, is more nurturing and beneficial than anything else we can do.

Al-Mubdi' comes from the root *b-d-'*, which contains the following meanings: to introduce, to originate, to start, to do for the first time, to be the first to do something, to devise, to contrive, to invent, to achieve unique and excellent results, to be amazing, to be outstanding, to think up, to regard as novel; marvelous, amazing, singular, unique, unprecedented; innovator, innovation, singularity, creative ability.

Al-Mubdi' is the beginning. When an idea comes up, when thoughts collect around it, when we are moved to write the idea down, when we want to put pen to paper and write the first letter—that is Al-Mubdi'.

To turn to Allāh with the name Al-Mubdi', the One who starts, the Creator, is to feel the force, the action that brings everything from the invisible, the transcendent, into the visible world.

At the beginning of our life, we are weak. Then we grow and there comes a period of strength before we eventually become weak again. This is the cycle of life. The balance between our inner and outer—spiritual and social—deeds is particularly important during our strong phase, which starts when we are forty.

Al-Mubdi' gives us the strength to go into action, to take one step and then the next, and it protects us from remaining stuck in our own quagmire, from obstructing our own path until we stop feeling

touched or concerned by anything. Whenever we start something consciously, Al-Mubdi' manifests in time and space.

If you doubt and feel unsure about what to decide, repeat this Divine Name 1,000 times and the right decision will come.

This Divine Name is filled with the qualities of light and secret knowledge. Repeated many times, it will lead you to a deeper vision of things. It influences the tongue, which gains wisdom and balance through those repetitions.

When you enter the space of Al-Mubdi', initiate every deed with this name. It will give you firmness and stability in times of indecision and uncertainty, as well as the strength to choose that which is good for you. It intensifies awareness and helps you reach utter concentration. Al-Mubdi' is one of the names of majesty because it contains life and death.

Sura al-Baqarah, سورة البقرة, The Cow (2:156)
Verily, unto God do we belong and, verily, unto Him we shall return.

For the Sufis, the beauty and the meaning of their entire path are contained in this verse. It is the clear, irrevocable decision to give precedence to the eternal over the ephemeral, to give precedence to the One who is not begotten, over that which is begotten, until the self starts on the way to its divine origin and the journey begins.

The Sufi path, the path of love, changes the direction of the heart
so that the energy of love may permeate it and flow into the world.

59

<div align="center">المعيد</div>

AL-MUʿĪD

The Restorer, the One who brings back, the One who leads back

124–496–15,376

The Divine Names Al-Mubdiʾ (58), the One who starts, and Al-Muʿīd, the One who leads back, are connected because He who has created everything restores it time and again. They contain death and awakening, the eternal flow of life, for life is constant transformation, eternal movement.

Al-Muʿīd takes back that which Al-Mubdiʾ has brought from the invisible into the visible world, thus closing the circle.

Sura al-Burūj, سورة البروج, The Great Constellations (85:13)
Behold, it is He who creates [man] in the first instance (mubdiʾ), *and He [it is who] will bring him forth anew* (muiʿīd).

These two Divine Names connect us above all with the movements of nature and the miracles that surround us every day. Those who observe the world and the universe become seers, the seers become knowers, the knowers become followers, and the followers find their goal. For after death human beings are brought back to life again.

Al-Muʿīd comes from the root ʿ-w-d, which contains the following meanings: to return, to come back, to flow back, to be traceable, to revert, to rebound, to refer, to go back, to belong, to give up, to abandon, to withdraw, to lead back, to bring back, to regain consciousness, to start something all over again, to get used to something, to recall, to reclaim, to reestablish, to repair.

Al-Muʿīd is the One who brings back. Step by step, everything goes back to Allāh. Al-Muʿīd closes the circle.

You can bring back all your lost memories through intensive recitation of the Divine Name Al-Muʿīd. When things go back a long way, repeat Yā Mubdiʾ (58), Yā Muʿīd. If you find it difficult or impossible to make up your mind, repeat Yā Muʿīd 1,000 times.

People who worry a lot, and fill their heart with constant sadness and pictures of imagined catastrophes, open with this name a space that helps them become free of this burden. Repeating Al-Mubdiʾ, Al-Muʿīd helps you if you wish to go deeper into questioning "Where do I come from?" "Where am I going to?" "What was my beginning and what will be my end?"

Sura al-ʿAnkabūt, سورة العنكبوت, The Spider (29:20)
Say: "God all over the earth and behold how [wondrously] He has created [man] in the first instance: and thus, too, will God bring into being your second life—for, verily, God has the power to will anything!"

Human beings were made of extremely primitive elements, and they gradually developed into highly complex beings who are not only endowed with a physical body but also with a spirit, with feelings, and with instincts.

The idea of resurrection exists in Judaism, Christianity, and Islam. The Sufis understand resurrection symbolically. They see it as the dissolution of the *I* in His light, the dissolution of the tension of duality between good and evil in which the soul embedded in this world lives, and the experience of Unity, of the creative force through which everything concrete exists.

Unity also means reunion. Therefore, always assign what is outside to the inner reality, always read outward appearances to gain deeper insights.

Repeating this Divine Name should help you to recognize yourself at the time before you had a form, at the time when you were given a form, and when you will leave that form again. It is the spiritual, intuitive experience of the eternal flow of coming, growing, extinguishing, and reappearing. This eternal river manifests in the coming and going of cultures and civilizations. Repeating together Al-Mubdiʾ, Al-Muʿīd is also helpful when people find it difficult to start or to complete things.

O Allāh, remind us of what we have forgotten,
grant us knowledge of that which we do not know yet,
and let every new day lend more kindness and compassion to our deeds
so that our end may be better than our beginning!

60

<div align="center">

المحي

AL-MUḤYĪ

The One who gives life

58–174–3,364

</div>

At the beginning there was nothing but Allāh. He made the Creation from naught, and He wrote death on each living being, and from the circle of death, life flowed into the creatures. Thus death precedes life and life follows death.

Al-Muḥyī is the One who gives life, the only One who can give and create life. Nothing alive is outside Al-Muḥyī. Al-Muḥyī is the opposite of Al-Mumīt (61), the One who gives death. Al-Muḥyī and Al-Mumīt lead you to the reality that causes life and death. On the other hand, Al-Ḥayy (62) contains them both. Al-Ḥayy is the One who lives forever, the undying divine primeval force, eternal and omnipresent.

Both Al-Muḥyī and Al-Ḥayy come from the root ḥ-y-w, which carries the following meanings: to live, to live to see, to experience, to witness, to live through a time, to be ashamed, to grant a long life, to lend life, to greet, to call into being, to give birth, to revive, to spare someone's life, to let live; active, energetic, unbroken, undaunted, undismayed, bashful, shy, modest; living being, life, life-blood, vitality, tribe, tribal community, snake, animal, timidity.

Ḥayya ʿalā ṣ-ṣalāt is the call to prayer: "Come to prayer!"

We human beings are forever bound by the cycle of life and death. Repeating this name gives us the strength to embed ourselves into this cycle, especially when we add the following name: Yā Muḥyī, Yā Mumīt. These two names strengthen the awareness that we lie in the hands of God. Those who know are given life through the light of knowledge, and their soul awakens to life through the sweetness of His face. May the mysteries of existence be unveiled to you through reciting this name!

The Divine Name Al-Muḥyī is repeated first and foremost by the angel Raphael (*Israfil*), may peace be upon him. When human beings repeat this name often, their heart comes to life, and their strengths and abilities manifest both on the inner and outer level.

Al-Muḥyī is the divine regenerative force in us and around us, that we feel especially after a crisis or an illness. Indeed, do we not come out feeling stronger?

When we reach the critical point of a serious illness, or the turning point in a major life crisis, we have no strength or space left for the nonessential, the ego is stripped bare, and the heart frees itself of all desires. We are seized by an unusual feeling of freedom and lightness, a radiant calm and quietness, akin to the light of dawn, and our soul attunes to a higher energy. The sun hidden within us rises.

We often witness this quiet state of the soul a few days before people pass on, and we then believe that they might go on living. It is a special honor and a deep nourishment to experience such moments with our fellow human beings because their sun nurtures us too and leads us to the depths of our being.

The sun symbolizes our soul and our heart sends its light into the darkness of our ego. The heart becomes the center of our existence when it connects with the light of our soul. By itself, the heart corresponds more to the moon. Our world is the night, the world that does not reflect knowledge. In the night sky, the moon is directed to the sun from which it receives its light and, by connecting to the soul and the spirit, it becomes the inner sun. Such is the superiority of the heart, where the capacities of the soul and the mind unite and become deep knowledge.

Sura al-Zumar, سورة الزمر, The Throngs (39:23)
[A divine writ] whereat shiver the skins of all who of their Sustainer stand in awe: [but] in the end their skins and their hearts do soften at the remembrance of [the grace of] God.

It is from this verse that the Sufis derive the importance of movement, of softening the skin, of shaking the body, of turning around the axis of the heart as tools that help us concentrate during the *dhikr* and in the holy dances of whirling.

"Their hearts soften" can be replaced by "their hearts become less hard." The Prophet Muhammad, peace and blessings be upon him, said, "There is a polish for everything that taketh away rust; and the polish of the Heart is the invocation of God."

Hard-heartedness is like clouds in front of the moon, like the rust of the heart or the dragon guarding the entrance to the life source.

Longing is the soul's song about separation.

61

<div align="center">المميت</div>

AL-MUMĪT

The One who gives death, the One who allows to die

490–1,960–240,100

We should never wonder why misfortune befalls the innocent. If the righteous suffer, that means that we all do, as is attested by old age and death, which spares no one. Death carries an equalizing justice which, by itself, is much more meaningful than the multiplicity of earthly fates.

The experience of death is like climbing out of a cave—suddenly we find ourselves on the top of a mountain and we can see the whole countryside in one glance. The soul recognizes the endless differences, understands for the first time the full context, the intricate networks and unexpected connections, and it realizes that life was but an instant, a game. The soul recognizes itself in the light of its true, eternal divine nature, without any distortion.

Sura al-Jum'ah, سورة الجمعة, The Congregation (62:8)
Behold, the death from which you are fleeing is bound to overtake you.

Repeating this name soothes the fear of living and of dying. We feel in our heart that everything lies in the hands of God. The two Divine Names Al-Muḥyī and Al-Mumīt are often repeated together. Whenever you repeat Al-Mumīt without Al-Muḥyī, you should always repeat it with Allāh: Yā Mumīt, Yā Allāh.

From the moment we are born, we start preparing for death, in a process of constant opening, transforming, and letting go of ourselves, until the moment comes when we are ready to surrender to the loving embrace of Allāh.

When we lose someone dear to us, repeating together Yā Muḥyī (60), Yā Mumīt helps us until our heart passes on and can be taken over by Yā Ḥayy (62) because both life and death originate and end in Al-Ḥayy.

Life is truth and truth is God, therefore life is only God.

Al-Mumīt comes from the root *m-w-t*, which contains the following meanings: to die, to perish, to lose life, to become dead, to abate, to die down, to let up (wind, heat), to be mad about, to be ready to die for, to be extremely fond of, to mortify, to suppress, to pretend to be dead, to seek death, to sacrifice oneself, barren land, lifeless, dead.

> Death, dear friend, is for everyone like himself. To a friend it is a friend and to an enemy it is an enemy. O you who fear death, while you are fleeing it, know that you are yourself the cause of that fear. It is your own ugly face—not that of death. Your soul is like a tree and its leaves are death. If you are tired of the thorns, you must transform them; and if you walk in finest silk, you have woven it yourself.
>
> —Rumi

Grief, pain, depression, and worries are a form of death. Sleep too is a small death. Thus we are constantly surrounded by forms of death. Every day our body embeds us in the cycle of life and death, reminding us of the constant movement of life.

The Sufis should tackle death consciously four times a day and prepare themselves inside so that they are ready whenever the Great Master calls. Live in the moment, exercise your humanity, take time for prayer and meditation, give and donate, enjoy the beauty and the wonders, and bring together heaven and earth!

Some Sufi schools distinguish four types of death a Sufi should abide by:

The white death is hunger. Never fill your stomach completely. Comply with the hadith: one-third food, one-third liquid, and one-third breathing. An empty stomach keeps the mind awake, lights up the heart, and protects consciousness from half-sleep, from negligence, and from forgetting the Beloved.

The green death is to remain modest in one's attire and polite in company so as to protect the self from vanity and arrogance.

The red death is the conscious battle against the power of the selfish, separating, complacent part of the *I* and its claim to rule.

The black death is to endure the loneliness, the wounds, the offenses, and the misunderstandings people will display towards them on their spiritual path.

So use Yā Mumīt, Yā Allāh whenever you are overcome by your lower impulses because it is powerful. Always keep the knowledge in your heart that we are all guests on this earth, guests who stay for a short while, and let this influence your conduct toward your fellow human beings because you never know whether this encounter is not your last. And never forget that the divine light awaits us after death.

The mystic knows that death does not exist,
that it is merely a change of consciousness.

62

AL-ḤAYY

The Living, the One who lives forever, the One who always exists

18–36–324

This Divine Name contains the quality of that which is alive beyond the ephemeral. It is the eternal life. It contains the eternity of life without beginning or end, beyond time and space. May this Divine Name remind you with every breath that your life and your longing belong to Allāh.

Repeating this name awakens the light of Unity in the heart. It is one of the names constantly repeated by the angel Gabriel, peace be upon him.

Al-Ḥayy and Al-Muḥyī (60) both come from the root *ḥ-y-w*.

Al Ḥayy carries a high life energy that is intensively activated by the repetitions. It gives strong force to the body and stimulates its magnetism almost unlike any other name. Energize your body and mind, and share this energy with everything around you as a gift to yourself.

Ibn al-ʿArabī explains the distinction of this name.

After Al-Wāḥid (66) and Al-ʾAḥad (67), Al-Ḥayy occupies the highest position of all Divine Names. All other Divine Names can only enter reality after Allāh has given Ḥayy, life, to the universe. Then comes Al-ʿAlīm (19) and consciousness flows into the Creation.

Breathing is life. Inhale, inhale the strength around you, then exhale and let the grass blades grow beneath you. Wherever you go, bring life to people, animals, and plants. Life is joy. Connect with the magnetic field of the cosmos and express this force in your words, thoughts, and deeds. Become one with the rhythm of life. That is Al-Ḥayy.

Al-ḥayy, the living, is the opposite of *al-mayyit,* the dead. Life, *al-ḥayāt,* derives from Al-Ḥayy. When people are sharp, noble, and decent, they are said to have a living heart, *ḥayy ul-qalb.* When they are blinkered and thoughtless, they are said to have a dead heart, *mayyit ul-qalb.*

The Divine Name Al-Ḥayy is used first and foremost to awaken the heart. Its repetition fills the heart with the light of Unity. If you feel cut off from your heart, if you have the feeling that cold-heartedness is spreading in you, this name will help you find the connection to your heart again. It helps you know yourself more deeply. It carries the qualities of observation and action. As self-awareness awakens and leads to observation, knowledge comes so that the things being observed can shift and embed themselves in their proper course.

When you feel under pressure, when you feel stress in your life, repeat this name 500 times every day before sunrise, and peace will spread within you.

This name is often recited together with Al-Qayyūm (63).

<div dir="rtl">أستغفر الله الذي لا إله إلا هو الحي القيوم وأتوب إليه</div>

'astaghfiru llāh al-ladhi lā 'ilāha 'illā hū wa-'atūbu ilayh

I seek refuge in Allāh, there is no God but Him, and I turn to Him in repentance.

The Prophet Muhammad, peace and blessings be upon him, said, "Those who repeat this sentence 3 times when they go to bed will have all their transgressions forgiven, even if they are as abundant as the foam of the ocean, the leaves on the trees, the sand on the beaches, or the days of the world."

No one gives the world as much beauty and spirit as artists and mystics.
Yet nothing is eternal, absolute, or complete but He.

63

AL-QAYYŪM

The One who exists eternally, the One who exists through Himself, the Reliable

156–624–24,336

This Divine Name carries a quality that indicates independence and autonomy. Allāh gives and without Him nothing lasts. All forms come from Him. He is the Everlasting, the Eternal. Everything exists because He is. Everything is ephemeral. Everything comes and passes, all beings and things stem from His existence, and because they arise from Him, they also exist after death.

Al-Qayyūm comes from the root *q-w-m*, which carries the following meanings: to get up, to stand up, to rise, to rise or turn against, to revolt, to attack, to rise in honor, to set out, to depart, to come to pass, to happen, to remain standing, to resist, to fight, to straighten, to stretch straight ahead (road), to be sincere, to be honest; resurrection, guardianship, resistance, firmness, bearing capacity, sincerity.

The form and the sound code of the Divine Name Al-Qayyūm point to its quality of continuous, eternal existence that grants existence to everything.

Al-Qayyūm lets the Divine arise in us, taking us away from our self before letting us stand up again, not in our self but in our true self! Al-Qayyūm makes us straight and correct until we have reached our essence.

The two Divine Names Al-Ḥayy (62) and Al-Qayyūm are mostly recited together—the One who lives forever, the One who exists through Himself, source of all existence! To repeat those names means to spread peace and harmony on earth, to strengthen the force of life and harmony against the forces of war and destruction.

Al-Qayyūm gives strength and trust in the Divine Providence, cools the pain and the heaviness

we feel in our heart, time and time again, when we observe what happens in the world. Repeating this name 99 times protects us from hard times, especially when we have lost our sense of security. He fulfills our needs and dissipates our sorrows, over and over again reviving the light in us with Al-Qayyūm.

When you experience Allāh as Al-Qayyūm, you free yourself from existential worries, your heart gives less importance to the material world and finds peace.

Al-Qayyūm is the One who exists through Himself, the One who is perfect in Himself. Many see Al-Ḥayy and Al-Qayyūm as the most significant and powerful Divine Names.

No one can see God without dying first. This is why life is often compared to a *hammam* (public bath): you come in, you feel heat everywhere, and this enveloping heat gives you the opportunity to cleanse, purify, and strengthen yourself. Yet only when you leave the *hammam* can you see the fire, the source of all the heat. The human body is like a *hammam*: only when you have left it, only in the hereafter do you recognize the divine love that kindled the fire of longing in you.

The Prophet Muhammad, peace and blessings be upon him, was once asked, "What can I do so that my heart does not die?" And he replied, "Repeat 40 times before sunset: Yā Ḥayy, Yā Qayyūm, there is no God but You (يا حي يا قيوم لا إله إلا أنت). These words will enliven your heart and protect it forever from dying, from hard-heartedness."

When you feel overcome by half-sleep, when you suffer from your own lethargy and laziness, you can recite Yā Ḥayy, Yā Qayyūm until sunrise. You will be granted deep understanding, knowledge, and you will enjoy your work. Do not stop at outside meanings. Ask for the insight, the taste, and the light that lie behind a Divine Name.

Those who carry this Divine Name become witness to the fact that everything exists through Allāh, and through that they learn to help and support others in the name of the Divine. People who find it difficult to remember things should repeat this name 16 times a day, and they will overcome this weakness. The following two invocations are considered to be the greatest support:

الم الله لا إله إلا هو الحى القيوم

'alif lām mīm allāhū lā 'ilāha 'illā hū al-ḥayy al-qayyūm

Alif lam mim there is no God but Him, Al-Ḥayy, Al-Qayyūm.

لا إله إلا هو الرحمن الرحيم

lā 'ilāha 'illā hū ar-raḥmān ar-raḥīm

There is no God but Him, Ar-Raḥmān, Ar-Raḥīm.

The second sura of the Qur'an contains the Verse of the Throne, 'Āyāt al-Kursī (آية الكرسي), which is referred to as the greatest protection verse. The two Divine Names Al-Ḥayy and Al-Qayyūm appear in the second line of this verse, after *allāh lā 'ilāha 'illā hū*. Here the Divine Name Al-Qayyūm opens the spiral between heaven and earth, and whispers its richness into the ocean of manifestations.

Is not Al-Qayyūm, the One who lives forever, the One who exists through Himself, source of all existence, the most beautiful way to revere Him?

64

الواجد

AL-WĀJID

The All-Existing, the All-Finding, the Perfect, the Bestower of existence

14–56–196

This is the One who needs nothing, nor is He incapable of anything. He leads everything that calls for Him. He differentiates everything that He wills. So it is up to you, O seeker of Allāh, to strive to fulfill everything that He wants from you.

This name is based on the root *w-j-d*, which contains the following meanings: to find, to hit upon something, to come across something, to meet with something, to get, to invent, to be found, to be there, to exist, to experience, to feel, to sense (affections), to suffer, to be in a state of painful agitation, to love, to be angry, to produce, to evoke, to bring into being, to cause, to bring about, to let someone find or obtain something, to be passionately in love, to grieve, to appear; finder, finding, strong emotion, passion, ecstasy of love, psychic forces, ecstasy, empathy, sympathy, presence.

Passion and the ecstasy of love, *wajd* (وجد), are also based on this root from which the words present, presence, existence, and knowledge, *wujūd* (وجود), are also derived.

Al-Wājid is divine ecstasy. Al-Wājid, the All-Existing, the One who is close, the One who answers, the Kind, the Loving. Call Him with this name and rely on Him so that your path may become a straight path. His absolute kindness is everlasting and omnipresent. Those who repeat the name Al-Wājid 100 times for a week will find the Finder in their heart, in their thoughts, in their whole being, and they will become a witness to His Unity.

Al-Wājid is the Rich One, Al-Ghanīy (88), and the Knower, Al-'Alīm (19). Al-'Alīm refers to the unlimited knowledge of everything, while Al-Wājid expresses the ability to carry out everything

without limitations. This is why the generosity of a human being is called *wājid* (واجد). This name carries the quality of generosity and its expression.

If you repeat this name before going to sleep and carry it into your sleep, your heart and vision will be enfolded in divine light. So repeat this name and become a seer. Know that Al-Wājid creates all things from naught. When you are overcome by repeating this name, you find in yourself knowledge and wisdom you had never touched before. Because Al-Wājid finds you, no matter where you are!

Those who repeat this Divine Name often will not lose the things that matter most to them, be they material things, motivation, or the commitments that they have made in this life.

Al-Wājid touches essentially our soul and our emotions, everything both inside and outside time and space, because none of our dealings escapes Him.

Allāh the Giver breathes life into us human beings out of His mercy. He gives permission to live and endows us with a unique nature. He puts us on earth on our two feet and stretches our spirit to the highest heaven before sending us on the journey to our true being. Search your center because this is where the intimate, liberating dialogue begins, the partner relationship between man and God—not by order, but out of longing and love. By recognizing Him, we become free and the eternal bond is sealed. May you find your center in the ecstasy of love of Al-Wājid!

So seek and find God's presence in you
and in everything around you!

65

<div dir="rtl">الماجد</div>

AL-MĀJID

The Glorious, the Praised, the Renowned

48–192–2,304

He is the One who supports most perfectly. All manifestations flow out of Him, including the deeds of human beings, whether intentional or not.

Al-Mājid is connected with Al-Wājid (64), but the latter also contains the dimension of eternity while attesting to, emphasizing, and confirming the Divine Name Al-Mājid. All praise and fame end in Him. The whole existence is permeated with the light of His beauty, *jamāl* (جمال), and His majesty, *jalāl* (جلال).

Al-Mājid comes from *majd*, which means honor, dignity, nobility, and fame, but also striving, effort, and endeavor. The root *m-j-d* also contains the following meanings: to be glorious, to praise, to extol, to glorify, to celebrate, to boost, illustrious, exalted, praiseworthy, glory, splendor, magnificence, nobility, honor, distinction.

Although the Divine Name Al-Majīd (48) comes from the same root, Al-Mājid lends this quality an active expression through its form and its sound code: the unique Doer, the only Performer of deeds. Ibn al-'Arabī explains Al-Mājid in this way.

Those who touch the quality Al-Mājid are noble beings whose deeds are clad in beauty and who give and share with great generosity. It is as if it had united the Divine Names Al-Jalīl (41), Al-Wahhāb (16) and Al-Karīm (42).

So invoke Him and ask Him, and know in all your surrender that not every one of your wishes will be fulfilled immediately, and that some of them never will. For if every wish were completely fulfilled,

this would cause imbalance and disharmony, and jeopardize humankind. Thus everything has its measure because God knows what is good for you, here and for your onward journey.

Sura Ibrāhīm, سورة إبراهيم, Abraham (14:34)
And [always] does He give you something out of what you may be asking of Him; and should you try to count God's blessings, you could never compute them.

Allāh fulfills every human wish, provided He sees it as useful for this person in His endless wisdom and kindness.

It is part of our nature and our limited insight to wish in good faith for things that are bad for us, and to want to hurry other things that need time. So let trust be the sister of your wishes and see truly: the world is perfect as it is. When we repeat these two Divine Names, we feel in our heart a noble force that carries us high into the light of Unity. This state cannot be reached either by beseeching or seeking.

Al-Mājid is the Bestower of wealth and blessings. Al-Wājid (64) is the One who is close, who answers your prayers, the Kind, the One who loves unconditionally. Al-Mājid is the One from whom all riches come and to whom they all return. The whole universe carries His fragrance and the light of His manifestations in all their diversity.

Those who carry the quality Al-Mājid have the strength to assume responsibilities. If you repeat this name 465 times during the day and 465 times during the night, others will understand your words according to your intention. Al-Mājid is the Divine Name whose deep and intensive repetition grants us the capacity to understand the language of minerals, plants, and animals, by the grace of God.

Those who repeat the name Al-Mājid feel, deep in their heart, an essential confidence that fills their whole being. They feel the riches in their veins because they are connected to the divine riches. But when we amass wealth without sharing it with our fellow human beings, when we sacrifice everything to the pursuit of fame in order to immortalize our name, we forget that we are but a dot on a radius and that this radius is a beam of the divine mercy that comes from the highest Center and leads back to it. When this dot turns into a dot of mercy and acknowledges its connection to the radius as a whole, it vibrates in the praise of God, and whether its name is famous or not becomes immaterial.

We should beware of the greed for more, the obsessive striving for additional comforts, material goods, advantages, tangible or intangible, more power over our fellow human beings or over nature, or for unlimited technological progress. Because if that is all we strive for, we are barring ourselves from any spiritual insight, thereby from any noble discipline of our being based on moral values. In the end, all inner stability gradually disappears, and with it any perspective of true happiness.

Life moves up and down in mysterious waves. Sometimes they bring good, fertile times of increasing peace, sometimes heaviness, gloom, struggle, and hardship. We human beings are embedded

in those movements that reveal our individual and collective potential. It is through these waves that we show our colors. Although we do not choose the scenario, the circumstances, we are beings who carry light and darkness, who unite heaven and earth, time and eternity, thereby contributing to balance or imbalance. Our deeds cause the corresponding positive or negative reactions.

In times of abundance, we are given the possibility to be grateful and generous, and to love our fellow human beings. In times of difficulties, we can practice patience, modesty, and perseverance. As our human imbalance clashes with our inherent divine peace of mind, we have the possibility to swim through with our fundamental virtues that cannot be separated from our human nature, to spread light, generosity, and truthfulness, thus turning to our true self with every wave. The fact that we do not know what will happen the following day shows that we are a tiny, insignificant aspect of an absolute element. It also shows that we are not of this world but that we were born in it in order to know, in the moment, the miracle, the all-encompassing holiness of life, Allāh.

Tile your private holy rooms with your meditations and your prayers
so that you may be saved from following the same course again.

66

<div align="center">

الواحد

AL-WĀHID

The One, the One and Only

19–76–361

</div>

Al-Wāḥid, the One in His essence, in His qualities, in His deeds, the divine uniqueness: God is One, there is no God but Him. He is the Absolute. He is the One who existed and nothing existed with Him.

Al-Wāḥid gives us the strength to inhale and exhale our life, while at the same time letting ourselves fall into Unity. He gives us the one love so that we may accept all the situations, all the people, all the processes we are confronted with as a teaching, a gift, and a healing.

The unity of the essence means to be without limits in time and space, in states without separation or division. He is the One who is present in everything. It is God's uniqueness reflected in every single aspect of existence, in all manifestations. All manifestations reflect Him; all manifestations mirror the One. The many reflect the One as well as every single little part of it. Everything carries the finite and the infinite simultaneously.

Al-Wāḥid comes from the root *w-ḥ-d*, which contains the following meanings: to be alone, unique, singular, unmatched, without equal, incomparable, to unite, to unify, to connect, to join, to link, to bring together; independence, oneness, singleness, unity, union.

Also derived from this root is the word *tawḥīd*, the belief in Unity, the individual's ascent in God's Unity.

The unity of the qualities means: all qualities lie in Him in their perfect state. To Him belong the Divine Names we know and those we do not know. To Him belongs absolute knowledge, absolute capacity. Human beings, angels, and *djinn*s—visible and invisible beings—are submitted to His power and all beings praise Him.

The unity of the deeds means: all His deeds come clearly from His knowledge and His boundless wisdom. They are not contradictory, and they cannot be changed. He carries the beginning and the end, and He knows neither beginning nor end. If you repeat this name 113 times, alone and in a quiet place, you free yourself from fear and illusions, Allāh willing.

By repeating the Divine Name Al-Wāḥid, you touch the light of your deep intelligence and wisdom.

Unity also means that there is a divinely ordained unity between mind and body, between spirit and flesh, both serving the same purpose. Although we should not attach too much importance to the physical and material life, at the same time our wishes and motivations connected with our carnal life are willed by God, and therefore they matter. To find our balance, to find the middle way between complete lack of restraint and asceticism, is what makes us compassionate, spiritual, happy human beings who enjoy beauty.

Al-Wāḥid is mentioned six times in the Qur'an, combined with Al-Qahhār (15).

Sura al-Ra'd, سورة الرعد, Thunder (13:16)
God is the Creator of all things; and He is the One (al-wāḥid) *who holds absolute sway over all that exists* (al-qahhār).

If Al-Wāḥid stamps itself in your heart with the clarity of a pillar of light, then Al-Qahhār is burning. Whatever else is in your life, whatever you do, your heart is seized by the incessant striving and longing for Allāh. This passionate yearning is the fire of love that the Sufis call *'ishq*. Al-Wāḥid Al-Qahhār (15) burns away all the egocentric identifications, all the erroneous images of the wounded *I*, until you become the divine flame.

Live the richness and the kindness of your true being:
acquire knowledge, do good, be kind to all living beings,
and thus attain your peace and your inner dignity.

67

AL-'AḤAD

The One and Only, the Indivisible

13–39–169

Al-'Aḥad is connected to Al-Wāḥid (66) like zero to one. Al-'Aḥad is the unmanifested state of Unity, the Indivisible which is not made up of elements.

He is the Unity in which all names, all qualities, and their relationships, come together.

Al-'Aḥad comes from the root '-ḥ-d, which contains the following meanings: to make into one, to unite, to unify, one, unity, oneness, Sunday.

A wall is made of stones, mortar, sand, bricks, water, pebbles, but when you look at the wall, you see it as a whole. The wall is the sum of all its parts, yet the wall is not the stone, the mortar, or the water. The materials lose their identity in the wall. The same goes for us, to a certain extent. You carry many qualities, thoughts, feelings, and judgments, with which you identify according to the situation, encountering others with different faces at different times. All relationships are similar in this world. The endless manifestations are all connected in Unity, where they cease to exist as separate parts.

The teachings of the Unity of Being, *tawḥīd*, express the fact that every seemingly isolated thing is in reality the presence of the Endless.

Sura al-Baqarah, سورة البقرة, The Cow (2:115)
And God's is the east and the west: and wherever you turn, there is God's countenance.
Behold, God is infinite (wāsi'), all-knowing ('alīm).

Divine omnipresence is carried by divine omniscience, for if God is omniscient, then He is also omnipresent because in absolute Unity, there is no separation between subject and object, between the knower and the known.

Every existence has two faces: its own face and individual existence, and a face of the Divine, a divine existence. In relation to the individual it is nonexistence, and in relation to the Divine it is existence. Therefore, nothing truly exists but the face of the Divine.

Neither one nor two: the singer and the song, the sun and its rays.

Sura al-Ikhlāṣ, سورة الإخلاص, The Declaration of [God's] Perfection (112:1–4)
SAY: "He is the One God:
God the Eternal, the Uncaused Cause of All That Exists.
He begets not, and neither is He begotten;
and there is nothing that could be compared with Him."

This is the sura that attests to God's perfection. To repeat it means to call out to God unreservedly, in sincere devotion, love, faith, and belief.

In this sura the Divine Names Al-'Aḥad, Aṣ-Ṣamad (68) appear visibly and the Divine Names Al-Wāḥid (66) and Al-Fard (the Unique, the Incomparable) invisibly.

This sura expresses the thought that everything that exists or can be imagined returns to Him as its source, and therefore depends on Him in its beginning as well as in its continued existence.

If you can find yourself in a single *I*, in your essence, beyond all the qualities and attributes that you give yourself, or others give to you, without any relationship, any connection to anything in you or around you, then you will perceive Unity in you. If you repeat this name 1,000 times, by yourself, calmly, noticing its deep quality and meaning as well as the feeling of Unity within you, your true self will show itself to you. Let your mind become the servant of your true self.

In the face of God, the various views and differences are conditional, and the values of one view are invariably found in some form in another view. On the outside, Unity is limited because of the existence of differences. Yet the omnipresence of the original substance is so real that an interaction takes place that makes Unity real. The mind, which differentiates, and the heart, which unites, bring holiness and wisdom.

"We must make all people one with us.
The Prophet Muhammad explained this to us, but some of us
who came to the world forgot the message of Allāh.
We must learn to wash away our separations and become one again."
—Bawa Muhaiyaddeen

الصمد

AṢ-ṢAMAD

The Eternal who is always present, the Lasting

134–402–17,956

Aṣ-Ṣamad is the One to whom the hearts turn respectfully, longing to discover the abundance of goodness and praiseworthiness that is in Him.

This name indicates the Divine Essence. Aṣ-Ṣamad is the One who contains dignity in its highest form, completeness in its absolute form. Aṣ-Ṣamad is the Everlasting, simultaneous and timeless.

Aṣ-Ṣamad comes from the root *ṣ-m-d*, which contains the following meanings: to betake on someone, to repair, to turn, to defy, to brave, to withstand, to stand up, to resist, to oppose, to hold out, to remain unaffected, to close, to plug, to save (money), Lord eternal and everlasting (epithet of God), staying power, resistant, massive.

It is difficult to find a consistent translation for the Divine Name Aṣ-Ṣamad. Aṣ-Ṣamad is like a clenched fist, like a cliff, dense, strong, and full, without any gaps or empty spaces. Aṣ-Ṣamad is existence through and through, untouched by time or space, subject to no changes. Aṣ-Ṣamad cannot be divided, nor is it composed of parts. Aṣ-Ṣamad is the completeness of all potentials; Aṣ-Ṣamad is eternity. Ibn al-ʿArabī explains, "Aṣ-Ṣamad is the universal support and the universal refuge."

Everything flows towards Aṣ-Ṣamad, in a continuous process of return and connection, like the fish swimming to the ocean in which it is.

Aṣ-Ṣamad helps us overcome our isolation and embed ourselves in Unity.

If you repeat this name 119 times several times, you will be cared for and you will need no one, but others will need you. To know your neediness will transform you and the taker you were will

become a giver. Do not seek protection from anyone or anything that can pass. Always ask protection from Him alone.

When we are not aware of our essence, we start to feel that something is missing and a hollow comes to be. When we lose touch with our own value, we feel empty, inferior, incomplete, and we need to fill this void from the outside in the form of praise, agreement, or recognition. We are solely aware of our own wishes and needs. "I want this and that. I want to be successful. I want so and so to love me. I want this help and that recognition!" The ego takes the lead and our essence fades more and more into the background, into the unconscious. Each of our hollows is filled with a psychological issue, with dogmas, specific experiences and traumas that have separated us from our essence. The ego identifies with those experiences, ideas, and pictures from the past so that we end up being not *in* this world but *of* this world. The Sufis describe those who are connected to their essence as being *in* this world but not *of* this world.

Praised be this generous essence for its many gifts in the form of conflicts, problems, crises, challenges, and limitations, so that we can develop inside, uncover our true being, and find a knowledge that is essential for us. As our ego suffers, our person hollows open to the water of eternity, and we mysteriously partake of the infinite in our finite form. The water of the ocean begins to flow into the isolated basin through its cracks and breaks. The basin starts tasting the ocean and can bravely surrender to the great water. By discovering His rhythm, by hearing the sound of His love calling, the basin becomes one and a part of the whole. Let yourself be touched every day by the water of the ocean, through your prayers and your *dhikr*.

Aṣ-Ṣamad helps us turn around; it helps us invoke the winds of wholeness and lets them blow through all the pores of our existence, shaking the ground of our being while the barriers of separation collapse. Aṣ-Ṣamad makes us knock on the gates of the subconscious and of our higher consciousness, until the dams become porous and we are flooded in the waters of Unity. Aṣ-Ṣamad, the Inscrutable, makes us wide and boundless, sweeping away all fear and doubt.

In Sura 112, the Divine Name Aṣ-Ṣamad comes after Al-'Aḥad (67). Repeat this sura as often as you can, as an expression of the faith in Divine Unity.

Be like a cliff, open to the waters of the ocean,
present for the creatures of the sea.

69

القادر

AL-QĀDIR

The One who is capable of everything, the Powerful

305–1,220–93,025

This name shows a quality of Allāh that manifests unlimited capacity and power. Everything in the universe is connected with this power. To discover it means to open up to one's own capacities and to be given the confidence that everything is possible. Al-Qādir grants courage, confidence, and strength, taking us from passivity into activity and enabling us to feel how divine strength works through us.

Repeating this Divine Name during ablutions gives the believer strength in every part of their body. If you repeat this name 114 times, your deep wishes will be fulfilled, God willing.

The Divine Name Al-Qādir is often used in combination with another name, Al-Muqtadir (70), the Powerful. When the tongue repeats the first name, the heart repeats the second one.

Al-Qādir and Al-Muqtadir (70) both come from the root *q-d-r*, which contains the following meanings: to decree, to ordain, to decide, to possess strength, power or ability, to be master of, to have the possibility to do, to be capable, to appoint, to determine, to predetermine, to appraise, to guess, to presume, to suppose, to believe, to think, to esteem highly, to enable, to put in a position.

The word *qadar* comes from the same root and includes the meanings of predestination and fate. Only Allāh can determine our fate, in this life and in the next, for He alone knows our motives, He alone understands the cause of our mistakes, and He alone can appreciate our spiritual achievements and shortcomings.

The word *qudra* is also derived from this root. It means potential, our inherent capacities, and the abilities we have been granted.

When we come into a situation where we are confronted with someone influential and powerful, our tongue may confirm that this person is capable of everything, yet the second Divine Name, Al-Muqtadir, rises in our heart and erases this illusion. In this way the heart lifts the veil of reason, showing us where power, unity, and capability truly lie. This knowledge dissolves the fear and opens the way to wisdom. Ibn al-'Arabī explains this.

Whether a request is heard or not depends on God's preordained measure. If a request is voiced at the time which is meant for it to be heard, it will be heard immediately; if it is meant to be heard later, whether in this world or in the hereafter, the fulfillment will come later, but the request will be heard because it is always answered by the Divine reply, "I am here!"

Thus our lives are pulled between two forces—freedom and predestination.

Sura Ghāfir, سورة غافر, Forgiving (40:60)
But your Sustainer says: "Call unto Me, [and] I shall respond to you!"

This sentence is fundamental for the Sufis. It frees them from alleged worries and fears, spreads peace in their heart, and lets all things flow back, through the heart, to their eternal origin.

Unveil your heart with this Divine Name and let your soul start moving towards Him!

Recite this name whenever you feel overcome by fear, inside and outside. When you feel that the clouds of fear are crowding your sky, repeat this name and any thirst for revenge will transform into a deep vision of things.

As a human being, you have the right to retaliate when you have been treated unfairly. It is human, it should not be judged, and it is understandable on the human level. Yet as we grow and mature it is our duty to reach that place where we no longer respond in kind, because hate cannot extinguish hate, only love can. Yet when human beings are not far enough on the path to be able to do so, it does not mean that they are bad, and they should not be judged because we are all in the process of growing and maturing.

The good comes from You, Allāh, but not the evil,
although everything comes from You, Allāh.

70

<div align="center">

المقتدر

AL-MUQTADIR

The One who has power, the One who determines everything

744–3,720–553,536

</div>

As previously mentioned, Al-Muqtadir completes the Divine Name Al-Qādir. Those who have integrated this name have no fear when all others are afraid, and they do not get lost either in the material or the spiritual world.

Al-Muqtadir has a direct and personal effect on us. It puts us on the path to God and gives us the capacity to pursue it and to accept our individual fate. Step by step, we are guided in order to fulfill our destiny. Lovers take whatever power and capacities the Beloved has given them, and they use it in the most beautiful of ways.

When we repeat this name 500 times, we become aware of the truth. This Divine Name lets the illusion of separation melt away, allowing us to see the wisdom that lies in our enemy and to feel the shade of confidence under the hottest sun. If you wish to embed yourself in the Almighty Divine, then connect with this name.

The Divine Names Al-Qādir (69) and Al-Muqtadir both come from the root *q-d-r*, but Al-Muqtadir is the comparative form of Al-Qādir.

This root contains the following meanings: power, strength, potency, capacity, ability, capability, aptitude, possessing power or strength, powerful, having mastery over something, being equal, capable of, talented, omnipotence, fate, destiny.

Al-Qādir manifests His unrestricted capacity, whereas Al-Muqtadir points out the all-encompassing manifestation of the capacity. Reciting these two names together gives us the strength and the capacity

to follow our vocation in life and to bestow this gift on ourselves, on humankind, and on the world.

A man gives a child to a woman, it manifests through her and she gives it to the man. It is therefore most natural that every child should feel himself to be a present to his parents.

Sura al-Qamar, سورة القمر, The Moon (54:49)
BEHOLD, everything have We created in due measure and proportion.

The more we drink from this name, the smaller our ego—lower self or *nafs* (نفس)—becomes, the more we are hindered from following its selfish impulses. When we give space to our deep being through the Divine Names Al-Qādir and Al-Muqtadir, the question spontaneously arises, "How can I help?" "How can I contribute?" The longing and the accompanying humility lead us to stand up for harmony between individuals and between the people, and to become true peacemakers for humankind. Peacemakers pray and wish happiness and blessings not only for their loved ones but for all human beings: examiner and examinee, patient and nurse, teacher and student. Through this spiritual attitude, circles of uniting light are born and God's light becomes visible.

Whenever you wish for a change, ask yourself honestly, "Does this wish feed my pride? Is it to my sole advantage? Does it merely serve to please me?" and then act authentically.

O you, capable human being, Allāh is more capable than you!
O Allāh, fill me with the power that will take me closer to You!
Make space for Allāh between your eyes and your heart.

71

<div dir="rtl">المقدم</div>

AL-MUQADDIM

The One who accelerates, the One who puts first, the One who fosters
184–736–33,856

72

<div dir="rtl">المؤخر</div>

AL-MU'AKHKHIR

The Postponer, the One who puts after, the One who delays
846–3,384–715,716

When you repeat these two Divine Names, you enter the deep state of surrender and you connect your heart to the Divine in times of difficulties and in times of ease, knowing that God, in His omniscience, is the One who furthers and the One who delays.

Al-Muqaddim comes from the root *q-d-m*, which contains the following meanings: to precede, to arrive, to come, to reach, to be old, to be ancient, to go before or lead the way, to prepare, to keep ready, to provide, to go forward, to progress, to turn, to apply, to submit, antique, archaic, foot.

If you are aware of your impulses and of your egotistical wishes, if you are conscious of what is superficial and what is deep in your being, you can repeat the name Al-Muqaddim 184 times a day. It will give you the strength and the wisdom to know and choose that which is essential in your life because He provides humankind with all the means required to really and truly progress.

Repeating the Divine Name Al-Mu'akhkhir gives us the strength to avert that which is negative. Repeating this name 100 times a day will give you a deep insight into your own weaknesses. If you wish to prevent a negative and dominant personality from obtaining an influential position, you should repeat this name 1,446 times before sunrise for 7 days. With Allāh's help, it will be averted.

Al-Muqaddim and Al-Mu'akhkhir both move us back and forth on the level of time. When the quality of Al-Muqaddim finds an echo in us, we recognize that everything happens at the right moment. Al-Muqaddim teaches us to deal with time and with our impatience. Al-Muqaddim enables us to go ahead, step by step, without the eye of the heart losing sight of the truth.

When the quality of Al-Mu'akhkhir resonates in us, we realize that everything appears at the right moment and finishes at the right time. Al-Mu'akhkhir enables us to step back into Unity, to draw moral support from there, and, acting from our deep self, to bring things to an end.

In both cases, calm and silence can grow in us, together with the confidence that everything is in His hands.

Al-Mu'akhkhir and Al-'Āhir (74) come from the root *'-kh-r*, which contains the following meanings: to delay, to put off, to postpone, to adjourn, to hinder, to hold up, to slow down, to draw out, to put back, to stay late, to keep waiting, to hesitate, last, ultimate, extreme, end, conclusion, close, foot, bottom, hereafter, to be late, to fall or to lag behind, to hesitate, remainder.

To some, Allāh gives that which He holds back from others. Through such acceleration and delay, an equality comes to be among human beings, that only manifests when they are open to one another and help one another, thus going into the state of complementing each other. Because what is lowered on the one side is raised on the other. May you have the strength to accept that which is delayed and to take that which is accelerated.

There is nothing wrong. It may seem wrong if we have a precise picture of what is right, but if we look without any prejudice, nothing is wrong. We human beings can only ever see a part of the picture—

never the entirety. All aspects of human life, the social and the individual, the spiritual and the material, form an indivisible whole and cannot be seen separately.

So exercise discipline, for true discipline means to learn in a receptive way, to look at things without any preconception.

Some people succeed in their undertakings, others fail. Seen from the outside, there is no visible cause for one's success and the other's failure. The reasons are sometimes individual, linked to the person's intention or to the way they carried out their task. It may also be that success is important for some people because it takes them closer to their essence, while others' inner progress depends on failure. Or it could be that success—or failure—do not fit in the great divine plan. May Allāh protect us from the darkness of conceit and open us to everything He gives to us so that we may be grateful. For everything we "own" has been entrusted to us by God, we are but enjoying His gifts. Empty we come and empty we leave. Use everything well! May we spread light and beauty through our deeds, for God is beautiful and God loves beauty.

Use Yā Muqaddim, Yā Mu'akhkhir to help you connect to the whole and attain your own true meaning. Break the barriers of your pond and become a river once more, for only rivers can reach the ocean. Go and meet the all-encompassing truth.

The One who sends away and the One who brings close are both very important names for the Sufis who see the closeness as their unawareness of themselves, and the distance as their presence to themselves.

O Allāh, grant us Your love and give us the ability to love Your Creation!
Protect us from the traps of self-flattery, self-abasement, greed, and lust for power, but above
all from a blind and deaf heart!

73

الأول

AL-'AWWAL

The First, the Beginning, the Origin

37–111–1,369

He is the First without a beginning; He is pre-eternity. The First is the One who exists eternally in Himself, outside time and space. He was and nothing was but Him, and when He wanted to be known, He made the Creation in order to be known by it. He showed Himself to the Creation, and the Creation recognized Him and praised Him, knowingly or unknowingly, joyfully or reluctantly. This name says that He was before everything was and He is the One who creates everything. He is first in freely bestowing good deeds on humankind without any request or demand.

Al-'Awwal comes from the root *'-w-l*, which contains the following meanings: first, foremost, most important, chief, main, first part, beginning, to lead, to become, to turn, to devolve; primary, original, elemental; fundamental truth, essential component, basic.

God's Creation is marked by the endless cycle of birth, death, and rebirth in all things material and spiritual. Water disappears underground to come up again, steam evaporates and rain, snow, and hail fall; seeds grow into plants and decaying plants turn into coal and oil, human and animal corpses are transformed into elements that feed new life; traces of civilizations buried in the earth are dug up so that later generations may see them and be aware of them; human wishes, hopes, and ambitions rise up to the sky and divine inspiration falls into the human spirit, reviving faith and thought, giving birth to new hopes and abilities.

Our existence lies in Him and depends on Him; He is the Unity of multiplicity, the cause and the effect, the One, the First, reflected in the endless mirrors of existence. He is the One, the All, yet He is none of His manifestations.

Those who carry this name with them are given what they long for, and they attain deep insights faster than others. Their awareness of eternity and infinity grows.

You are the First and nothing comes before You, for You are the Existence of all existence.

Al-'Awwal, everything is for Him, through Him, and from Him.

74

AL-'ĀKHIR

The Last, the End

801–2,403–641,601

He is the Last without an end; He is post-eternity. You are the last and nothing comes after You; everything passes and You remain. From Him comes the beginning and to Him is the end. He is the One who remains when everything has gone. All thoughts, all plans, all knowledge eventually come to pass.

Those who, time and again, repeat the Divine Name Al-'Ākhir 600 times will bring joy into their lives and they will have a good end.

Al-'Ākhir comes from the same root as Al-Mu'akhkhir (72): *'-kh-r*.

Al-'Awwal (73) and Al-'Ākhir are connected. Most of the time, they are recited together. Some add to this combination Az-Zāhir (75) and Al-Bāṭin, (76) and repeat those four Divine Names together.

He is called Al-'Awwal because He was and nothing was with Him, and He is called Al-'Ākhir because He will be and nothing will be with Him. He symbolizes the perfect circle, without beginning or end.

Sura al-Ḥadīd, سورة الحديد, Iron (57:3)
He is the First and the Last, and the Outward as well as the Inward: and He has full knowledge of everything.

Like Az-Zāhir and Al-Bāṭin, Al-'Awwal and Al-'Ākhir are outside time and space. They are the eternal beginning and the eternal end, the eternal appearance and the eternal concealment, the eternal ascent and the eternal descent, permanent, everlasting movements of the absolute majesty and beauty.

They are like the rhythm of breathing. When we inhale all the way to the top of our head, we unite with Allāh, and we come to the place where we can let go of everything through experiencing our highest level of fullness. This is the place where everything stops, what the Sufis call *fanā'*, annihilation. When we exhale after *fanā'*, we return to the world and this is *baqā'*, exhaling from our true self.

The Prophet Muhammad, Allāh's blessings and peace be upon him, explains Al-'Awwal and Al-'Ākhir as follows: "His Being is eternal, nothing precedes His existence or outlasts His eternity."

Everything that exists, everything that happens, has a meaning and a purpose.

Al-'Awwal and Al-'Ākhir give us human beings the possibility to embed ourselves in the eternal circle. Al-'Awwal precedes every birth, every beginning, every opening, every awakening. Al-'Ākhir follows every end, every closing, every conclusion, every arrival. Once we are aware that we are embedded between these two absolutes, we become capable of stretching and finding our place in eternity. Our breath and our spirit expand, and we can discover our own eternity, the moment beyond time.

The word *al-'ākhira* comes from the same root as the Divine Name Al-'Ākhir, and it means the life to come, the continuation of life after the death of the body, therefore, the fact that our deeds and attitudes in this world have specific consequences in the hereafter.

If you recite this Divine Name 100 times every day, you will have the strength not to delude yourself and to see the true reality. If you repeat this name 1,000 times, your heart will fill with divine love.

Nothing was in Him, therefore everything comes from Him.

You always come to Allāh in the end because He is behind everything. He created space and He created time, and there is neither "where" nor "when" for Him.

The end is contained in the beginning. It is a closed circle of love
in which everything is present from the very first moment.

75

الظاهر

AZ-ZĀHIR

The Manifested, the Revealed, the Visible

1,106–4,424–1,223,236

This Divine Name shows the Divine manifested in the visible world, the existence of Unity in the existence of all things, in both qualities and deeds. In their essence, human beings know that they are connected to the Divine, and on their path, through learning, understanding, courtesy, and honorable conduct, it becomes more and more refined and crystallizes until it fills all their cells.

Az-Zāhir comes from the root *z-h-r*, which contains the following meanings: to be evident, to come to light, to show oneself, to come up, to emerge, to win the upper hand, to win, to overcome, to obtain knowledge, to unveil, visible, recognizable, noon, midday.

The Sufis see all manifestations and phenomena as symbols, and the veil, hijab, is very important. It stimulates our attention, and although its role is to veil and mislead, it also acts as a signpost that helps us find God. The hijab is what the Hindus call *maya*. On the level of manifestation, the hijab is a separation, but nothing escapes the absolute, so that it veils and unveils at the same time. The highest veil is Ar-Raḥmān, through whose breath the world comes to exist. The substance of this world, *nafas ar-raḥmān*, is the breath of the Compassionate, the All-Merciful.

Repeat this name 15 times after a meditation or a prayer, and you will feel the divine light in your heart. Repeating this name gives you the capacity to see things that had previously been veiled to you. When people have a problem and cannot see a solution, they should repeat Yā Ẓāhir 1,106 times after the night prayer or the night meditation, and Allāh will show them a solution, possibly in a dream. So learn to recognize Allāh's signs and to decipher them in all beings.

271

Sometimes life or a situation requires us to be brave and explicit, to uncover our positive deeds and to show them clearly and honestly. Connecting with the Divine Name Aẓ-Ẓāhir will grant you the necessary strength, and your mind and your heart will not forget where this power and this influence come from.

Aẓ-Ẓāhir and Al-Bāṭin are usually recited together: one shows the Divine manifesting in His unveiled forms that veil Him at the same time, while the other shows that no form veils Him without unveiling Him at the same time.

The knowledge of the heart restores union, so always connect outer things to the inner truth they symbolize, always experience in your heart how the inner reflects the outer and how the outer reflects the inner. Know that nothing in this world exists as separate reality, but that all things depend totally and utterly on the existence of the hidden treasure whose splendor they were created to unveil.

To unite the inner and outer senses also means
to unite the visible life of this world with the hidden life of the beyond.

76

AL-BĀṬIN

The Hidden, the Invisible, the Secret One, the Inward

62–248–3,844

Al-Bāṭin is the One who is veiled because of the omnipotence of His visibility. Whoever is visible is veiled from the invisible and whoever is invisible, is veiled from the visible. This is how the visible is connected to the invisible, and the invisible to the visible. You are the Visible, the Manifested, and nothing is higher than You. You are the Invisible, the Hidden, and nothing exists without You.

He is both the transcending cause of everything that exists and immanent in every phenomenon of His Creation.

Allāh Al-Bāṭin veils Himself from the physical eye and becomes Aẓ-Ẓāhir through the eye of the heart. He is Aẓ-Ẓāhir through His names, His qualities, and the light of His signs and symbols, and He is Al-Bāṭin through the divine truth that exists in all things. Human beings proclaim the light of the Divine Name Aẓ-Ẓāhir through their body and the light of the Divine Name Al-Bāṭin through their soul.

Sometimes life or a combination of circumstances requires us to remain in hiding and to exert our influence and our love from there. Connecting with the Divine Name Al-Bāṭin and discovering its resonance in you will help you restrain your ego that loves showing itself, and it will give you the calm and the poise to turn only to Him.

Whenever doubt attempts to conquer your heart, repeat those four Divine Names: Al-'Awwal, Al-'Ākhir, Aẓ-Ẓāhir, Al-Bāṭin.

Al-Bāṭin comes from the root *b-ṭ-n*, which contains the following meanings: hidden, secret, to hide, to try to discover, to have profound knowledge, to know exactly, to penetrate, to become absorbed; belly, womb, depth; inner, interior, inward, inmost.

Allāh is Ẓāhir and Bāṭin, Bāṭin because He is not visible and Ẓāhir through the manifestations that point to Him, through His effects and actions that lead to the knowledge of Him. Ẓāhir is therefore the ascension that enfolds Bāṭin.

Ẓāhir and Bāṭin represent God's exoteric and esoteric aspects, and the two-fold (outer and hidden) prophetic message of Prophet Muhammad, Allāh's peace and blessings be upon him.

Sura al-Ḥadīd, سورة الحديد, Iron (57:3)
He is the First and the Last, and the Outward as well as the Inward: and He has full knowledge of everything.

The four Divine Names Al-'Awwal, Al-'Ākhir, Aẓ-Ẓāhir, and Al-Bāṭin capture and cover, in time and space, the beginning and the end, the high and the low. Pre-eternity and post-eternity are the before and the after. Because everything that precedes, *sābiq*, leads to its precedence, *'awwaliyya*, to His fundamental truth, and every ending leads to its subordination, *'akhiriyya*, to His ultimate truth. This is how His fundamental truth and His ultimate truth enfold every beginning and every end, His outwardness and His inwardness enfold every outside and every inside. Nothing external exists that is not enfolded by Allāh and below Him, just as nothing internal exists without Allāh being below it and close to it. Those are the four pillars of Unity.

—Ibn al-'Arabī

Repeating together the four Divine Names Al-'Awwal, Al-'Ākhir, Aẓ-Ẓāhir, and Al-Bāṭin takes us to the center of peace and quiet, beyond beginning and end, beyond visible and hidden. This is the encounter with eternity.

Whenever you find yourself overwhelmed by your ego, torn and distorted by doubt and despair, repeat these words:

How can He be veiled from me whereas He makes everything visible!
How can He be veiled from me whereas He shows Himself in all things!
How can He be veiled from me whereas He manifests Himself for all things!
How can He be veiled from me whereas He was visible prior to any existence!
How can He be veiled from me whereas He is more visible than anything else!
How can He be veiled from me whereas He is the One next to whom there is nothing else!
How can He be veiled from me whereas He is closer to me than anything else!
How can He be veiled from me whereas there would be no existence without Him!

O Allāh, how close You are to me and how far I am from You! O You who are close, You who are

familiar, You are the One who is close and I am the one who is far! Your closeness to me made me doubt everything and my distance from You made me beseech only You. So be here for me and take me closer to You so that I may be free from supplication and from the supplications of others.

Repeat Al-Bāṭin every day and you will be able to see the truth in things. Observe the signs in the heavens above and deep within yourself.

The Sufis always use outer events and situations to gain inner awareness because in reality the outside is always at one with the inside. In this way, the whole world becomes a world of symbols. To awaken from half-sleep means to awaken from the state where we only pay attention to the things of this world for their own sake. The inevitable insight that the natural is permeated by the supernatural influences and transforms our being. We develop a feeling for the holy, a feeling for God because this is what holy things rightly demand of us human beings.

Indeed the outer world is not God, yet it cannot exist without Him.
When we are held by the inner path, the outer world can quietly disintegrate,
for the long journey home has begun.

77

<div align="center">

الوالى

AL-WĀLĪ

The Regent, the Ruler

47–188–2,209

</div>

Repeating this Divine Name fills you with a feeling of security and the certainty that you are enfolded in divine protection. When you say Yā Wālī, it is as if you were saying, "O You who love me and whom I love, You have enfolded me in Your kindness and Your blessing, and You have helped me carry You in my heart and on my tongue. You have made me a gift of gratefulness and opened to me the way that leads to You."

Al-Wālī guards us against seeing what we have achieved as ours, thereby falling into arrogance and complacency. Al-Wālī protects us from yielding to and obeying the voice of the tyrannical ego, and takes us time and time again back to our inner guidance. Al-Wālī grants us help, support, and protection on the path to our true self. Sometimes this intimate, protective love holds out its hand, sometimes it puts up a mirror on our way to Allāh, making sure that we do not succumb to the delusion of selfishness.

To invoke Al-Wālī means to open both your hands and to ask for protection, for a self-discipline born out of love, for harmony and balance.

The Sufis carry out their duties, do their work, and use their external activities and circumstances to grow inside on their path to their own perfection, to Allāh, without ever losing sight of Him.

Those who sow this name in themselves and who carry this quality into their life are ready to stand up for people's rights and for justice, free from any self-interested motives.

Their actions are prompted and influenced by their awareness of the Divine, not by changing circumstances or by the varying conditions of human societies.

Al-Wālī and Al-Walīy (55) both come from the root *w-l-y*, which contains the following additional meanings: to support, to connect directly, to lead, close, intimate.

Compared to Al-Walīy, Al-Wālī emphasizes essentially the protective aspect of the intimate relationship to Allāh.

Al-Wālī is the One who looks after all the affairs of the Creation. He is the Lord of all things, and He determines their progress. He is their guide; He is the deed and the doing.

Those who hold high positions and lead other people should repeat this name 1,000 times every week in order to be regents over themselves before they are regents over others, to awaken generosity and magnanimity in themselves before they can do so in others, and to experience kindness and compassion before they can exude them for others.

If you are going through difficult times and are faced with problems that weigh upon you, repeat this name often and it will bring relief.

Polishing the mirror of our heart begins with the Sufi practice of *dhikr*, when we focus our attention on the hereafter, throwing ourselves completely into the void, beyond reason, beyond the self. We concentrate inwards in order to open to the energy of the beyond, an energy that sweeps away the impurities of the *nafs*, or lower self. We realize that we are both a soul whose core is free from the chains of this world and human beings caught in the duality of good and evil, light and darkness. To stay connected, to stay present regardless of our inner or outer situation, to remain focused on Him while leading a balanced daily life, to behave according to the conditions of the moment—such is the work of the Sufis.

"When the wālī sees, he sees God's signs
and when he hears, he hears God's verses, and when he speaks, he praises Him
and when he moves, he moves in His service."
—Fakhr al-Din al-Razi

78

AL-MUTA'ĀLĪ

The Sublime, the Highest, the Uppermost
551–3,306–303,601

Life is constant movement, constant change. Today you are young and strong, tomorrow you may be weak and fragile. Today you are poor and in a difficult situation, tomorrow you may be rich and full of strength. Those who carry this divine quality focus their attention on understanding, finding, and being with Allāh, and keep whispering to themselves "O Lord, increase my knowledge and my understanding."

Al-Muta'ālī is superior to everything, and nothing can be compared to Him. He stands above everything transient, and He is the Source that never dries up and from which everything comes. Al-Muta'ālī is His infinite superiority to every existence, to every potential, to everything that may be described with human concepts.

Like Al-'Alīy (36), the Divine Name Al-Muta'ālī comes from the root *'-l-w*. The following words are derived from the same root: high, tall, elevated, exalted, sublime, excellent, resounding, ringing.

Al-Muta'ālī appears only once in the Qur'an, in the form Al-Muta'āl.

Sura al-Ra'd, سورة الرعد, Thunder (13:9)
*He knows all that is beyond the reach of a created being's perception, as well as all that can be witnessed by a creature's senses or mind—the Great One, the One far above anything that is or could ever be (*al-muta'āl*)!*

During childhood we develop strategies in order to cope with the overwhelming, incomprehensible world. We start to isolate ourselves, either by withdrawing or adapting. Then we start to elaborate a

strategy: we decide to become better and stronger than everyone else, or especially helpful, or remote from others. We do all that in order to cover our pain, our shame, our sensitivity—and we do it all looking for love because we were born out of the ocean of the One Love, and this is where our soul longs to return. But we identify with the veil of the isolated, wounded self. The One Love ceases to be our center and orientation, while the self-protective, complacent ego becomes our judge. We start seeking the peace, love, and happiness we yearn for in the outer manifestations. We begin to manipulate our environment in order to gain acknowledgment, protection, and security, so that we may finally overcome separation and the feeling that something is amiss. The ego takes the God-given love that belongs to our true self, with all its facets of virtues and potential, distorts it, and uses it to overcome fear and provide distraction. The first step toward our true self is to acknowledge this dilemma and to decide to walk back to love. Take a few brave steps and love will run to meet you.

We have all been shaped by life. The patterns and conditioning that influence our life and our viewpoints were formed first and foremost during our childhood, but we already carried some of them before coming into this physical world. On the level of the soul, we attract specific experiences in order to gain specific knowledge. This is how the main themes and issues are born that will be our lifelong companions. Some only feel loved for what they do and not for who they are, others feel excluded from paradise, some suffer from the helper syndrome and others keep playing victims. Others feel that they have not been protected properly, that they have not been seen, that they have not been treated with love.

It is worth striving to examine the origin and the causes, thereby clarifying our vision. Yet it is vital to experience them all as opportunities, as a deep potential serving a spiritual goal.

A distorting, consuming feeling of loneliness, weak self-esteem, jealousy, and the intensity of the various forms of desire and aggression can all lead to confusion and difficulties in our daily life.

Spiritual teachers identify these different states in their students, they know their true cause and their underlying meaning.

They know the aspects of the psyche and their connection to the potential and the spiritual goal. The students are acknowledged, loved, and transformed. By being understood, but above all by being loved, they can surrender completely and enter the circle of pre-eternal Unity. Indeed, transformation needs trust and love.

Al-Muta‘ālī gives us the strength to rise progressively to an expanded, superior consciousness. That consciousness carries us into new dimensions of knowledge. It makes us true servants of this earth, knowing that we cannot escape our responsibility. We are the burning point where everything comes together. Indeed we can bring balance, we can bring the light of Allāh into the world, we can bring about harmony or disharmony. We are bridges between heaven and earth, meant to mirror the divine light in the world, and our way of life should comply with this truth.

When you repeat this name time and time again, you can regain lost capacities. If you have been unfairly removed from a position or a job, you can regain it by repeating this name 540 times, God willing. Repeating this name before important meetings can help you be more effective. To be courteous and polite towards self and others means to be courteous to the Divine, because in Unity lies the Highest, the only truly existing One, Allāh.

Al-Muta‘ālī should help us follow the path of balance, responsibility, knowledge, and honesty, and to share that knowledge generously. It protects us from existing below the level that is ours as human beings.

Sura Ṭā Hā, سورة طه, O Man (20:114)
[Always] say: "O my Sustainer, cause me to grow in knowledge!"

AL-BARR

The One who relieves the burden, the Loving, the One who does good, the Kind
202–404–40,804

The Divine Name Al-Barr is the Benevolent, the One who kindly and generously dispenses health, material blessings, friends, and children. On the spiritual level, Al-Barr grants faith, returns good deeds, and fosters piety in the heart. Piety is simple—all it takes is an open face and a gentle tongue.

Al-Barr comes from the root *b-r-r*, which contains the following meanings: to be reverent, dutiful and devoted, to be charitable, to be beneficent, to do good, to give out of charity, to obey (especially Allāh), to honor, to be honest, to be true, to keep a promise or an oath, to warrant, to justify, to absolve, to carry out, to fulfill, to justify, to be justified; pious, truthful, rural, exterior; piety, righteousness, goodliness, kindness, gift, mainland, open country, wild, desert, outside, foreign, paradise.

When you do good to people, animals, plants, and to the Creation around you, you feel the reflection of the divine Al-Barr in you.

Al-Barr appears in the Qur'an once, combined with Ar-Raḥīm.

Sura al-Ṭūr, سورة الطور, Mount Sinai (52:28)
Verily, we did invoke Him [alone] ere this: [and now He has shown us] that He alone is truly benign (al-barr), *a true dispenser of grace* (ar-raḥīm)!

Zamakhshari says, "Since Adam's time until today, no human being has ever been free of mistakes." Perfection is a quality that belongs to God alone.

He shows kindness to those who oppose Him, He forgives the evildoers, He forgives those who ask for forgiveness and He accepts apologies, He covers our mistakes and weaknesses, and He is the

One whose blessings never end, even when the blessed one lives in rebellion. All that flows from the Divine Name Al-Barr.

Al-Barr fills the heart with joy and heals it. Al-Barr grants us dignity and helps us cope with our life.

Those who repeat this name often and carry it in their heart are given that which they long for. This name protects those who travel on land, on water, and in the air. It makes the journey easy, smoothes the way, and protects the travelers, their companions, and their possessions.

Out of love, Al-Barr helps us find inner and outer balance, so that inside and outside are consistent. Out of kindness, it helps us take an honest look at the way we see ourselves, time and time again, and it helps us transform in an honest, magnanimous, sincere, and respectful way. Al-Barr is a love that purifies and expands us so that we may come close to Allāh. Those who live divine love are called *al-'abrār*.

Truthfulness and sincerity take us to Al-Barr. Those who wish to come close to this divine quality do not cause pain to anyone, they do not wish any harm to anyone, they are not jealous of anyone; they are kind to their parents and lenient towards their enemies. Repeating this name protects from misfortune. We can express with Al-Barr all the various forms of kindness, mercy, and blessings we have been given. Allāh has created us to see us happy.

It is to our mothers that we owe a lot of the blessings we receive and in which we live because Allāh knows that every difficulty, every suffering that happens to her child brings grief and heaviness to a mother's heart.

Parents who have lost a young child should repeat this Divine Name, and if it is meant for them, they will be given another child, out of God's kindness and mercy. This kind name will also help those who tend to blame their environment and those whose listlessness prevents them from becoming involved in life.

The Divine Name Al-Barr contains our connection to our parents. It helps us learn to close our heart to any arrogance towards them and to open ourselves to mercy. It is the kindness and the good deeds that flow from you to your tribe, and can therefore flow from you to the branches that come after you.

If you are wondering how to reach goodness, how to reach that which is good in you, then answer yourself, "by being truly happy for the good things that befall others, without feeling any envy."

We human beings have been granted the intellectual and spiritual resources that enable us to distinguish between good and evil, and to make good use of the opportunities given to us by our earthly surroundings.

Allāh gives without question, and He asks for nothing in return. May we learn to do likewise. Those who carry this divine quality are kind and do good on the material as well as on the spiritual level. They draw their kindness and their compassion from their knowledge of the divine mystery.

Kindness is when you give of that which you love.
A smile too is an act of kindness.

80

التواب

At-Tawwāb

The One who accepts repentance, the One who leads to the return
409–1,636–167,281

To return always means to lead our senses to the essential, away from distracting outer forms, and that means to awaken our heart anew, time and time again. No matter how dark our path, how terrible our deeds, the way back to the Divine Essence, to God, is always open, until our very last breath. So remember that the way home is always there.

The Sufis are wanderers, *sālikūn*, who aim to attain holiness. Holiness is to clad the self with the divine qualities, the outer form with dignity, the inner form with beauty. But in order to do so, we must first transform and purify the flaws, bad habits, and prejudices that have become second nature to us, so that we may reach the virtues of our true nature.

Holiness is to withdraw and become absorbed in our own ephemeral self while turning to our divine origin. This is what the Prophet Muhammad, Allāh's peace and salvation be upon him, used to call the great holy war. It is to decide to give precedence to the eternal over the transitory in all things, thoughts, and pictures, until it touches our innermost being.

The Sufis' repentance, *tawba*, is the perfectly clear and sincere decision to walk this path and to put themselves at the mercy of the attractive force of the hereafter. Yet everyday life is both the starting point and the place of this spiritual journey. The world of manifestations becomes the place where we experience the Divine.

At-Tawwāb comes from the root *t-w-b*, which contains the following meanings: to repent, to be penitent, to turn from (sin), to renounce, to forgive, forgiving, merciful (Allāh), contrition.

In the Qur'an, the Divine Name At-Tawwāb is mentioned seven times, in combination with Ar-Raḥīm.

Sura al-Hujurāt, سورة الحجرات, The Private Apartments (49:12)
O you who have attained to faith! Avoid most guesswork [about one another]—for, behold, some of [such] guesswork is [in itself] a sin; and do not spy upon one another, and neither allow yourselves to speak ill of one another behind your backs. Would any of you like to eat the flesh of his dead brother? Nay, you would loathe it!
And be conscious of God. Verily, God is an acceptor of repentance (at-tawwāb), *a dispenser of grace* (ar-raḥīm)!

When a teacher explains things and makes them more accessible to the students, it is correct and fair towards them. But when a teacher alternates praise and scolding, cheers and punishment, smiles and seriousness, sometimes summoning their parents, all that in order to encourage the students to give their best and to spur them on the path of knowledge and uncover the capacities that lie dormant in them—that is mercy, that is Ar-Raḥīm. It is out of mercy that our path is formed, out of mercy that difficulties and hardships come. We are treated with the quality of mercy in order to reach the depths of our being and find paradise.

The Divine Name At-Tawwāb is a name of return. Its form and sound code carry the quality of continuous recurrence. Allāh keeps giving us situations and circumstances so that we return to the divine love, embed ourselves in the divine laws and live according to our deep being, in the ups and downs of the universe formed by the constant flow of Allāh's loving breath.

The Prophet Muhammad, Allāh's blessings and salvation be upon him, advised us, "Deal with this world as if you were to live a thousand years, and with the next as if you had to die tomorrow." Both attitudes complement and depend on one another because outer concentration requires inner concentration.

When you are capable of forgiveness, when you can forgive those who have upset or hurt you, at least partly, or when you can forgive yourself, you feel the quality of this Divine Name within you.

In order to receive the support, the strength, and the awareness to do so, repeat this Divine Name 409 times in the morning. May the weaknesses that stand in your way dissolve, and may you wake up one morning without remembering them. Beware of two things that can hold you up on your path: arrogance and half-sleep. For the Sufis, repentance also means to turn away from indifference.

Admit when you have been unjust, resolve not to do it again, use your bad conscience to strengthen your intention not to repeat the injustice, and seek inner purity by trying to make up for it. Put it into God's hands. In this way, you will be able to forgive both your own and your fellow human beings' carelessness.

Repentance is purification; it means to start again on the way home
after getting lost.

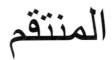

AL-MUNTAQIM

The Avenger, the One who repays justly

630–3,150–396,900

On the outside, this Divine Name carries the quality of majesty, and, hidden inside, it carries the quality of beauty. Majesty encompasses that which is powerful, overwhelming, and awesome. Beauty encompasses kindness, surrender, love, and inner peace. The Divine Names invariably carry both qualities, but sometimes beauty is more apparent, sometimes majesty.

The root *n-q-m* contains the following meanings: reward through punishment, to take revenge, to deny, to reject a gift, to harbor hostile feelings, to detest, to take in bad part, to be angry, to hate, to hold something against someone; vindictive, revengeful; avenger.

When you repeat this Divine Name, your heart starts quivering violently and you feel as if it were going to jump out of your chest. It is squeezed by fear, a fear as deep as basic trust. In that moment of dissolution, divine mercy manifests, the qualities of divine beauty open, and the heart returns more trusting and calmer than before. This is how the shaking was the source of peace. Because everything is always about healing the heart.

Al-Muntaqim is the great avenging campaign against our own selfishness, against that numbing force that leads us to only see ourselves, cut off from Unity and the connection of all beings, wrapped in self-pity. It is the fight against lethargy, narrow-mindedness, racism, arrogance, prejudice, and the lack of awareness that constantly threaten to capture us again.

To learn to start on our own, individual journey to our origin while simultaneously focusing on the whole, on the energy of Unity, to be guardians of this planet, to overcome isolation and separation,

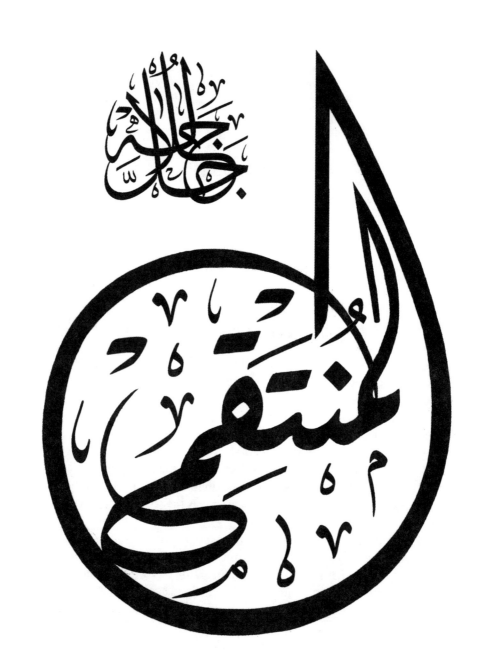

and to find the connection to all of Creation—that is the next step in our human spiritual evolution. To allow and to follow the feeling of mutual attachment forces open the chains of the illusion of separation and brings the peace we long for.

Control your anger, forgive those who have been unjust to you, connect and bring together that which has been broken, exercise love and knowledge where ignorance rules, and in so doing, always keep the face of Allāh in your heart. He is the Eternal Reality.

When we are connected to our true nature, the light of the higher energies of our inner world can manifest. This is how the inner knowledge of the true self, a knowledge of love and Unity, can be brought down to a lower level of manifestation.

To come out of our ego, to divert our attention from our ego, to stop seeing ourselves as the center of the universe and to participate in it leads us to our wholeness. We become many centers!

The vortex and the forces of materialism have become so powerful and dense that we need the help of all those who carry in their heart a commitment to humankind and to the creatures of this earth.

Allāh grants the strength to work for humankind to all those who participate in that work.

In our cultures, we have come to identify too much with the patterns of hierarchy and the various forms of exclusion. Our selfishness makes us support, consciously or unconsciously, systems based on oppression and exploitation that inevitably lead to aggression and wars. We have come to overlook the original truth, namely the all-embracing dimension of Unity. But our true nature longs for harmony and peace. At some stage in our life, we should clearly decide whether we want to follow the path of love, with everything that comes with it, or the path of separation, because our daily dealings are based on this conscious assertion. This forms our center, from which we can weigh and put everything into perspective.

The way of the Sufis is the path to Allāh, and He is their only center. Their love for Him shapes their deeds and their relationships, and they are able to look over the edge of their small self and work for Unity in this world. It does not matter whether you have just started on the path or have years of spiritual practices behind you. Everyone is granted equal access for such is the law of Unity.

When suffering comes to you from others, trust the divine energy.

حسبيا الله ونعم الوكيل

hasbiya llāh wa ni'ma l-wakīl

God is enough for me and He is the One who repays me most fairly.

If the suffering inflicted by a tyrannical person persists, then repeat Yā Muntaqim, Yā Jabbār (9), Yā Kabīr (37), Yā Muta'ālī (78).

To shape strength and healing power in you, repeat Yā Muntaqim, Yā Qahhār (15) 1,000 times in one day. The tyranny will cease, Allāh willing.

Use this name to wipe from your heart everything that feels superficial or unnatural, including that which you have adopted in order to please others. Set your true nature free so that you may recognize the Divine in you. Look outside, at situations, events, and relationships in your life, then turn your gaze inwards and see if the impressions and the voices in you come from your deep self or if they are foreign, adopted, and it is not up to you to deal with them. Anchor yourself in your essential being. Look at your life situation with the eye of your heart. What can be adjusted, purified, relinquished? What does your inner house look like and how can you give things their appropriate place, taking into account the meaning and goal of your life? Honor the space of your heart and treat your soul with love and respect. Let the winds of respect and dignity flow through your lungs.

There are two levels in healing the heart. One heals the hardened hearts, freeing them from the rust that has darkened them as a result of all kinds of suffering, and covered the light that lives in them. The other increases the compassion and mercy of open hearts. Remember that the state of the heart influences the body.

May you always have the strength to transform your revenge into compassion, the injustice done to you into justice, and estrangement into affection; in doing so, may your heart always be turned towards Allāh.

Mankind's greatest enemy is selfishness
because all evil comes through selfishness.

82

العفو

AL-'AFŪW

The One who forgives

156–468–24,336

When you repeat this Divine Name, you feel enfolded in the light of mercy and compassion, a light that awakens hope and gentleness, a light that dissolves worries and lightens the heart.

The quality Al-'Afūw gives us the strength to overcome humiliations and upsets without threat or punishment, solely through kindness and generosity, without shaming the other by reminding them of their weaknesses. This name erases all traces and lets mistakes fall into oblivion. Such is the quality of Al-'Afūw.

The quality of forgiveness is also explained as follows: those who forgive cover up the tracks of injustice. They let the winds of forgiving mercy blow them away from their heart and wipe them from the board of their own memories, because forgiving means to wipe out and to forget. When we regret our mistakes truly and deeply, divine mercy comes and lets our senses and our heart forget them, and it removes all traces of our mistakes from the earth.

If you have made a mistake and you are afraid of the consequences and punishment, you should repeat this name many times and Allāh will protect you from what you fear.

Al-'Afūw comes from the root '-f-w, which contains the following meanings: to eliminate or to be eliminated, to forgive, to regain health, to heal, to ask for someone's pardon, to wipe out, to free, to exempt, to eliminate, to restore to health, to cure, to protect, to save, to dispense, to recover, free, effacement, obliteration, favor, kindness, pardon, forgiveness, young donkey.

Therefore Allāh Al-'Afūw does not only carry the power of forgiveness. He makes even the slightest traces of wounds and upsets vanish so that we do not retain any memory of them. Al-'Afūw makes the

heart free again and lets it recover once more. Al-'Afūw is a gift of God that emerges from the depths of our being and frees us. At-Tawwāb (80) is the Divine Name that prepares us for Al-'Afūw.

If you recite this name 156 times during the day, you will gain greater control over your ego, your character will become more refined, and your surroundings more forgiving.

When you feel overcome by anger or rage, reciting this Divine Name will appease you and help you find your center again. Hold this sentence in your heart in deep compassion for yourself: Allāh treats me as I treat the Creation.

The bitter and the sweet are Allāh's generous gifts, sometimes to test us, sometimes as fair punishment or consequence, yet invariably as a real possibility, a remedy on the way to maturity, freedom, and perfection.

The day when the veils are lifted and the wisdom that underlies our difficulties is revealed, we will dissolve, overwhelmed by Allāh's love.

The deep mercy that lives in this name opens the heart to the One who grants it and expands the spirit with a touch of knowledge about His divine plan.

> *O Allāh, overlook and absolve me from the humiliations*
> *I have brought upon myself and teach me to love!*

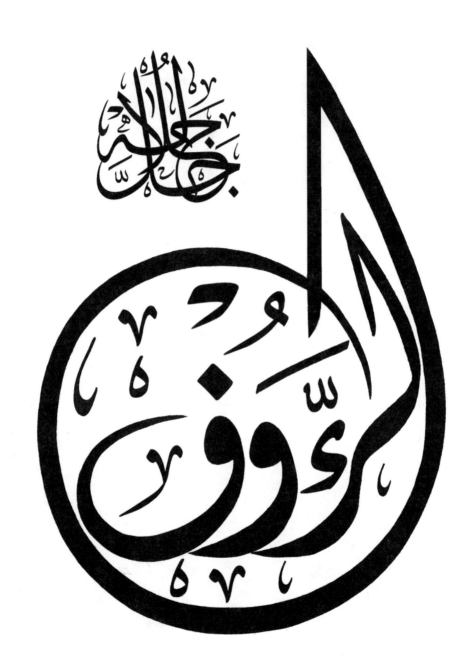

83

الرؤوف

AR-RA'ŪF

The Mild, the Tolerant, the Compassionate, the Kind, the Friendly
292–1,168–85,264

Hadith Qudsī
On the Day of Judgment, God will say, "O son of Adam, I was sick but you did not visit Me."
He would say, "O my Lord! You are the Lord of the worlds. How could I have visited You?"
God answers, "One of My servants was sick but you did not visit him. Had you visited him,
you would have found Me by him." And God continues, "I asked you for food and you did not
feed Me; I was thirsty but you did not give Me anything to drink."

This hadith illustrates the union between Allāh and humankind. It shows that the core of humans is
identical to God, that humans discover their happiness and their immortality when they reach God, and
that they are unhappy when they become estranged from God.

Sura al-Baqarah, سورة البقرة, The Cow (2:156)
Verily, unto God do we belong and, verily, unto Him we shall return.

Sura al-'Ankabūt, سورة العنكبوت, The Spider (29:8)
*It is unto Me that you all must return, whereupon I shall make you [truly] understand [the
right and the wrong of] all that you were doing [in life].*

Gentleness and tolerance are essential qualities, especially toward children, and toward the sick,

the suffering, the weak, and the old. To fill one's heart with gentleness, tolerance, and kindness means to have found one's dignity as a human being. Gentleness and compassion do not abide by any laws.

Human beings who carry the qualities of gentleness and tolerance have opened the source of divine grace within themselves. If you repeat this name 287 times, your heart will fill with compassion for others. It will give you the strength to help others and create a bridge of compassion between you and them.

Ar-Ra'ūf comes from the root r-'-f, which contains the following meanings: to show mercy, to have pity, to be kind; mercy, compassion, pity, kindness, graciousness, benevolence, indulgence.

The word ra'fa, which means compassion and kindness, comes from the same root. In connection to humans, it indicates the process that leads to softening of the heart. To expand ra'fa beyond our loved ones means to pass over to the all-encompassing mercy, rahma.

Ar-Ra'ūf and Ar-Rahīm (2) are often repeated together because they carry the same nature. In connection to God, ra'fa is great kindness, mercy, and friendliness.

Sura al-'Imrān, سورة آل عمران, The House of 'Imrān (3:30)
On the Day when every human being will find himself faced with all the good that he has done, and with all the evil that he has done, [many a one] will wish that there were a long span of time between himself and that [Day]. Hence, God warns you to beware of Him; but God is most compassionate (ra'ūf) towards His creatures.

Ar-Ra'ūf awakens in our heart a quality of softness, kindness, and friendliness so delicate and permeating that it can resonate through the walls of hatred and malice because we then act from the seat of our true self, in quiet, calm love, instead of reacting from our wounded self where we are upset and hurt. Ar-Ra'ūf does not help us endure or overcome malice; it eliminates in us every response to it. When Ar-Ra'ūf exists, there is nothing to defend because we are enfolded in the light of kindness, which enables us to touch the wounds in the hearts of others. Because it is out of those wounds that the fears, the oversensitivity, and the attacks come.

Allāh in His quality Ar-Ra'ūf brings us to go into repentance before we make a mistake. If we do make a mistake and consequences manifest, then Ar-Rahīm is the One who will neutralize them.

The grace and the kindness of Ar-Rahīm are all-embracing. They can take us in completely and at the same time paralyze us in their greatness. Ar-Ra'ūf carries a more specific quality. It is the feeling of mercy and compassion for someone in particular that can express itself more concretely due to this 'limitation.'

When we see to it that we do not give someone the opportunity to do something bad—for instance, tempting someone into theft by leaving jewelry lying around—it comes from the quality Ar-Ra'ūf. To take the time to talk with our children, to advise and accompany them so that they grow stronger and may be protected from making the wrong choices, also comes from Ar-Ra'ūf.

Ar-Ra'ūf is the attentive, watchful, protective hand whose outer expression may be soft or sharp, but is invariably led inside by the boundless ocean of mercy and gentleness. Ar-Ra'ūf gives us a quiet inner strength that we can retain even in moments of panic and fear or amid great difficulties. For Ar-Ra'ūf touches and soothes our deepest fears.

Respect other people's ways and do not disdain anyone's existence.
In the beginning is kindness, in the end forbearance and gentleness.

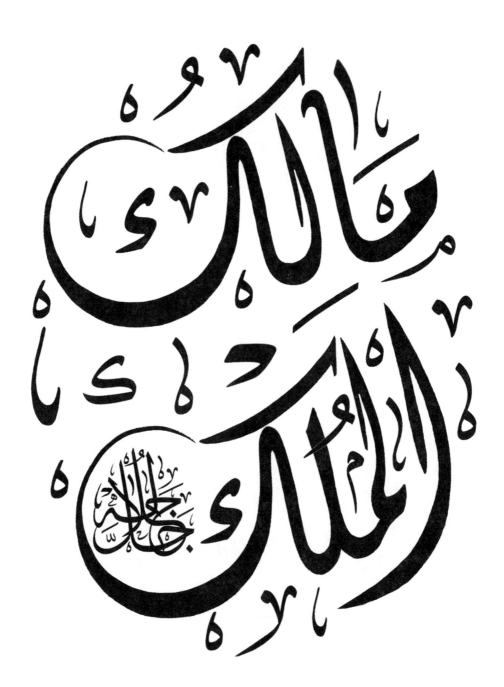

84

<div align="center">

مالك الملك

</div>

MĀLIKU-L-MULK

The ultimate Owner, the Ruler of power, the Lord of the worlds

212–1,908–44,944

When you repeat this Divine Name, you dive into a world where you feel and realize that you own nothing of what belongs to you.

Māliku-l-Mulk shows that every manifestation in the universe rests entirely on Allāh. When we repeat Māliku-l-Mulk or Yā Malika-l-Mulk (by adding *Yā, Māliku*, it changes into *Malika*), the knowledge opens in our heart that although everything in life keeps changing, it is forever in God's hands. This discovery enables us to become involved and participate in life. The awakening of Māliku-l-Mulk removes from us the veils of meaninglessness and gives us trust in life and in humans. Everything rests in His hands, and when our heart opens to this knowledge, we can see life's transitions and changes as the moving picture of eternity. This is how we can live in time while bearing witness to eternity.

The universe is a macrocosm that is reflected in the human microcosm. Human beings are divine representatives on earth. For a period of time, some are given wealth, others knowledge, and yet others power. Human beings are free to choose how they deal with what they have been given. They can choose to embed themselves in humankind by kind, well-considered deeds that lead to connection, or to follow their ego. Whatever you decide, always remember that nothing you own is yours. May your warmth and the sweetness of your heart always dispel the demons of greed and envy that invariably enter through the gate of doubt.

Like Malik (3), Mālik and Mulk come from the root *m-l-k*.

Mulk means rule, reign, supreme authority, dominion, dominance, power, sovereignty, kingship, royalty, right of possession, ownership.

Malik means reigning, ruling, owning, possessing, holding; owner, master, possessor, holder.

When we repeat this Divine Name, we realize that we have been sent to this earth as divine representatives in order to rule and serve the universe and ourselves. If you repeat this name 212 times every day, doubt will change into confidence, and the fear of owning nothing will dissipate. Repeating this name teaches us one of the greatest feats: self-control.

Allāh has given us the whole universe as a sign of His existence in order to lead us to faith and to praising Him, and He has created the whole universe as an expression and proclamation of His Divine Names and attributes.

The whole universe, with all its creatures, minerals, plants, and animals, is represented in the singular *al-mulk*. The singular form is used here because everything is connected. Every part stands for the whole and contributes to our being together—the animals for humankind, the plants for the animals, the earth for the plants, the water for the earth. The greatness of the earth fits human capacity and strength, and its rotation fits human faculties. All complement one another in Unity, and all submit to a single divine will. One kingdom for one King—Māliku-l-Mulk.

To know that whatever happened had to, and could not have happened if it was not in accordance with God's unfathomable plan—that gives us the capacity to react with conscious equanimity and trust in whatever happens to us, be it good or difficult.

Those who see themselves and everything as belonging to Allāh become one with Him, and they will need nothing else.

85

<div dir="rtl">

ذو الجلال والاكرام

</div>

DHŪ-L-JALĀLI WA-L-IKRĀM

The Lord of majesty and magnanimity, the One who is full of dignity and honor

1,100–17,600–1,210,000

This Divine Name is made of three parts: *Dhū* means lord, owner, proprietor, gifted or endowed with, containing something; *Al-Jalāl* means the all-encompassing, powerful majesty, sublimity, splendor, and glory; *wa* is the conjunction "and"; *Al-Ikrām* is unconditional, loving generosity, honoring, friendly reception, and kindness.

This Divine Name carries power and beauty in a very balanced and obvious way. It grants balance and shows the all-embracing, omnipotent presence of the Divine in everything. It harmonizes and takes us to the state of Unity.

Like the Divine Name Al-Jalīl (41), Al-Jalāl comes from the root *j-l-l*, which contains the following meanings: to be great, to be beyond something, to be far above something, to be innumerable, to honor, to dignify, to envelop, to border; lofty, exalted, illustrious, sublime, great, outstanding.

Like the Divine Name Al-Karīm (42), Al-Ikrām comes from the root *k-r-m*, which contains the following meanings: nobler, more distinguished, more precious, more valuable, most honorable, very high-minded, very noble-hearted, most generous.

Dhū-l-Jalāli wa-l-Ikrām or Yā Dhā-l-Jalāli wa-l-Ikrām can bring balance, especially in dealing with power or control, generosity or wastefulness.

All perfection belongs to Him. Divine generosity is to let us discover the divine manifestation in everything. The recitation of each Divine Name arouses a very specific quality of praise in the heart. Sing in your heart and have trust! The greatest divine generosity manifests when a human being has

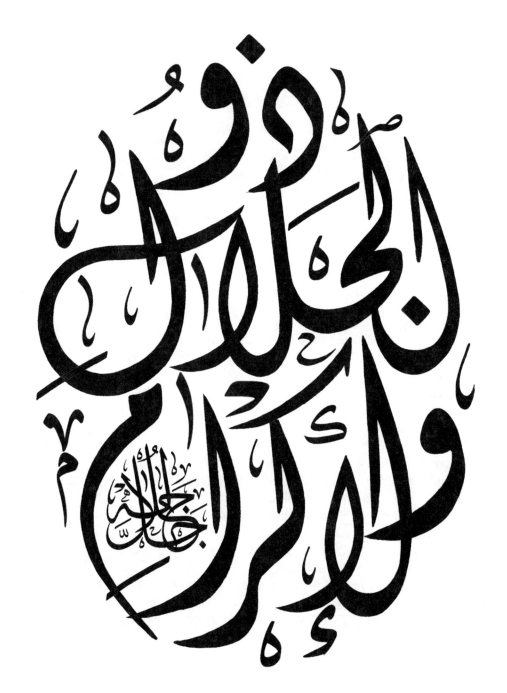

been granted knowledge. Allāh is openhanded and generous, and He loves those who are generous. Repeat this name whenever you ask Allāh for something, whether for your material or spiritual life. Repeat this name 100 times every day; it carries the divine light and divine wisdom.

Dhū-l-Jalāli wa-l-Ikrām appears in the Qur'an twice.

Sura Ar-Raḥmān, سورة الرحمن, The Most Gracious (55:27)
But forever will abide thy Sustainer's Self, full of majesty and glory.

Sura Ar-Raḥmān, سورة الرحمن, The Most Gracious (55:78)
HALLOWED be thy Sustainer's name, full of majesty and glory!

Each of these two names contains thousands of degrees of sublimity and splendor, thousands of levels of perfection and blessings.

All forms and expressions of perfection and beauty are gathered in the Divine Name Al-Ikrām, while all manifestations of power and strength are gathered in Al-Jalāl. The qualities we admire converge in Al-Jalāl, those we love in Al-Ikrām.

All aspects of dignity and power, as well as beauty and kindness, unite in the Divine Name Dhū-l-Jalāli wa-l-Ikrām, therefore bringing together all the Divine Names.

Perfection befits Allāh, and He is beyond all praise and glorification. Every creature depends on Him, all dignity, strength, beauty, and honor come from Him, and every need is fulfilled by Him.

Yet He has bound His creatures with the invisible thread of mutual need so that kindness, tolerance, communication, and joy may develop among them all. But do not forget the One who granted you the strength, the capacity, and the great honor to be able to help. What a privilege it is to carry and disseminate Allāh's kindness! O Allāh, may Your will be done in me!

Allāh's visible blessings manifest as comforts and good fortune,
His invisible blessings as problems and misfortune.
Diverse and beyond counting are His favors.

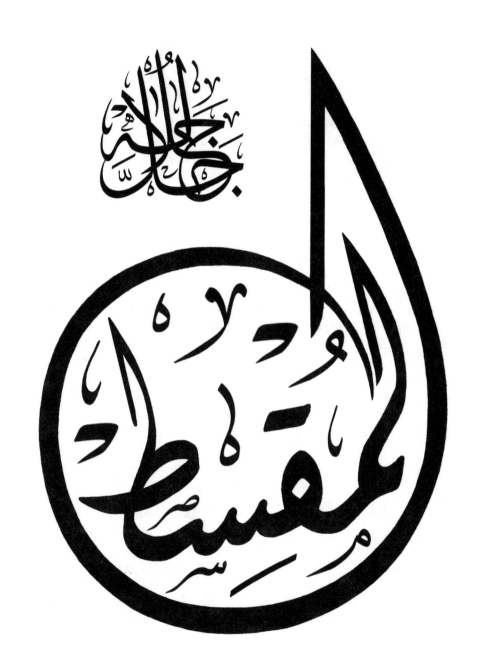

86

<div align="center">

المقسط

AL-MUQSIṬ

The Righteous, the Impartial, the One who judges impartially

209–836–43,681

</div>

When you repeat this Divine Name, you feel that your soul becomes quiet and the waves of anger and loss of self-control slowly ebb away, which had been brought about by life's efforts, misunderstandings, and obstacles, as well as by the injustices suffered at the hands of human beings.

Al-Muqsiṭ comes from the root *q-s-ṭ*, which contains the following meanings: to distribute, to pay in installments, to act justly, to act in fairness, to act equitably, doing right; justice, fairness, fair-mindedness, rightness, correctness, part, share, stiffness of a joint.

Al-Muqsiṭ is the One who allocates to everyone what they justly deserve. Although the shares are not necessarily equal, they are still fair because Allāh only gives fairly. Gifts and talents may not always seem just, but there is a justice. Al-Muqsiṭ always comes to us, even when we have the feeling that it is not present or that our needs have not been satisfied. Like Al-'Adl (29), Al-Muqsiṭ is a Divine Name of justice, but in a different way because it brings to the forefront balance, impartiality, and equal rights.

To repeat Al-Muqsiṭ will especially help us when we feel that life is not treating us fairly. This happens in particular on the material level or when we want to have children. We often believe that Allāh loves more those who are rich or who have had children. Al-Muqsiṭ helps us go deeper, discover the wisdom of divine soundness, and expand our heart to the divine plan. Al-Muqsiṭ cannot be accepted without an open heart. Allāh has given their share to every being. The reason why some get more and others less is veiled from our individual, personal point of view. Al-Muqsiṭ is the scale, in which Allāh sometimes lifts us and sometimes lowers us, both on the material and spiritual level.

Sura Ar-Raḥmān, سورة الرحمن, The Most Gracious (55:7–8)
And the skies has He raised high, and has devised [for all things] a measure, so that you [too, O men,] might never transgress the measure [of what is right].

Every mother knows that her child is unique and that it should be seen and accompanied according to its uniqueness. Her love to all her children is the same, yet every child needs a different kind of attention. But when a child has the feeling that it is getting less than the others, when it has the feeling that it is not seen or valued, then a deep wound appears, a hollow that will be filled and protected by self-pity, an enduring feeling that one comes off worse, a permanent feeling of lack, or egocentrism. This is what brings about the veils of envy, malevolence, malice, greed, and jealousy.

Al-Muqsiṭ opens for us the path to the uniqueness of our soul, enabling us to see, realize, and treasure the part that has been given to us so that we may fulfill our task, our part in life, our contribution to this world. When we connect to our true self, when we walk the path that leads there through the wound, we realize that our true existence does not depend on outer circumstances. Al-Muqsiṭ reflects the beauty and the majesty of our soul, our true self.

Human beings who carry this quality have learned to see behind duality, and they are able to remain just and balanced in difficult situations. Those who can seek refuge in the Divine when they realize that they have been mistaken or unfair in their judgment or deeds, and apologize to those they have treated unjustly, carry the quality Al-Muqsiṭ.

Al-Muqsiṭ is the Righteous. The closer we come to this name, the more we are careful to treat all humans, in fact all beings, fairly. We stand up for justice in this world, we help those who need protection, we strive for truthfulness and balance, and we also motivate others to do so.

Start by learning to be fair to yourself, balanced in your viewpoint and in the way you treat yourself before extending it to your fellow human beings, to all animals, plants, stones, and minerals.

Yet only Allāh is truly righteous. He is the source for all those who long for justice.

Drinking from this name changes our vision and our understanding. We learn to judge not those who harm us but what they do, not the corrupt but their aberrations, not the hostile ones but enmity itself. Al-Muqsiṭ touches the senses and transforms them into servants of justice. Al-Muqsiṭ gives us the strength and courage to grow by admitting our own mistakes because people of goodwill have always longed for justice.

Repeating this Divine Name 209 times calms people who are in the state of anger and depression. It will also help you collect wandering thoughts whenever you find it difficult to concentrate during meditation or prayer. Seek refuge in the Divine, help people reconcile, including with themselves, and be fair to your fellow human beings, be they friend or foe.

As long as you give more to yourself than to someone you have never seen before, you have not touched the core of your soul.

On Judgment Day all the animals will bow in front of Allāh
to thank Him for not making them human,
because great are the offenses of humans and countless their shaming deeds in this world.
Allāh loves those who treat His Creation with tender love.

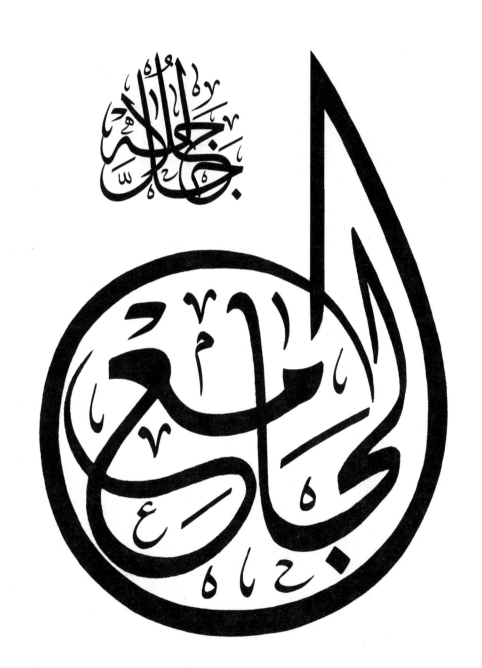

87

AL-JĀMI‘

The One who gathers, the All-Embracing, the One who brings together

114–456–12,996

The Divine Name Al-Jāmi‘ brings together that which belongs together and that which does not, that which is similar and that which is different. It brings together the stars and the galaxies, the earth and the oceans, the plants and the animals; it brings together what is big and what is small, what is of different shapes and colors, and in the bodies of the creatures it brings together fire, water, air, and earth, humidity, dryness, heat, and cold. To be on the path of love means to let go inside, and to bring together and unite outside. For our deeds are the companions we retain. The day when the bird of your soul leaves the cage of your body, you find yourself alone with your deeds, which are the children of your intentions. So let this encounter be filled with light and meaning, not lost and worthless.

The Divine Name Al-Jāmi‘ comes from the root *j-m-‘*, which contains the following meanings: to gather, to collect, to unite, to combine, to bring together, to put together, to join, to set, to compose, to have sexual intercourse, to compile, to sum up, to add, to pile up, to pull together into unity, to be or to get together, to meet; broad, general, universal; collector, mosque, Friday, university, union.

Al-Jāmi‘ gives us the ability to unite our inner worlds into an organic whole by bringing about unity between feelings, thoughts, and deeds. Al-Jāmi‘ sets off the process of inner union. On the outer level, it is the ability to bring together people with their different wishes and capacities, the surrounding energy and the different circumstances under a shared spiritual force of security, belonging and love, so that they become a living community.

Allāh unites us human beings, for instance on the Day of Resurrection. But He also brings us together through what we call chance meetings, which often develop into meaningful encounters.

If you have lost something, be it a loved one or a favorite object, repeat the Divine Name Al-Jāmi' 114 times. Then recite these words.

<div dir="rtl">يا جامع الناس ليومٍ لا ريب فيه إجمع بيني وبين حاجتي</div>

yā jāmi' an-nāsi li-yawmin lā rayba fihi ijma' baynī wa bayna ḥājatī

O You who gathers humankind on the day when there is no doubt,
unite me to that which I have lost.

Yā Jāmi', help me unite my actions with my inner truth!

There will come a day when we are all gathered by Allāh, the oppressor with the oppressed, the weak with the powerful, the giver with the taker. He will gather us all and He will take from the oppressor to give to the oppressed. He will take from the exploiter to give to the exploited. May our deeds protect us like a mantle on that day!

Allāh Al-Jāmi' connects similarities and differences, uniqueness and universality, opposites and complements, up and down, the visible and the invisible.

When Adam and Eve were separated from paradise and sent to earth, they found each other again by repeating this name. Those who carry this quality live their inner state in harmony with their outer deeds. They can bring opposites together both in themselves and around them. People who repeat this name often are granted the ability to collect themselves and to connect to the richness in their heart. The world greets them with open arms, and they can take it without becoming a slave to it. This freedom brings a deep knowledge that touches the hearts of the people and attracts them. Heart connections come to be.

Let your individual will become one with the divine will. Everything that happens is ultimately Allāh's will.

Thanks to the Divine Name Al-Jāmi', every being shares in the Divine, taking its essence and its substance from Him and returning to Him.

88

AL-GHANĪY

The Rich, the Self-Sufficient
1,060–3,180–1,123,600

Allāh is the Rich One who depends on no other, yet all depend on Him. The divine quality Al-Ghanīy means the One who owns in abundance, the One without ties, the Independent. It is opposite to *faqīr*, which is poverty and neediness, necessary qualities of all created beings. When we acknowledge our own neediness, when we experience our achievements and successes as gifts from Al-Ghanīy, and we ascribe them to Him, an inner transformation begins that takes us to the expanses of freedom.

Many rich people let their heart darken through arrogance, vanity, and pride, forgetting that true beauty is born from gratefulness for wealth and from modesty at the service of human beings. If you repeat the name Al-Ghanīy often, envy will disappear from your heart. People who are in material need should repeat this name 1,060 times on Saturdays, and they will not need the help of others. When you know that Allāh alone is absolutely rich, you only need to ask Him for help.

The Divine Names Al-Mughnī (89) and Al-Ghanīy both come from the root *gh-n-y*, which contains the following meanings: to be free from want, to be or to become rich, to be wealthy, not to need, to be able to spare (someone or something), to manage, to have no need, to sing, to chant, to make free from want, to enrich, to be adequate, to be of use, to be of help, to avail profit, to satisfy, to lay off; prosperous, well-to-do, wealth, riches.

The Divine Name Al-Ghanīy appears nine times in the Qur'an, together with Al-Ḥamīd (56).

Sura Luqmān, سورة لقمان, (31:26)
Unto God belongs all that is in the heavens and on earth. Verily, God alone is self-sufficient (al-ghanīy), the One to whom all praise is due (al-ḥamīd)!

315

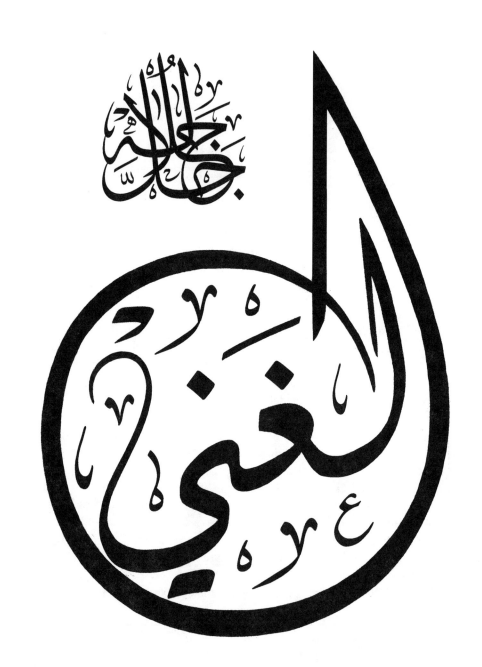

Not to depend on other people still means to share in their worries, to look after them, to take part in their joy and their pain, to be open to their needs and wishes. The combination of these two names reminds us that in His independent wealth Al-Ghanīy, Allāh is always present for people, giving to them, forgiving them, and leading them.

Repeating this generous name helps us when we are constantly confronted with difficulties despite our inner and outer exertions on our spiritual path. It is like asking for the breathing space we need or believe we need. May Allāh's answer shed light on our situation.

This Divine Name should always remind us that generosity and kindness are the basis of our origin, whence we come and to which we return. Repeating Al-Ghanīy nourishes the generosity in us, putting an end to the pettiness that is so often an obstacle.

> *Do not long for that which you do not find*
> *and do not take greedily of that which you find.*
> *Do not look at others' possessions*
> *and do not envy what is given to others.*

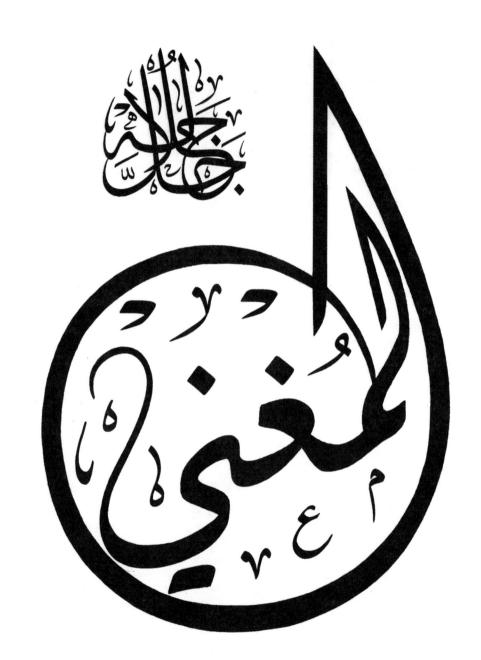

AL-MUGHNĪ

The One who makes rich, the Enriching

1,100–4,400–1,210,000

Most of the time, the Divine Names Al-Ghanīy (88) and Al-Mughnī are repeated together.

The Divine Name Al-Mughnī, the One who makes rich, awakens first and foremost the quality of contentedness in the heart, because true richness expresses itself in contentedness. One can be made rich through material goods, and this is the common understanding of richness. One can be made rich through knowledge, and that is a precious form of richness. One can also be made rich through contentedness and freedom from attachment. Yet the greatest richness lies in the heart of the believer.

And what is true poverty? True poverty is greed and miserliness. It is this invisible demon that never leaves the heart in peace. It is the feeling never to be sated. Trust in Allāh and keep your dignity through contentedness, patience, and gratitude. Act and speak in such a way that you remain truthful without hurting others' feelings through your words or deeds.

This earth is the place of experiences and getting to know oneself. It is the place where we admit to a color. Interestingly, in Arabic, people ask, "How are you, what is your color?" And the color of a human being is known by the way they deal with what belongs to them: the material goods they have been given, time, and above all the Creation—and Creation starts with oneself.

Truly enriched are those who have been given knowledge, wisdom, and faith.

Whatever we are given, whatever situation we are put into, it is always an opportunity. Some of us are given material riches—with the danger of arrogance. Others are given poverty—with the danger of

doubt and complaint. Gratefulness and generosity in the former, trust and patience in the latter bring together lack and abundance. Allāh helps those who are willing to change their states and themselves.

If you repeat the Divine Name Al-Mughnī 1,121 times on 10 consecutive Fridays, it will contribute to releasing nervous tensions. Al-Mughnī helps us become free of the torments of greed.

Al-Mughnī is a channel through which God's riches flow into the world. The energy of the Divine Name Al-Mughnī is considered one of the most healing that can bring about changes on the bodily, material, and spiritual levels, and should therefore be used in a responsible way. Everything is connected, because whatever we do has consequences. So always ask the question, "May I, can I, should I, O Allāh?" before you undertake anything.

Whoever wants to walk the path of richness must become generous.

90

AL-MĀNIʿ

The One who averts harm, the One who wards off, the One who hinders

161–644–25,921

Every Divine Name carries a secret and a deep knowledge, whose truth manifests in the heart after many repetitions. There are two spiritual practices meant to awaken the sweetness of surrender in the heart: *dhikr* (ذكر), the collective ritual in which the heart is addressed through constant, voiced remembrance of God, accompanied by breathing and movements, and *fikr* (فكر), the silent remembrance of God performed during individual meditation. Through them we aim to know love and closeness to the Divine, and the eternal light present in and behind all manifestations.

The Divine Name Al-Māniʿ comes from the root *m-n-ʿ*, which contains the following meanings: to stop, to detain, to keep from entering or passing, to hinder, to prevent, to restrain, to hold back, to block, to withdraw, to take away, to forbid, to prohibit, to refrain, to fortify, to strengthen, to put up resistance, to act in opposition, to stand up, to rise against, to refuse, to forbear, to leave off, to avoid, to seek protection, to resist; hindering, forbidding; obstacle, power, force.

The Divine Name Al-Māniʿ, the One who averts and wards off harm, is carried by the quality of giving. For whoever wards off, gives, and whoever gives, wards off. When He wards off poverty from you, He gives you wealth, and when He averts illness from you, He gives you health. And when He wards off ignorance from you, He gives you knowledge. So carry in your heart the words, "O God, no one can withhold what You wish to give me, and no one can give me what You wish to withhold from me."

Our love for God truly shows when we prefer the withholding to the giving, that is, when we are equally satisfied with the one as with the other. For everything comes from You, Allāh.

The Divine Name Al-Māni' always contains the averting of harm through protection and mercy. However, what is given or held back can be felt as negative because we wished for something else. But whenever something is held back, something more useful is given, even if what is given or held back is hard to endure because it always sets off an inner process and demands a transformation, a refinement. The inner fire begins to glow and the heart calls, "Remove one more veil of half-sleep from me!"

Those who carry the quality Al-Māni' are protected and protective people. They protect the people around them from negative things, even when those things appear in seductive guises such as fame, riches, or joy.

The wish to serve becomes noticeable when we enter into contact with our soul. It is the soul that wishes to serve because it is in its nature. Once we touch our soul, our first reaction—whether we follow it or not—is to long to serve the world in one way or another.

Those who know say, "When Allāh opens the eye of your heart, you know that warding off and rejecting is the source of giving!"

Do not take the world and its gifts as a yardstick for giving and refusal, reward and punishment, because neither is giving a sign of God's reward, nor refusal a sign of His punishment. Both are signs of His wisdom and mercy. All beings are given according to what is useful and beneficial to them.

Repeating this Divine Name 161 times mornings and evenings helps relieve pain and fear. When passion in a couple has become weak, repeating this name silently when in bed will kindle love. Repeating this Divine Name during a journey helps to keep danger and difficulties at bay.

The ways to God are as many as His creatures,
but the shortest and the fastest
is to serve others, to disturb no one,
and to make others happy.

91

AḌ-ḌĀR

The Creator of harm, the One who gives disadvantage

1,001–3,003–1,002,001

The two Divine Names Aḍ Ḍār and An-Nāfiʻ are repeated together.

There are several pairs among the Divine Names that are preferably used together because Allāh gives harm, (Aḍ-Ḍār), so that the good and useful, An-Nāfiʻ (92), can come into being; He gives lowering, Al-Khāfiḍ (22), so that elevation, Ar-Rāfiʻ (23), can exist; He contracts, Al-Qābiḍ (20), so that expansion, Al-Bāsiṭ (21), may blossom; He humiliates, Al-Mudhil (25), so that honor, Al-Muʻizz (24), can come. Every circumstance, every situation carries wisdom and an opportunity to grow as a human being and on the spiritual level. All states are guests, sometimes painful, sometimes sweet. They come and affect us. It is up to us to decide how we want to deal with them, how and how much we want to understand ourselves through them, to learn, to listen to them, to accept them or reject them. O Allāh, lead me and heal me through Your wisdom! Contentment is one of the greatest gifts and blessings.

"O Allāh, are you satisfied with me?" a man prayed and behind him someone asked, "Are you satisfied with Him so that He may be satisfied with you?" Surprised, the man replied, "How can I be satisfied with Him when I am seeking His satisfaction?" And the answer came, "If you are equally happy with misfortune and good fortune, then you are satisfied with Him!"

—Traditional Sufi story

Aḍ-Ḍār comes from the root *ḍ-r-r*, which contains the following meanings: to harm, to impair, to damage, to injure, to do harm, to force, to compel, to oblige; blind; loss, disadvantage, need, distress, necessity, emergency, plight, adversity, injury.

Damage is invariably inflicted by Allāh in a good cause and serves a useful purpose because everything that happens carries a wisdom and offers us an opportunity to heal. The Divine Names Aḍ-Ḍār and An-Nāfiʿ belong together so that we may understand the underlying Unity and wholeness.

Learn when to speak and when to be silent, when to open your heart to others and when to simply partake in polite conversation.

When storms gather in your life, repeat the prayer recited by the Prophet Muhammad, Allāh's peace and blessings be upon him:

> O Allāh, I beseech You for what is good about it and for the good it contains and for the good for which is has been sent. I seek refuge in You from everything that is evil about it, from the evil it contains, and from the evil for which it has been sent.

The material world carries in its substance the potential for good and for evil. We human beings are capable of discernment, we have the freedom of choice, and we must choose how we react to whatever comes to us.

The good always comes from Him and the evil always comes from Him, yet the cause for the latter comes from human beings.

To direct one's fear and hope towards Allāh
means to be free of all fears and expectations.

92

An-Nāfiʿ

The One who creates that which is useful and good, the One who grants advantage

201–804–40,401

When we remember the Divine by repeating the two names Aḍ-Ḍār and An-Nāfiʿ, our attachment to people and our expectations from them slowly dissolve, and our turning to Allāh intensifies. Unity is strongly highlighted by these two names. He is the One who creates harm, whether to purify our heart and prepare it for higher stages, or as a consequence of our deeds. Thus, what damages on the one hand can indeed be useful on the other.

The Divine Name An-Nāfiʿ comes from the root *n-f-ʿ*, which contains the following meanings: to be useful, to be beneficial, to be advantageous, to be of use, to be of help, to be of avail, to utilize, to turn to use, to turn to advantage, to turn to good account; serviceable, wholesome, salutary; gain, good, welfare.

We have been cutting ourselves off from the force of darkness for too long, from that source of energy that lies buried in the dark, in the background, in what has been forgotten. Darkness is real and dangerous, but it possesses a force and energy that we need. Like chaos, darkness carries the energy of creation, the energy of that which is undefined, undifferentiated, not yet limited by form.

A treasure lies in what we have been ignoring. Golden honey flows through the veins of the earth, along the streams, at the bottom of the ocean. In those dark, forbidden places where the wind is wild and restless, we can discover a passion and a magic that belong to us. When we touch those places for His sake, without worrying about ourselves, without wanting to learn or grow, but only to live more fully, something can finally happen, can finally be released. Complete, perfect surrender to God enables us to touch the darkness of the world for His sake. Surrender is the servant's only true protection and place of real security. If we enter darkness without surrender, it will seize us, engulf

327

us, and then we will be lost, without further use. In Him lies the protection and through Him comes the power.

The Divine Name An-Nāfiʿ is used for healing. Repeat it continuously with a sincere, loving heart while sweeping the sick person's body with one hand.

Evil is not the opposite of God; evil is resistance to God. Everything is made of the same energy. Divine energy is dark and light, male and female. It contains both the white light and the black void. Although we use the concept of duality, the world is only made of apparent opposites; they complete one another and are not really contraries. Duality is only used in this world to lead us to Unity. Everything is interwoven in inseparable patterns. We are not separate parts of a whole—we are the whole. Become acquainted with the positive sides of your fellow human beings because that is love.

Meditation and prayer help us transcend the linear mind, and they enable us to understand the reality that all things are intertwined. See where you stand and where you are heading.

The only thing that matters is what have you attained, since your existence requires you to be merciful, generous, humble, and above all grateful. The deeds in this life shape the body for the soul in the next.

93

النور

AN-NŪR

The Divine Light
256–768–65,536

The One Reality is the One Light. All of Creation is connected to and carries this One Light. All spiritual paths connect light with the Divine. Whenever we say that we want to touch that which is eternal in us, we mean this universal, eternal light that hides behind the outer forms. To follow an enlightened, spiritual path means to recognize this light in everything and to bow in gratitude, a bow that contains serving without being a victim, knowing that we are forever connected by eternity despite all our differences.

The Divine Name An-Nūr comes from the root *n-w-r*, which contains the following meanings: to flower, to blossom, to be in bloom, to light, to illuminate, to fill with light, to furnish with lights, to shed light, to enlighten, to elucidate, to clarify (a problem), to be uncovered, to be disclosed, to be revealed, to receive enlightenment, to seek enlightenment, to receive information, to get an explanation; ray of light, lamp.

An-Nūr makes the world visible, thereby making it exist. In the Qur'an, a whole sura is dedicated to the Light, *Al-Nūr*, سورة النور, which enables us to contemplate light in all of existence.

Sura al-Nūr, سورة النور, The Light (24:35)
God is the Light of the heavens and the earth. The parable of His light is, as it were, that of a niche containing a lamp; the lamp is [enclosed] in glass, the glass [shining] like a radiant star: [a lamp] lit from a blessed tree—an olive tree that is neither of the east nor of the west the oil whereof [is so bright that it] would well-nigh give light [of itself] even though fire had not touched it: light upon light!

The Sufis understand this mysterious verse to be a metaphor for the human heart that is inhabited by the Divine Light and leads us on the journey to Him.

An-Nūr is the Divine Light, the basis of all existence, which guides us in the darkness of our earthly exile.

Allāh cannot be defined, not even by a metaphor or a comparison since *"there is nothing like unto Him"* (42:11), *"and there is nothing that could be compared with Him"* (112:4). Therefore the allegory "God is the light" is not meant as the expression of the divine reality, but of the enlightenment that He grants the spirit and the feelings of every one who is willing to be guided.

We carry two natural revelations of the divine presence. One is the heart that forms our center, the other the air that we breathe. Air carries light. When we inhale, in that moment we are taking into us God's all-encompassing presence. With every breath, we take possession of that presence, we connect to the world and embed ourselves in the whole world since we are breathing the light, out of which everything, including ourselves, has been created. Every inhaling is a return to Unity, to Him; every exhaling is the creative transformation, the expression of gratefulness in the world of multiplicity and change. The pause between inhaling and exhaling is lingering in the knowledge of Unity, in the awareness of the reflection that we are. To be aware of the Divine is to breathe with the heart, to widen the breast, and to grant the sky admission into the heart.

This is how the bond between the Creator and His Creation is renewed with every moment, constantly. The words *nūr* (light) and *nār* (fire) come from the same root *n-w-r*. At the end of time, light will separate from heat. The heat will be hell, and the cool heavenly light will be paradise. Thus, paradise and hell come from the One original substance. When we die, we are confronted with the enormous space of eternal reality, and our own, intimate reality comes to light, consuming itself through everything false, everything that has been brought out of balance. Our own knowledge appears and bears witness to our truth. Thus, we are our own judges as our own limbs accuse us.

Sura al-Nūr, سورة النور, The Light (24:24)
Their own tongues and hands and feet will bear witness against them by [recalling] all that they did!

But we do not only burn because of our adulterated nature. We burn because of our dignity as an image of the Divine.

Repeating the Divine Name An-Nūr fills the heart with softness and humility, and it enables the heart to sense the divine veils of light. We begin to see the invisible world with the eye of the heart. Just as the sun warms our breast and our face, our entire being becomes warm, as peace and quiet comes through the gate of the One.

There are two kinds of light: a sensory light that we can sense through our eyes, and a spiritual light that we can experience with our spirit. When we are faced with a problem, when we strive to find a solution and, after much thinking and studying, a solution comes up, this is spiritual light. Our spirit is *nūr*, the Qur'an is *nūr*, or light. When we take a bottle in our hand whose content we do not know, and someone comes and sticks a label on it describing its content, then the words on the label are *nūr* because they have taken us from the darkness of ignorance into the light of knowledge. For light is knowledge.

Every invention, every discovery, every knowledge is a spiritual light, *nūr*, from Allāh. But this light has a price, and the price is honest enquiry and effort. Every invention, every discovery, every knowledge is ninety-nine percent sweat and hard work in order to receive the one percent divine inspiration, *ilhām*. Allāh does not change things according to our wishes but according to our honesty and our sincerity. To bring something from nonexistence into existence is An-Nūr. Do not deal with everything in your life from the point of view of usefulness but from the point of view of knowledge. That is An-Nūr because An-Nūr is guidance and weighing up. Our cognitive powers perceive God because they are themselves of a divine nature; they can know and understand the meanings of coincidences. This is how we move between mercy and knowledge.

When you have the feeling that your heart is darkening and that deep sorrow is impending, repeat this name 1,000 times. If you have lost your way, repeat this name 256 times and you will find it again. An-Nūr is recited to purify and free the heart, as well as to strengthen inner vision and outer sight.

An inner purification begins when we repeat the Divine Name An-Nūr. This light does not belong to the created world. The approach takes place in steps and stages, the soul rising to increasingly higher spheres of light until it sinks into the light of Unity, beyond all forms.

Divine light lies within each and every one of us, yet it is beyond us. It knows the mysteries of matter, the countless flowers of the realm of forms that make up the garden and the fire and are but an endless, shining play of light.

<div align="center">

نورٌ على نور

nūrun 'ala nūr

Light above light.

</div>

Turn to reality itself and the forms disappear. To observe the creatures is to see no face but the Creator's. That is the behavior of the Sufis.

When the heart becomes pure, so does the body. The special way of the Sufis does not come from what they say or do, but from the attitude of their heart. Our eyes need sunlight to see things, and our spirit needs divine light to know the truth of things.

It is recorded that the Prophet Muhammad, Allāh's peace and blessings be upon him, said,

O Allāh, praised be You, You are the light of the sky and of the earth and everything that is between them.

O Allāh, put light, *nūr*, into my heart and light into my tomb and light in front of me and light behind me and light to my right and light to my left and light over me and light below me and light in my hearing and light in my sight and light in my hair and light in my skin and light in my flesh and light in my blood and light in my bones. O Allāh, increase the light in me and give me light. O Allāh, transform me into light!

It is that simple: born into the world, open through your deeds the gates of paradise!

94

<div align="center">

الهادى

AL-HĀDĪ

The One who shows the right way, the Leader, the Guide

20–80–400

</div>

This Divine Name carries the quality of divine leadership for the whole Creation—minerals, plants, animals, and human beings. This leadership can also be described as divine help. This name lets wisdom flow and it guides the heart to the knowledge of its essence.

This Divine Name is based on the root *h-d-y*, which contains the following meanings: to lead the right way, to show the way, to bring, to lead towards, to be led to, to find the way, to make a spiritual discovery, to be led back, to ask for divine guidance; way, direction, behavior, donation.

Al-Hādī is the all-encompassing source of guidance granted to humankind, to a community. Al-Hādī touches the guidance given to humanity by Allāh in all His revelations. Al-Hādī shows the continuity and the essential unity of all revelations. The universe is the place where the Divine Names manifest. He created the universe with Al-Khāliq (11). In the universe we see knowledge, Al-ʿAlīm (19), and through the universe we see wisdom, Al-Ḥakīm (46), almightiness, Al-Qādir (69), and mercy, Ar-Raḥīm (2). In the stormy ocean we see the Powerful, Al-Jabbār (9), in a caress the Gentle, Al-Ḥalīm (32). The universe constantly confronts us with the divine absoluteness, and through the universe we can know Him.

Sura al-ʾAʿlā, سورة الأعلى, The All-Highest (87:1–5)
EXTOL the limitless glory of thy Sustainer's name: [the glory of] the All-Highest,
who creates [every thing], and thereupon forms it in accordance with what it is meant to be,
and who determines the nature [of all that exists], and thereupon guides it [towards its fulfillment],
and who brings forth herbage, and thereupon causes it to decay into rust-brown stubble!

Everything in the universe is provided with an inner coherence and with qualities according to the requirements of their existence and to the tasks they must fulfill.

Al-Hādī, divine guidance, leads us to *taqwā*, the universal awareness of divine existence.

Al-Hādī gives us the strength to keep walking towards our goal, despite all storms and obstacles, because it allows us to see divine signs in everyday occurrences. Those who carry the quality Al-Hādī are capable of listening to the guiding voice of their true self. They have received the answer to their prayers.

Sura Ṭā Hā, سورة طه, O Man (20:50)
Our Sustainer is He who gives unto every thing [that exists] its true nature and form, and thereupon guides it [towards its fulfillment].

Repeating this Divine Name 200 times every day leads to success and to the right choice when one cannot decide. This name opens the way to spiritual knowledge. Those who live this name in their heart, through their tongue and their noble, humane deeds, will be granted ever-deepening knowledge. They will see the scope and the wisdom behind all things, and the fact that everything is as it should be; everything is in order.

When you have the feeling that your life path is darkening, repeating this name will help you discern the deeper meaning again. If you write this Divine Name and carry it with you, repeating it time and time again, you will be well guided in all your deeds and states, visible and invisible.

A spiritual guide leads the seekers to their own potential and awakens in them satisfaction with everything around them, lifting the veil from their heart so that they can see, in themselves and in the book of nature, the great miracles and signs of Creation.

Al-Hādī means to be open to everything that is and will be, lovingly gentle, full of kindness, attentive, awake, concentrated, present, without judging, without knowing, without wanting to attain anything, without repressing anything, without holding on to anything, without verbalizing.

إهدنا الصراط المستقيم

'ihdinā ṣ-ṣirāṭa l-mustaqīm
Guide us the straight way.

This sixth verse of the opening sura, *al-Fātiḥah*, means: O Allāh, let our hearts long for You and bow to You and lead us through You to You!

O Allāh, grant us *himma* (همة), that longing, that hunger to know reality, that life energy that strives to restore the connection with reality!

It is in the nature of *himma* to make every act pleasant to the seeker as long as it leads to Him.

Love is the path, the food, and the goal.
Whoever wishes to be guided, will be guided!

95

البديع

AL-BADĪ‘

The Discoverer, the Creator, the One who starts anew

86–344–7,396

Allāh is the Creator of this world with all the beauty it contains. Nothing can be compared to Him; He is the One, the Eternal. If you wish to understand this name more deeply, nature and the Creation are there for you. Nature has the capacity to address the mind and the heart simultaneously, whereby the mind will analyze and explain, the heart will take in and know. It is the heart that guides your analyses and explanations towards wisdom, thus opening a world that leads you from the complexity of multiplicity into the calm of Unity.

Al-Badī‘ comes from the root b-d-‘, from which the following meanings are derived: to be incomparable, to introduce, to originate, heresy, to be the first to do something, to bring out, creating anew; wonderful, amazing, rare, different from, incredible, unique, perfect, uncommon; creator, incomparable women, innovation, novelty.

Allāh Al-Badī‘, the One out of whom everything comes into being. When you pronounce this name, you stimulate and use the unique creative powers that lie in you. Al-Badī‘ is seen in those astounding flashes of lightning that reveal a totally new viewpoint and understanding, leading us to new dimensions.

Al-Badī‘ expresses the miracle through which the Creation comes into existence.

Sura al-Baqarah, سورة البقرة, The Cow (2:117)
The Originator (badī‘) is He of the heavens and the earth: and when He wills a thing to be, He but says unto it, "Be"—and it is.

The Divine Name Al-Badī' represents that which has never existed. It can help us trust more in our spontaneity, free us from our usual way of thinking, make us think and dare the unthinkable, and bring out the uniqueness of our being. Al-Badī' helps us when we tend to force our convictions on others. It widens our chest and enables us to taste the all-encompassing divine beauty.

When you repeat this Divine Name, you feel all its manifestations in your being. You start by acknowledging your uniqueness, your richness, and the miracle that you are, and then you find the whole universe reflected in you. The whole world lies in each of your wrinkles, and it is in this state of amazement that the tongue starts praising, the heart becomes soft, and the soul begins to shine. One hour spent contemplating nature and the Divine Creation is equal to a whole year of prayers. The evidence is in you and around you.

If you repeat this name 86 times every day after prayers, your understanding will expand, your inner eye will open, and you will penetrate the deeper meaning of knowledge. Your words will carry the wisdom of your heart and lighten even difficult tasks.

Ibn al-'Arabī explains the nature of understanding that this name expands.

There are three levels of knowledge: first the knowledge of the mind, *al-'aql*, that knowledge we attain by inference or as a result of speculation in a string of argument structured in the world of thought. Thinking collects and selects from this form of knowledge, deciding what is valid and what is not.

The second type of knowledge is the knowledge of states, *'aḥwāl*, and it can only be accessed by direct experience. Those who rely mainly on their mind cannot grasp it or use it as evidence. It is knowing the sweetness of honey, the bitterness of the aloe plant, the pleasures of sexual union and passion, ecstasy and longing. No one can have this type of knowledge without experiencing and being permeated by it.

The third type of knowledge is the knowledge of the secrets, *'asrār*. This knowledge is beyond the nature of the reasoning mind. It breathes into the heart the perfect power of existential experience. No form of knowledge is nobler than this all-embracing knowledge that contains everything known.

In case of depression or stress, it helps to repeat this phrase 1,000 times.

يا بديع السموات والأرض

yā badī' us-samawāti wa-l-arḍ

O Creator of heavens and earth.

O Allāh, free our heart from doubt and despair, and fill it with trust and the request for increased knowledge of the mysteries of Creation and of Your Divine Names!

Those who have recognized their own uniqueness are no longer interested in comparing people or judging them according to predetermined standards.

How can you tell the lovers of truth? When you see them, they remind you of Allāh. You come to see your own light, beyond all the illusory darkness that plagues you and keeps you from inner peace. You stop running away from the past and into the future, and you stand in the reality of the moment.

The artist himself must be shaped before he in turn can shape his work of art.

96

<div dir="rtl">الباقى</div>

AL-BĀQĪ

The Eternal, the Everlasting, the Lasting

113–452–12,769

Time only exists for the constantly changing Creation, yet we human beings can be in eternity if we do not tie our heart to this world. We learn to do this when we work not only for our personal benefit on this earth, but connect our deeds, our words, and our thoughts with the Eternal One, when we do things to glorify Allāh, for the benefit of humankind and all beings, here and for the future. Because even once everything is over and our body is called back to the earth, our deeds carry on into eternity.

Work with your *nafs* (نفس), your ego self. Do good for selfish reasons. Feed your *nafs* with the positive results of your good deeds. Let it become your partner, turn it from an enemy into a servant, for your soul knows that your *nafs* does good for the Beloved. Introspection will help you in this.

The Divine Name Al-Bāqī comes from the root *b-q-y*, which contains the following meanings: to remain, to stay, to continue to be, to keep up, to maintain, to last, to continue, to go on, to leave, to leave behind, to make someone stay, to preserve, to hold back, to spare, to save, to protect; permanent, unending, everlasting, eternal (Allāh); continuation of existence after life, immortality, eternal life, duration, survival.

All things and beings come to pass, *fanā'* (to waste away, to become extinct). Only the Divine stays the same, continuously remaining in the original state *baqā'* (to be unchanged, to continue). This is why surrendering to the divine law of the universe is called *baqiyya* (to rest in the Eternal). Everything comes into being wih the divine command *kun!* (be!) and everything ceases to exist with the word *zul!* (disappear!). Humans are time and time passes; the Divine is eternal, everlasting. But part of

us belongs to the same eternity, so look after this eternity within you, as the fifteenth-century poet Jami explains.

> At every moment, with every breath, the universe changes and is renewed. Every instant a contracting movement (*al-qabḍ*) takes one universe back to the origin and through an expanding movement (*al-basṭ*) another resembling it takes its place. In consequence of this rapid succession, the spectator is deceived into the belief that the universe has a permanent existence.

People who are connected with the Divine contemplate that which is everlasting in relation to that which is ephemeral. Their center is the search for knowledge because knowledge is rooted in divine consciousness and attained through Him. Peace in the Divine purifies our consciousness.

Our longing for the Eternal, the Everlasting, the Unchangeable, for our real nature, will always exist because we carry divine consciousness as part of our being. The journey from earth to heaven transforms us into channels of mercy and kindness for this earth. We become bridges that allow heaven and earth to meet. In order to be happy, we must remain aware of our bridging role and live accordingly.

When we are not—or no longer—aware of this task, we bring disharmony to this earth. Since by nature we have the capacity to unite things, we can bring about harmony or disharmony on this earth. We have been granted this power because we carry the features of divine being. Everywhere the soul seeks the signs of its original divine home. It is moved by the beauty of nature, of a song, a painting, a human being. Thus, the breath of the Eternal touches the soul through the beauty of the manifestations.

Take your deeds to Allāh by accomplishing them with love, and He will make them endless and eternal!

Eternity is revealed to those who know where they come from and where they are heading. Human finiteness is reconciled through eternity.

When you are with people, forget everything you see or hear, and hold on to that which reveals itself to you inside. Be independent so that your inner being may be in tune with your outer being. Live and taste in time the present of eternity.

All beings have two faces, their own and the Divine. In relation to their own face, they are nothing, and in relation to the divine face, they are eternal.

The Divine Name Al-Bāqī gives us the possibility to taste eternity beyond time, to free ourselves from our limited concepts of time and space, from our constant, busy striving, and to set off for a deeper level of knowledge. We become deeper, wider, and this enables us to deal with time and space more clearly, more efficiently, as we learn to let in, to let go, and to let be.

In case of recurring fears, repeating this name before going to sleep will help you become free of them.

Al-Bāqī grants constancy and brings much of life into perspective, because it engraves into the heart that He alone is endowed with constancy and eternity. So focus first and foremost on your inner development.

<div dir="rtl">سبحان الله الحمد لله لا إله إلا الله الله أكبر</div>

subḥāna llāh, al-ḥamdu li-llāh, lā ʾilāha ʾilla llāh, allāhu ʾakbar
Glory to Allāh, praised be Allāh, there is nothing but Allāh, Allāh is greater!

If we assume that we have a soul, a deep, eternal form of existence, then we can also say that everything has a soul. Every bacterium has a shape, a color, and a spiritual aspect. To remove the bacteria or the virus, the infection, without healing the spiritual aspect leaves the doors open and the traces remain.

Love is a unique disease of the heart. It guides us to God and in the end it always takes us to Him, regardless of whom we love in this world. So forget everything and love!

"Oh!" the heart sighs in wonderment, "were we ever far from love?"

97

<div dir="rtl">

الوارث

</div>

AL-WĀRITH

The Sole Heir, the Inheritor

707–2,828–499,849

This Divine Name indicates that Allāh inherits everything from heaven and earth, that everything comes from Him and returns to Him. Repeating this name helps us become free from the dominance of our impulses and pierce the superficiality of perception. This name gives us the freedom to recognize that of all the beauty, all the riches that we are given to live and experience, nothing truly belongs to us. Everything is lent for a period of time before flowing on again. Know that every Divine Name carries a light, a secret, and a shadow. The light of each name shines in the heart of those who go deeply into that name and invoke Allāh through it, time and time again.

The Divine Name Al-Wārith comes from the root *w-r-th*, which contains the following meanings: to be someone's heir, to inherit, to transfer by will, to leave, to make over, to draw down, to bring down, to inherit successively or from one another; heritage, legacy, heir, inheritor.

Al-Wārith reminds us of where we come from and of what we have brought with us as inheritors.

Al-Wārith, the Inheritor, is the One to whom all possessions go once their owners are gone, and that is Allāh because He is the One who will be when the Creation is gone. Everything returns to Him. He is the One who will then ask, "Who is the Ruler?" And it is He who will answer: "The All-Powerful." People endowed with spiritual perception have always known the truth of this announcement: that everything belongs to God, every moment of every day, and that it is forever so. Yet only those who recognize the truth of Divine Unity in the work of

347

Creation can understand this, and they know that He who alone exercises power and sovereignty, is the Only Existing One.

— Al-Ghazālī

Those who find it difficult to make up their minds should repeat Yā Wārith 1,000 times between sunset and the night prayer, and they will come to the right decision. Those who repeat this Divine Name 707 times and ask for something to which they are rightfully entitled will receive it if it is meant for them.

To learn not to identify with our limited self is often a long process that is strange and unpleasant for the ego. Transformation begins as soon as we decide to set out on the search for our true self. All our capacities, our potential, our talents, our experiences, our encounters, and relationships go through a change. We are born for the second time, not from our mother, but from ourselves. In Arabic, transformation is called *taqallub*, which means as much as: to turn back, to turn and examine from all sides, to search, change, to change. Interestingly it comes from the same root as *qalb*, the heart. Indeed the heart is the center of this change that takes place as we do all the things that are linked to transformation.

But when we deal with transforming our identification with the ego into turning to our true self, to our soul, we connect everything to the One who is eternal, and our field of activity is the whole Creation. Our behavior and our acts show us where we stand and how we should continue. They enable us to truly see the state of our heart—covered or pure. This is the reason why meditation, contemplation, and reflection are so important. The closer we come to our inner self, the closer we come to the source of love, the clearer the freedom, the maturity, and the signs of eternity become. This is how Allāh inherits every one of our states and stations, and becomes our goal. In the end, all beings return to Him. When we recognize this, every loss, every pain, every death receives content and meaning.

Sura al-'Imrān, سورة آل عمران, The House of 'Imrān (3:180)
For unto God [alone] belongs the heritage of the heavens and of the earth; and God is aware of all that you do.

Al-Wārith unites inner and outer knowledge. It helps us to let go, to overcome our greed and concentrate our strength on the essential, championing our natural right to nurture our soul.

Allāh is the Inheritor of all, and everything that remains after death returns to Him.

Sura Maryam, سورة مريم, Mary (19:96)
Behold, We alone shall remain after the earth and all who live on it have passed away and [when] unto Us all will have been brought back.

Allāh has bequeathed everything to us human beings. We can enjoy and use this blessing. We can choose how to deal with this inheritance because Allāh granted us free will, but in the end, everything returns to Him. If we lose our sight, it goes back to the Inheritor of all. If we lose our youth, it goes back to Him, if we lose our capacity to walk, it goes back to Him. Everything is from Him and to Him it returns. We are the trustees. May Allāh preserve our sight, our strength, and our mobility for a long time!

Love contains traces of His presence. Love is the substance of which the Creation is made. Love is always present. The Sufi path reveals it to our consciousness by orienting our heart towards it.

Ar-Rashīd

The One who shows the right way, the One who gives the direction

514–2,056–264,196

The Prophet Muhammad, Allāh's peace and blessings be upon him, said. "Question your heart. In reality, it is uprightness that brings peace to your soul. Conversely, evil is what settles in your inner being and keeps plaguing your conscience."

Guidance entails self-observation of our ego and impulses. This Divine Name reflects the Divine Being on the one hand, and a divine quality on the other. Heaven and earth are built on both and carried by an endless mercy. All beings, including animals, insects, and plants, are enfolded in divine guidance. They carry out their deeds in the manner that corresponds to their being, and their ways are full of wonders. When we human beings are given an insight into their ways, we receive an insight into the wonders and mysteries of this world. Everything praises and sings the divine song in its way.

But human beings are free, so they have to make a conscious decision to follow this way. In truth, every human being is attuned to the divine song and is an instrument in the great orchestra of life. Yet, the difference between a human being who is half-asleep and one who is awake is that one has clearly said yes to his path and oriented his life accordingly, while the other does not know his center yet.

Whoever wishes to follow the path of awakening must knock on the door of knowledge, and the key to that door is inner questioning. Knowledge comes from an inner attitude that reflects in our words and deeds, in our behavior, and in the way we interact with other people. Knowledge is a path that frees the heart from anger, envy, arrogance, pride, and slander, and enfolds it in trust and deep faith.

Ar-Rashīd comes from the root *r-sh-d*, which contains the following meanings: to be on the right way, to follow the right course, to be well guided, not to go astray (especially in religious matters), to have the true faith, to be a true believer, to become sensible, to become mature, to grow up, to come of age, to lead the right way, to guide well, to direct, to show the way, to call someone's attention, to point out, to teach, to instruct, to acquaint someone with the facts, to advise, to counsel, to ask someone to show the right way, to ask someone for guidance or directions, to be guided, to come to one's senses, to calm down, to sober up; intelligent, discriminating, discerning; integrity of one's actions, reason, good sense, consciousness, maturity.

There is a connection between Al-Ḥakīm (46) and Ar-Rashīd: the former takes things to their right place and the latter leads to the right deeds. Ar-Rashīd shines divine light on our path.

Ar-Rashīd, from which the name *murshid*, spiritual teacher or teacher of the inner, spiritual path, is also derived, is when God takes a seeker by the hand, so to speak, and helps them make decisions. A *murshid* or a *murshida* (feminine form) gives us the courage, the love, the strength, and the faith to confront our wounded self and our identification with it, to examine our inner pictures, wishes, and desires, and to walk through everything accompanied by the words of the Divine, until we experience divine loving mercy.

Those who have integrated Ar-Rashīd can tell truth from falsehood. They hold on to the path that leads to truth without ever losing sight of the goal or taking upon themselves unnecessary efforts. Ar-Rashīd brings balance between inside and outside. Excessive outer dependence and involvement can bring about anger and rage; excessive introspection can bring about instability, confusion, and a lack of steadfastness. Ar-Rashīd teaches us to see inner reality in the outer signs and to walk the path to our essence and to God.

Repeating this name 152 times every day increases our strength, both on the inner and outer levels. By repeating this name 504 times, those who teach will protect themselves from transmitting erroneous information and from being misunderstood. This name gives us the strength to stand by our deeds.

If you wish to lead a group or a community, repeating this name will help you fulfill this wish.

To become void of all egocentricity means to become full of God. Wherever the self is free from self-centeredness and everything that comes with it, Allāh, love itself, fills that space.

Every one of us wishes to feel peace and happiness. Allāh grants health, intelligence, well-being, and beauty to many of us. Yet He only grants *sakīna*, the inner peace and quiet that comes from God, to those who come near Him, who have made room for Him in their heart. When *sakīna* manifests, peace comes and the warm stream of happiness spreads out, resting on the deep knowledge of divine omnipresence, in and around us. When we start to love our essence, our true self, unconditionally, the path to Allāh is open.

Sura al-Kahf, سورة الكهف, The Cave (18:10)
O our Sustainer! Bestow on us grace from Thyself, and endow us, whatever our [outward] condition, with consciousness of what is right!

Allow your gait to reflect the dignity and the deep pride of your soul that stem from knowing that we have been created in God's image. We are spiritual beings and at the same time we are human, caught in the duality of light and darkness. We are the dividing line between light and darkness, and we can unite them by transforming our best-concealed enemy: arrogance.

The heart is the ocean, the thoughts are the waves. Guide them well!

99

الصبور

AṢ-ṢABŪR

The Patient, the Long-Suffering

298–1,192–88,804

Patience is one of the greatest virtues. It makes us enduring and long-suffering, granting us incredible strength to stand up to inner and outer influences.

Aṣ-Ṣabūr is the strength that enables us to persevere with things until the very end. It grants us willpower and helps us focus and collect in our center so that, even in difficult times, instead of complaints and self-pity, we can experience the merciful love of the Divine. Aṣ-Ṣabūr gives the spiritual seeker the energy to follow the straight path in confidence and to learn from everything.

The Divine Name Aṣ-Ṣabūr comes from the root *ṣ-b-r*, which contains the following meanings: to bind, to tie, to fetter, to be patient, to be forbearing, to have patience, to bear calmly, to renounce, to withstand, to ask to be patient, to comfort, to make durable, to conserve, to preserve, shackling; enduring, perseverant, steadfast; endurance, steadfastness, firmness, self-control, self-command, self-possession, aloe, severe cold, heap, pile.

The word *ṣabr* means not only patience, but also tenacity, and above all perseverance in the good and surrender to the will of the all-enveloping Divine. Nothing prolongs life more than patience, and patience makes us beautiful, for patience is pure and purifies all things.

Patience, steadfastness, self-control, comfort, perseverance, resistance, forbearance are *ṣabr*, and all of them are beauty because *ṣabr* leads you to the essential, to your beauty, and to the One who created beauty.

We human beings find it difficult to retain our equanimity when we see things that we fail to understand or have never experienced. To have patience and wisdom, and to know that outer appearance

355

does not always match reality, requires patience and *tawakkul*, trust in God, in a power that is absolute, all-encompassing, and beyond our powers of discernment. When we open our heart to a greater power and make space in our heart through being conscious of the Absolute, a deeper dimension opens and we can recover from life's efforts and demands. The balance that emerges in us brings unity between the worlds, an equilibrium between the ephemeral and the eternal, the visible and the hidden world, this life and the hereafter. A light settles on everything and brings unity and peace, anchoring us in the Divine, in the mystery of life.

The name Aṣ-Ṣabūr gives us the strength and capacity to hold the knowledge that Allāh has granted us and to let it shine more and more.

When we repeat this Divine Name, a feeling of fear, as well as a feeling of mercy and compassion, manifest in our heart. When we repeat this name, we stand clearly in front of our ego self, reproaching its misconduct and weaknesses, while enfolding it in the knowledge of God's endless mercy and compassion, which forgive everything. Thus, the heart is turned this way and that. God gives everything to human beings, and He forgets nothing and no one.

Fear and trust are two wings of the same bird. The wing of fear dissolves arrogance, leads to self-observation and remembrance, and protects us from many mistakes and weaknesses through vigilance and wakefulness. And the wing of trust, together with the knowledge of the unconditional divine mercy and love, chases away the demons of doubt and despair, leading us to compassionate deeds. Yet the bird itself is the heart. So correct your flight by lifting at once the wing of fear, in times of superficiality and lukewarm presence, and at once the wing of trust, in times of fearfulness and self-judgment.

There are three types of patience: patience with what is good in someone, patience with what is lethargic and negligent, and patience with catastrophes and difficult times. The Divine Name Aṣ-Ṣabūr gives us all three types of patience, for He is the One who grants patience and transforms the energy of lament and complaint into confidence and trust. Hold the ocean of your patience against the waves that bring you out of balance!

The traveler does not go his way blindly in the dark. He uses the light of is love and his own sensitivity in order to follow the flow of life. The name of God is one of the traveler's greatest protective shields because it connects him directly with Him whose name he calls.

Allāh gives us the strength, the self-control, and the resistance to complete the tasks we have undertaken. To have patience in God is faithfulness. He gives us patience and helps us remain true to ourselves through the mountains and the valleys of life, in the deep springs of loneliness, and in the changing winds of doubts and fears.

Patience is born of gentleness. The gentler the heart, the greater the patience. God's patience manifests through the guidance He offers us time and time again despite our constant disobedience.

Help patiently and creatively bring the energy of love to this earth. Then we can restore the harmony that has been disrupted by our materialism and greed.

Patience is quoted 101 times in the Qur'an, and it is with patience that the circle of the Divine Names comes to a close.

Sura Hūd, سورة هود, (11:115)
And be patient in adversity: for, verily, God does not fail to requite the doers of good!

The day will come when the earth bears witness to everything ever done to it by humankind. Each and every one of us carries an individual, non-transferable responsibility for their deeds. May our deeds and words bring light to this world and to its creatures! May Allāh assist us on the path to our true self. May He equip us with perseverance, patience, and love, and guide us with the light of knowledge and wisdom, so that we can become the peacemakers of our society.

Patience is the key.

الشافي

ASH-SHĀFĪ

The Healer, the One who restores health

391–1,564–152,881

The Divine Name Ash-Shāfī carries the source of health and recovery.

Our essence, our deep self, consists of the endless kindness that Allāh has bestowed upon us as our essential quality. It deals with positive things and is stimulated by them, hence the proverb, "A good word is half the cure." Every ounce of positive energy is attracted by our deep self, which awakens, stimulates, and nourishes it. Hearts awaken in a positive, harmonious space.

The root *sh-f-y* contains the following meanings: to heal, to bring back to health, to restore, to quench one's thirst, to cool one's feelings, to take revenge, to be decided, to be determined, to seek healing; healing, medicine, remedy, hospital (which means "house of recovery" in Arabic).

The following forms are also derived from the root *sh-f-y*: *shāfi*: healer; *'ashfā'*: edge, rim, border; *shafā*: to heal, to cure (wound or disease), to make well, to restore someone to health, to recover; *shifā'*: cure, healing, restoration, recovery, recuperation, convalescence, satisfaction, gratification; *ashfiya*: remedy, medication, medicine; *'istishfā'*: to seek a cure; *shāfin*: healing, curative, medicative, satisfactory, clear, unequivocal (answer); *shafawī*: lips, oral; *mushfin*: moribund, doomed to death; *tashaffin*: to calm down, gratification of one's thirst for revenge, satisfaction; *'istashfaya*: to seek a cure; *shufūf*: transparent state of being; *shafāhu-l-llāh*: Allāh has brought healing to someone's body, heart, and soul.

According to 'Abdullah Ansari, the Sufi law of life demands kindness towards the young, generosity towards the poor, good advice to friends, leniency towards enemies, indifference to fools, and respect for those who know.

Hakim Gulam Moinuddin Chishti summarizes the Sufi philosophy by encouraging his students to love everyone and to hate no one, to ask help from no one but God, to develop fully their abilities and their potential, to put themselves at the service of truth, and above all, to serve the needy and the poor.

Wakefulness is a state of understanding.

Dhikr is the song of mercy that reminds us of our eternal home, waking us from the slumbers of forgetfulness, stimulating what lies hidden within us and healing it. It is sisterly or brotherly love in the Divine Presence.

In the *dhikr*, two basic positions help the energy circulate and remain in the body: when you put your hands on your knees or when you place one hand above the other in your lap. The first position stimulates more intensively the area of the breast and the heart; the second one helps you concentrate.

To intensify the repetition of a Divine Name, *dhikr*, for someone else, touch them with your left hand and put your right hand on their left shoulder. This will connect the person to the flow of energy.

When you deal with pearls, you have to take care not to destroy their beauty. Similarly, it befits those who wish to heal human bodies—the noblest creature of this earth—to treat them gently and lovingly.

—Islamic proverb

The wisdom of the heart and the wisdom of love flow where they are needed; they multiply, and they can also flow back—it has always been so.

May I, should I, can I? Those questions protect us human beings from falling into the latent tendency of the ego—pride and arrogance—and they help us make space for the qualities of gratefulness and humanity that are based on the knowledge of our shared human neediness. It is always an honor to touch another human being, to be allowed to accompany them and to bring good into this visible world.

Seven are the chains laid upon us by the ego: envy, hatred, greed, ignorance, negative passions, arrogance, and avarice.

To give and to take, to receive love and to be selfless, has nothing to do with wealth or social status; it is not something material. It is through love that we first become civilized beings. Once the capacity to love has been awakened, the path to the Great Ocean opens. To contact the hidden forces of one's culture is to come to nature, to the essence.

The path of love is to start to move, knowing that the path will guide those who walk it trustingly. It is to find the hidden strength in everyday life, to trust feelings and intuition, to lead a disciplined life while exercising care with our surroundings and with the way we treat ourselves.

We arouse the facets of love in others through silence, compassion, and all things inspiring that go beyond the visible world and life on this earth.

It is a blessing and an enrichment for all when a harmonizing group works together, especially when some in the group are endowed with different qualities or more advanced in some fields, because that is exactly what helps the others progress. Those who are not as advanced find support and those

who are more advanced become clearer. Hence the attempt, especially in spiritual communities, to involve people with different qualities in the same activity. We then come to really taste connectedness. The exchange takes place on the level of the deep self, out of the One underlying Reality.

Even if you tie a hundred knots, the string remains one.

—Rumi

The path that leads from the head to the heart through the belly can be very long and time consuming. Some find themselves painfully thrown on it by fate, others simply feel that without it life has neither joy nor the slightest meaning. Everyone is different, and everyone follows their own outer path.

Sickness usually manifests in a body which has come into disharmony and whose vibrations clash. To bring the body to its deepest, fundamental level starts a healing process. It is essential for the accompanying person to bring their own vibrations to a harmonious, relaxed level before they start the healing practice.

So become the way you were when you did not exist!

—Junaid

The following healing prayer is repeated 19 times. It can be used if the person is present or absent.

يا الله
يا شافي
بسم الله أرقيك مما فيك
إشفي أنت الشافي
شفاء لا يترك سقماً
بسم الله أوله وآخره

Yā Allāh
Yā Shāfī
bismillāh 'arqīka mimmā fīka
ishfī anta sh-shāfī
shifā'un lā yatruku saqaman
bismillāh awwaluhu wa 'ākhiruhu

O Allāh
O Healer
In the Name of Allāh I heal you from that which you carry in you.
Heal, You are the eternal healer
A healing which leaves no sickness behind
In the Name of Allāh is the beginning and the end.

361

Sickness and Healing

The Prophet Muhammad, Allāh's blessing and peace be upon him, said "Allāh has not sent down an illness without sending down a cure for it."

The feminine knows Unity. A woman understands it instinctively in her body. She feels how everything is interconnected. She knows that even if children come from her belly, they may be completely different, each one unique in his being, yet all belonging to the One source; as the small womb, so the great womb. This is the deep wisdom of the feminine that knows about relationships and senses the wickerwork of Creation. This type of wisdom finds little space in the analytical, scientific approach of the world that we have built for ourselves, leaving most women no choice but to repress or marginalize this wisdom, anesthetizing it and trying to emulate masculine ways of thinking. It is precisely through this spiritual attitude of separation, which permeates most human domains, that we have created our present reality. Yet if we learn to unite the wisdom of the feminine with masculine consciousness, if we develop a relationship between the parts and the whole, the whole and the One, this new knowledge will help us heal our world, and the ways to restore balance shall be revealed to us.

The same applies to our own healing and becoming whole. Most tensions in our world result from our actions as human beings. But this means that solutions also rest in our hands, with Allāh's help.

For many people, being healthy means being able to function faultlessly, while being sick means that one or several parts of the body are damaged or have stopped functioning. They must then be repaired or replaced so that everything functions again. Each person is seen as an isolated, limited organism. In traditional Western allopathic medicine, this is still the dominant approach to the treatment of disease. The focus is on the dysfunctional part, and ignores the whole person, namely the healthy parts of the person, which want to understand and, in fact, are essential to the healing process. In German, for instance, the word for hospital is *Krankenhaus*, meaning "house for the sick," whereas the Arabic word for hospital is *mustashfa*, meaning "healing house."

In traditional cultures, a more holistic view of the world expresses itself. Life is viewed in its interconnectedness and interdependency—birth and death, health and sickness, joy and grief. Such societies are based on relationships, not an achievement.

This understanding of life integrates death, which is not seen as a failure, notwithstanding the deep grief of parting, but as part and parcel of life. The most important thing is for the patient to be able to die in peace, healed and united. Healing is not necessarily conducive to an extension of life, but our existence is not limited to the time between birth and death, as expressed in the following great Sufi story.

A stream, from its source in far-off mountains, passing through every kind and description of countryside, at last reached the sands of the desert. Just as it had crossed every other barrier, the stream tried to cross this one, but it found that as fast as it ran into the sand, its waters disappeared.

It was convinced, however, that its destiny was to cross this desert, and yet there was no way. Now a hidden voice, coming from the desert itself, whispered, "The wind crosses the desert, and so can the stream."

The stream objected that it was dashing itself against the sand and only getting absorbed. The wind could fly, and this was why it could cross a desert.

"By hurtling in your own accustomed way you cannot get across. You will either disappear or become a marsh. You must allow the wind to carry you over, to your destination."

But how could this happen?

"By allowing yourself to be absorbed in the wind."

This idea was not acceptable to the stream. After all, it had never been absorbed before. It did not want to lose its individuality. And, once having lost it, how was one to know that it could ever be regained?

"The wind," said the sand, "performs this function. It takes up water, carries it over the desert, and then lets it fall again. Falling as rain, the water becomes a river."

"How can I know that this is true?"

"It is so, and if you do not believe it, you cannot become more than a quagmire, and even that could take many, many years; and it certainly is not the same as a stream."

"But can I not remain the same stream I am today?"

"You cannot in either case remain so," the whisper said. "Your essential part is carried away and forms a stream again. You are called what you are even today because you do not know which part of you is the essential one."

When he heard this, certain echoes began to arise in the thoughts of the stream. Dimly, he remembered a state in which he—or some part of him, was it?—had been held in the arms of a wind. He also remembered—or did he?—that this was the real (not necessarily the obvious) thing to do.

And the stream raised his vapor into the welcoming arms of the wind, which gently and easily bore it upwards and along, letting it fall softly as soon as they reached the roof of a mountain, many, many miles away. And because he had his doubts, the stream was able to remember and record more strongly in his mind the details of the experience. He reflected, "Yes, now I have learned my true identity."

The stream was learning. But the sands whispered, "We know, because we see it happen day after day: and because we, the sands, extend from the riverside all the way to the mountain."

And that is why it is said that the way in which the Stream of Life is to continue on its journey is written in the sands.

—The Tale of the Sands, retold by Idries Shah

Healing versus Curing

Healing is related to being whole, but also to holiness. To be safe and sound means to be embedded in the great harmony of being. Even when an individual dies, the process does not stop at the gate of death, as the *we* of humankind resonates with the *I*. Thus, an individual's well-being is a matter of concern for the whole human community, indeed for the Creation. Harmony with one's deep individual being brings harmony to us all.

When people are "cured" and can "function" again, yet have found no meaning to their lives, no connection or integration into their community, then no healing has taken place in the holistic sense of the term. Any sickness we experience should give us the possibility to become better human beings, and take us closer to our own perfection. For that to happen, we need to be adequately, meaningfully accompanied and to receive the appropriate remedy.

Healing practices from the Islamic culture, as well as from other cultures endowed with holistic approaches such as Native American, Tibetan, or Indian, are based on the existential unity of all beings, in the knowledge that all forms of being are intertwined.

In the Sufi perspective, all sickness stems from separation, from having forgotten the intertwined unity of all beings. This illusion of separation can manifest on the physical, psychological, or emotional levels, where veils appear between body, spirit, and soul, expressing that separation inside the sick person, but also outside, in their family or social relationships where they are overcome by loneliness, isolation,

and a feeling that they do not belong. No longer aware of their connection to the Divine, they become lost and confused. One of the most important purposes of healing is to dissolve the isolation of the individual and embed them again in the whole.

All treatments, all forms of support, aim at dissolving the veils of separation, embedding and reconnecting the sick, and helping them to find their place in life and embrace it wholeheartedly. Healing happens when people regain knowledge of their interrelation with all levels of being, root themselves in the unity of all existence, and find their place again — inside and outside. For every human being born in this world carries an essential contribution to it. Every human being is a gift to humankind, to Creation. Remembering again that we are connected makes us healthy. The aim is not the individual independence, but conscious acceptance that everything in Creation is intertwined, all creatures completing one another and interdependent.

Although sickness and pain may be arduous to carry, they are part of our human existence. Sickness only turns into suffering when we associate it with punishment or exile, when we believe that we have been bad and are being sentenced to a disease, an accident, or a problem. Often this pain is much deeper and greater than the sickness itself. To believe that we have been inadequate, insufficient, or "ugly," and thus undeserving of God's many blessings, is the deepest suffering we can inflict upon ourselves, adding shame, guilt, and insult to the pain and the disease.

Sufis see in a disease one of the many ways that Allāh chooses for us to transform us into better, more compassionate, integrated human beings. It is the great gate that opens to enable the transformation of the *I* into the true self. Disease is one of the many possibilities that lead us — as well as our family and community — to our perfection that pulsates everywhere within us. According to Sufi thought, diseases blow away our complacent view of things like autumn leaves.

To hurt your finger is painful. But to believe that it is God's reprimand and punishment — that is suffering. We spend so much of our time judging and sentencing ourselves. We judge our behavior, our job successes and failures, our past actions, and most of the time we reach the conclusion that we are never good enough, that we do not know much, and that what we do is not really worth anything. The ego loves to whisper, "You're not good enough." By judging and sentencing, not only do we close the path to deeper self-knowledge but we deprive ourselves of the possibility to grow, to truly learn from every situation, and to integrate it into the ripening process of transformation. Because the ego loves to dwell in self-pity, we deny ourselves happiness and the path to knowledge.

If we assume that to sin is to separate oneself from becoming complete, then to judge and sentence oneself is to sin because it causes suffering, nourishes the veils of self-pity, and separates us from the path to the divine light of the soul. Furthermore, it cuts us off from faith in Allāh's mercy, Ar-Raḥmān, and compassion, Ar-Raḥīm, from faith in Allāh's all-forgiveness, Al-Ghaffār, and from Allāh's love,

Al-Wadūd, as well as from His endless capacity to transform everything, Al-Qādir, and from His guidance through His eternal plan, Ar-Rashīd. For Allāh created the world of multiplicity through which Unity contemplates itself, and He created everything for humankind, and humankind for Himself.

It is of paramount importance to know—and to remember—the existential unity of all beings, because that unity is the tool to reach holiness and is itself rooted in holiness. Knowing that the things of this world do not exist as independent reality, but that they are utterly dependent on the existence of the hidden primeval substance, then to unveil this magnificence is to experience bliss. To unite the inner and outer senses also means to unite the visible life here with the hidden life beyond.

"Read!" Such is the first injunction of the Qur'an. It also means to contemplate, to know, to take time to absorb outer things, to join the outer flow of things with inner learning, to see with our whole being and with the inner eye of the heart. Use your whole being to read the signs and symbols around you—the kingdoms of plants, animals, and minerals, the clouds in the sky, the encounters and movements in your life—and take it all inside to the place where these outer ideas and symbols lead to your truthfulness.

Sura al-Hajj, سورة الحج, The Pilgrimage (22:46)
Have they, then, never journeyed about the earth, letting their hearts gain wisdom, and causing their ears to hear? Yet, verily, it is not their eyes that have become blind—but blind have become the hearts that are in their breasts!

Sufism is based on the reality of our being, the stable and constant center of our existence. This center cannot be inherited. Every being in the universe has a source, a center of stability, and in human beings this is the heart. This is also the reason why the heart is valued so highly in Sufism and by all the prophets. It is seen as the door to the invisible, the gate to the celestial, divine kingdom. The heart can unite everything. To look through the eyes of the heart is to see the universe as one. And that Unity is Allāh!

In healing, the confidence and the intention that you carry in your heart are most important. Therefore radiate confidence that you can help. If your intention to help and heal is strong and focused enough, it will affect the person you are accompanying. Work *for* people, not *on* them. Acknowledge the importance of the situation or state in which they find themselves, while at the same time reducing the danger of that state. Indeed, giving people confidence is already half the cure.

Regardless of the type, disease is basically something created by the organism itself in order to restore balance and harmony. Human beings are endowed with homeostasis. Supporting and accompanying the sick should first and foremost open a space of love and trust in which this process can take place, together with the required healing knowledge.

Whenever you formulate your intention clearly prior to doing something, you attract the energy of Unity. Everything in life has a deeper meaning! There is a natural dialogue from light to light known

to all healers when they listen to their patient's body. When the stable healthy being of one person communicates with the being of another, together they can reorient body and soul.

Healing is always a spiritual matter. Spiritual development is the aim that expresses itself in our life and in our environment. Health means to be in harmony with the world, to experience the universe and all its creatures as made of the same, unique original substance. Health means to grow beyond individual consciousness in order to feel the vibrations and currents of the universe. This universal truth manifests itself in all traditions and at all times. Its outside face is diversity and multiplicity, yet both confirm its universality: although truth unfolds its boundless creative force in countless worlds and possibilities, they all reflect the One Truth.

The Sufis believe that every human being can reconnect to the Divine and become healed and whole. Every being corresponds to their dimension. We human beings are complex masterpieces, universes with our own laws, unique in our existence. The Sufis use various practices to restore the connection needed for healing: prayers, fasting, mystical dances, music, bodywork, breathing techniques, and the power of the Divine Names.

Sura al-Inshiqāq, سورة الإنشقاق, The Splitting Asunder (84:19)
[Even thus, O men], are you bound to move onward from stage to stage.

Invariably, our life and daily routine are our training ground, the place where we transform. Yet without a connection to the highest, all-encompassing Truth, life has no basis, no meaning or shine. Like driftwood, we are then exposed to the currents, without knowing who we are or where we are going. Let love be the basis for your life. Treat your environment differently from when you were living in fear and isolation, maintain a loving attitude towards life and the creatures of this universe, and then everything will flow back to you. For whatever we do for others, we do for ourselves, and everything we do for ourselves, we do for others—such is the law of Unity. So have confidence and trust! Love, trust, freedom, and serenity in God. Wisdom is sweet!

Recitation and the Body

Every Divine Name is based on a sound code that carries a particular vibration. During recitation, this particular resonance and meaning are passed on to the being of the reciter. Every single divine form of love, every Divine Name, brings about harmony where there is disharmony, brings healing where there is pain, gives rise to trust and confidence where there is despair and isolation. Whether the disease is of the nervous system, mental, or physical, it is always rooted in disharmony.

In Sufi tradition the body itself is seen as vibration, as an energy field endowed with a soul. For the purpose of understanding, this materialized energy field can be divided into sound and rhythm, whereby the sound is our vital energy, or *qudra*. *Qudra* is the individual capacity and strength that is given to every human being. On the other hand, *qudra* is also available throughout the universe, permeating the cosmos and all living beings. It is connected to our breath, that absolute expression of life, and is stimulated and supported by it. The rhythm is the pulse that flows through our body with the circulation of the blood. The "song" born from that sound and rhythm takes shape in the heart and is colored on the inner level by our thoughts and feelings, and on the outer level by our deeds.

The center where breathing and pulse unite is the heart. This is where thoughts and deeds become attuned, colored through feelings, and carried in our inner and outer world. Of course, we have the capacity and choice not to connect our words or deeds to our heart. The laws of the heart differ from those of the mind. The heart is direct, free, and uncompromising towards the reservations of the *I*. That is why the *I* often avoids seeking counsel from the heart, whose answer most often will be uncomfortable for it. To a certain extent, the mind always asks, "How can I get more?" while the heart asks, "How can I give more?" To find a solution that also gladdens the heart is the basis of the Sufi path.

We are embedded in two rhythms—our breathing and our heartbeat. In an ordinary, quiet, resting state, they are in a ratio of 1 to 4: every minute we experience 15 to 20 breaths for 60 to 80 heartbeats. In this ratio, 1 is the basic unit, and 4 stands for the four basic qualities found in nature: cold, hot, wet, and dry. Unifying knowledge is connected with the mind, while wisdom is found in nature—both our own and one that surrounds us. Nature is the perfect companion of faith. Nature teaches the mind humility. As the Sufis say, "Neither have you invented water or the tree, light or the eye!" By acknowl-

edging its limitations, the mind can open to the necessity of faith, thus to the higher spheres where embedding is given its form.

Breathing is connected not only to thoughts but to feelings, as two sides of the same coin. Breathing is the physical aspect of thought, thinking is the psychological aspect of the breath—and feelings connect the two. Thus, every change in spirit and thoughts—in consciousness—immediately affects the breathing. When we observe our breathing, it becomes distinctly deeper, and our thoughts slow down and become quiet. When we are in turmoil, this too influences our breathing.

The interplay of body, thoughts, and feelings is both precious and essential to reaching our innate treasure.

The mental level is more sensitive than the physical, which means that our mental attitude has a major influence on our body.

Strengthening our sound, our life energy, our center, is key to becoming or remaining healthy. Disease throws us out of our familiar rhythm, and it is essential to recover it so that no sign of disease remains. The being of the disease, and the ground available to it, are not removed until the person has found their rhythm again. In other words, the person is truly free from disease, no longer prone to it, once the roots—not just the leaves or flowers—of the disease have been pulled out, or as healers would say, once the spirit of the disease has been expelled. Each human being has their own rhythm, which is essential for them to find and respect. To embed our rhythm into the rhythm of nature, we need to eat adaquate food, to achieve a balance between rest and activity, and to follow a daily, as well as seasonal, rhythm. We become whole again by breathing consciously, by developing a life-affirming mental attitude, as well as through prayer and meditation.

In the short term, all transitions to a new rhythm provoke stress, restlessness, and crises, and should therefore be approached with care. The healer's task is to accompany, motivate, and support.

All atoms are alive, whether we call them rays, traces, electrons, microbes, germs, or bacteria. Traditional healers used to call them entities, spirits, and living beings. Since their perception did not stop at the outer form but also encompassed its spirit, they endeavored to also remove the spirit of the bacteria or microbe. Thus do we become healed and free.

Reflect on death and live a conscious life.
Live in love and do your work.
Master your words and let each one come from your heart!

—Saadi Shirazi

The interplay of thoughts, body, and feelings gives rise to magnetism. Magnetism is that energy which keeps body and soul together. It is connected to the immune system, which forms the interface between body and soul.

The immune system is a defense system, and to ward off means to not let in. The opposite of defense is love. Love is the act of letting in. Every defense, every boundary, every isolation reinforces our ego and hampers us on our path to perfection. The ego puts all impulses, including the most clever, most decent, and most devout affirmations, to the service of isolation. Yet, the path of love says, "Everything that exists is good!"

Defense is most certainly important, because in our world of duality, it leads us to experience frictions and resistances—what we usually call difficulties and problems—so that we may progress through knowledge. Difficulties are legitimate. They are necessary, just as sickness has a right to be present until we transform it into healing. All are helpers on the path of love, maturity, and freedom. Everything in this world strives for maturity and freedom. To accept all circumstances and take up all challenges that divine love brings into my life—that is to become one. For that I have to make space in my heart and spirit, and think well of the One Giver. Make place for trust. "Trust is dangerous. It is life-threatening!" cries the mind. "But indispensable!" answers the heart. Trust in the wisdom of mercy, in the boundless loving hand that lies behind the bitterest medicine.

With sickness it is not so important to destroy the pathogen as to strengthen the immune system in such a way that it can defeat any pathogen. The whole human being is involved—physically, spiritually, and morally.

A body that has fallen into disharmony becomes susceptible to disharmonious influences. Indeed, it attracts them unconsciously and, together with the mind, participates in disharmony. Every physical disease is in some way associated with a mental one. Since every element attracts a similar one, disharmony attracts disharmony, and harmony attracts harmony.

THE SCIENCE OF THE LETTERS

In Islamic tradition, each of the twenty-eight letters of the Arabic alphabet has a numerical value. In his book *Al-futuḥāt al-makkiyya* (*The Meccan Openings*), Ibn al-ʿArabī describes the esoteric meanings of Arabic letters. Ibn al-ʿArabī compares the universe to a book in which every letter represents both a divine idea and a number. He also establishes a connection between the universe or macrocosm (*al-kawn al-kabīr*) and the human being or microcosm (*al-kawn aṣ-ṣaghīr*), where each letter corresponds to a part of the body. These correspondences enable the therapeutic application of the secret science of the forces hidden in the letters.

The science of the letters leads to knowledge of the levels of existence. In the highest sense, it leads to knowledge of the primordial principles, in the intermediate sense, to knowledge of the creation of the perceptible world, and in the lower sense to knowledge of the qualities of the words and names made of letters, as well as of the numbers. For the letters of a name clearly show the nature of a creature.

Human beings were given knowledge of the names.

Sura al-Baqarah, سورة البقرة, The Cow (2:31)
And He imparted unto Adam the names of all things.

In every letter pulsates an individual force that enables it to take part in the shaping of matter. The pattern of certain letters carries an individual revelation that can influence the human organism, because every organ has a particular basic vibration, a hue, which corresponds to those of a particular letter.

Every Arabic letter is also connected to an element. The order follows the inner sequence of the letters. It starts with the letter *alif*, which is connected to the fire element; the second letter, *bāʾ*, is connected to the earth element (see table of the Arabic alphabet). Since a word is the combination of specific letters, certain elements resonate automatically, thus providing another insight into the effect of the word.

The three numbers following each Divine Name in this book are calculated as follows. The Divine Name Ar-Raḥmān, which is composed of the consonants r-ḥ-m-n. Each consonant is associated with a number (r = 200, ḥ = 8, m = 40, and n = 50). If we add those numbers, the sum amounts to 298. This total represents the number of repetitions of this name used for healing on the level of the body. The second number is obtained by multiplying this total, or 298, by the number of consonants in the name, in this case 4: 4 x 298 = 1,192. This number of repetitions is especially used when dealing with the

THE 28 LETTERS OF THE ARABIC ALPHABET:
TRANSLITERATION, NUMEROLOGY, AND ELEMENTS

OUTER SEQUENCE (Alphabetical)	NUMEROLOGY	ELEMENT	INNER SEQUENCE (Numerical)	NUMEROLOGY	ELEMENT
أ = '	1	Fire	أ = '	1	Fire
ب = b	2	Air	ب = b	2	Air
ت = t	400	Air	ج = j	3	Water
ث = th	500	Water	د = d	4	Earth
ج = j	3	Water	ه = h	5	Fire
ح = ḥ	8	Earth	و = w	6	Air
خ = kh	600	Earth	ز = z	7	Water
د = d	4	Earth	ح = ḥ	8	Earth
ذ = dh	700	Fire	ط = ṭ	9	Fire
ر = r	200	Earth	ى = y	10	Air
ز = z	7	Water	ك = k	20	Water
س = s	60	Water	ل = l	30	Earth
ش = sh	300	Fire	م = m	40	Fire
ص = ṣ	90	Air	ن = n	50	Air
ض = ḍ	800	Air	س = s	60	Water
ط = ṭ	9	Fire	ع = '	70	Earth
ظ = ẓ	900	Water	ف = f	80	Fire
ف = f	80	Fire	ص = ṣ	90	Air
ق = q	100	Water	ق = q	100	Water
ع = '	70	Earth	ر = r	200	Earth
غ = gh	1000	Earth	ش = sh	300	Fire
ك = k	20	Water	ت = t	400	Air
ل = l	30	Earth	ث = th	500	Water
م = m	40	Fire	خ = kh	600	Earth
ن = n	50	Air	ذ = dh	700	Fire
ه = h	5	Fire	ض = ḍ	800	Air
و = w	6	Air	ظ = ẓ	900	Water
ى = y	10	Air	غ = gh	1000	Earth

need to integrate anew into one's family or social community. The third figure is the square of the first figure, in this case 298 x 298 = 88,804. This third figure primarily helps when we seem to have lost awareness of our connection with the Divine. So the numerical expression of the three levels for the Divine Name Ar-Raḥmān would be 298–1,192–88,804. Each level helps us expand our consciousness and free it from separation.

The Forms of the Arabic Language: Meaning and Effect

The sound and the meaning of the Divine Names are embedded in Arabic grammatical structure, which consists of basic roots flowing into various forms. Most of the time, the basic root is made of three, sometimes four, consonants. The forms are endowed with a basic quality and a resonance that affect us on all levels—physical, mental, psychological, and spiritual. This is how all the words that belong to a given form also have a sound code and a specific basic meaning in common.

When the water drops of the consonants flow into the different forms, various words, concepts, and meanings come into existence. The set forms carry active or passive, sometimes both active and passive, qualities, together with degrees of comparison. Forms with the prefix mu indicate either interaction or instrumentalization. Thus, the meaning of a Divine Name is not carried by its sound, but its form gives us an insight into its sphere of activity.

All Divine Names carry therefore an active quality, which makes it important for us to know their meaning when we repeat them. Indeed, the same forms are used throughout the Arabic language. Were the form or the sound alone decisive, we could choose any word, hoping to achieve through it a positive or negative effect, but this is not the case. Therefore, we cannot rely solely on the vibrations or form of a Divine Name to derive their meaning from their sound. All Divine Names come from the everlasting One Existing Source, Allāh, and flow out like streams into the world of existence.

The Divine Names are listed below according to their form so that the basic meaning of a form, or stem, may be brought home to us.

In Arabic, there are fifteen forms or stems. Some roots, or combinations of consonants, flow into all fifteen stems, some only into ten or less. Every stem is formed by lengthened vocals, double consonants, prefixes, an additional consonant, or a combination of the above. Each extension of the basic stem changes the meaning of the word. Thus, every stem affects a different field. The sound code has a specific effect. It is as if the light of a given Divine Name would focus on an area of life through its particular form and sound.

The following twelve sections list the most common forms and sound codes. They are meant to facilitate our use of the Divine Names. Gaining a deeper understanding of their innate potential helps us grasp their healing power and, through their recitation, bring balance, wisdom, and healing into all

areas of our life so that we may become whole. The Divine Names help us realize our psychological and spiritual potential and become what we truly are. They are places of transformation whose aim is to establish a connection between us human beings and God.

Many people find some Arabic letters difficult to pronounce. However, when we use the Divine Names, it is more important for us to know their meaning and to stay with their sound code or form than to pronounce all the individual letters in a correct way. For instance, if it is difficult for you to pronounce the silent guttural plosive q in the Divine Name Quddūs, you can be content with pronouncing it like a *k* as in kilo.

I. FĀ'IL: *the active, sole doer*

The combination of form and sound code *fā'il* is the essential active form, and it carries the meaning, the active, sole doer. It engraves itself in the heart with the clarity of a column of light that shows itself through the long vowel *alif*, *ā*. Every Divine Name based on this form penetrates us deeply and activates composure on the spiritual, emotional, and perceptual levels.

Nineteen Divine Names are based on this form. Three additional Divine Names may be added to this category, although their last vowel is long because of their special grammatical form.

The first part of the compound Divine Name Māliku-l-Mulk, Mālik, falls into this category because of its form and sound. The addition of the second name, Mulk, emphasizes its absolute and all-encompassing quality.

Al-Khāliq	Al-Bā'ith	Al-Khāfiḍ	Al-'Ākhir	Al-Māni'	Al-Hādī
Al-Bāri'	Al-Wājid	Ar-Rāfi'	Aẓ-Ẓāhir	An-Nāfi'	Al-Bāqī
Al-Qābiḍ	Al-Mājid	Al-Wāḥid	Al-Bāṭin	Al-Wārith	Māliku-l-Mulk
Al-Wāsi'	Al-Bāsiṭ	Al-Qādir	Al-Jāmi'	Al-Walī	

II. FA'ĪL: *permeating all beings without distinction*

The Divine Names that appear in this form and with this sound carry a pervading quality, their resonance permeating all beings without distinction, both on the individual and collective level. *Fa'īl* is the superlative form of *fā'il*. The heart is moved to and fro, until it finds its balance between the visible and invisible worlds, thus attaining deep inner peace.

Twenty-seven Divine Names are based on this form.

Ar-Raḥīm	Al-Laṭīf	Al-Kabīr	Ar-Raqīb	Al-Qawīy	Al-Badī'
Al-'Azīz	Al-Khabīr	Al-Ḥafīẓ	Al-Ḥakīm	Al-Matīn	Ar-Rashīd
Al-'Alīm	Al-Ḥalīm	Al-Ḥasīb	Al-Majīd	Al-Walīy	
As-Samī'	Al-'Aẓīm	Al-Jalīl	Ash-Shahīd	Al-Ḥamīd	
Al-Baṣīr	Al-'Alīy	Al-Karīm	Al-Wakīl	Al-Ghanīy	

III. FA'ŪL: touching the abyss

The Divine Names that appear in this form and with this sound carry the quality of deep penetration, reaching every pain, every suffering, no matter how deep they lie in the heart. Those names are the loving, penetrating hand that brings healing. Through their sound code and meaning, they wash and cleanse our deepest wounds, even those we can hardly bear to look at in our most exposed moments. *Fa'ūl* is the intensified form of *fā'il*, on which five Divine Names are based.

The Divine Name As-Salām is built on *fa'āl*, which is a variation on the above form, where the ū is replaced by an ā. Through this sound code, which carries additional opening, this Divine Name goes even deeper into the heart and brings elevation and a feeling of being connected to everything and everyone.

Al-Ghafūr	Ash-Shakūr	Al-Wadūd	Ar-Ra'ūf	Aṣ-Ṣabūr	Al-'Afūw	As-Salām

IV. FA"ĀL and FA"ŪL: continuity, eternally recurring

The combinations of form and sound code *fa"āl* and *fa"ūl* carry the meanings of "eternal" and "always." Their resonance is constancy, flow, eternal recurrence, without interruption or pause, like the beating of the heart. They convey the sound of continuity without beginning or end.

The doubling of the central consonants points out the quality of intensity, which is like a stamp on the heart, into which the heart eventually melts. Seven Divine Names are based on this form.

The variations *fa"ūl* and *fu"ūl* also have a doubling of the central consonant and they vibrate in the same quality, with the additional aspects of all-encompassing depth and eternity. Divine names based on those variations enter the deepest layers of the heart.

The Divine Name Al-'Awwal belongs to this category, although the meaning of its sound code can also be understood completely in connection with its opposite pole, Al-'Ākhir. Together these two names form the circle of endless continuity.

Al-Jabbār	Al-Qahhār	Ar-Razzāq	At-Tawwāb	Al-Quddūs
Al-Ghaffār	Al-Wahhāb	Al-Fattāḥ	Al-Qayyūm	Al-'Awwal

V. FA'L: the innate, omnipresent, essential quality of existence

The meaning and the effect of a permanent characteristic resonate in the combination of form and sound code *fa'l*. Whether visible or invisible, it exists free of all manifestations, as an essential, innate quality of existence whose permanence is expressed through this sound. The Divine Names built on this form are omnipresent, even if not always in an obvious manner, and they belong to the basic characteristics underlying every form of existence. Through this sound code, an ecstatic sobriety arises in the heart, granting us steadfastness even amid the heaviest storms of life. Four Divine Names are based on this form.

Another two names, Aḍ-Ḍār and An-Nūr, belong to this category, although they are based on a different grammatical outer form.

Through its vowel *i*, Al-Malik constitutes another variation, yet carries the same basic meaning.

Al-'Adl Al-Ḥaqq Al-Ḥayy Al-Barr Aḍ-Ḍār An-Nūr Al-Malik

VI. FA'AL: the permanent, steady course of the Absolute

The combination of form and sound code *fa'al* refers to the primeval nature of things, the innate, fundamental nature of the primordial substance, the Absolute. As in the previous one, the Divine Names built on this form carry the meaning of a steady course, with the additional meanings of process—its initiation and development. Three Divine Names are based on this form.

When the prefix mu is combined with a form, it carries the meaning, continuously causing.

Al-Ḥakam Al-'Aḥad Aṣ-Ṣamad

Whenever a combination of form and sound code starts with the prefix mu, it points to a constant, continuously creating, fundamental, causal force. Such a form clearly expresses that something is being done to us, something works through us.

VII. MUFA"IL: the act eternally carried out

The combination of form and sound code that pertains to the following Divine Names indicates an act being continually, indeed eternally, carried out without beginning or end. Allāh creates the manifested world anew in every moment.

Al-Muṣawwir Al-Muqaddim Al-Mu'akhkhir

VIII. MUF'IL: the all-encompassing Cause

This form and sound code shows that Allāh is the One who causes and shapes all things, all manifestations and events, that there is no Cause but Him. This particular sound code engraves absoluteness in the heart.

Due to a grammatical rule, some of the following Divine Names end with a long weak vowel.

Al-Mu'min	Al-Mubdi'	Al-Mudhil	Al-Muhyī	Al-Mu'īd	Al-Muqīt
Al-Muqsiṭ	Al-Mu'izz	Al-Muḥṣī	Al-Mughnī	Al-Mumīt	Al-Mujīb

IX. MUFAY'IL: the deeply penetrating force of transformation

This combination of form and sound code expresses both continuity and the penetrating force that find their way deeply into a being's fundamental structure. Despite this power, this name also contains lightness and softness, as in the expression "to be like wool in God's hands."

Al-Muhaymin

X. MUTAFA"IL: the state of constant mirroring

This combination adds two aspects to the essential continuity quality of the prefix *mu*. These result from the added *t* and the double "that cause a reflective, mirroring state. As a consequence, great efforts are required of the reciters who wish to enter this state. In order to reflect light well, a mirror must first be polished well.

Only one Divine Name radiates this sound. Interestingly, a longer list of the Divine Names appears only once in the Qur'an (59:23), and the list ends precisely with this name.

Al-Mutakabbir

XI. MUFTA'IL: that which is everlastingly mutual

The presence of the additional letter *t* in this sound code expresses the quality of mutuality. Allāh grants a quality, and this talent is used by the one who receives it. We take responsibility for our deeds, in the knowledge that everything comes from Allāh and that all deeds are His. This is one interpretation of the sentence, "Your will and My will are one."

Al-Muqtadir
Al-Muntaqim

XII. MUTAFĀ'IL: uniting reciprocity

This form also contains the notion of evident mutuality, to which the sound code adds the resonance of the quality of deep surrender. It carries both the active and surrendering aspects, thus uniting fire and water, courage and trust, high and low.

Al-Muta'ālī

Formulas

Repeating formulas gives us the possibility to consciously embed ourselves and that which happens around us in the all-embracing divine presence.

Through the ensuing remembrance of the all-encompassing Unity, life is given a spiritual direction that enables us to participate consciously in the blessing and the mercy.

This repetition of formulas is not a matter of morals, but expresses the cleansing of the heart and our opening to Unity.

In accordance with a hadith, the formulas *subḥāna llāh* (سبحان الله), "Limitless in his glory is God"; *al-ḥamdu li-llāh* (الحمد لله), "Praise be to God"; and *allāhu 'akbar* (الله أكبر), "God is greater," are often recited together.

By calling *subḥāna llāh* (سبحان الله), "Limitless in his glory is God," we express our recognition of the divine movements and the omnipresence of the hidden face of justice and truth.

A thief steals the handbag of an old lady, runs away, stumbles on a stone, falls down, gets caught, and the handbag is returned to its rightful owner. *Subḥāna llāh!*

This formula is also used in situations or for things whose wisdom escapes us and that we fail to understand completely. Since it concerns God, the all-encompassing quality of this formula often remains unexplained to us human beings. By pronouncing it, we separate from visible, limited things and perspectives, and embed ourselves in the Absolute, inhaling the fragrance of eternity.

The formula *al-ḥamdu li-llāh* (الحمد لله), "Praise be to God," elevates an earthly deed to heaven. It is called *al-ḥamd*. Most of the time, it either follows the realization or completion of a deed. To a certain extent, it is the counterpart of *bismillāh ar-raḥmān ar-raḥīm* (بسم الله الرحمن الرحيم), "In the name of the All-Merciful, the All-Compassionate."

Every act is initiated with *bismillāh ar-raḥmān ar-raḥīm*, "In the name of the All-Merciful, the All-Compassionate," the One who creates out of love and saves out of compassion. This formula, named *basmalla*, calls down on every act a benevolent celestial ray, blessing it in the knowledge of Unity, divine love, and mercy. May it echo in all our deeds! Whenever there is a change, whenever we enter another space, our intention is opened with this *basmalla*.

If we start our meal with *bismillāh ar-raḥmān ar-raḥīm* and end it with *al-ḥamdu li-llāh*, by pronouncing this second formula, we connect our deeds and all things with God, lifting them and embedding them in Unity.

The formula *allāhu 'akbar* (الله أكبر), "God is greater," is called *takbīr*. It is used in the call to prayer and indicates the change of position during prayers. The word *'akbar* is the comparative form (greater) of *kabīr* (great), although it is often confused with the superlative (the greatest). This formula expresses that God will always be greater than anything or anyone.

It is often used in daily life when one is surprised or overwhelmed. But it is also used to encourage or strengthen a group.

Another frequently used formula is *inshallah* (إن شاء الله), "God willing." It expresses our ignorance, our dependence, and our reliance on God, and frees us from arrogance. It shows our calm, our trust in God and in the fact that whatever is right and good will happen through His will—or not, as the case may be—and that it is good. Allāh is the goal, and everything comes from Him and returns to Him. There is no present or future without Him.

This formula is repeated in everyday life whenever one says something about the future. "I'll drive into town tomorrow, *inshallah!*" "We'll pass our exam in five days, *inshallah!*"

The formula *mā shā'a llāh* (ما شاء الله), "what God wanted (has occurred)," applies both to past and present. The event or its beginning is past, but its unfolding, its effect or our observation of it is part of the present. This formula is also used when a human being or a thing is admirable and one wishes to praise it without giving rise to envy or jealousy, simply to remind oneself that everything depends on God and everything returns to Him. Thus our heart remains free, we are content and become enjoyers of beauty.

When you see a beautiful child, you say *mā shā'a llāh!* To praise a person's melodious voice or the fact that someone is quick-witted, or when a beautiful landscape appears, you say *mā shā'a llāh!*

All acts fall into five types: imperative: *farḍ* (فرض) or *wājib* (واجب); recommended: *mustaḥab* (مستحب); allowed, left to our discretion: *mubāḥ* (مباح); to be avoided: *makrūh* (مكروه); or prohibited: *ḥarām* (حرام).

Allāh's perfect names are mentioned four times in the Qur'an.

Sura al-Aʿrāf, سورة الأعراف, The Faculty of Discernment (7:180)
AND GOD'S [alone] are the attributes of perfection; invoke Him, then, by these.

Sura Ṭā Hā, سورة طه, O Man (20:8)
God—there is no deity save Him; His [alone] are the attributes of perfection! (20:8)

Sura al-Isrā', سورة الإسراء, The Night Journey (17:110)
Say: "Invoke God, or invoke the Most Gracious: by whichever name you invoke Him, [He is always the One—for] His are all the attributes of perfection."

Sura al-Ḥashr, سورة الحشر, The Gathering (59:24)
He is God, the Creator, the Maker who shapes all forms and appearances!
His [alone] are the attributes of perfection. All that is in the heavens and on earth extols His limitless glory: for He alone is almighty, truly wise!

"When thirsty I do not drink a single drop of water,
without finding Your image in the glass."
—al-Hallaj

"Not only the thirsty seek water,
the water as well seeks the thirsty."
—Rumi

Bibliography

Akkach, Samer. *Cosmology and Architecture in Premodern Islam*. Albany, N.Y.: State University of New York Press, 2005.

Asad, Muhammad. *The Message of the Qur'an*. Kuala Lumpur, Malaysia, 2011.

Bakr, Isma'il Muhammad. *Asma'u llah al-husna, Athariha wa asrariha* [The Most Beautiful Names of Allāh, their effect and their secrets]. Cairo, Egypt: Dar al-Manar, 2000.

al-Hurani, 'Abdallah Ahmad. *Asma'u llah al-husna lil-dakirin wa-l-dakirat* [The Most Beautiful Names of Allāh for those who recite them]. Palestine: 2007.

al-Jerrahi al-Halveti, Shaykh Tosun Bayrak. *The Name and the Named*. Louisville, Ky.: Fons Vitae, 2000.

Makhluf, Hasanayn Muhammad. *Asma'u llah al-husna* [The Most Beautiful Names of Allāh]. Cairo: Dar al-Ma'arif, 1974.

an-Nabulsi, Shaykh Muhammad Ratib. *Mawsu'at asma' u llah al-husna* [Collection of the Divine Names], vol. I-III. Damascus: Dar al-Maktabi, 2004.

al-Qusayri ash-Shafi'i, 'Abd al-Karim. *At-takhbir fi-t-tadkir sharh 'asma'i llah al-husna* [Explaining and reciting the Divine Names]. Beirut: Dar al-Kotob al-Ilmiyah, 1999.

al-Rifai, Muhammad Jamal. *The Meanings of the Names of Our Lord*. Petaluma, Calif.: Sidi Muhammad Press.

Salim, 'Abd al-Maqsud Muhammad. *Fi malakuti llah ma'a asma'u llah* [In the spheres of the Divine Names]. Cairo: Sharikat ash-Shamarli, 2003.

az-Zira'i ad-Dimashqi, Shams ad-Din. *Asma'u llah al-husna* [The Most Beautiful Names of Allāh]. Cairo: al-Tawfikia Bookshop.

CONTRIBUTORS

Fawzia al-Rawi (author) holds a PhD in Islamic studies and is the author of several books, including *Grandmother's Secrets: The Ancient Rituals and Healing Power of Belly Dancing*, *Midnight Tales: A Woman's Journey through the Middle East*, and *Golden Sky, Red Earth: Women's Lives in Palestine*. Born in Iraq, she has lived and studied in several countries both in Europe and the Middle East. After completion of her Arabic, Islamic, and ethnological studies at the Universities of Vienna and Cairo, she spent twelve years in Jerusalem, where she raised her children and deepened both her theoretical and practical knowledge of Sufism under the guidance of Shaykh Muhammad al-Rifai. Her bicultural background enables her to draw a bridge of understanding between East and West in a unique manner, thus contributing to peace.

Monique Arav (translator) MA, Dip. Int. has worked with Fawzia Al-Rawi on many projects that have required cross-cultural sensitivity to achieve their vital communicative aims. Her own multicultural origins and background, together with her generosity of spirit and love for inner beauty, serve to make her more than a fitting communicator for this book.

Majed Seif (calligrapher) is a New York-based visual artist specializing in Arabic calligraphy, arabesque, and other Islamic arts. He currently teaches Arabic calligraphy at the United Nations and at New York University. Majed was born in Jerusalem. He received a bachelor's degree in archaeology and history from Birzeit University and a degree in Arabic calligraphy from the Institute of Fine Arts in Ramallah, Palestine. He is currently a graduate student in archaeology and anthropology at Hunter College in New York City. He has participated in numerous art exhibitions and workshops in Palestine and the US.

INDEX